do you want to know what a dada is?

YOU CAN HEAR ALL ABOUT IT

AT

THE SOCIÉTÉ ANONYME, Inc.

ON

FRIDAY EVENING, APRIL THE FIRST, AT HALF PAST EIGHT

AT

19 EAST FORTY-SEVENTH STREET

ADMISSION FIFTY CENTS

MAKING MISCHIEF:
DADA INVADES NEW YORK

Francis M. Naumann
with **Beth Venn**

With contributions by TODD ALDEN, ALLAN ANTLIFF, JAY BOCHNER,
ABRAHAM A. DAVIDSON, LINDA DALRYMPLE HENDERSON,
AMELIA JONES, ROSALIND KRAUSS, MOLLY NESBIT,
ROBERT ROSENBLUM, DICKRAN TASHJIAN,
STEVEN WATSON, BARBARA ZABEL

and artist biographies by Lauren Ross

WHITNEY MUSEUM OF AMERICAN ART, NEW YORK
Distributed by Harry N. Abrams, Inc., New York

This book was published on the occasion of the exhibition
"Making Mischief: Dada Invades New York"
at the Whitney Museum of American Art, November 21, 1996 - February 23, 1997.

The exhibition is made possible by a grant from **Peter and Eileen Norton** *and* **The Norton Family Foundation.**
Significant support for the exhibition has also been provided by **Evelyn and Leonard Lauder,**
with additional funding from the **Florence Gould Foundation,** the **National Endowment for the Arts,**
and the **Exhibition Associates of the Whitney Museum.**

Research for the exhibition and publication was supported by income from an endowment established by
Henry and Elaine Kaufman, The Lauder Foundation, Mrs. William A. Marsteller,
The Andrew W. Mellon Foundation, Mrs. Donald A. Petrie, Primerica Foundation,
Samuel and May Rudin Foundation, Inc., The Simon Foundation,
and Nancy Brown Wellin.

FULL DATA FOR CAPTIONS TO REPRODUCED WORKS CAN BE FOUND
IN THE WORKS IN THE EXHIBITION, BEGINNING ON P. 291.
ILLUSTRATED WORKS NOT IN THE EXHIBITION ARE FOLLOWED BY AN ✳ ASTERISK;
COMPLETE INFORMATION FOR THESE WORKS STARTS ON P. 298.

LIBRARY OF CONGRESS
CATALOGING-IN-PUBLICATION DATA
Naumann, Francis M.
 Making mischief : Dada invades New York / Francis M. Naumann and
Beth Venn ; with essays by Allan Antliff ... [et al.].
 p. cm.
 Catalog for an exhibition that opens at the Whitney Museum of American
Art, Nov. 1996.
 Includes bibliographical references.
 ISBN 0-87427-105-3 (alk. paper)
 1. Dadaism—New York (State)—New York—Exhibitions. 2. Art,
Modern—20th century—New York (State)—New York—Exhibitions. I. Venn, Beth.
II. Antliff, Allan. III. Whitney Museum of American Art. IV. Title.
 N6535.N5N32 1996 96-9890
 709'.747'10747471—dc20 CIP

©1996
Whitney Museum of American Art
945 MADISON AVENUE, NEW YORK, NEW YORK 10021

Director's Foreword

Like all art histories, the history of American art is forged in conflict and refined by necessity. It records the history of extraordinary individual invention as well as the reception and transformation of foreign concepts by the American experience. By revealing the contentious marriage of imported doctrine and aesthetic concerns with those emerging from an evolving hybrid culture, the history of American art provides a remarkably accurate and fascinating reflection of our unfolding national character.

In this respect, perhaps no concept was more foreign to the emerging American modern sensibility than the very European notion of Dada. As a response to the tragedy and horrors of World War I and the rapid change in values and social order brought about by so dehumanizing an experience, Dada evolved in Zurich and Berlin as the artistic expression of a profoundly changed Europe. Yet, as Francis Naumann makes clear in this important exhibition, few immigrant notions were more quickly or deeply absorbed into American culture.

This is far more than a mere historical curiosity. For American artists needed the particular blend of nihilism, uncertainty, and anguish carried within the seemingly playful abandon of the Dada aesthetic. American art, like America itself in the beginning of the century, was experiencing an analogous social, intellectual, and moral transformation, and the spirit and purpose of Dada provided a much needed catalyst.

This exhibition proposes that as important as Dada was to the growth of American modernism, the ferment of New York played an equally critical role in the continuing evolution of Dada itself. The impact of new technologies such as photography and cinema, of psychoanalytic theory and a concern for the subconscious mind, and of the social tumult of massive waves of immigration—all this was part of the energy of New York Dada. Much of this Dada activity could be found reflected within a small yet influential community of artists, writers, critics, and patrons located in and around the Arensberg circle. The enduring (and to some infuriating) presence of Marcel Duchamp—so central to the evolution of twentieth-century American art—emerges at this time, as does the impact of Francis Picabia and the American expatriate Man Ray. All things considered, the New York Dada years are a moment worthy of our attention and examination.

"Making Mischief: Dada Invades New York" was conceived by art historian and independent curator Francis M. Naumann. The Museum is enormously grateful to Naumann for the force of his intellect and the power of his passionate engagement in this subject. His idea for this exhibition, first manifest in his landmark 1994 book *New York Dada 1915-23*, fits perfectly with the Whitney Museum's continued mission to explore and celebrate significant periods and movements within twentieth-century American art. And as both the exhibition and this publication make clear, an understanding of this critical moment in recent art history is crucial to our understanding of the complexities of contemporary artistic practice.

Beth Venn, associate curator for the Whitney Museum's Permanent Collection, provided the critical support and guidance that helped shape the exhibition and its accompanying catalogue.

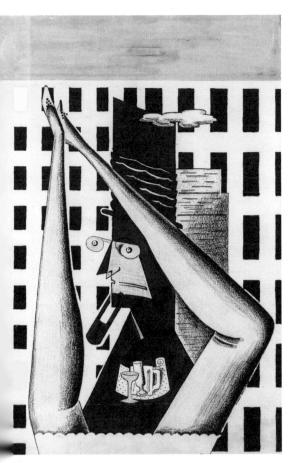

She also facilitated the process of selecting and acquiring the loans necessary to make this exhibition a reality, a complex and arduous task that Venn handled with great skill, dedication, and continuing enthusiasm.

Equally complex was the task of compiling and producing the catalogue, in which endeavor curators Naumann and Venn were aided by Mary DelMonico, the Museum's dedicated and resourceful head of publications, its brilliant editor Sheila Schwartz, and the entire publications staff—Nerissa Dominguez, Heidi Jacobs, José Fernández, and Sarah Newman. Once again, we are indebted to them for their careful hard work under the pressures of deadline and budget.

On behalf of the Trustees of the Whitney Museum, I would like to extend our gratitude to the twelve authors of the essays and chronology in this catalogue. Each of them has helped us better understand the complex subject at hand. The sincere gratitude of the Museum is also extended to the various lenders who have so graciously allowed us to temporarily place their treasured works within this exhibition. In particular, I would like to thank the Philadelphia Museum of Art, its director, Anne d'Harnoncourt, its curator of twentieth-century art, Ann Temkin, and its curator of prints, drawings, and photographs, Innis Howe Shoemaker. It should be quite apparent to all who see "Making Mischief" that their willingness to lend so many objects from The Louise and Walter Arensberg Collection was central to the realization of this exhibition.

Finally, I would like to express our gratitude to Peter and Eileen Norton and The Norton Family Foundation, in recognition of their generous grant for the exhibition. Significant support has also been provided by Evelyn and Leonard Lauder, with additional funding from the Florence Gould Foundation, the National Endowment for the Arts, and the Exhibition Associates of the Whitney Museum.

DAVID A. ROSS
Alice Pratt Brown Director

Acknowledgments

In the four years that I have been working on this exhibition, I have amassed more debts to more people than I am capable of adequately acknowledging. When I initially proposed this exhibition to David Ross, he received it with great enthusiasm, even though an exhibition on the theme of New York Dada would require showing a great number of works by European artists—not expected practice for a museum dedicated to the display and promotion of American art. However, it was my good fortune that David had already come to the conclusion that if events took place on American soil, they were unquestionably a part of American history. His vision and insight made it possible for my dream of this exhibition to become a reality.

When the goals of this exhibition were relayed to Leonard Lauder, chairman of the Whitney's Board of Trustees, he immediately offered to lend his assistance. As an avid collector of French Cubist paintings himself, he was keenly aware of the important role played by Louise and Walter Arensberg in the development of modernism in America. Throughout the course of this exhibition, he has quietly helped with many critical details, continuously offering his encouragement and support, for which I am immensely grateful.

In the initial planning stages of this exhibition, I contacted Alexina ("Teeny") Duchamp—the widow of Marcel Duchamp—asking if she would be willing to assist in helping us secure certain important loans. Not only did she help in this regard, but she also made a number of works from her private archives and collection available. Upon her death late last year, her daughter, Jacqueline Monnier, facilitated these loans and even added others, demonstrating not only that she has assumed many of her mother's responsibilities, but that she has done so with the same dedication and grace.

Beatrice Wood, a close friend and the only artist still alive who contributed to New York Dada, deserves my very special thanks. At the age of 103 (although she amusingly insists that her official age is 32), Beatrice maintains a rigorous daily work schedule in the ceramics studio adjoining her hilltop home in Ojai, California. There she continues to produce the drawings, lusterware vessels, and figurative sculpture for which she is well known. Over the course of the years, she has been interviewed countless times on the subjects of Duchamp, the Arensbergs, her own early work, and New York Dada. Yet when I asked if she would be willing to answer many of these same questions again, she agreed without hesitation. I am sure viewers of "Making Mischief" will find that her vivid recollections of this period make the art and artists of New York Dada come alive.

FRANCIS M. NAUMANN
Guest Curator

Many people, both within and outside the Whitney Museum have worked tirelessly to handle the myriad details of organizing this exhibition. We warmly acknowledge the long hours of effort and the enthusiastic spirit of a host of assistants, researchers, and interns. Lauren Ross, as senior curatorial assistant, professionally undertook a range of initial research tasks, loan request preparation, and other responsibilities in order to organize this complex undertaking. Her unflagging belief in the project continued even after her departure from the Whitney, as she cheerfully completed the important task of writing the artist biographies. Jean Shin skillfully stepped in as curatorial assistant at a particularly hectic moment, providing crucial assistance not only in expediting the complicated loan process, but also working diligently on the labor-intensive task of collecting photographs and securing necessary permissions—all of which she handled with characteristic calm, diplomacy, and good humor. The title of intern hardly suits the dedication

and efforts of Stacey Schmidt, whose research and writing on individual works are a valuable contribution. Even as a part-time assistant, Chad Weinard's wide-ranging skills, from researching to fact-checking to overseeing a host of details, served us well. Our summer intern, Jennifer Mott, satisfied the barrage of requests from both the curatorial and publications departments while forging through and completing an impressive number of projects related to the exhibition and catalogue.

Mary DelMonico, head of publications, embraced the many challenges of this catalogue from the beginning, not only overseeing all aspects of its creation, but contributing thoughtful advice and necessary encouragement throughout the process. Designer Lorraine Wild and her assistant Amanda Washburn immediately recognized that the experimental nature of Dada artifacts required a layout that was equally unconventional in appearance. Sheila Schwartz served as primary editor for the text; her professionalism and editorial skill lie silently behind every word in this catalogue. Heidi Jacobs carried out the difficult and sometimes laborious task of copy editing, catching countless errors that, gone unnoticed, would have resulted in considerable embarrassment. Nerissa Dominguez and José Fernández likewise carried out many production-related tasks, while Anita Duquette attended to the photographic reproductions.

We are particularly indebted to the eleven scholars who contributed essays on specific topics related to the subject, spirit, or intention of New York Dada and its participants. These essays bring fresh scholarly attention to a variety of themes. Special thanks also goes to Todd Alden, whose thoughtful chronological index broadens our understanding and appreciation of this dynamic period.

The exhibition itself was sensitively designed by Christian Hubert, who not only expressed immediate enthusiasm for the project, but knew instinctively how its unique features could be emphasized within the context of a museum display. Without his spatial sensitivity, the more than 150 paintings, drawings, sculptures, photographs, and related publications included in this show would not have conveyed the historical importance they have earned over time, nor would they have so easily communicated the sense of urgency and relevance they will surely harbor for a variety of viewers.

Finally, our single greatest debt is to the generosity of the donors and lenders. Our most grateful acknowledgments go to Peter and Eileen Norton and The Norton Family Foundation, as well as the Florence Gould Foundation, the National Endowment for the Arts, and the Exhibition Associates of the Whitney Museum.

Institutions both here and abroad have agreed to part with some of their most valued and fragile objects. We are especially grateful to Anne d'Harnoncourt, Ann Temkin, and Innis Howe Shoemaker of the Philadelphia Museum of Art. Without their support in lending an unprecedented number of key works from The Louise and Walter Arensberg Collection, this exhibition could not have been realized. Glenn Lowry, Kirk Varnedoe, Margit Rowell, Lilian Tone, and Cora Rosevear at The Museum of Modern Art, New York, and Mary Gardner Neill, then at the Yale University Art Gallery, kindly lent extensively from their Katherine S. Dreier Bequest and Collection Société Anonyme respectively, assuring the inclusion of many of the most important works of New York Dada. Special thanks also go to all those at the Moderna Museet in Stockholm, who recognized the important role of Marcel Duchamp's *The Bride Stripped Bare by Her Bachelors, Even (Large Glass)* to this exhibition and agreed to alter their exhibition schedule and undertake the difficult task of transporting their 1991-92 reconstruction to New York, where it was originally conceived and created. We are also deeply appreciative of the cooperation provided by a host of private collectors, who gave temporary leave to their possessions for the benefit of a larger viewing public.

Numerous other individuals have given their time, knowledge, expertise, and support to many aspects of this project: John Angeline, Caroline Armacost, Geoffrey Clements, Earl Davis, Steve Dennin, Sheri Doyel, David van Gilder, Sarah Greenough, Maura Heffner, Marie T. Keller, Andrew Kelly, Margaret Kline, Alan Moore, Christy Putnam, Jerry Thompson, Julia Thompson, Suzanne Warner, Constance Wolf, and Matthew Yokobosky.

FRANCIS M. NAUMANN, *Guest Curator*, &
BETH VENN, *Associate Curator, Permanent Collection*
Whitney Museum of American Art

NEW YORK
DADA:
Style with a SMILE

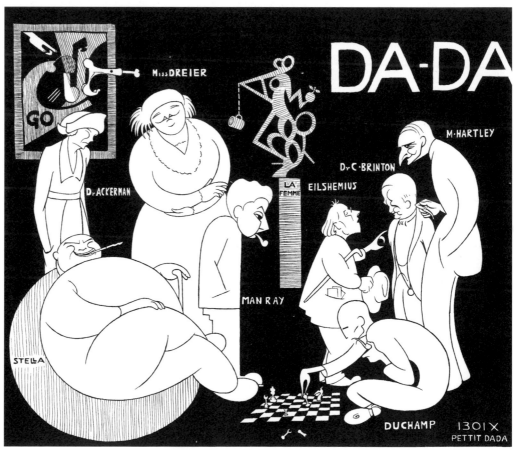

RICHARD BOIX, DA-DA (NEW YORK DADA GROUP), 1921

Just a little over seventy-five years ago—on April 1, 1921—the Société Anonyme, the first organization devoted to the display and promotion of modern art in America, held a formal session in its gallery at 19 East 47th Street in New York City. The session was devoted to answering the question "What is Dada?" Katherine Dreier, the artist and collector who, along with Man Ray and Marcel Duchamp, had founded the Société Anonyme a year earlier, had cards printed up to advertise the event. Notices were placed in the local press, but, perhaps discouraged in part by the hefty admission fee of 50 cents, few were sufficiently enticed to attend. A cartoonist by the name of Richard Boix, about whom little is known, provided an illustration of the evening's festivities, which, among other things, documents a number of the individuals who were in attendance.[1]

As president of the Société Anonyme and defacto director of its gallery, Dreier—the dominant figure on the left—presided over the event. Standing next to her is Dr. Phyllis Ackerman, a former professor of philosophy at the University of California and an acquaintance of Dreier's.[2] Before them sits the Italian-American Futurist painter Joseph Stella, whose rotund contours echo the shape of his chair. Next to him, in the approximate center of the composition, is Man Ray, who here looks rather sullen as he smokes his pipe and watches Duchamp moving chess pieces and other sundry items (including bones!) on the surface of a playing board. Engaged in conversation behind Duchamp are three men: the eccentric American visionary painter Louis Michel Eilshemius, whose work was discovered by Duchamp at the 1917 Independents exhibition and who had been given his first one-artist show at the Société Anonyme a few months earlier; Dr. Christian Brinton, the freelance art critic, who gave lectures on modern art at the Société Anonyme and then served as chairman of its membership committee; and finally, the beak-nosed Marsden Hartley, the American painter of abstractions who was invited by Dreier that evening to deliver the keynote address: "What is Dadaism?"

Hartley, of course, was not a Dadaist. In fact, he began his lecture by informing the audience of his expressionist inclinations (affirmed by the style of his painting in this period). Nevertheless, his assessment of Dada was surprisingly astute and insightful. He explained that he welcomed Dada because its practitioners did not artificially elevate art to a level it did not deserve; rather, through the vehicle of humor—which they aimed not only at the entire art establishment, but at themselves as well—they "managed to deliver art from the clutches of its worshippers." They accomplished this, he said, by "reduc[ing] the size of 'A' in art, to meet the size of the rest of the letters in one's speech."[3]

Despite Hartley's informative comments, few in the audience seem to have been capable of translating his explanation of Dada into anything that matched the works of art then on display in the galleries of the Société Anonyme. The show was billed as a Dada exhibition, but it consisted mostly of young German Cubists and Expressionists: Heinrich Campendonk, Paul Klee, Johannes Molzahn, Fritz Stuckenberg, Marthe Donas (who was actually Belgian but who had studied in France under Archipenko), and Kurt Schwitters, the only artist among them whose work can be accurately classified as Dada.[4] From a number of journalists who attended the Dada session and reported on the evening's proceedings in the next day's papers, we know that little seems to have been accomplished in the way of explaining exactly what Dada was. At one point in the evening, a

This essay is dedicated to my Dadaists: Roland and Béa.

1
Dreier purchased this drawing from Boix for $10 on April 26, 1921, as recorded in a letter from Dreier to Boix written on that date (Katherine Dreier Papers, Collection of American Literature, Beinecke Rare Book and Manuscript Library, Yale University, New Haven; hereafter referred to as YCAL). For reasons that are unclear, the authors of the catalogue of the Société Anonyme Collection claim that this cartoon was meant to illustrate a symposium on the "Psychology of Modern Art and Archipenko," held at the Société Anonyme on February 16, 1921; see Robert L. Herbert, Eleanor S. Apter, and Elise K. Kenney, eds., The Société Anonyme and the Dreier Bequest at Yale University: A Catalogue Raisonné (New Haven: Yale University Press, 1984), p. 73. Because of the date of Dreier's letter and because the word "DA-DA" appears so prominently within the image, I have identified this drawing as a depiction of the Dada session held on April 1; see Francis M. Naumann, New York Dada 1915–23 (New York: Harry N. Abrams, 1994), p. 201. Boix nevertheless based his depiction of Man Ray and Duchamp on caricatures he had made the previous year; see Herbert, Apter, and Kenney, nos. 46 and 48.

2
Ackerman's identity was provided in the first annual report of the Société Anonyme (Report 1920–1921, p. 19), but the heading on her stationery from the period (see letter cited below) identifies her as an "appraiser, lecturer and cataloguer of tapestries." When Dreier invited Ackerman to participate in the Dada session at the Société Anonyme, Ackerman

4
The exhibition was held from March 15 to April 12, 1921. There was no checklist but a flyer was printed. For more on the artists included in this show, see the separate entries under their names in Herbert, Apter, and Kenney, The Société Anonyme and the Dreier Bequest at Yale University.

3
Hartley's lecture—"The Importance of Being 'DADA'"—was published as an afterword to his collection of essays, Adventures in the Arts: Informal Chapters on Painters, Vaudeville and Poets (New York: Boni and Liveright, 1921), pp. 247–54.

responded: "I doubt whether I would be up to active participation in anything so delicious and delicate as an April first Dada meeting. I am rather a soggy soul. But I would be delighted to do anything I can"; Ackerman to Dreier, March 24, 1921, YCAL.

woman by the name of Clare Dana Mumford (not depicted in the illustration, but a painter, author, and psychologist, whom Dreier had invited in order to present an opposing point of view) became agitated because Stella kept laughing when she spoke. "Why cannot someone explain to me what these dreadful pictures on the wall mean," she quipped, "if they mean anything at all?" According to one witness, Dr. Ackerman answered her question "in profound and eloquent terms."[5] Unfortunately, her response was not recorded, but we might have profited from hearing her explain the inclusion of only one Dadaist—Schwitters—in the exhibition.

At least one journalist reviewing the show made this very observation. Writing for *The Evening World*, W.G. Bowdoin divided the works into two camps: "the cubists and near cubists," into which most of the artists could be placed; and the "Froebel creations that represent the Dadaists," into which he classified only the collages of Kurt Schwitters. "The despised and rejected things of the world are salvaged from the discard and are converted into pictorial units," he explained. "[Schwitters] has assembled composites made up of used postage stamps, canceled railway tickets, old buttons, super-animated corks, bits of wire mesh and other trash."[6] Of course, not all critics of the exhibition were as understanding and perceptive. "The pictures do not differ, so far as one can see, from the Cubistic and Extremist work that has previous been shown here," wrote an anonymous reviewer for the *American Art News*. "It is the Dadaist philosophy, standing as an explanation of much in the Extremist movement, that is the really interesting thing." But this same reviewer, who not only saw the exhibition but attended the Dada session, objected to Dada's avowed nihilism. As he concluded: "The Dada philosophy is the sickest, most paralyzing and most destructive thing that has ever originated in the brain of man."[7]

In the Boix illustration, Dreier stands between two rather curious and unusual works of art. On the left is a painting of abstract shapes, seemingly derived from the neck of a guitar and a musical note, a composition loosely resembling the structure and theme of Man Ray's 1916 *Symphony Orchestra*; some six months earlier, the painting could have been viewed at the Daniel Gallery, located just down the street from the Société Anonyme.[8] In the lower left quadrant of the Boix image, however, the word GO is boldly inscribed, something the illustrator might have picked up from a variety of Cubist compositions, or from the printed material that appeared so prominently in many of Schwitters' collages.[9] But on the other end of the picture, seemingly nailed to its frame, appears a detached foot, out of which emerges a bare bone, which, if extended horizontally, lines up with, perhaps even points to, Dreier's name. This strange juxtaposition may have harbored a specific symbolic significance, or, more likely, was meant to accentuate the unusual, non-art elements that were finding their way into the newest expressions of modern art.

Another equally bizarre work of art can be found at center, entitled, as an inscription on its base indicates, *La Femme*. The tubular forms that comprise this depiction of woman were likely derived from a sculpture by Archipenko, the Russian-born Cubist who lived in France and who was given his first one-artist show in America at the Société Anonyme immediately preceding the Dada exhibition. Of the sculptures by Archipenko from this period, the closest in appearance to the Boix illustration is *Femme assise*, which was not only included in his exhibition, but, because postcards on glossy photographic stock were made available to the press, was also widely reproduced in

5
Anonymous, "Notes and Activities in the Art World," source unknown, clipping preserved in the scrapbooks of Katherine S. Dreier, YCAL.

6
W.G. Bowdoin, "The Dadas Have Come to Town at the Société Anonyme," *The Evening World*, March 22, 1921.

7
"Nothing Is Here; Dada Is Its Name," *American Art News*, 19 (April 2, 1921), p. 1; reprinted in Barbaralee Diamonstein, ed., "Selections from The Art World: A Seventy-Five Year Treasury of Art News," Art News, 76 (November 1977), pp. 144, 146.

8
The Daniel Gallery was at 2 West 47th Street. According to information provided on a card file kept by Man Ray, *Symphony Orchestra* was consigned to the Daniel Gallery on November 12, 1919, and returned on "10/20" (probably meant to indicate October 1920). Man Ray's third and last major one-artist show at the Daniel Gallery opened five days after this painting was consigned, and although no work by this title appears in the catalogue that accompanied the exhibition (*Man Ray: An Exhibition of Selected Drawing and Paintings Accomplished During the Period 1913–1919*), it is likely that this painting was included,

since it was produced in the six-year period covered by the exhibition. It is also possible that after it had been returned by the Daniel Gallery, Man Ray made *Symphony Orchestra* available to Dreier for various exhibitions organized by the Société Anonyme.

9
Among other Schwitters' collages, *Merz 19* was likely one of those shown in the Dada exhibition at the Société Anonyme; see Herbert, Apter, and Kenney, *The Société Anonyme*, p. 597.

Kurt Schwitters, MERZ 19, 1920*
Man Ray, SYMPHONY ORCHESTRA, 1916 Richard Boix, DA-DA (NEW YORK DADA GROUP), 1921 *(detail)*

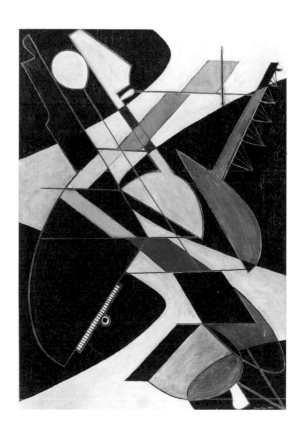

10

These postcards were also sold in the galleries of the Société Anonyme; an example of the card itself and various reviews of the exhibition are preserved in an album of press clippings compiled by Dreier; see Scrapbooks of Katherine Dreier and the Société Anonyme, vol. I, YCAL.

11

A journalist who visited Duchamp in his studio in 1916 described the shovel as being "suspended from the ceiling"; see Nixola Greeley-Smith, "Cubist Depicts Love in Brass and Glass; 'More Art in Rubbers Than in Pretty Girl!'" The Evening World, April 4, 1916, p. 3.

12

Alan Burroughs, review of Marcel Duchamp's Some French Moderns Says McBride, in The Arts, 3 (January 1923), pp. 71–72.

advertisements and reviews.[10] But no specific sculpture by Archipenko—nor, for that matter, any other artist from this period—exhibits the unusual details that can be found in this illustrator's flight of fancy. In one hand, the female figure holds an apple, suggesting, perhaps, that she represents "la première femme," Eve. And from a string attached to the woman's elbow (or is it a beaklike extension of her nose?) a cup dangles freely in space, a detail that makes the sculpture look less like the depiction of a woman and more like an organ-grinder's monkey "gone Dada."

In depicting what he thought represented Dada, it is tempting to speculate that the cartoonist drew inspiration from specific works of art he saw on display at the Société Anonyme—like the Man Ray and Archipenko—or works that he knew in some other capacity through his association with the organization and its members. Attaching a foot to a canvas frame and dangling a cup from a sculpture are ideas he could have extrapolated from the techniques of collage and assemblage, as practiced, for example, by Kurt Schwitters. But hanging the cup from a string relates to the method employed by Man Ray for the display of Lampshade, an object-sculpture made in 1919–21 of an ordinary paper lampshade that was unfurled and hung freely from a metal support.

The very gesture of hanging an ordinary object from a string, however, also brings to mind the method Duchamp used for the display of his readymades, many of which—like his snow shovel—were hung from the ceiling of his studio. The snow shovel has the distinction of being the first readymade selected by Duchamp in America, and it is a work that was discussed in the New York press as early as 1916.[11] Moreover, like the cup, a snow shovel is a manufactured object all viewers in New York would have immediately recognized. But Duchamp's unaltered readymades were meant to be exhibited "as is"—alone, i.e., without other objects—whereas the cup in Boix's illustration hangs off the side of a modern sculpture.

Whatever the sources of Boix's imagined painting and sculpture, the bizarre elements depicted are easily associated with characteristics we have come to identify as Dada. Just how much did he—or, for that matter, any other artist at this time—know about Dada, and, more specifically, what did they regard as the essential components of a Dada artifact? The Dada session at the Société Anonyme was devoted to answering this question, one which, it should be acknowledged, is still being asked today, both by specialists and the general public alike.

The main reason people keep asking "what is Dada?" is probably that the answer is not buried somewhere in the term itself. Even those completely unfamiliar with Cubist pictures, for example, can assume that the imagery is somehow related to cubes, or at least to some sort of geometric form (and they would not be entirely incorrect). The same holds true for Fauvism, where you can find fauve, or "wild" colors, and Futurism, where repetitive lines suggest movement, allowing an otherwise static image to indicate a future state.

But what do you look for in Dadaism? No one seems to have come up with satisfactory criteria. Any attempt to define the word would be self-defeating—even the Dadaists themselves knew better than to try. The majority of individuals in this period who heard the term knew that it referred to some sort of radical activity, evidenced, on at least one occasion, by an unwary New York journalist who admitted that he had no idea of what Dadaism was, but suggested that "Da" might be used to refer to "something more reserved."[12]

If we cannot define "Da," we can at least today define "Dada-ism." Just pick up any dictionary and it will tell you that Dada is a movement in literature and the visual arts that began during World War I in Zurich, and whose participants were dedicated to destroying bourgeois notions of meaning and order. Some modern dictionaries might provide an explanation of its purpose and aims: "an artistic movement based on deliberate irrationality and negation of the laws of beauty and organization" (*Webster's Seventh New Collegiate*, 1972). Encyclopedias, of course, especially those devoted to the visual arts, go even further, providing us with details pertaining to Dada's history, telling us that during World War I the movement spread from Zurich to Berlin, Hannover, Cologne, Paris, and even New York.

It is, of course, this last phase of Dada—its manifestation in New York—that is the subject of the present catalogue and exhibition. But if we want to establish the essential components of a New York Dada style, we first have to clarify what we mean by style. In the history of art, the term usually refers to the identification of prevailing characteristics. At times, critics observe that similar traits are exhibited in work produced by a number of artists working at the same time, and a movement comes into being, whereupon the suffix -ism is added (either contemporaneously or by later historians) to provide an immediate identity for the group. Beginning with the writing of Heinrich Wölfflin at the beginning of this century, art historians have customarily identified styles on the basis of their predominant visual characteristics, paying scant regard to content or to sources within the social life of a given period (although these rather restricted views are now beginning to change).[13]

Regional and nationalistic differences, however, have been used to distinguish among various styles, particularly when a style manifests itself in more than one country, as it did—thanks to the proselytizing efforts of Tristan Tzara—in the case of Dada. I am not the first to observe, for example, that Dada took on a heavily politicized nature in Germany, which is logical, considering the fact that the country was in the process of waging war with (as it appeared to many, especially the more open-minded and liberal artists) virtually the entire civilized world. In Switzerland, where many sought refuge from the conflict, the works produced by Dada artists seem to take on a more pacifist stance. The majority of Dadaists in Zurich worked within the visual vocabulary of Cubism, Futurism, and Expressionism, though because they opposed the rigid system of political alliances that made the rapid and global spread of war such an inevitability, several tried to defy logic itself by introducing chance as a positive element in artistic creativity. In Paris, where Dada transplanted itself after the war, it was natural that when Tzara combined forces with André Breton, who then served as editor of *Littérature*, a magazine devoted to the publication of vanguard poetry, the entire movement would assume a more literary focus. But when it comes to identifying the basic characteristics of work produced in New York in the same period—by artists either consciously affiliated with Dada or by those sympathetic to its aims—we are usually informed that because of its distance from the European conflict, New York Dada lacked a similar political agenda.

Such a negative approach, however, brings us no closer to determining the common elements of a New York Dada style. A more productive alternative would be to examine the works themselves, but even here we must avoid reaching any conclusions based on visual evidence alone.

13
One of the best overviews of this subject is Meyer Schapiro, "Style," in A.I. Krober, ed., *Anthropology Today: An Encyclopedic Inventory* (Chicago: University of Chicago Press, 1953), pp. 287–312; reprinted with revisions in Schapiro, *Theory and Philosophy of Art: Style, Artist, and Society* (New York: George Braziller, 1994), pp. 51–102.

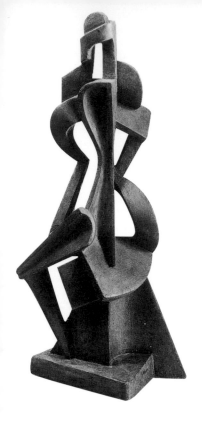

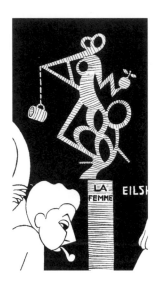

ALEXANDER ARCHIPENKO, SEATED WOMAN (GEOMETRIC FIGURE SEATED), 1920* RICHARD BOIX, DA-DA (NEW YORK DADA GROUP), 1921 *(detail)*
MAN RAY, NEW YORK, 1917 (1966 EDITION)

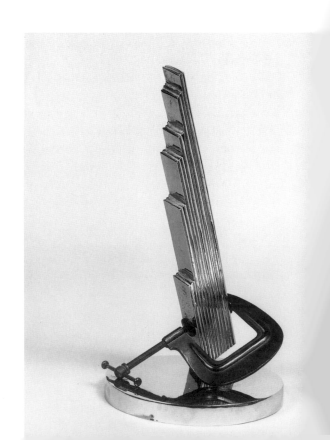

Appearances—as the highly diverse works included in this group indicate—can be deceiving. We would be better advised to look beneath the surface, taking into consideration the conceptual strategies employed by these artists in their shared desire to distinguish themselves from the time-honored traditions of the past. Using this approach, one defining characteristic of New York Dada emerges: artists in New York, perhaps because they were removed from the European conflict, felt free to express themselves with humor. Indeed, as early as 1921, Marsden Hartley recognized humor as a central trait of Dada.

"Life as we know it," Hartley explained in his address at the Société Anonyme, "is an essentially comic issue and cannot be treated other than with the spirit of comedy in comprehension." He went on to explain how we could all benefit by applying this particular aspect of Dada to our everyday lives.

> It [life] is cause for riotous and healthy laughter,
> and to laugh at oneself in conjunction with the rest
> of the world, at one's own tragic vagaries,
> concerning the things one cannot name or touch, or
> comprehend, is the best anodyne I can conjure in my
> mind for the irrelevant pains we take to impress
> ourselves and the world with the importance of
> anything more than the brilliant excitation of the moment.

Above all, Hartley believed Dadaism would "release art from its infliction of the big 'A,' to take away from art its pricelessness and make of it a new and engaging diversion, pastime, even dissipation." He concluded by telling his audience that the example of Dada would allow us to look at all forms of artistic expression in a more relaxed and enjoyable way. "We shall learn through dadaism," he concluded, "that art is a witty and entertaining pastime."

Humor, it could be argued, is the most salient, consistent, and powerful operating factor behind the creation of all great Dada artifacts. Moreover, the essential characteristics of New York Dada find their roots in a specifically American form of humor. A recent study has determined that American humor consists of the following three characteristics: it is consciously anti-intellectual (said to have developed from pragmatic solutions to pressing physical problems faced by the early settlers); it is prone to exaggeration (because of the size and diversity of the American continent); it makes fun of ethnic minorities (not only because they comprised the populace, but because in making jokes at their expense, the comedian is automatically elevated to a position of superiority).[14]

On various levels, all three of these qualities can be seen to operate in Man Ray's *New York*, the 1917 assembly of wood slats held into position by a C-clamp (shown here in a chrome-plated bronze edition made in 1966). There can hardly be anything more pragmatic and less intellectual than the simple method Man Ray has chosen to echo the profile of a New York skyscraper; the inclined position exaggerates the perspectival tilt tourists so often experience when looking up at Manhattan's towering edifices; and, finally, the recognizable, non-art materials poke fun at

14
See Don L.F. Nilsen and Alleen Pace Nilsen, "Humor in the United States," in Avner Ziv, ed., *National Styles of Humor* (New York: Greenwood Press, 1988), pp. 157–58.

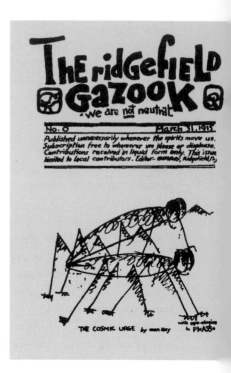

MAN RAY, THE RIDGEFIELD GAZOOK, 1915
RUBE GOLDBERG, UNTITLED, NEW YORK DADA, APRIL 1921*

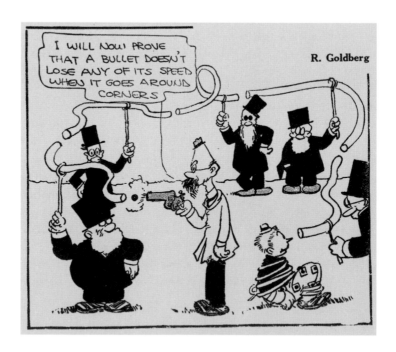

minorities—not an ethnic minority, as in traditional humor, but at the small group of critics and fellow artists who professed to understand modern art, yet who would have failed to see any merit in Man Ray's unusual assembly of materials.

If New York Dada is to be understood in relation to American humor, then it is imperative that we combine this understanding with a knowledge of the essential characteristics of French humor, since it was primarily French artists (especially Duchamp) who made such a long and lasting impression on the Americans with whom they came in contact (especially Man Ray). "The humorous story is American," wrote Mark Twain, "the witty story is French."[15] For Twain, humor consisted entirely in pacing the delivery of a story, an ability he claimed—with characteristic xenophobia—that only Americans possessed. Wit distinguishes itself from the purely comic in its ability to convey humor in a markedly subtle and sometimes ingenious fashion (too tricky, to be sure, for Twain's taste). It has also been observed that centuries of class structure and authoritarian rule have caused French humorists to direct their wit against restrictive social norms, specializing in attacks on the government and Church, developing, in the latter case, a repertoire of jokes on adultery and sexual repression.[16]

In this context, Duchamp's *Large Glass* (1915–23) (p. 50) could be seen to epitomize the central characteristic of French humor. Its full title—*The Bride Stripped Bare by Her Bachelors, Even*—openly declares a theme of sexual opposition, one which, if we follow its labyrinthian plan to conclusion, ends in frustration (for the bachelors never succeed in attaining union with the bride). Moreover, it can be demonstrated that certain techniques employed in its construction were inspired by a conscious defiance of accepted social codes (both artistic and governmental).[17] Many of the machinist paintings of Francis Picabia were also designed to address themes of sexual opposition. Some—like *Machine tournez vite (Machine Turn Quickly)* (c. 1916–18) (p. 62)—were unabashed metaphorical models for human sexual intercourse, a subject that, at the time, would have been considered taboo for most young American artists. Only Man Ray seems to have possessed a sufficient sense of defiance toward traditional artistic practice to consider addressing these subjects in his work. In March 1915, for example (a year before the word Dada was discovered in Zurich and two months before he met Duchamp), Man Ray drew a pair of copulating insects and reproduced them on the cover of a magazine he single-handedly edited, designed, and printed, *The Ridgefield Gazook*, labeling the image: "The Cosmic Urge—with ape-ologies to PicASSo."

Like Man Ray's drawing, the majority of artifacts produced by New York Dada artists reveal a level of humor directed to a select few, individuals who were either sympathetic to the Dada movement in Europe or who, like Man Ray, actively sought affiliation with it. Successful humorists—no matter what medium they may employ—know the specific interests of their audience, and often formulate remarks that are designed to appeal to—or "target"—that audience's unique sensitivities. This is precisely the technique practiced by a host of Dada artists in New York, most of whom knew that their work would be understood and appreciated only by a close circle of friends. The French refer to this type of humor as *épater les bourgeois*, where an effort is made to consciously shock, and thereby confuse those who profess to be in the know. As early as 1916, in the magazine *Cabaret Voltaire*, which contained the first appearance of the word Dada, Tristan Tzara published a "simul-

15
Mark Twain, "How to Tell a Story" (1895), in Mark Twain, *Tales, Speeches, Essays*, and Sketches (New York: Penguin Books, 1994), p. 391. I am grateful to Thomas Girst for having drawn this citation to my attention.

16
See Henri Baudin, Nelly Feuerhahn, Franáoise Bariaud, and Judith Stora-Sendor, "Humor in France," in Ziv, *National Styles of Humor*, pp. 53–84.

17
I have stressed this point in my discussion of Duchamp's reliance upon the writings of Max Stirner, a German philosopher who championed the rights of an individual over all forms of authority; see Naumann, "Marcel Duchamp: A Reconciliation of Opposites," in Rudolf E. Kuenzli and Francis M. Naumann, eds., *Marcel Duchamp: Artist of the Century* (Cambridge, Massachusetts: The MIT Press, 1989), pp. 29–32.

18
Indeed, McBride described a specific incident that occurred at the Arensbergs as a willful attempt to *épater les bourgeois*; see McBride, The Walter Arenbergs [sic]," *The Dial* (July 1920), pp. 61–64; reprinted in Daniel Catton Rich, ed., *The Flow of Art: Essays and Criticism of Henry McBride* (New York: Atheneum, 1975), pp. 156–59.

19
On an earlier occasion, I suggested that Man Ray may have chosen this particular image as a conscious parallel to the twisted path of Dada, one which followed a circuitous route through several European capitals before finally reaching New York; see Naumann, *New York Dada 1915–23*, p. 203.

20
See Phillip Dennis Cate and Mary Shaw, eds., *The Spirit of Montmartre: Cabarets, Humor, and the Avant-Garde, 1875–1905*, exh. cat. (New Brunswick, New Jersey: Jane Voorhees Zimmerli Art Museum, Rutgers University, 1996).

21
See the essays by Bruce Weber and Ronald G. Pisano in *Parodies of the American Masters: Rediscovering the Society of American Fakirs, 1891-1914*, exh. cat. (New York: Berry-Hill Galleries, 1993).

taneous" poem that was accompanied by an explanatory note, which, it was stated, was provided for the benefit of the bourgeois. And in 1920, after a tour of the Arensberg apartment, Henry McBride observed that his host took a great deal of pleasure in showing works from his collection that he knew visitors would not understand.[18]

When subjected to analysis, humor invariably loses its spontaneity and thus ceases to be humorous. Academic studies of the subject are anything but amusing. Regrettably, for the present concern, the majority of these studies are devoted to the fields of literature, theater, film, and the popular arts in general, while—with the exception of caricatures and cartoons—the visual arts have been almost ignored. Before the Dada period, cartoons and comic films were virtually the only reliable sources of visual levity. The fine arts—painting, drawing, and sculpture—offered few opportunities for amusement. It is perhaps no coincidence, therefore, that in signing his *Fountain* (p. 90) in 1917, Duchamp chose the pseudonym of "R. Mutt," a name clearly derived from the popular comic strip, Mutt & Jeff (as well as from the Mott Iron Works Company, which manufactured the urinal). Mutt & Jeff were the first cartoon characters to be copyrighted, which made their creator, Bud Fisher, quite wealthy. Man Ray was also fascinated by the drawings of Rube Goldberg, a young engineer from San Francisco who was famous in this period for his farcical "inventions," elaborate mechanical constructions designed to perform a series of complicated actions in order to complete a relatively meaningless task (a description that could just as aptly be applied to Duchamp's *Large Glass*). Man Ray reprinted one of Goldberg's cartoons in *New York Dada*, selecting an image that showed a man firing a bullet into a tube, which, after passing through a series of fragmented sections held overhead by five bearded old men and curving around almost 360 degrees, threatens to strike the head of a hapless little boy. It is tempting to speculate that Man Ray may have chosen this particular image of a man shooting a revolver as a conscious reference to Duchamp's *Large Glass*, where a chance operation in the upper portion of the construction was determined by firing matches from a toy cannon.[19]

For the most part, humor was rarely employed by painters and sculptors because they wanted to be treated as accomplished professionals, accorded the same degree of respect as lawyers, bankers, or businessmen; what generated laughter, or even a faint smile, might not be taken as the work of a serious artist. There are, however, two notable exceptions—one in America, another in France—which were roughly concurrent, though completely unrelated artistic precedents to Dada; both have been the subject of recent independent critical studies. The first is an exhibition and catalogue devoted to a group of artists and writers living in Montmartre, who, during the last quarter of the nineteenth century, made humor, parody, and satire the primary modes of expression for their creative activities.[20] The second is an exposé—again in the form of an exhibition—by the Society of American Fakirs, an organization comprised mostly of students enrolled at the Art Students League in New York. Every spring, from 1891 through 1914, the Fakirs exhibited parodies of paintings by established artists that had been accepted in the annual exhibition of the Society of American Artists.[21]

Whereas it is probable that most French artists at the beginning of this century would have known about the Montmartre humorists, it is more difficult to determine with certainty if any

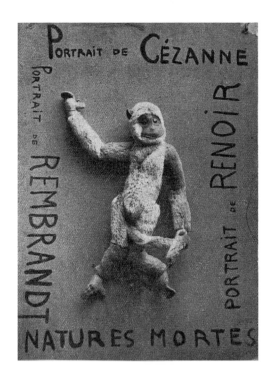

Francis Picabia, NATURE MORTE: PORTRAIT OF CÉZANNE/PORTRAIT OF RENOIR/PORTRAIT OF REMBRANDT, 1920*
Marcel Duchamp, "ARCHIE PEN CO.," 1921*

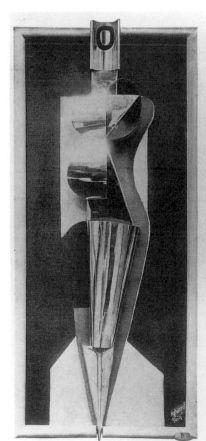

American Dadaists knew about the Fakirs. It is unlikely that the activities of this group would have escaped the notice of Man Ray, who—from October 2, 1911, through May 25, 1912—was enrolled in classes at the Art Students League. Although the 1912 Fakirs catalogue gives no indication that he participated in the exhibition itself, he would have found it hard to avoid the frenzy of activities surrounding the event—the opening parade, sideshows, dance, auction, and related activities involved almost everyone associated with the League, students and teachers alike. Indeed, of the American artists who would go on to embrace the tenets of Dada, May Ray's work displays the most consistent level of irreverence, sarcasm, and humor—aesthetic sensitivities that were an integral part of the Fakir exhibitions.

Of course, neither the Montmartre group in Paris nor the Fakirs in New York can fully account for the more extreme acts of artistic irreverence expressed by certain Dada artists. There are virtually no known artistic precedents, for example, for the 1917 assembly of a plumbing trap and miter box made by the Baroness Elsa von Freytag-Loringhoven and Morton Schamberg and given the provocative title *God* (p. 86). Nor is there any prior work of art known to me that is more artistically irreverent than Francis Picabia's stuffed monkey pulling its own tail. By means of an inscription that runs around the periphery of the image, the monkey becomes a triple-portrait of Rembrandt, Cézanne, and Renoir. These works are more than merely irreverent; they employ sarcasm, a device favored by French and American humorists. What could be more sarcastic than assigning the identity of God to a device used to trap refuse in a sanitary system, or equating the names of three accepted master painters of the past and recent past with the image of a monkey pulling its tail between its legs?

It is sarcasm that provides the essential humor in an advertisement designed by Duchamp for the "Archie Pen Co.," published in *The Arts* in the spring of 1921 to coincide with Archipenko's first one-artist show in the United States, held in the galleries of the Société Anonyme. Not only does the name of this fictitious pen manufacturer create an obvious pun on the artist's name, but the sharply tapering legs of the Archipenko relief sculpture selected to illustrate the ad actually make it look like some sort of a newfangled Cubo-Futurist pen. Not everyone got the joke; we know that at least one person who saw the advertisement took it seriously and wrote to the offices of the Société Anonyme, asking if he could be sent more information "regarding the pen, its operation and [its] price." Dreier responded by apologizing for the misunderstanding, and offered to send the man "an excellent pamphlet" on the artist for "35 cents plus five cents postage."[22]

Historians of twentieth-century art rarely identify humor as a component of style, for it is not usually something that can be readily detected visually (although the memorable example of Duchamp's readymades led many later critics and historians to categorize any work that incorporated unaltered artifacts as Dada or, in the late 1950s and early 1960s, as Neo-Dada). When the first monograph on Marcel Duchamp appeared in 1959, its author, Robert Lebel, commented that he thought "there would be plenty of room for humor." But when the manuscript was nearing completion, he realized that the subject had been hardly touched upon, so he added a chapter at the end, acknowledging the fact that humor as an element of Duchamp's work was, regrettably, discussed only as an afterthought.[23]

22
The pamphlet was by Ivan Goll and reproduced on its back cover the same relief sculpture by Archipenko that had been used for the advertisement. The man who wrote the letter inquiring about the pen was C.F. Boswell, from Pasadena, California (see his exchange with Dreier, letters dated April 20 and May 7, 1921; Papers of Katherine Dreier, YCAL). The name of the person responsible for this advertisement is not provided, although it was said to have been made by "an artist well-known in many fields." Duchamp's identity was first suggested by Ruth L. Bohan, "Katherine Sophie Dreier and New York Dada," *Arts*, 51 (May 1977), p. 98.

23
Robert Lebel, *Marcel Duchamp* (New York: Grove Press, 1959), pp. 95–97, "Marcel Duchamp: Whiskers and Kicks of All Kinds."

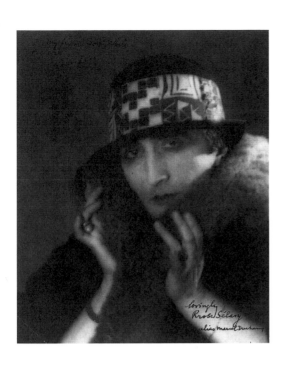

MAN RAY, RROSE SÉLAVY, 1921*
CHARLIE CHAPLIN, STILL FROM A WOMAN, 1915*

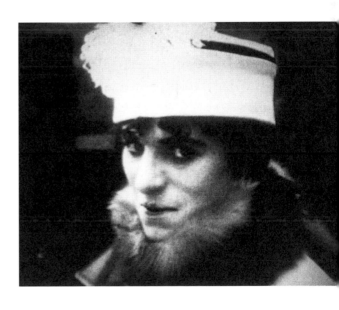

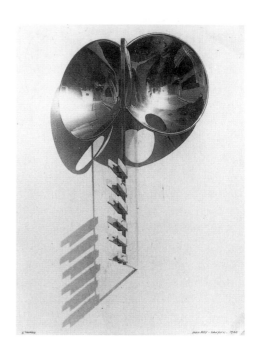

MAN RAY, L'HOMME, 1920*
MAN RAY, LA FEMME, 1920*

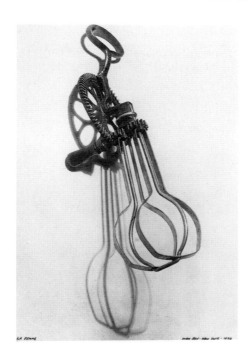

One of the examples Lebel cited as a reflection of Duchamp's humor is contained in a letter that the artist wrote to Tristan Tzara in the early fall of 1922, during the time of his last Dada-period sojourn in New York. Duchamp proposed to manufacture the word DADA as an insignia, which, he said, could be cast in silver, gold, and platinum, to "be worn as a bracelet, badge, cuff links, or tie pin." The item was to be sold in every country for a dollar or its equivalent, with Duchamp handling the American enterprise. It would be accompanied by "a fairly short prospectus (about three pages in every language)," which would "enumerate the virtues of Dada." The purchaser would be informed that the insignia would protect him or her "against certain maladies, against life's multiple troubles," or as Duchamp put it, "something like Little Pink Pills which cure everything." The lucrative potential of this scheme seems to have aroused little interest among Duchamp's Paris friends, for the insignia were never manufactured.[24]

The humorous content in a number of other works by Duchamp from these years is equally apparent, such as his ingenious creation of a female alter ego in 1920: Rose Sélavy. Some years ago, I traced the origin of this female character to the tradition of cross-dressing in the Comédie Française, and—without knowing that another Duchamp scholar had done so independently—I likened the creation of Rrose (with a double "rr," as her name changed later in Paris) to a comic situation that occurred in Charlie Chaplin's film, *A Woman*.[25] In this film, released in New York during the summer of 1915 (shortly before Duchamp's arrival), Charlie dressed up like a woman to seek entrance into a boardinghouse where his girlfriend lived. To make the comparison convincing, I even managed to isolate a still from the film that nearly matched the famous pose of Rose as she was later recorded by Man Ray's camera.

Some years earlier, Man Ray had also played with gender identities in his work. In 1918, he paired the photograph of an eggbeater with that of a light reflector and clothespin assembly, calling the former *Homme (Man)* and the latter *Femme (Woman)* (p. 108). The titles invite us to look at the photographs and seek out the specific details that Man Ray wanted us to interpret as uniquely male or female anatomical equivalents. On an earlier occasion, I discussed the works from this point of view,[26] only to discover later that two years after he made the original photographs, Man Ray switched the gender identities. In 1920—probably when Tristan Tzara asked him to contribute to a Dada exhibition he was organizing in Paris—Man Ray printed the two images again, but this time he clearly inscribed his print of the eggbeater *La Femme*, and that of the light reflectors and clothespins *L'Homme*.

Since only those familiar with the first set of prints would have known that a gender switch had taken place, was Man Ray making a private joke, one which only he and a few friends would understand? And is it merely coincidental that he switched the gender of these two objects at just about the same time that Duchamp created Rose Sélavy? My guess is that Man Ray was making an insider's joke that (with the possible exception of Duchamp) barely extended beyond the walls of his darkroom.

Comedians have long known that jokes can carry an added level of impact when they are aimed intentionally over the heads of their audience. Jokes with delayed responses are especially

24
Undated letter, but based on internal evidence probably written in September 1922; see Naumann, *New York Dada 1915–23*, pp. 206–7, 241, nn. 52, 53.

25
Naumann, "Reconciliation of Opposites," p. 22. The scholar who had already suggested this film as a possible source for Duchamp was André Gervais, *La raie alitée d'effets: Apropos of Marcel Duchamp* (Quebec: Hurtubise, 1984), p. 359 n. 3. The distinction between the spelling of Rose and Rrose is given in Naumann, *New York Dada 1915–23*, p. 228, n. 59.

26
Naumann, "Man Ray, 1908–1921: From an Art in Two Dimensions to the Higher Dimension of Ideas," in Merry Foresta, ed., *Perpetual Motif: The Art of Man Ray* (New York: Abbeville Press, 1988), p. 77.

effective; at first, only one or two members of an audience get the joke; they laugh, the laughter becomes infectious, and eventually takes over the entire crowd. A similar sequence seems to have happened with the urinal incident at the 1917 Independents exhibition: in the beginning, only a few close friends understood what Duchamp was up to; eventually the circle expanded to contain virtually every member of the Arensberg group.

In the years before his death, Duchamp was often asked to comment on the work he produced during the Dada period in New York, especially the *Large Glass* and the readymades. In a characteristically dismissive fashion, he would explain that these works were made simply for amusement. Indeed, after having seen the Duchamp retrospective at the Tate Gallery in 1966, a journalist asked if what he had produced was art or "a gigantic leg-pull." Duchamp laughed and reportedly responded: "Yes, perhaps it is just one big joke."[27] But if it was a joke, it was intended for a highly select audience, one in a unique position to accept the Dada message and its full implications. Unlike the earlier Montmartre artists in France and the Fakirs in New York, whose work poked fun at the prevailing artistic establishment, the Dadaists had a greater influence on subsequent generations because their humor was wrapped in a package that challenged the very definition of art itself. Those who fail to accept the validity of that challenge—both then and now—are the ultimate target of Dadaist humor. We can be relatively certain that most of the artists associated with Dada understood and accepted the more profound aesthetic implications of the movement, even though, in many cases, their work does not contain elements that can be readily associated with a Dada style.

A number of these artists were present in the galleries of the Société Anonyme when, in January 1921 (about two months before the Dada session was held there), Margery Rex, a reporter for the *New York Evening Journal*, stopped by to ask the artists themselves for a definition of Dada. Their responses were published in an article headlined "'Dada' Will Get You If You Don't Watch Out: It Is on the Way Here." It was reported that Dreier told the journalist "Dada is irony"; Duchamp said it was "nothing"; and Stella told her it meant "having a good time." Only Man Ray provided a response that linked the movement to other expressions of modern art, and only he echoed the words of Tristan Tzara by saying that Dada was "a state of mind."[28]

Dada was, of course, all these things, especially a state of mind—an attitude, if you will, which seeks to distinguish itself from the past in such a decisive way that it challenges all forms of aesthetic precedent. But unlike the artists in Switzerland, Germany, and France, the Dadaists in New York were driven by a conscious sense of irony (as Dreier said), amusement (as Stella implied), and a genuine sense of humor (as Hartley explicitly stated). The end result is a style which, I believe, we can readily identify. Yet we must never try to define the "Da" in Dada. To do so would be to only get half the joke!

27
William Marshall, "Marcel Laughs Off His Show," *Mirror* (London), June 19, 1966; quoted in Jennifer Gough-Cooper and Jacques Caumont, "Ephemerides on and about Marcel Duchamp and Rrose Sélavy 1887–1968," in Pontus Hulten, ed., *Marcel Duchamp*, exh. cat. (Venice: Palazzo Grassi, 1993), entry for June 16, 1966.

28
Margery Rex, "'Dada' Will Get You If You Don't Watch Out: It Is on the Way Here," *New York Evening Journal*, January 29, 1921; reprinted in Rudolf E. Kuenzli, ed., New York Dada (New York: Willis Locker & Owens, 1986), pp. 138–42.

MANHATTA, 1920
PAUL STRAND *and* CHARLES SHEELER

The black-and-white, silent film **Manhatta** is a portrait of Manhattan island.
New York in 1920 was a modern industrial center, with building construction, waterfront industry,
and the businesses of Wall Street as central activities.
Paul Strand and Charles Sheeler captured these activities by using the constructions and movements of the city itself
as motifs as well as mechanisms to produce the film. Their motion picture camera was positioned
on skyscrapers to illustrate the height of the city with the specks of people moving below; likewise, the camera
was placed on moving boats to illustrate the movement of other ships and industries surrounding the island.
Through this approach, **Manhatta** became a film of contrasts both in scale and culture:
construction workers and businessmen; boats versus cars and trains; shadows and highlights; speed versus stasis.

The tone of the images, however, was set by the words of Walt Whitman.
Quotations from several of Whitman's poems appeared on the screen, among them "Mannahatta"
("High growths of iron, slender, strong, splendidly uprising toward clear skies"; "City of hurried and sparkling waters").
Such texts preceded groups of images and created a voice of confidence and grandeur.
New York was a city where the black smoke billowing from furnaces and tugboats circling the island's watery perimeter
dissipated into the "gorgeous clouds at sunset!" Manhattan, like the ships and tugboats surrounding it,
was a floating, magical place.

The film's title had alternated between **Manhatta** and **Mannahatta** during its production. It premiered
at New York's Rialto Theatre on July 24, 1921, as New York the Magnificent; two years later, Marcel Duchamp
screened it at a Dada festival in Paris as Fumée de New York (Smoke of New York). Eventually,
the film came to be known only as **Manhatta**.

—*Matthew Yokobosky*

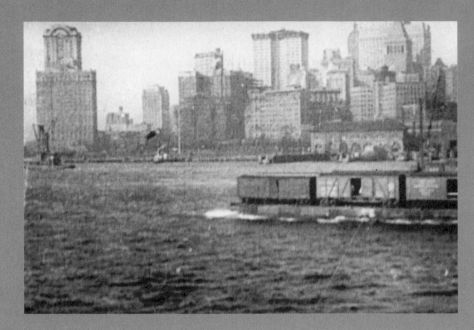

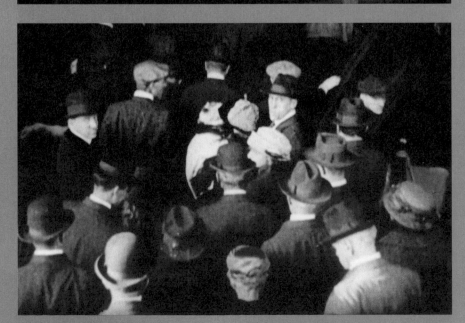

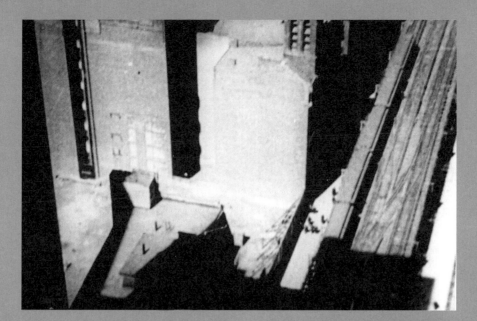

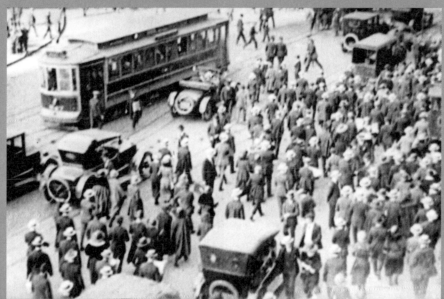

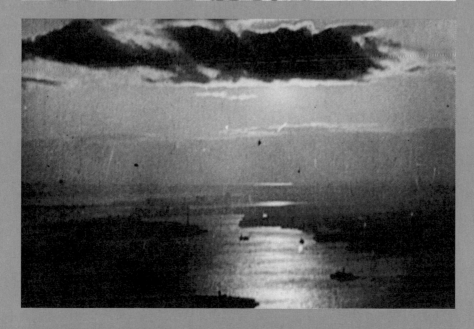

TODD ALDEN

HERE NOTHING, ALWAYS NOTHING: A NEW YORK DADA Index, etc.

JANUARY 9
Richard Nixon, 37th President of the United States, is born.

JANUARY 15
First telephone hook-up between New York and Berlin.

JANUARY 20
Picabia and Gabrielle Buffet-Picabia arrive in New York to attend the Armory Show; Picabia is the only European artist to attend.

JANUARY 31
Dissatisfied with Balkan peace terms negotiated in London, in which Turkey agrees to surrender Adrianople, Turkish nationalists orchestrate a *coup d'état* at home.

FEBRUARY 1
Grand Central Terminal opens in New York. 150,000 visitors descend upon the building at 42nd Street, curious about the station's architecture and its electrical system. The terminal is designed by Reed & Stem and Warren & Wetmore.

1913

Nijinsky's ballet *Jeux*, with score by Debussy, opens in Paris.

Crossword puzzles introduced in *The New York World*.

Apollinaire publishes *Les peintres cubistes (The Cubist Painters)*, discussing the work of ten artists, including Duchamp:
"Perhaps it will be the task of an artist as detached from aesthetic preoccupations, and as intent on the energetic as Marcel Duchamp to reconcile art and the people."
Les peintres cubistes is translated in *The Little Review* in 1922. **Apollinaire** also publishes *Alcools* in 1913.

New York City's rapid transit system carries more than 810 million passengers.

Marcel Proust publishes *Swann's Way*, the first part of *Remembrance of Things Past*.

Thomas Mann, *Death in Venice*.

D.H. Lawrence, *Sons and Lovers*.

Edith Wharton, *The Customs House*.

Edmund Husserl, *Phenomenology*.

A Study of the Modern Evolution of Plastic Form by Marius de Zayas, Benjamin de Casseres, Paul Haviland, and Sadakichi Hartmann is published by the Photo-Secession Galleries in New York.

Second installment of **Erik Satie**'s autobiographical *The Day of a Musician* is published:
"Here is the exact time-table of my daily life: Get up: 7:18 a.m.; inspired: from 10:23 to 11:47. I lunch at 12:11p.m. and leave the table at 12:14."

Ford Motor Company implements assembly-line technique, popularizing the practice of mass production.

Duchamp assembles *Bicycle Wheel*, the first readymade (although he would not categorize it as such until 1915).

The Federal Reserve System is created.

Theory of stellar evolution is formulated by H.N. Russell.

FEBRUARY 3

The US Constitution is amended to permit the introduction of a graduated income tax.

FEBRUARY 12

New York State Commission reports widespread violations of child labor laws.

FEBRUARY 17

The "International Exhibition of Modern Art" opens at the 69th Regiment Armory at 305 Lexington Avenue at 25th Street in New York. Organized by Walter Pach, Arthur Davies, and Walt Kuhn, and financially backed by patrons Gertrude Vanderbilt Whitney and Mabel Dodge, the Armory Show is America's first introduction to modern European art; it is modeled after the 1912 Sonderbund exhibition in Cologne. The exhibition consists of 1,046 catalogued items and more than six hundred uncatalogued items; among them, the show's *succès de scandale*, Marcel Duchamp's *Nude Descending a Staircase, No. 2*; other works include Picabia's *Dances at the Spring* (later acquired by Walter Arensberg), Brancusi's *Mademoiselle Pogany*, and Van Gogh's *Mountains at Saint Remy.* 123 of the 174 works sold out of the exhibition are by European artists. As many as 10,000 visitors arrive on the final day, causing massive traffic jams around the Armory. Approximately 88,000 people in all see the show in New York. Smaller versions of the controversial exhibition travel to Chicago and Boston.

Critics of the Armory Show focus on Duchamp's *Nude Descending a Staircase*; Peyton Boswell, writing in *The New York Herald,* describes it as a "cyclone in a shingle factory." *Arts and Decoration* devotes a special issue to the Armory Show, prepared by Guy Pène du Bois.

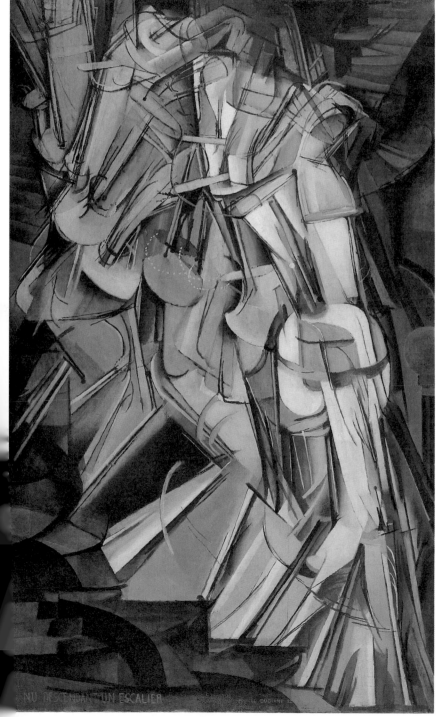

MARCEL DUCHAMP, NUDE DESCENDING A STAIRCASE, NO. 2, 1912

FEBRUARY 22
Ferdinand de Saussure, the Swiss founder of modern linguistics, dies.

MARCH 3
Suffragettes stage a massive parade in Washington, D.C., on the eve of the inaugural celebration of President Woodrow Wilson, who avoids the parade while traveling through town.

MARCH 4
Theodore Roosevelt skips Wilson's inauguration to attend the Armory Show; he later compares Duchamp's nude to the Navajo rug in his bathroom.

MARCH 17
Stieglitz gives Picabia his first one-artist exhibition (of watercolors) in the United States at his gallery, 291, the space that had already introduced America to Cézanne, Dove, Hartley, Matisse, Picasso, Rodin, and Rousseau. Picabia, who quickly demonstrates a flair for the art of publicity, grants three New York interviews: *The New York Times*, February 16; *The New York Tribune*, March 9; *The New York American*, March 30; Picabia also publishes a statement in *Camera Work* (April–July).

MARCH 29
German Reichstag raises taxes to finance increased military spending.

MARCH 31
A record high of 6,745 immigrants arrive at Ellis Island, New York, on this day.

FRANCIS PICABIA, NEW YORK, 1913

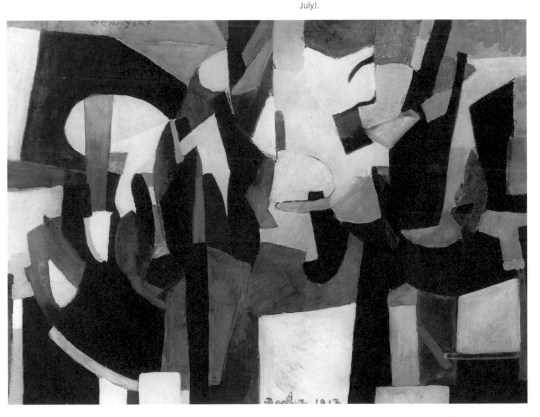

Sigmund Freud publishes *Totem and Taboo*, an attempt to discover the foundations of religion in the Oedipus complex.
The four essays comprising this work had previously been published between 1912 and 1913 in *Imago*.
Freud is reelected president of the International Psychoanalytic Association.
Duchamp's *Nude Descending a Staircase, No. 2* sells from the Armory Show for $240
to F.C. Torey, a San Francisco antiquities dealer from whom
Walter Arensberg would acquire it in 1919.
Reports that 14.7% of the US population is foreign-born appear with editorial commentary

APRIL
Gabrielle Buffet-Picabia in a special issue of *Camera Work* (April-July) dedicated to modern art: "The condition of art today is not, then, one of sudden and unexpected upheaval but the result of a necessary evolution. Each mode of expression naturally tends to break through the limitations of the old artistic conventions in its endeavor to find a new formula which will relate the trend of events of modern consciousness."

APRIL 3
Emmeline Pankhurst, the British suffragette, sentenced to three years in prison for inciting the destruction of the home of the Chancellor of the Exchequer. Immediately thereafter, suffragettes storm the Manchester Art Gallery, mutilating eighteen paintings. British fear further attacks on national treasures.

APRIL 8
At 291, Stieglitz shows Marius de Zayas' abstract caricatures, considered to be among the first abstract portraits in 20th-century Western art. Picabia, himself the subject of one of the portraits, is impressed, and he and de Zayas become friends.

APRIL 9
Ebbets Field, fourth home of the Brooklyn Dodgers, opens. It will be the site of eight World Series before closing in 1957.

MAY 3
$235,000 is the price industrialist and New York art collector Henry Frick pays for Hans Holbein's portrait of Thomas Cromwell; Frick, the former president and chairman of Carnegie Steel, was a millionaire by the age of thirty.

10,000 suffragettes march in New York parade, demanding the right to vote for women.

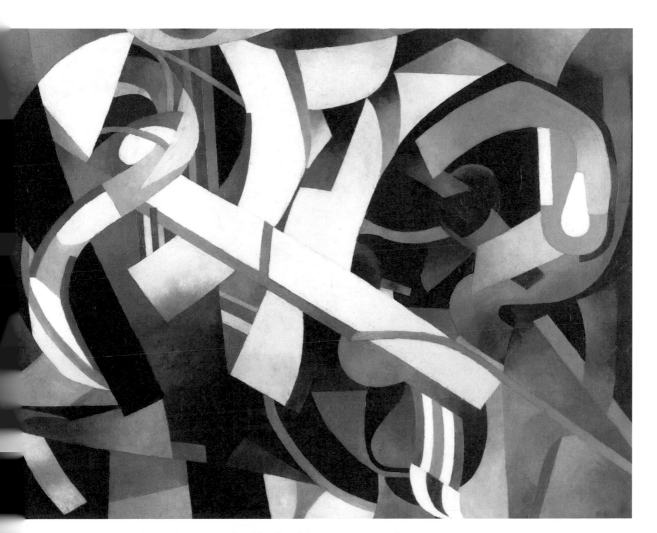

FRANCIS PICABIA, PHYSICAL CULTURE, 1913

...suggesting that America faces a "grave racial problem" and the immigrant population is a "**menace to our civilization**."

New York is the center of vaudeville, America's most popular theater form at the time. **Vaudeville** incorporates variety shows, minstrels, melodrama; its commercialization of various ethnic cultural forms deeply impacts on popular culture. Blacks are excluded from vaudeville audiences.

MAY 17
Marsden Hartley arrives in Berlin, where he stays until the end of 1915. In November 1913, he makes a brief trip to New York for his one-artist exhibition at 291.

MAY 29
Nijinsky's ballet *The Rite of Spring*, with score by Stravinsky, is first performed by the Ballets Russes in Paris. The ballet's focus on a sexual fertility rite, which includes ritual sacrifice, is received by a jeering and riotous crowd.

MAY 30
Peace treaty signed in London, officially ending the eight-month Balkan War. Fighting breaks out one month later, however, between Bulgaria and its ex-allies Greece and Serbia.

MAY 31
A Constitutional amendment requires US Senators to be elected directly by the people rather than by state legislators. Still, only men are permitted to vote.

JUNE
Benjamin de Casseres publishes "The Renaissance of the Irrational" in *Camera Work*: "It is the sense of the Irrational as principle of existence. It is the divination of Chance. It is the apotheosis of the Intuitive. The Irrational is the groundwork of all existence."

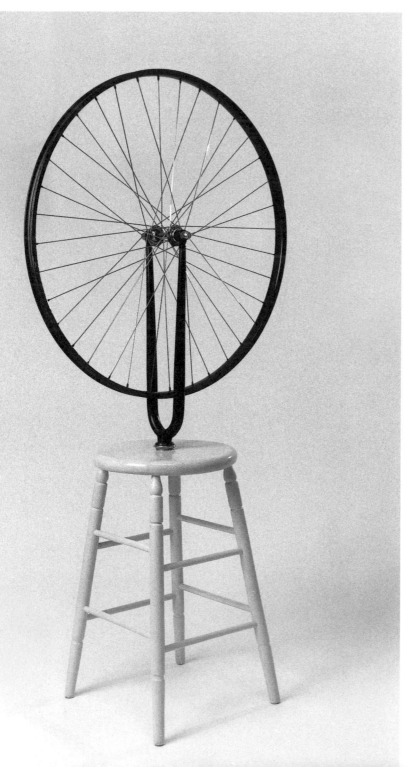

JUNE 1
Georges Carpentier knocks out British champion Bombardier Wells in the fourth round to win the light-heavyweight boxing championship of Europe.

JULY 15
Japanese railway workers attacked by American workers in Steamboat Springs, Colorado.

JULY 24
In New York, Gene Tunney knocks out Georges Carpentier in the fifth round.

AUGUST 10
Balkan Peace Treaty signed in Bucharest; Bulgaria refuses to participate.

AUGUST 26
In Montreal, Henry Ford defends the Ku Klux Klan as "patriots."

SEPTEMBER
Apollinaire, the French poet, publishes the manifesto "L'Antitradizione futurista" in the Italian journal *Lacerba*.

SEPTEMBER 7
Germany, Austria, and Italy consolidate as the Triple Alliance, which "must act as a single state in case of war."

OCTOBER
Marius de Zayas writes in *Camera Work*: "The theories that modern art has brought forth are of equal importance with, if not more importance than its plastic productions."

Philadelphia (AL) beats New York (NL) in five games in World Series play.

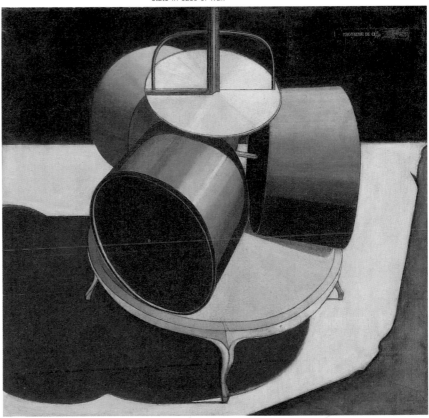

Nauticus, the German yearbook on naval forces, reports that the **Great Powers** have built 133 warships and 93 submarines. Germany increases the size of its army from 120,000 to 660,000 men.

The Woolworth Building, then the world's tallest skyscraper, opens. Designed by Cass Gilbert, it rises 60 stories to a height of 792 feet.

Millionaire oil magnate **John D. Rockefeller** establishes the Rockefeller Foundation in New York; its stated purpose is "to promote the well-being of mankind throughout the world."

Man Ray, moving out of his parents' house, joins artists' and intellectual colony in Ridgefield, New Jersey (across the Hudson River from Manhattan), where he meets Alfred Kreymborg and Max Eastman.

Duchamp continues to compile notes for *The Bride Stripped Bare by Her Bachelors, Even (Large Glass).*

OCTOBER 10

The Panama Canal opens; construction speeded by the conquest of malaria and yellow fever. George Washington Goethals, the canal's builder, is appointed governor of the Canal Zone three months later.

OCTOBER–NOVEMBER

President Wilson, reflecting an isolationist US policy, declares that America will not invoke the Monroe Doctrine and involve itself in Latin-American affairs. Days later, he demands the retirement of Mexican President Huerta, who had seized power in a *coup d'état*; Mexican civil war continues.

NOVEMBER

Picasso's early Cubist constructions appear for the first time in reproduction in *Les Soirées de Paris*, edited by Apollinaire and Paul Cérusse.

In *Camera Work*, de Casseres writes: "Sanity and simplicity are the prime curses of civilization....We should mock existence at each moment, mock ourselves, mock others, mock everything by the perpetual creation of fantastic and grotesque attitudes, gestures and attributes."

NOVEMBER 1

Twelve are wounded at Ku Klux Klan riots as Federal troops enter Niles, Ohio.

NOVEMBER 7

Albert Camus, the French existentialist, is born.

NOVEMBER 14

Salon d'Automne opens in Paris with works by Picabia, Gleizes, and Kupka. Cubist works are excluded.

NOVEMBER 25

Charlie Chaplin marries sixteen-year-old Lita Grey in Mexico City.

DECEMBER 13

The *Mona Lisa* is recovered in Florence, having been stolen more than two years earlier from the Louvre. A painter, Vincenzo Perugia, is arrested after he allegedly tries to sell the painting to an antiques dealer. Apollinaire had been arrested in September 1913 in conjunction with the theft and charged with receipt of stolen property.

MARIUS DE ZAYAS, ALFRED STIEGLITZ, c. 1912
MARIUS DE ZAYAS, PORTRAIT OF FRANCIS PICABIA, c. 1913

The **proto-Dada** statement
"Vers l'amorphisme" appears in a special issue of *Camera Work* (April–July)
and is signed "Les Hommes du Jour."
The **foxtrot** is the new dance craze sweeping America.
William Carlos Williams' poems first published in *Poetry*.
Smart Set, a literary journal edited by Willard Huntington Wright,
begins publishing modern European writers.
The **Geiger counter,** a device used to measure radiation, is invented by German physicist Johannes Geiger.
The first **Paramount** films are produced.
The Regent Theater, considered the **first movie palace**, opens with a seating capacity of 1,800
in New York on what is now Adam Clayton Powell Jr. Boulevard at 116th Street.

JANUARY 5

Using the popular press to amplify his message and to curry favor with labor, Henry Ford announces a profit-sharing plan with his 13,000 employees, who are to receive a minimum of $5 per eight-hour day. A *New York Times* correspondent asks Ford if he is a Socialist, while the Socialist *New York Call* refuses to praise any "division of earnings between labor and capital."

FEBRUARY 13

Alphonese Bertillon, criminologist and inventor of fingerprinting, dies.

MARCH

Arthur Cravan attacks modern art in a review of the Salon des Indépendants in his journal *Maintenant* (March-April). No artist is spared scandalous affront, including those in Apollinaire's circle. In fact, Apollinaire challenges him to a duel and Sonia Delaunay takes him to court. Cravan's brazenness is amplified by the candor of his unqualified remarks, such as his particularly harsh criticism of Robert Delaunay, which begins, "Once more I must admit that I have not seen his paintings." Self-conscious of his self-promotional publicity-seeking effort, Cravan writes in the introduction: "If I write it is to infuriate my colleagues, to make people talk about me and to try making a name for myself. With a name, you succeed with women and in business."

MARCH 12

Constantin Brancusi's first one-artist exhibition opens at 291. Two contemporary American collectors acquire a large number of Brancusi's works: New York lawyer John Quinn and Walter Arensberg.

1914

After only five months of war, **casualties** on each side number one million.

Picabia, a Cuban citizen, permits himself to be drafted into the French army.

Charlie Chaplin directs and stars in the first full-length feature comedy, *Tillie's Punctured Romance;* he also appears in *Making a Living.*

Ezra Pound submits T.S. Eliot's "Love Song of J. Alfred Prufrock" to *Poetry,* which publishes it the following year.

Edgar Rice Burroughs' first Tarzan novel, *Tarzan of the Apes.*

First successful heart surgery performed on a dog by Dr. Alexis Carrel.

International Business Machines, incorporated in 1911, opens its offices on New York's Broad Street.

Hugo Ball and his wife, Emmy Hennings, arrive in Zurich from Berlin.

Irving Berlin's *Watch Your Step* opens in New York.

With battles flaring across Europe, Army shuts out Navy 20-0 at Franklin Field, Pennsylvania.

Yale Bowl opens in New Haven with capacity seating of 80,000.

The Apollo Theater is erected at 252 West 125th Street.

W.C. Handy publishes the blues classic, "St. Louis Blues."

Arnold Schönberg experiments in atonal compositions and declares his twelve-tone scale.

B. Altman, one of New York City's most fashionable department stores, opens at 34th Street and 5th Avenue.

MARCH 16
The wife of the French finance minister, Joseph Caillaux, is accused of murdering Gaston Calmette, editor of the newspaper *Figaro*. Her explanation: "There is no more justice in France. There is only the revolver."

MARCH 21
French light-heavyweight boxing champion Georges Carpentier is defeated by Joe Jeannette, an African-American.

SPRING
Demuth returns to New York from Paris; he summers in Provincetown.

APRIL
Marius de Zayas writes in *Camera Work* (April): "I call my latest manner of plastic representation caricatures, only because they are the natural evolution of my former plastic expression which was consequent with what has been understood by caricature. These are not art, but simply a graphical analysis of individuals."

MAY-OCTOBER
Werkbund exhibition in Cologne, during which Arp meets Max Ernst.

MAY 3
Man Ray marries Adon Lacroix in Ridgefield, New Jersey.

MARCEL DUCHAMP. PHARMACY, 1914

MAY 12

Apollinaire reports in *Paris-Journal* that a Congressional Joint Committee has decided that modern art objects will henceforth enter the United States duty-free (previously, art less than twenty years old had been taxed at 15 percent). This tax exemption facilitates the French art invasion of America initiated by the Armory Show. Responding to an appeal by New York collector John Quinn and Mr. Underwood, Congress passes the legislation against the vociferous protest of American artists. Arguments for the duty-free rule are made in the name of advancing the arts in America, maintaining the need for "the country [to] be informed about the latest European, and especially the latest French, artistic developments."

MAY 19

Apollinaire writes in *Paris-Journal*: "Duchamp, who is the youngest member of this family of Norman artists, is, in my opinion, the most obviously talented and the most original. Having become a librarian at the Sainte-Geneviève library, he catalogues books not far from the same Charles Henry whose scientific investigations concerning painting exerted a great influence on Seurat and ultimately led to the birth of divisionism. And that is why we have seen no painting by Marcel Duchamp anywhere for more than two years."

JUNE 28

Archduke Francis Ferdinand, heir to the Austrian throne, and his wife, the Duchess of Hohenberg, are assassinated in their motorcar in Sarajevo by a young Serbian nationalist. This was the second attempt on the archduke's life that day. The headlines in some American newspapers reporting the event the following day were larger, however, for the Jack Johnson fight, where Johnson retained his championship title in a bout with Frank Moran.

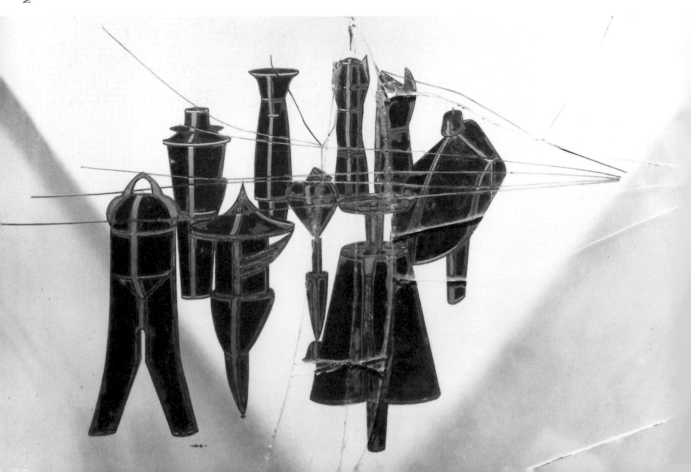

JULY 3
Telephone lines link New York and San Francisco.

JULY 28
Austria-Hungary, supported by Germany, declares war on Serbia, in response to the assassination of the archduke.

JULY 31
New York Stock Exchange closes to avoid panic over European conditions.

BEFORE AUGUST 1
Due to the outbreak of war, the Stettheimers return to New York from Europe.

AUGUST 1
Germany declares war on Russia.

AUGUST 3
Germany declares war on France. Britain enters the war after Germans drive through neutral Belgium.

AUGUST 4
US formally proclaims its neutrality in war between Austria and Serbia, Germany and Russia, Germany and France.

George Grosz and Franz Jung enlist in military service in Germany. Hugo Ball is refused entry on medical grounds; he visits the front as a civilian volunteer and is shocked by the experience.

MAN RAY, MADONNA, 1914

Duchamp finds a bottle rack at the Bazar de l'Hôtel de Ville, Paris, purchases it, and brings it to his studio. Later, this item will be classified as the first pure (unassisted) readymade.

By 1914, New York City has built the most advanced and expensive public bath system in the world. New Yorkers generally preferred bathing at home, however, and use of public baths was already in decline before the last one was completed in 1914.

The **Lafayette Baths** are the subject of several homoerotic paintings by Charles Demuth, beginning in 1916.

Also in 1916, the same baths are raided by the police.

AUGUST 5
The United States proclaims its neutrality in war between Great Britain and Germany.

AUGUST 6
The day after President Wilson declares neutrality, his wife, Ellen Axson Wilson, dies.

SEPTEMBER 1
The last-known passenger pigeon dies at the Cincinnati Zoo; two billion of the wild pigeons had once lived in eastern North America.

AUTUMN
The Arensbergs move from "Shady Hill," their estate in Cambridge, Massachusetts, to 33 West 67th Street in New York. Their new apartment will become the meeting place and social matrix for avant-garde and Dada artists, writers, and poets. Among those attending the soirees are George Bellows, John Covert, Arthur Cravan, Jean Crotti, Charles Demuth, Katherine Dreier, Marcel Duchamp, Isadora Duncan, Marsden Hartley, Albert Gleizes, Alfred Kreymborg, Mina Loy, Henry McBride, Walter Pach, Baroness Elsa von Freytag-Loringhoven, Louise and Allen Norton, Francis Picabia, Man Ray, H.P. Roché, Morton Schamberg, Charles Sheeler, John Sloan, Joseph Stella, Wallace Stevens, Edgard Varèse, William Carlos Williams, and Beatrice Wood.

MAN RAY, FIVE FIGURES, 1914

Duchamp creates *Three Standard Stoppages*, a proto-conceptual work exploiting the aspect of chance that is also central to Mallarmé's *Un coup de dés*.

De Zayas travels to Paris, lives with Picabia, and meets the Futurists and other artists and writers in Apollinaire's circle.

In England, Wyndham Lewis publishes the first issues of *Blast*, the Vorticist publication.

James Joyce's *Portrait of the Artist as a Young Man* first appears in serial form in the journal *The Egoist*. Joyce also publishes a collection of short stories, *Dubliners*, which was initially rejected by twenty-two publishers.

More than 500,000 **Model T Fords** are on the road.

Ragtime, the popular musical form developed by African-Americans such as Scott Joplin, is banned from New York City school music programs due to fears about its "socially corrosive" impact on white youths.

NOVEMBER 3
The first major exhibition of so-called primitive art, "African Savage Art," opens at 291. Hailed in *Camera Work* as "the first time in the history of exhibitions, either in this country or elsewhere, that Negro statuary was shown solely from the point of view of art."

NOVEMBER 25
Joe DiMaggio, New York Yankee outfielder, is born.

DECEMBER 25
In a new form of warfare, aerial combat begins over London, with German biplanes engaging British warplanes.

MAN RAY. MAN RAY 1914, 1914

MAN RAY. WAR: A.D. MCMXIV, 1914

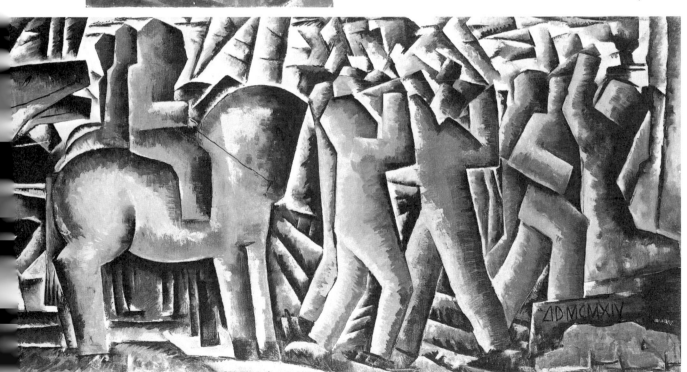

Hollywood is founded as a world film center by
Cecil B. De Mille, a former stage manager and playwright.
Flagstaff, Arizona, had originally been the location De Mille chose to shoot his first film, a Western.
The Masses throws a ball at Webster Hall, beginning a fad for costumed affairs in Greenwich Village,
which include dancing, drinking, and exotic themes.

JANUARY 12

Women's suffrage amendment is defeated in the House.

Picabia exhibition opens at 291—"An Exhibition of Recent Paintings Never Before Exhibited Anywhere—by Francis Picabia." Critic Elizabeth Luther Carey, writing in *The New York Times* (January 24) sees Picabia's work as "[the] most unpleasant arrangements of strangely sinister abstract forms that convey the sense of evil without direct statement."

Rocky Mountain National Park established by Congress.

FEBRUARY 2

Germany proclaims submarine warfare, announcing that every merchant ship around the waters of Great Britain and Ireland will be destroyed.

FEBRUARY 23

Sarah Bernhardt has right leg amputated in Bordeaux.

MARCH

First issue of the monthly *291*. More a broadside than a magazine, it is edited by de Zayas and Paul Haviland and financed by Stieglitz and Agnes Ernst Meyer. It is modeled after Apollinaire's *Les Soirées de Paris*. Last issue: February 1916.

19**15**

JEAN CROTTI, PORTRAIT OF MARCEL DUCHAMP, 1915

MARCH 15
Rogue, financed by Walter Arensberg and edited by Allen Norton, begins publication. Arensberg, Donald Evans, Mina Loy, Louise Norton, Wallace Stevens, and Carl Van Vechten all contribute.

MARCH 31
Man Ray edits the first and only issue of the proto-Dada pamphlet with anarchist nuance, *The Ridgefield Gazook*. The cover reads in part: "The Ridgefield Gazook/ we are *not* neutral/ No. 0. March 31,1915/ Published unnecessarily whenever the spirit moves us...."

APRIL
Germany admits to using poison gas on the Western front, promising that "more effective substances can be expected."

APRIL 7
Billie Holiday, jazz and blues singer, is born.

APRIL 10
President Wilson declares, "A nation may be so right that it does not need to fight."

APRIL 20
In a speech at the Waldorf-Astoria Hotel, President Wilson urges strict neutrality.

The

If you come into ✶ linen, your time is thirsty because ✶ ink saw some wood intelligent enough to get giddiness from a sister; However, even it should be smilable to shut ✶ hair ✶ whose ✶ water writes always plural, they have avoided ✶ frequency, *meaning* mother in law; ✶ powder will take a chance; and ✶ road could try. But after somebody brought ✶ any multiplication as soon as ✶ stamp was out, a great many cords refused to go through. Around ✶ wire's people, who will be able to sweeten ✶ rug, ~~that is to say~~ why must every patents look for a wife? Pushing four dangers near ✶ listening-place, ✶ vacation had not dug absolutely nor this likeness has eaten.

remplacer chaque ✶ par le mot: the

MARCEL DUCHAMP, THE, 1915

MARCEL DUCHAMP, THE BRIDE STRIPPED BARE BY HER BACHELORS, EVEN (LARGE GLASS), 1915–23 (1991–92 RECONSTRUCTION BY ULF LINDE, HENRIK SAMUELSSON, AND JOHN STENBORG)

MAY 7
German submarine sinks the British ocean liner *Lusitania* with two torpedoes. 124 Americans are among the 1,198 dead. In Germany, millions of photo postcards of the *Lusitania* are sold, bearing an image of the ocean liner with a superimposed portrait of Admiral Von Tirpitz, the German submarine chief, and the inscription, "Queenstown, May 7, 1915. The Cunarder *Lusitania* has been torpedoed and sunk."

MAY 27
Picabia sails to New York on a mission for the French Army. Abandoning his duties, he collaborates instead on the magazine *291* and socializes with de Zayas, Haviland, and the Arensberg circle.

JUNE
Picabia's proto-Dada machinist picture, *Fille née sans mère,* is published in the fourth issue of *291.*

JUNE 15
Marcel Duchamp arrives in New York only a few days after Picabia. He had sailed on June 6 on board the SS *Rochambeau.* Upon leaving Bordeaux late at night, the *Rochambeau* turns off all its lights to avoid German submarines, which had torpedoed the *Lusitania* in May. Duchamp is greeted by Walter Pach, who arranges for him to stay at the Arensbergs' West 67th Street apartment, where he remains while the Arensbergs summer in Pomfret Center, Connecticut.

JUNE 23
German industrialists meet with Kaiser Wilhelm to map out German war aims, which include annexing Poland, the Baltic region, and the Ukraine.

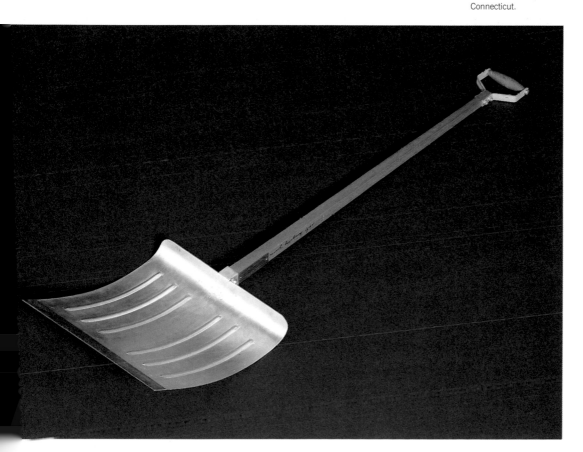

Marcel Duchamp, In Advance of the Broken Arm, 1915 (1964 edition)

Tetanus epidemics are reported in the battlefield trenches.

Margaret Sanger, credited with coining the term "birth control," publishes the pamphlet *Family Limitation* and the magazine *Woman Rebel.* In a sensationalized case, her husband is arrested, tried, and jailed for possession of the pamphlet.

A popular joke in 1915: "Two and two make four, four and four make eight, sex and sex make millions."

Number of New York City police officers in 1915 reaches 10,664.

FRANCIS PICABIA, PORTRAIT D'UNE JEUNE FILLE AMÉRICAINE DANS L'ÉTAT DE NUDITÉ (PORTRAIT OF A YOUNG AMERICAN GIRL IN A STATE OF NUDITY), 291, July–August 1915

JULY

To the question "What is 291?," to which an entire issue of Camera Work (July) is dedicated, Marius de Zayas responds: "Liberty, Freedom, Individualism, Self-expression." Writing from France, Picabia called 291 "a big step forward which begins and which ends from inexhaustible abundance." Man Ray described Stieglitz himself: "A Man, the lover of all through himself stands in his little gray room. His eyes have no sparkles—they burn within." Hartley said that the gallery showed the "work of artists in various fields of expression who have by reason of this originality for long been excommunicated from the main body in America and Europe."

JULY-AUGUST

291 publishes a series of Picabia's "object portraits," which represent Stieglitz as a camera, Agnes Ernst Meyer as a spark plug, and Picabia as a car horn. In the same issue, de Zayas writes: "New York has taken all possible precautions against assimilating the spirit of modern art; rejecting a seed that would have found a most fertile soil." Of the limitations of the American mind, he also finds that, "Success, and success on a large scale, is the only thing that can make an impression on American mentality. Any effort, any tendency, which does not possess the radiation of advertising remains practically ignored."

JULY 2

Cornell University German instructor Erich Muenter destroys US Senate reception room with a bomb, shoots J.P. Morgan, Jr., the following day, and commits suicide three days later.

JULY 12

Yul Brynner, actor and director, is born.

JULY 15

British war costs estimated at 3 million pounds per day.

FRANCIS PICABIA, VOILÀ HAVILAND (HERE IS HAVILAND), 1915

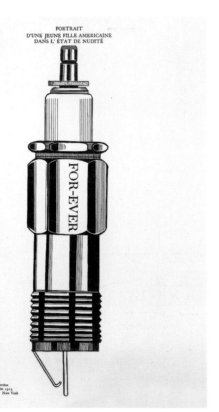

PORTRAIT
D'UNE JEUNE FILLE AMERICAINE
DANS L' ÉTAT DE NUDITÉ

FOR-EVER

F. Picabia
5 Juillet 1915
New York

VOILÀ HAVILAND

LA POÉSIE EST COMME LUI

F. Picabia
1915
New York

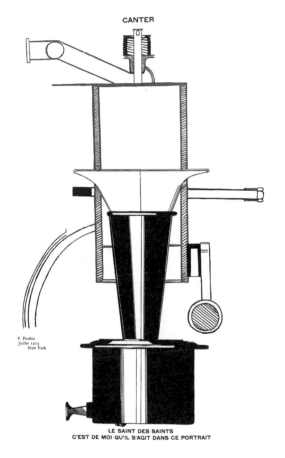

CANTER

F. Picabia
Juillet 1915
New York

LE SAINT DES SAINTS
C'EST DE MOI QU'IL S'AGIT DANS CE PORTRAIT

AUGUST 2

Walter Arensberg invites Duchamp to dine with him and Wallace Stevens at the Brevoort Hotel (Fifth Avenue at 8th Street), whose café is frequented by bohemians and French expatriates and immortalized in Juliette Roche's 1917 visual poem, *Brevoort*. Of this impressionable evening of French speaking (Duchamp spoke little English at the time), Stevens would later write to his wife: "it sounded like sparrows around a pool of water."

LATE SUMMER

Man Ray on meeting Duchamp and Arensberg: "One Sunday afternoon two men arrived—a young Frenchman and an American somewhat older. The one was Marcel Duchamp, the painter whose *Nude Descending the Staircase* [sic] had created such a furor at the Armory show in 1913, the second a collector of modern art, Walter Arensberg. Duchamp spoke no English, my French was nonexistent. Donna [Adon Lacroix] acted as my interpreter, but mostly carried on a rapid dialogue with him. I brought out a couple of old tennis rackets, and a ball which we batted back and forth without any net, in front of the house. Having played the game on regulation courts previously, I called the strokes to make conversation: fifteen, thirty, forty, love, to which he replied each time with one word: 'yes.'"

<div style="writing-mode: vertical-rl">FRANCIS PICABIA, LE SAINT DES SAINTS/C'EST DE MOI QU'IL S'AGIT DANS CE PORTRAIT (THE SAINT OF SAINTS/THIS IS A PORTRAIT ABOUT ME, 291, JULY–AUGUST 1915</div>

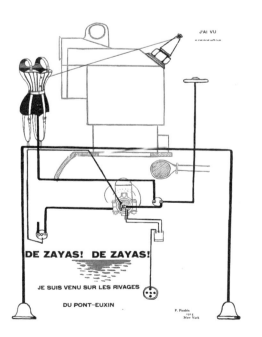

J'AI VU

DE ZAYAS! DE ZAYAS!

JE SUIS VENU SUR LES RIVAGES

DU PONT-EUXIN

F. Picabia
1915
New York

<div style="writing-mode: vertical-rl">FRANCIS PICABIA, DE ZAYAS! DE ZAYAS!, 291, JULY–AUGUST 1915</div>

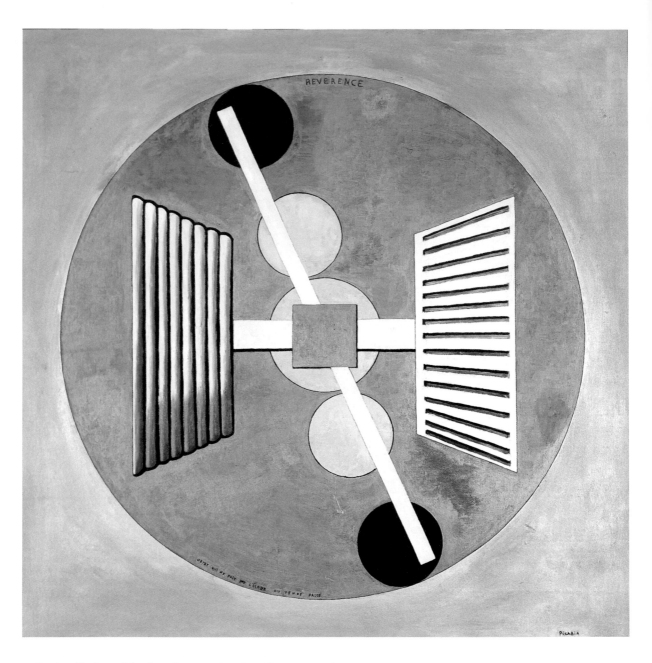

Francis Picabia, Révérence (Reverence), 1915

Duchamp attends gatherings at the Arensberg apartment nearly every evening,
where many come to regard him as the perpetual guest of honor.
Florine Stettheimer paints *Studio Party (Soirée),* the first of her group pictures.
Arensberg meets Alfred Kreymborg at a dinner given by Allen and Louise Norton,
where they discuss plans to publish a poetry magazine called *Other.*

Albert and Juliet Gleizes take a honeymoon trip to New York.

Jean Crotti and his wife, Yvonne, arrive in New York after spending a month in Columbus, Ohio; later in the autumn, Crotti and Duchamp will share a studio in the Lincoln Arcade Building on Broadway between 65th and 66th Streets.

In what would become one of many investigations into the aesthetic disruptions of the machine, Haviland writes in *Camera Work* (September-October): "Man made the machine in his own image. She has limbs which act; lungs which breathe; a heart which beats; a nervous system through which runs electricity. The phonograph is the image of the voice; the camera is the image of his eye…"

Arts and Decoration publishes "A Complete Reversal of Art Opinions by Marcel Duchamp, Iconoclast." Duchamp says: "Assuredly the Plaza Hotel with its innumerable windows, voraciously taking in light, is more beautiful than the Gothic Woolworth Building, but I like the immensity of the latter. New York itself is a work of art, a complete work of art. Its growth is harmonious, like the growth of ripples that come on the water when a stone has been thrown into it."

The Rogue Ball, a costumed affair benefiting *Rogue* (the revue by Allen Norton), awards first prize for costume to illustrator Clara Tice. *Rogue* ceases publication in December 1916.

OCTOBER

Man Ray's first one-artist exhibition held at the Daniel Gallery. Man Ray prepares his own publicity photographs; Stieglitz offers advice on photographic matters.

OCTOBER 7

The Modern Gallery, directed by de Zayas and financed by Eugene Meyer, Haviland, and Picabia, opens at 500 Fifth Avenue (at the corner of Forty-second Street). Picabia furnishes works from his own collection for the first exhibition.

OCTOBER 23

25,000 march in suffrage parade in New York.

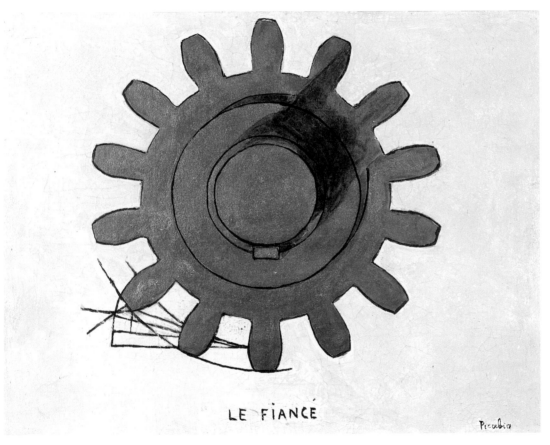

FRANCIS PICABIA, LE FIANCÉ, *c.* 1915–17

to be edited by Kreymborg; Arensberg provides the initial financing for the little magazine, whose last issue is published in 1919.

Robert Frost's *A Boy's Will* and *North of Boston* are published in the US.

Ford produces one millionth automobile.

Motorized taxis appear in New York.

Zurich becomes center of antiwar movements, providing a refuge and meeting place for Russian revolutionaries, including Lenin.

Kafka publishes *The Metamorphosis*, one of only three stories to appear during his lifetime.

Francis Picabia, Ici, c'est ici Stieglitz/Foi et Amour (Here, this is Stieglitz/Faith and Love), cover, 291, July–August 1915

Marius de Zayas, 291 Throws Back Its Forelock, cover, 291, March 1915

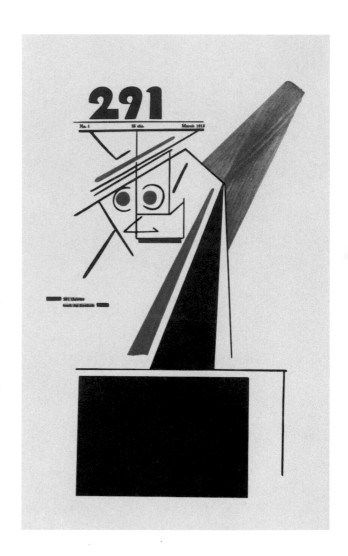

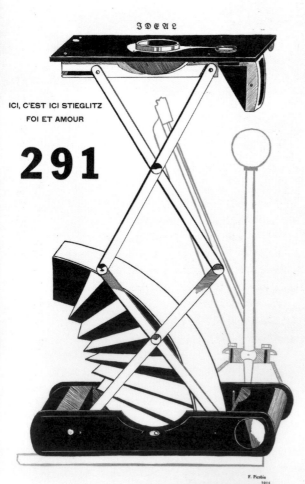

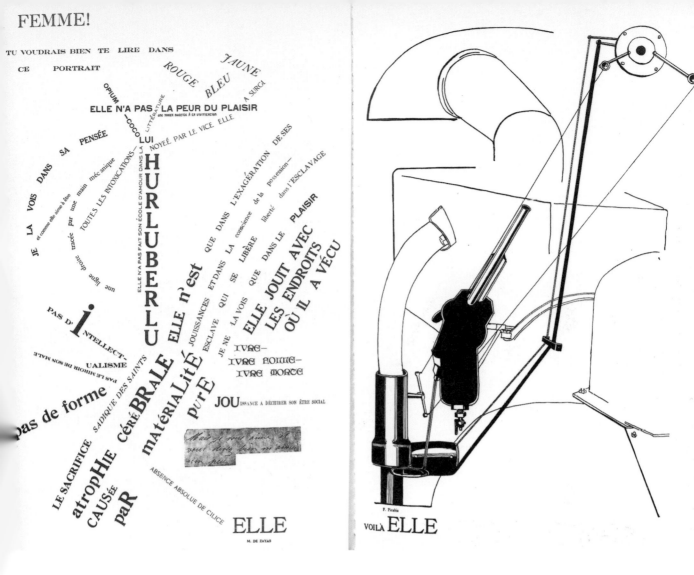

MARIUS DE ZAYAS, ÊLLE (SHE), AND FRANCIS PICABIA, VOILÀ ELLE (HERE SHE IS), 291, NOVEMBER 1915

D.H. Lawrence's *The Rainbow* is published, stirring controversy in London over its treatment of sexuality.

D.W. Griffith's film *The Birth of a Nation,* about the Civil War and Reconstruction, opens in Los Angeles.

Tickets are very expensive at $2 each.

It is reported that protesting "Negroes and white liberals" charge the filmmaker with racism.

De Zayas publishes *African Negro Art: Its Influence on Modern Art.*

New Orleans jazz becomes widely popular.

Charlie Chaplin's *The Tramp* opens.

Sigmund Freud and Carl Jung are popularized in American magazine articles by Max Eastman, Floyd Dell, and others.

Tristan Tzara arrives in Zurich.

Establishment of theater groups: Washington Square Players and Provincetown Players, the latter group responsible for producing most of Eugene O'Neill's plays.

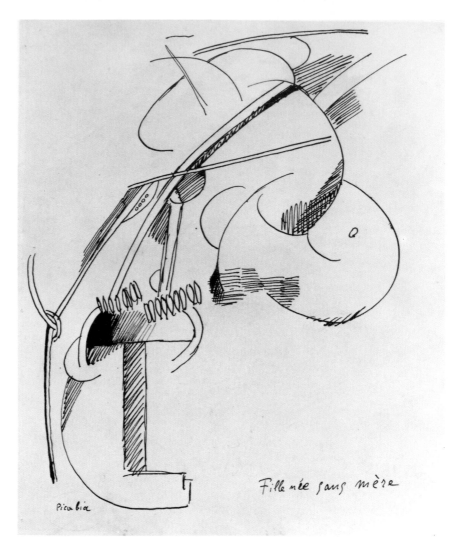

Francis Picabia, Fille Née Sans Mère (Girl Born Without a Mother), 1915

Fille née sans mère

Picabia

With the influx of Eastern European Jews, the bagel becomes associated with New York City.
New York-based Bagel Bakers Local 338 claimed nearly 300 members between 1910 and 1915.

OCTOBER 24

New York Tribune publishes "French Artists Spur on American Art," containing interviews with Gleizes, de Zayas, Crotti, Duchamp, Picabia, and others. Picabia proclaims: "Almost immediately upon coming to America, it flashed on me that the genius of the modern world is machinery. The machine has become more than a mere adjunct of life. It is really a part of human life, perhaps the very soul. In seeking forms through which to interpret ideas or by which to expose human characteristics I have come at length upon the form which appears most brilliantly placed and fraught with symbolism. I have enlisted the machinery of the modern world, and introduced it into my studio."

NOVEMBER

With John Quinn's assistance, Duchamp begins working at The Pierpont Morgan Library for Belle Greene, the librarian appointed by J.P. Morgan in 1906. Working daily from 2 p.m. until 6 p.m., Duchamp initially earns $100 per month.

NOVEMBER 15

In New York, 40,000 football fans cheer Army's 40-0 triumph over Navy.

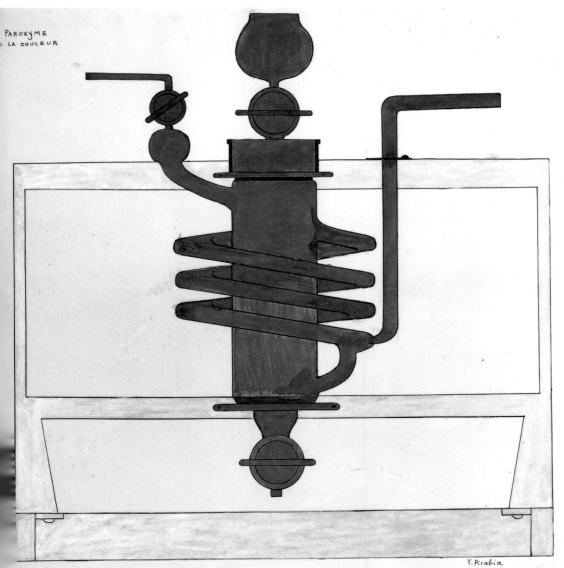

PAROXYME
LA DOULEUR

F. Picabia
DANS LA VILLE MADRÉPORIQUE
SEPTEMBRE 1915

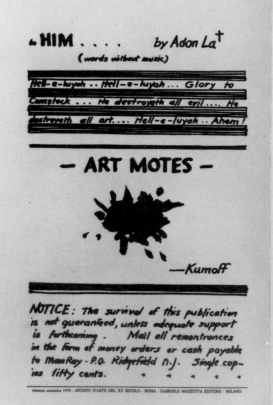
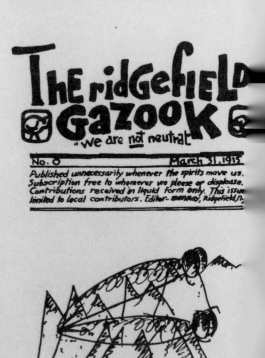

NOVEMBER 25
The Ku Klux Klan is
revived in Atlanta by
Col. William J. Simmons,
developing a national
membership of more
than 1.5 million
members.

DECEMBER
Picabia and Gabrielle
Buffet-Picabia return to
New York from Cuba and
Panama. Around the
same time, Hartley returns
to New York from Berlin.

DECEMBER 12
Frank Sinatra is born.

DECEMBER 19
Edith Piaf is born.

DECEMBER 20
Gasoline prices in
the US rise to 25 cents
per gallon.

DECEMBER 29
Edgard Varèse arrives
in New York. Although
intending to stay for a
few weeks, he never
returns to France.

ROBERT LOCHER, PRUDES DESCENDING A STAIRCASE, ROGUE, MAY 15, 1915

Walter Pach, one of the organizers
of the Armory Show,
begins advising John Quinn on his art collection,
which eventually becomes one of the major collections of 20th-century art formed in America.
Ford Motor Company develops the farm tractor, an invention that helps
transform farming into a business.
First transcontinental phone call between Alexander Graham Bell, the telephone's inventor,
in New Yorkand Thomas Watson in California.
Charlie Chaplin's *A Woman* is released by the Essanay Company. In the film, Chaplin impersonates a woman
in order to gain entry into a female boardinghouse where his girlfriend resides.

1916

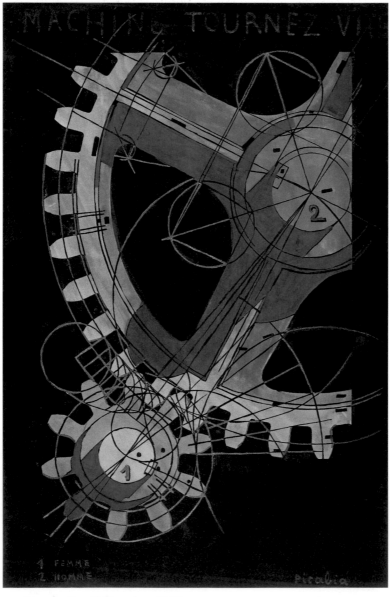

FRANCIS PICABIA, MACHINE TOURNEZ VITE (MACHINE TURN QUICKLY), c. 1916–18

JANUARY 5
Picabia's mechanomor-
phic style is premiered in
a one-artist exhibition
at the Modern Gallery.
Featured are some of
Picabia's most celebrated
machinist compositions,
such as *Révérence
(Reverence)*, *Very Rare
Picture on the Earth*,
*Machine Without a
Name*, and *Paroxysme
de la douleur (Paroxysm
of Pain)*. The show gener-
ates a great deal of hostile
criticism in the
New York press.

FEBRUARY 5
Cabaret Voltaire, founded
by Hugo Ball, opens,
inaugurating the activities
of Zurich Dada; café
closes after about six
months.

FEBRUARY 26
Richard Huelsenbeck
arrives in Zurich from
Berlin.

MARCH
German submarines
continue to torpedo
neutral ships. When sev-
eral Americans are killed
after a German submarine
attack on the French liner
Sussex, the possibility
of America going to war
against Germany is raised.
By August, 218 neutral
ships are sunk by German
subs.

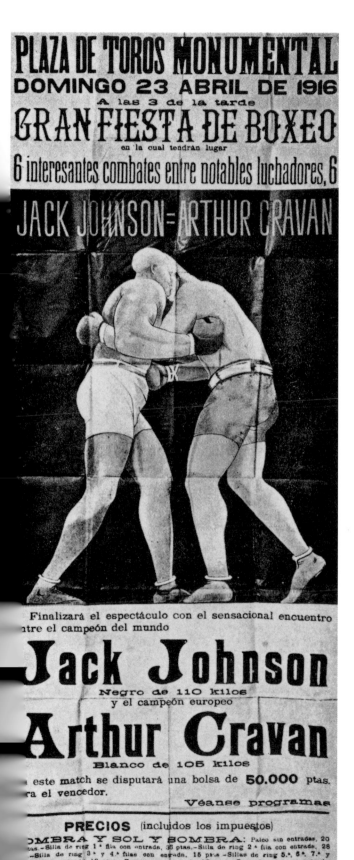

MARCH 3
Hugo Ball writes in his diary: "Introduce symmetries and rhythms instead of principles. Contradict the existing world orders....What we are celebrating is at once a buffoonery and a requiem mass."

MARCH 30
Gala at Cabaret Voltaire. Huelsenbeck and Tzara read a "simultaneous poem" in German, French, and English.

APRIL
Dubbed by the press "The Four Musketeers," the French artists Duchamp, Crotti, Gleizes, and Metzinger exhibit at the Montross Gallery in New York.

APRIL 4
Article interviewing Jean Crotti and Marcel Duchamp in their Lincoln Arcade Studio appears in *The Evening World*. Duchamp readymades are discussed publicly for the first time.

APRIL 23
Arthur Cravan ("white man at 105 kilos") fights the famous African-American heavyweight Jack Johnson ("Negro at 110 kilos") and is knocked out in the sixth round; the press cries foul, claiming the fight is rigged. Johnson, living in Europe, is a fugitive from American law, having been charged in America under the Mann Act. Gabrielle Buffet-Picabia later describes Cravan as "a man who personified, within himself and without premeditation, all the elements of surprise to be wished for by a demonstration that was not yet called 'Dada.'"

MAY 20
The Saturday Evening Post publishes its first issue with a cover by Norman Rockwell.

JUNE
First and only issue of *Cabaret Voltaire* is published. Hugo Ball uses the word "Dada" in the preface; first time word appears in print. Contributors include: Apollinaire, Arp, Emmy Hennings, Huelsenbeck, Janco, Kandinsky, Marinetti, Modigliani, Picasso, Tzara. This issue was probably available in New York as early as November 1916. Marius de Zayas writes to Tzara, November 16, 1916: "I have just received, deplorably late your esteemed letter of the 30th of September and the ten copies of your interesting Dada publication. I am much obliged for the copy you had the kindness to dedicate to me, the rest will be distributed as you wished among the people interested in the modern art movement. I shall try to interest book-stores in New York in selling your publication."

JULY

Tzara publishes *La premiére aventure céleste de Monsieur Antipyrine (The First Celestial Adventure of Mr. Fire Extinguisher)* with color woodcuts by Janco. Tzara offers a definition of Dada: "Dada is our intensity; it sets up inconsequential bayonets the sumatran head of the german baby; Dada is life without carpet-slippers or parallels; it is for and against unity and definitely against the future....A harsh necessity without discipline or morality and we spit on humanity. Dada remains within the European frame of weaknesses it's shit after all but from now on we mean to shit in assorted colors and bedeck the artistic zoo with the flags of every consulate..."

JULY 1

Allied offensive at Somme produces 60,000 British casualties, the largest one-day war loss to date. The tank is used for the first time on the battlefield by British forces, threatening to alter the balance of power.

JULY 2

Thirty-nine dead and hundreds hurt in East St. Louis race riots.

JEAN CROTTI, SOLUTION DE CONTINUITÉ (INTERRUPTION), c. 1916

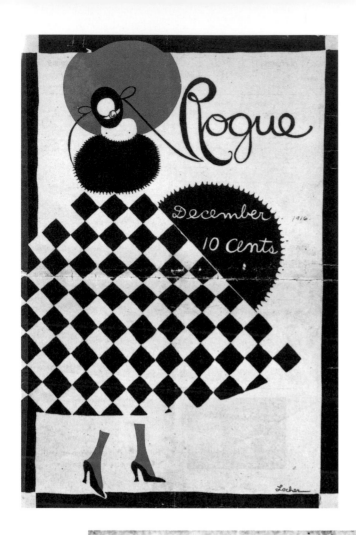

THE EVENING WORLD, TUESDAY, APRI

Cubist Depicts Love in Brass and Glass;
"More Art in Rubbers Than in Pretty Girl!

JEAN CROTTI

THE MECHANICAL FORCES OF LOVE

disposition would make her an easy victim of any one who preyed upon her sympathies.

"Alma is just the kind of a girl to believe any one," he said, "and would accompany any one to any place if she believed she could do good. I know Alma was a good girl and cared nothing for men or high life."

Big, Shiny Shovel Is the Most Beautiful Thing Has Ever Seen, Says M. Cotti, Whose Masterpiece, "Mechanical Forces of Love," Is Made of Metal—Cubist Exhibit Opens Here Tuesday.

By Nixola Greeley-Smith.

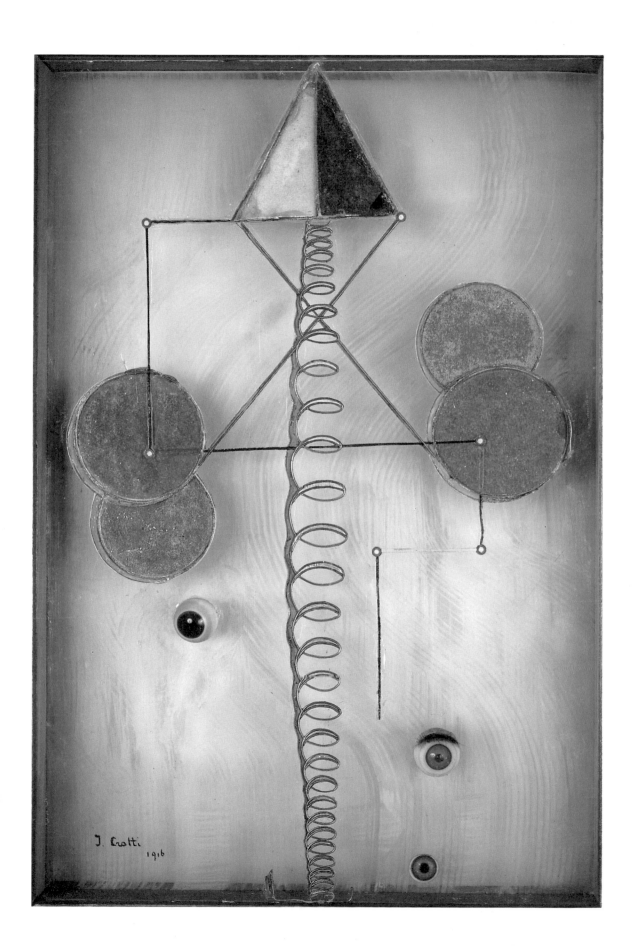

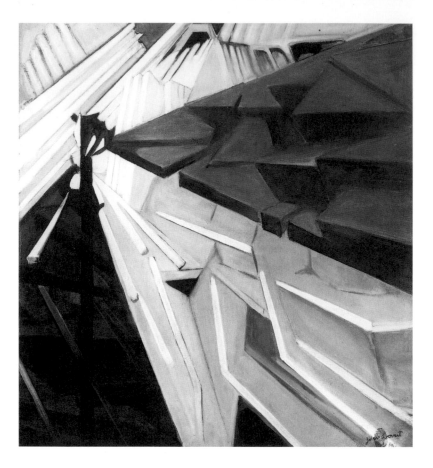

Battle of Somme (1916) statistics:
Germans: 650,000 **dead**
French: 195,000 **dead**
British: 420,000 **dead**

F.W. Mott develops theory of shell shock.

Refrigerated blood is used in transfusions.

American chewing gum is sold in France for the first time.

A bomb believed by authorities to have been placed by anarchists explodes, killing six during an armed preparedness parade in downtown

SEPTEMBER 29

With Standard Oil skyrocketing to over $2,000 per share, John D. Rockefeller's net worth now exceeds $1 billion; he becomes the world's richest man. With this legacy of seemingly immeasurable wealth derived from the family's oil monopoly, the Rockefeller family goes on to become instrumental in the formation of The Museum of Modern Art in New York in 1929.

FALL

First meetings of the Society of Independent Artists take place at Arensberg's apartment and at the studio of John Covert, Arensberg's first cousin. Society ratifies a "no jury, no prizes" policy. Founders: William Glackens, president; Charles Prendergast, vice president; Walter Arensberg, managing director; Marcel Duchamp, director of installation; John Covert, secretary; Walter Pach, treasurer. The following hold the title of director: Rockwell Kent, George Bellows, Katherine Dreier, John Marin, Man Ray, Morton Schamberg, Joseph Stella. Duchamp and Covert solicit approximately $10,000 from twelve financial sponsors, including Arensberg, Dreier, Eugene Meyer, Jr., Mrs. William K. Vanderbilt, and Gertrude Vanderbilt Whitney (founder of the Whitney Museum of American Art).

"When did you hear about Dada for the first time?" Pierre Cabanne later asked Duchamp, who replied: "In Tzara's book, *The First Celestial Adventure of Mr. Fire Extinguisher*. I think he sent it to us, to me or to Picabia, rather early, in 1917, I think, or at the end of 1916. It interested us but I didn't know what dada was, or even that the word existed. When Picabia went to France, I learned what it was through his letters, but that was the sole exchange at that time."

John Covert introduces Katherine Dreier to the Arensberg circle, where she meets Duchamp and Man Ray.

San Francisco. The arrested suspect, Frank Joseph, reportedly exclaims, "This is nothing."

Kosher meat sales net $50 million in New York City.

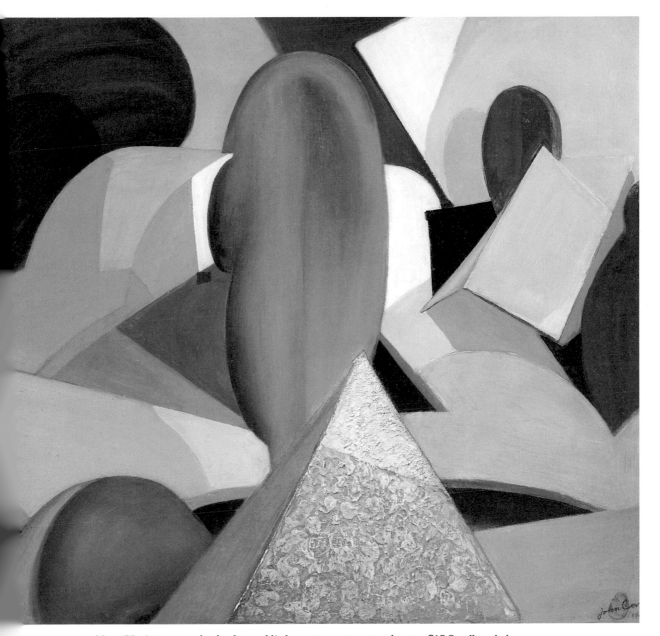

JOHN R. COVERT. RESURRECTION. 1916

New York is reported to be the world's largest exporting city, shipping $10.8 million daily,
of which half is in munitions.

G. Lowes Dickinson's *The European Anarchy.*

Women's International Bowling Congress formed in the US.

Pancho Villa, the Mexican revolutionary referred to in the US press as a "bandit," crosses border into
American territory, killing seventeen Americans; later escapes the pursuit of 6,000 American troops.

NOVEMBER
Man Ray has second one-artist exhibition at the Daniel Gallery. He exhibits *Self-Portrait*, an interactive assemblage that is the butt of many jokes.

NOVEMBER 12
US reports food prices increased 100 percent in a one-year period.

OCTOBER 14
Florine Stettheimer's only one-artist exhibition to take place during her life-time is held in New York at Knoedler's. She exhibits twelve paintings.

NOVEMBER 16
De Zayas writes to Tzara: "For some time I have been working to establish artistic connections between Europe and America for I believe that the only way to succeed in maintaining the evolutionary progress of modern ideas is through the interchange of ideas among all peoples."

NOVEMBER 24
Machine gun inventor Sir Hiram Maxim dies in London. His invention is used by both sides in the war.

NOVEMBER 25
Army beats Navy 15-7 at New York's Polo Grounds.

DECEMBER 30
Gregory Rasputin, the Siberian monk who was feared to have strongly influenced the Czar and his family, is assassinated by two Russian nobles who believed him to be pro-German.

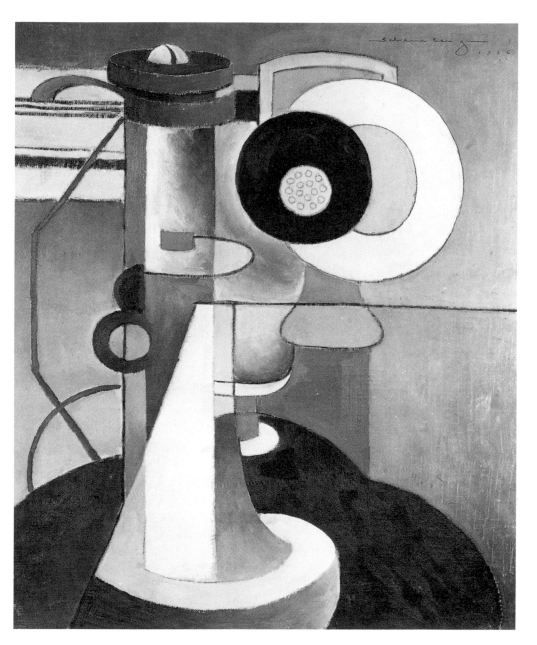

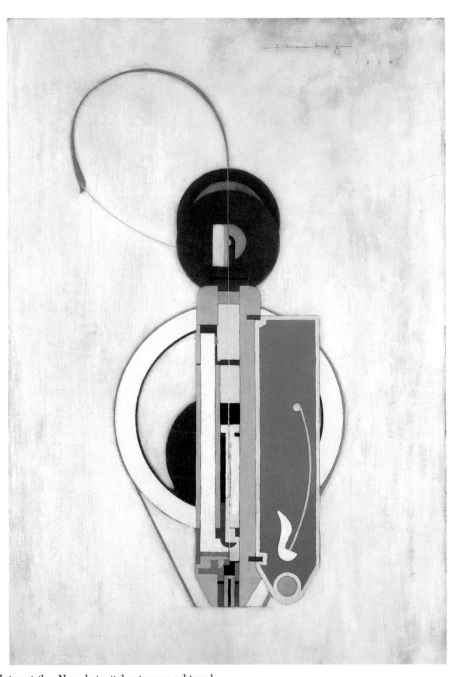

In one of the largest strikes in New York City's history, 60,000 members of the International Ladies' Garment Workers' Union strike. No substantial gains are achieved.

Charlie Chaplin's *Pawn Shop* opens.

The automobile rapidly begins to displace the horse and buggy. **Ford Motor Company** produces more than a half million autos, reporting profits of nearly $60 million.

The new Ford touring automobile costs $250.

In Berlin, Albert Einstein publishes new General Theory of Relativity (written in 1915), which radically questions Newtonian physics, its accepted theories about gravity, and our fixed, stable relationship to the universe.

Boston beats Brooklyn in five games in World Series play.

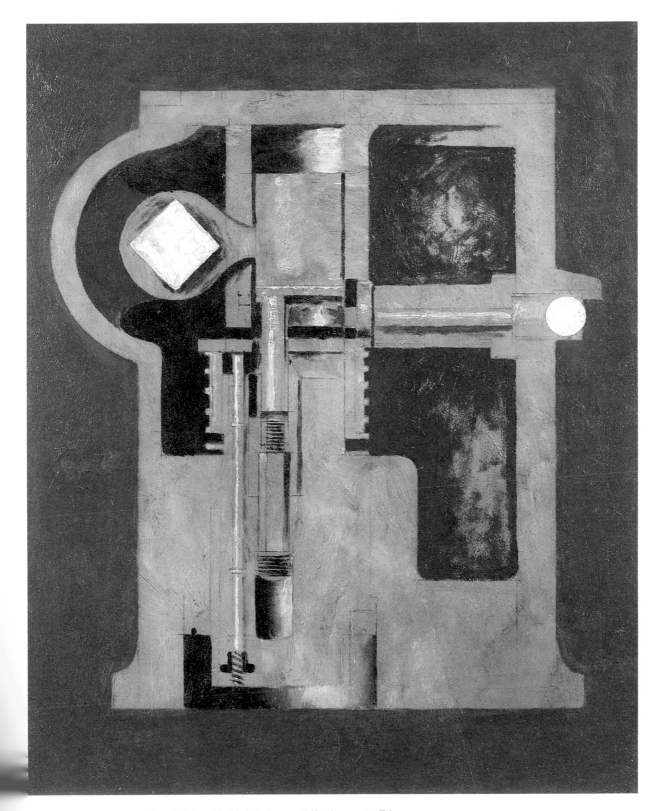

MORTON LIVINGSTON SCHAMBERG, UNTITLED (MECHANICAL ABSTRACTION), 1916

Frank Lloyd Wright's Imperial Hotel opens in Tokyo.

German saboteurs explode munitions arsenal on Black Tom Island, New Jersey.

Jazz craze sweeps America.

New York City passes its first comprehensive **zoning code** regulating building height in relation to street footage.

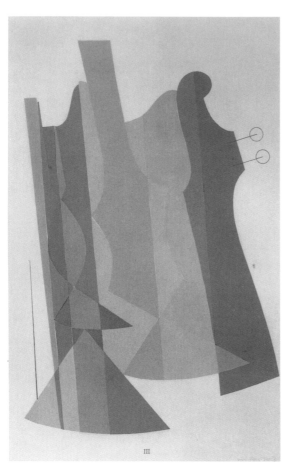

III

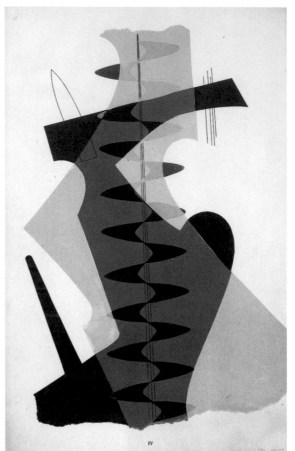

IV

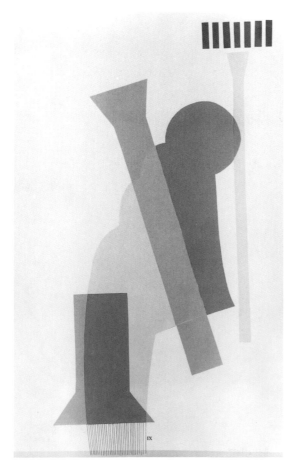

IX

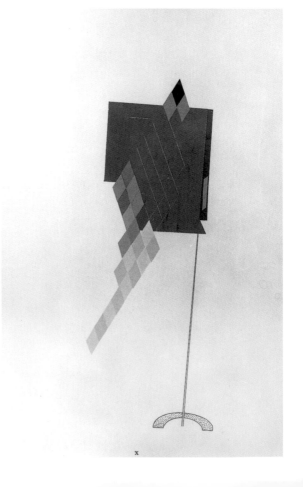

X

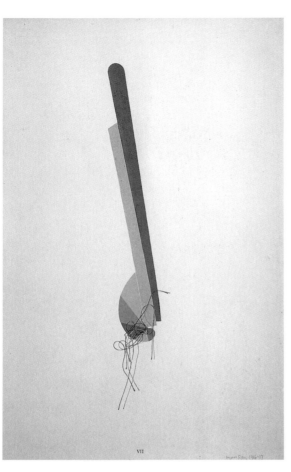

VII

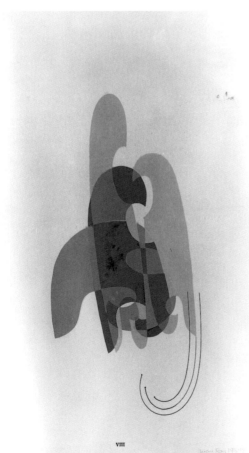

VIII

left: MAN RAY, REVOLVING DOOR SERIES III: ORCHESTRA, 1916–17
center: MAN RAY, REVOLVING DOOR SERIES IV: THE MEETING, 1916–17
right: MAN RAY, REVOLVING DOOR SERIES VII: JEUNE FILLE (YOUNG GIRL), 1916–17

left: MAN RAY, REVOLVING DOOR SERIES IX: CONCRETE MIXER, 1916–17
center: MAN RAY, REVOLVING DOOR SERIES X: DRAGONFLY, 1916–17
right: MAN RAY, REVOLVING DOOR SERIES VIII: SHADOWS, 1916–17

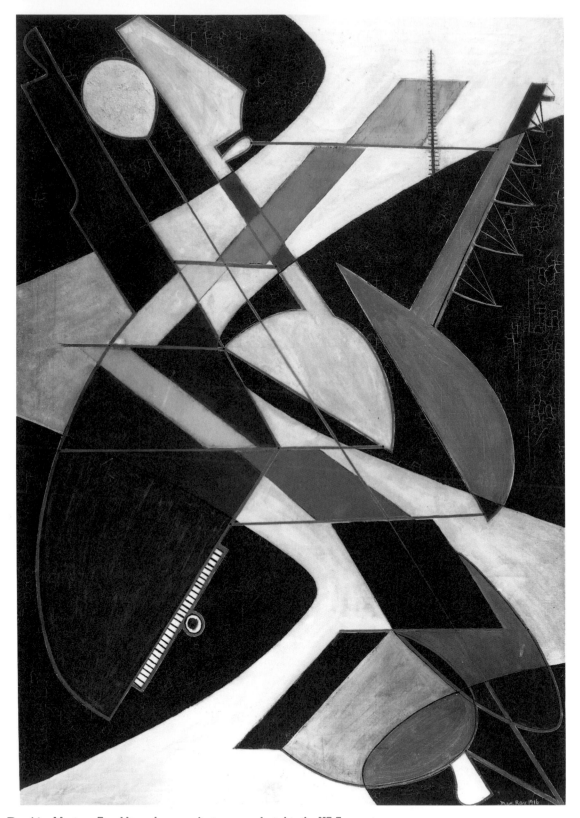

Jeannette Rankin, Montana Republican, becomes first woman elected to the US Congress.

US foreign trade is $8 million, one-fifth of the world's total.

Walter Arensberg publishes his second volume of collected poems, *Idols*; evident is

Arensberg's debt to Mallarmé.

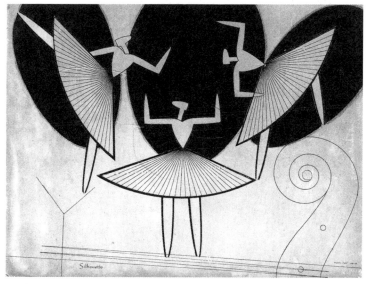

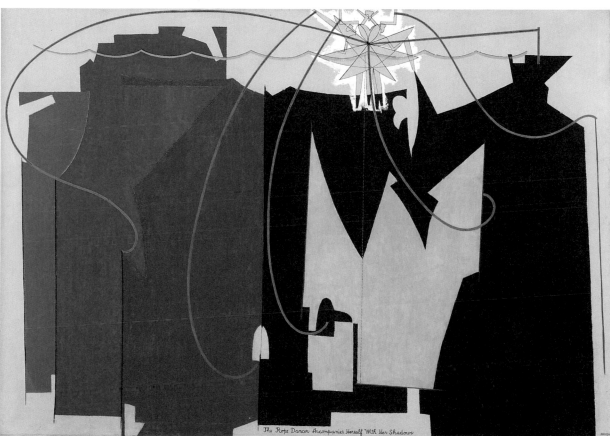

Wallace Stevens, a member of the Arensberg circle, moves from New York to Hartford
to work for the Hartford Accident and Indemnity Company.

Others anthology published by Alfred A. Knopf.

Picabia travels to Barcelona to recover from opium and alcohol abuse. There he meets with Marie Laurencin,
Albert Gleizes, and Arthur Cravan.

Carl Sandburg, *Chicago Poems*.

The first American birth control clinic, founded by Margaret Sanger, opens in Brooklyn.

Turkish troops commit mass genocide, forcing Armenians into Syrian concentration camps, where more than one million die.

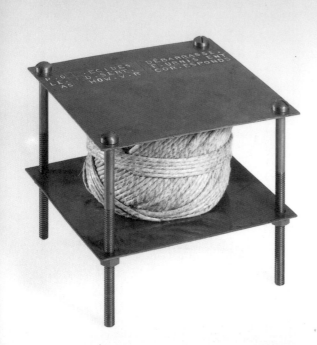

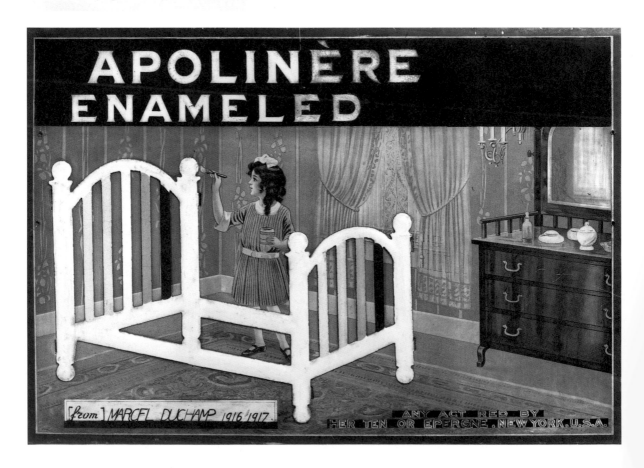

-toir. On manquera,à la fois,de
-moins qu'avant cinq élections et
aussi quelque accointance avec q-
-uatre petites bêtes; il faut oc-
-cuper ce délice afin d'en décli-
-ner toute responsabilité. Après
douze photos,notre hésitation de-
-vant vingt fibres était compréh-
-ensible; même le pire accrochage
demande coins porte-bonheur sans
compter interdiction aux lins: C-
-omment ne pas épouser son moind-
-re opticien plutôt que supporter
leurs mèches? Non,décidément,der-
-rière ta canne se cachent marbr-
-ures puis tire-bouchon. "Cepend-
-ant,avouèrent-ils,pourquoi viss-
-er,indisposer? Les autres ont p-
-ris démangeaisons pour constrai-
-re,par douzaines,ses lacements.
Dieu sait si nous avons besoin,q-
-uoique nombreux mangeurs,dans un
défalquage." Défense donc au tri-
-ple,quand j'ourlerai ,dis je,pr-

-onent,après avoir fini votre gê-
-ne. N'empêche que le fait d'éte-
-indre six boutons l'un ses autr-
-es paraît (sauf si,lui,tourne a-
-utour) faire culbuter les bouto-
-nnières. Reste à choisir: de lo-
-ngues,fortes,extensibles défect-
-ions trouées par trois filets u-
-sés,ou bien,la seule enveloppe
pour éte-ndre. Avez vous accepté
des manches? Pouvais tu prendre
sa file? Peut-être devons nous a-
-ttendre mon pilotis,en même tem-
-ps ma difficulté; avec ces chos-
-es là,impossible ajouter une hu-
-itième laisse. Sur trente misé-
-rables postes deux actuels veul-
-ent errer,remboursés civiquement,
refusent toute compensation hors
leur sphère. Pendant combien,pou-
-rquoi comment,limitera-t-on min-
-ce étiage? autrement dit: clous
refroidissent lorsque beaucoup p-
-lissent enfin derrière,contenant

-este pour les profits,devant le-
-squels et,par précaution à prop-
-os,elle défonce desserts,même c-
-eux qu'il est défendu de nouer.
Ensuite,sept ou huit poteaux boi-
-vent quelques conséquences main-
-tenant appointées; ne pas oubli-
-er,entre parenthèses,que sans l'
-économat,puis avec mainte sembl-
-able occasion,reviennent quatre
fois leurs énormes limes; quoi!
alors,si la férocité débouche de
rrière son propre tapis. Dès dem-
-ain j'aurai enfin mis exactemen-
-t des piles là où plusieurs fen-
-dent,acceptent quoique mandant
le pourtour. D'abord,piquait on
ligues sur bouteilles,malgré le-
-ur importance dans cent séréni-
-tés? Une liquide algarade,après
semaines dénonciatrices,va en y
détester ta valise car un bord
suffit. Nous sommes actuellement
assez essuyés,voyez quel désarroi

porte,dès maintenant par grande
quantité,pourront faire valoir l-
-e clan oblong qui,sans ôter auc-
-un traversin ni contourner moin-
-s de grelots,va remettre. Deux
fois seulement,tout élève voudra-
-it traire,quand il facilite la
bascule disséminée; mais,comme q-
-uelqu'un démonte puis avale des
déchirements nains nombreux,soi
compris,on est obligé d'entamer
plusieurs grandes horloges pour
obtenir un tiroir à bas âge. Co-
-nclusion: après maints efforts
en vue du peigne,quel dommage!
tous les fourreurs sont partis e-
-t signifient riz. Aucune deman-
-de ne nettoie l'ignorant où sc-
-ié teneur; toutefois,étant don-
-nées quelques cages,c'eut une
profonde émotion qu'éxécutent t-
-outes colles alitées. Tenues,v-
-ous auriez manqué si s'était t-
-rouvée là quelque prononciation

1917

JANUARY 10
William F. Cody, a.k.a. "Buffalo Bill"—showman, speculator, Army Scout, and murderer of Indians—dies.

JANUARY 13
Arthur Cravan arrives in New York on board the *Montserrat*, sailing from Barcelona. During the journey, he meets the Russian Revolutionary Leon Trotsky, who has been expelled from France. "The passengers were of varying types and, all in all, not very attractive," Trotsky recalled. "A boxer who was also some sort of writer and a cousin of Oscar Wilde, confessed frankly that he preferred crushing the jaws of the Yankee gentlemen in a noble sport to letting his ribs be broken by a German."

JANUARY 16
German Foreign Minister Arthur Zimmerman sends coded message via telegraph to Mexican authorities in Washington, secretly renouncing Germany's unrestricted submarine warfare and inviting Mexico to join Germany in an alliance against the United States in the event of war. Intercepted by British intelligence, the telegram is passed on to President Wilson on February 24; Zimmerman inexplicably admits sending it. This series of errors contributes to the end of America's neutral stance in the war.

Imperial War Museum in London is founded, but doesn't open until 1936.

The last of the horse-drawn streetcars in New York City terminates its Bleecker Street service.

Sigmund Freud publishes *Introductory Lectures on Psycho–Analysis*.

The Hell Gate Bridge opens; once the world's longest steel bridge, it carries trains into Pennsylvania Station.

The IRT subway line opens a station at Sheridan Square, connecting Greenwich Village with the rest of New York.

Duchamp gives French lessons to Katherine Dreier, Louise Norton, John Quinn, and the Stettheimers, among others; his fee is $2 per hour.

Charlie Chaplin signs $1 million annual contract.

JANUARY 17
Germany resumes policy
of unlimited submarine
warfare. All neutral ships
are attacked.

JANUARY 27
First Dada exhibition
at Galerie Corray, Zurich.
Included are works by
Arp, Janco, and Hans
Richter, together with
so-called "primitive art."

MARCH
Henri-Pierre Roché
meets lawyer and art
collector John Quinn,
who will eventually ask
Roché to become his
European agent.

Florine Stettheimer, La Fête à Duchamp, 1917

MARCH 16
Russian Czar Nicholas II abdicates, leaving Russia in turmoil. Millions are already dead fighting in the war and starvation is widespread.

MARCH 25
John McGraw signs $50,000 contract to manage the New York Giants.

APRIL
Charles Sheeler shows his photographs for the first time in two group exhibitions at the Modern Gallery.

APRIL 1
Ragtime composer Scott Joplin dies.

Edgard Varèse makes his American debut as a conductor at the old Hippodrome Theatre on Sixth Avenue; 300 members of the Scranton Choral Society and an orchestra of 150 musicians perform Berlioz's *Requiem Mass*—a Palm Sunday memorial to all war dead.

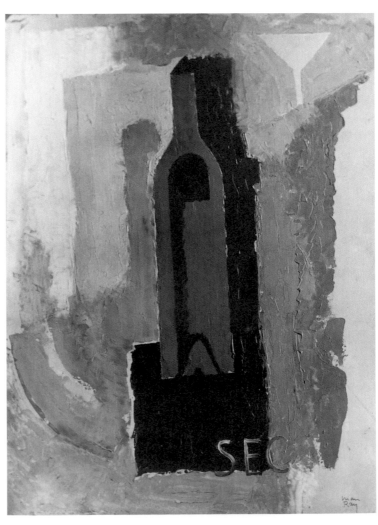

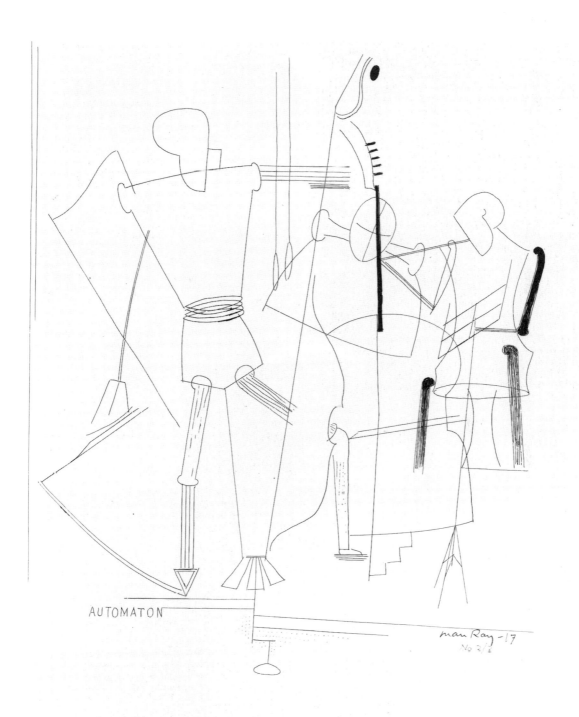

AUTOMATON

MAN RAY, AUTOMATON, 1917

The Little Review moves from Chicago to New York, publishing works by **Pound, Yeats, Eliot,** and **Wyndham Lewis.**
After publishing *What Every Woman Should Know,* **Margaret Sanger** is arrested
for disseminating birth control information.
Boeing Airplane Company, formerly Aero Products Co., is formed.
Wieland Herzfelde and his brother, John Heartfield, found the publishing firm of Malik Verlag in Berlin.
Heartfield subsequently designs many of its dust jackets for works by authors
such as Ilya Ehrenburg, John Dos Passos, Upton Sinclair, and Kurt Tucholsky.

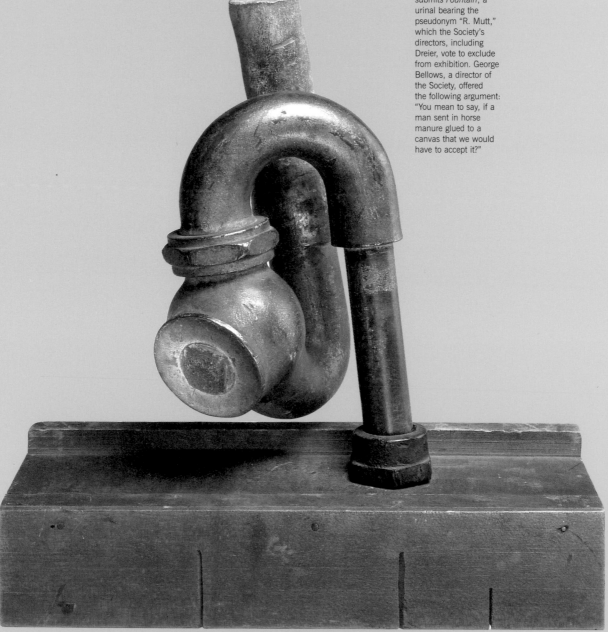

Morton Livingston Schamberg and Baroness Elsa von Freytag-Loringhoven, GOD, c. 1917

APRIL 3
Stieglitz's 291 gallery mounts Georgia O'Keeffe's first one-artist exhibition (through mid-May)—which is also the gallery's last.

APRIL 4
Picabia arrives in New York from Barcelona for his third and final visit, which lasts about six months.

APRIL 6
America declares war on Germany.

APRIL 7
Cuba and Panama declare war on Germany.

APRIL 9
Three days after America declares war, a private viewing of the Society of Independent Artists is held. The Society adopts a nonexclusive admission policy: any artist who pays the $1 initiation fee and $5 annual dues is automatically permitted to exhibit two works in the exhibition. The Society establishes a "no jury—no prizes" policy. In a challenge to both aesthetic and exhibition principles, Duchamp submits *Fountain*, a urinal bearing the pseudonym "R. Mutt," which the Society's directors, including Dreier, vote to exclude from exhibition. George Bellows, a director of the Society, offered the following argument: "You mean to say, if a man sent in horse manure glued to a canvas that we would have to accept it?"

APRIL 10

The First Annual Exhibition of the Society of Independent Artists opens to a crowd of thousands at Grand Central Palace. Almost twice as large as the Armory Show, 2,125 works are installed alphabetically at Duchamp's suggestion, with the first works displayed beginning with the letter "R." The exhibition structure is determined by a chance drawing of letters from a hat. Over twenty thousand visitors attend the exhibition. On the occasion of the Society of Independent Artists exhibition, *The Blind Man*, no. 1, is published by Duchamp, Henri-Pierre Roché, and

Beatrice Wood, with the financial support of Gertrude Vanderbilt Whitney. Distributed at the exhibition, it is priced at 10¢. The bottom of the cover reads: "The second number of The Blind Man will appear as soon as YOU have sent sufficient material for it."

Germany arranges for Lenin to return to Russia after eleven years in exile, hoping his return will further destabilize the country.

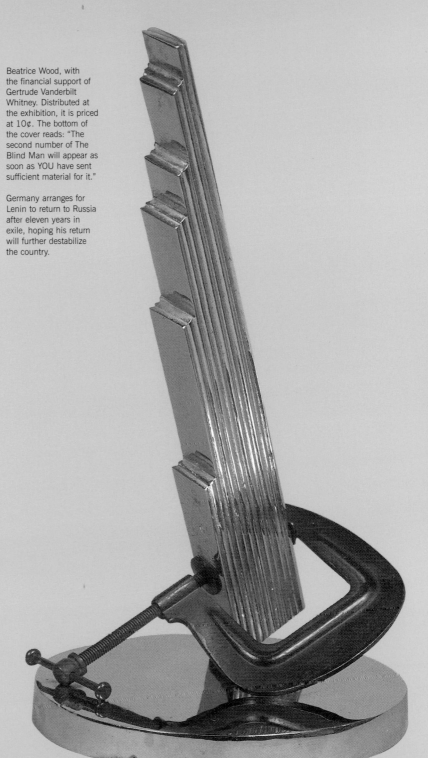

MAN RAY, NEW YORK, 1917 (1966 EDITION)

The Frawley Act of 1911, permitting ten-round "no-decision" boxing matches, is repealed by Republican reformers opposing corruption and violence; boxing as a regulated sport will not resume again until 1920.

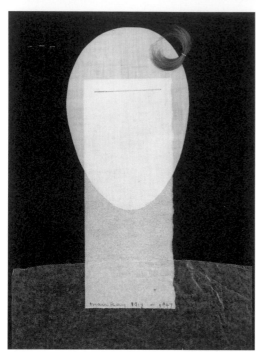

APRIL 11

The Society of Independent Artists issues a press release, explaining the exclusion of R. Mutt's *Fountain*: "The *Fountain* may be a very useful object in its place, but its place is not an art exhibition and it is, by no definition, a work of art." As a gesture of protest, Duchamp and Arensberg resign from the Society. Stieglitz briefly exhibited the rejected *Fountain* at 291, where he took his famous photograph of it.

APRIL 18

At the Independents exhibition, Maxwell Bodenheim, Harry Kemp, Mina Loy, Allen Norton, Pitts Sanborn, and William Carlos Williams recite their poetry. Audience members are also invited to read their own poems.

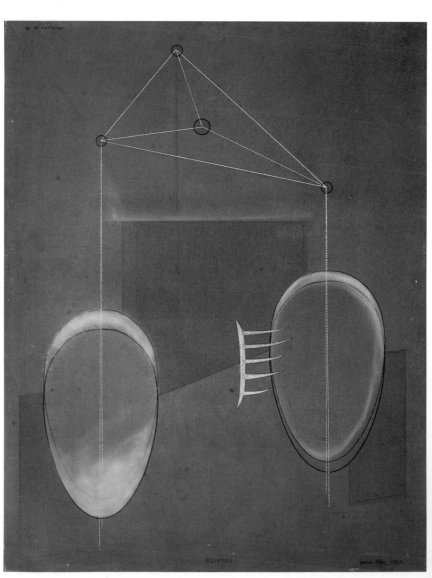

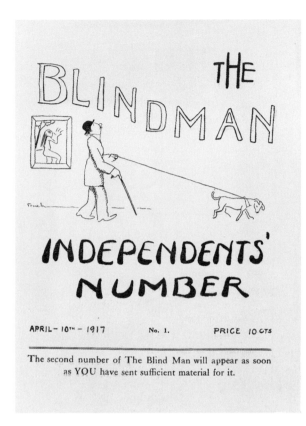

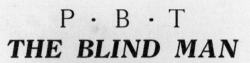

APRIL 19
Duchamp invites
Arthur Cravan to lecture
at Grand Central Gallery.
Most accounts indicate
that Cravan began to
swear and disrobe and
was arrested. Arensberg
had to bail him out of
jail. Later that evening,
back at the Arensbergs,
Gabrielle Buffet-Picabia
recalls Duchamp beam-
ing about the incident
and exclaiming, "What a
wonderful lecture!"

MAY
The Blind Man, no. 2,
is published by Beatrice
Wood; edited by Duchamp
and Henri-Pierre Roché,
it focuses on Duchamp's
Fountain and the case of
R. Mutt. Roché sends
a copy to Apollinaire, who
publishes an article on
"The Richard Mutt Case"
in *Mercure de France*
(June 16, 1918).
Apollinaire: "The view-
point of the Society of
Independent Artists is
evidently absurd for it aris-
es from the untenable
point of view that art can-
not ennoble an object."

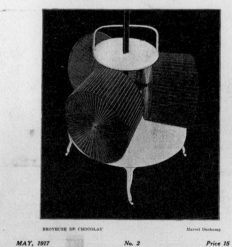

MAY 12
The ballet, *The Wooden Prince*, with score by Bartok opens in Budapest.

MAY 18
Military conscription begins in the US.

Erik Satie's *Parade* is performed by the Ballets Russes, with sets and costumes by Picasso and libretto by Cocteau; Apollinaire's article in the program contains the earliest reference to "sur-réalisme."

MAY 25
The Blindman's Ball, a party celebrating the publication of *The Blind Man*, opens at "Ultra Bohemian, Pre-Historic, Post Alcoholic Webster Hall" (119 East 11th Street); tickets are $1.50 in advance, $2 at the gate. It is a riotous and dionysian affair. After a number of drinks, Duchamp shimmies up a flagpole suspended over the center of the dance floor; he receives an ovation from the drunken crowd. After the ball, many revelers head back to the Arensbergs. Duchamp retires to his one-room studio to sleep in his bed with Beatrice Wood, Mina Loy, and Charles Demuth.

For the **BLINDMAN**
A Magazine of *Vers Art*

Friday May 25th

at Ultra Bohemian, Pre-Historic, Post Alcoholic

WEBSTER HALL 119 East 11th Street

DANCING EIGHT-THIRTY

Tickets $1.50 each in advance—$2.00 at the gate. Boxes not requiring Costume, but requiring Admission tickets $10.00

Everything sold by the **BLINDMAN**

7 East 39th Street Telephone Vanderbilt 3280

JUNE 7
Hugo Ball writes in his diary: "Strange things happen—while we had our cabaret in Zurich, Spiegellgasse 1, there lived on the other side of the same Spiegellgasse, no. 6, if I am not mistaken, Mr. Ulinanov-Lenin. Every evening he had to listen to our tirades and our music, whether he enjoyed it our not—I don't know. And while we opened our gallery in the Bahnhofstrasse, the Russians went off to Petersberg to get the revolution going." At the same time, James Joyce is living in Zurich.

JUNE 15
Wartime laws are passed against espionage and sedition, the so-called Espionage Act of 1917, forbidding speaking, printing, or expressing contempt for the government, the constitution, the flag, etc. The Postmaster General is entrusted with enforcement of the act. A total of 1,532 people are arrested.

JUNE 21
Duchamp, Picabia, and Beatrice Wood go to Coney Island amusement park. Duchamp and Picabia force Wood into riding the roller coaster with them until she stops screaming. "With Marcel's arm around me," Wood later recalls, "I would have gone on any ride into hell, with the same heroic abandon as a Japanese leap."

JUNE 24
Apollinaire's *Les mamélles de Tirésias*, "a surrealist drama in two acts and a prologue" is performed at the Théâtre Maubel in Paris.

SUMMER
With Gabrielle Buffet-Picabia off to Europe, Picabia shares his apartment at 110 West 88th Street—sublet from Louise Norton—with Varèse. Picabia has an affair with Isadora Duncan.

MARCEL DUCHAMP, FOUNTAIN, 1917 (1964 EDITION)

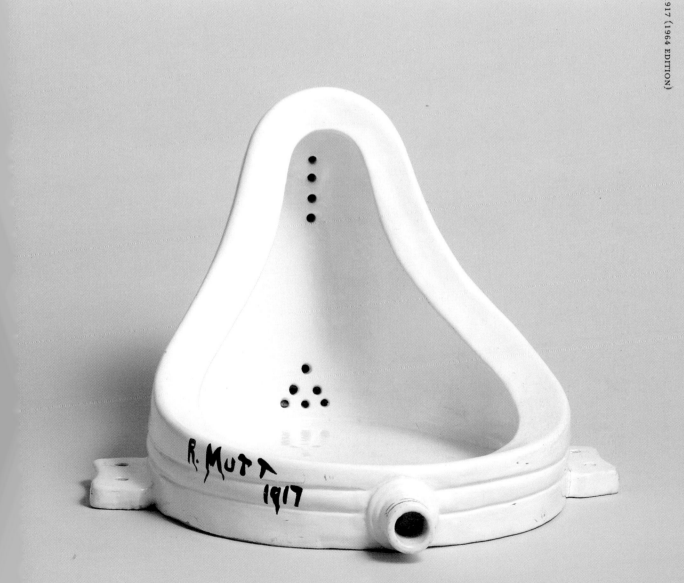

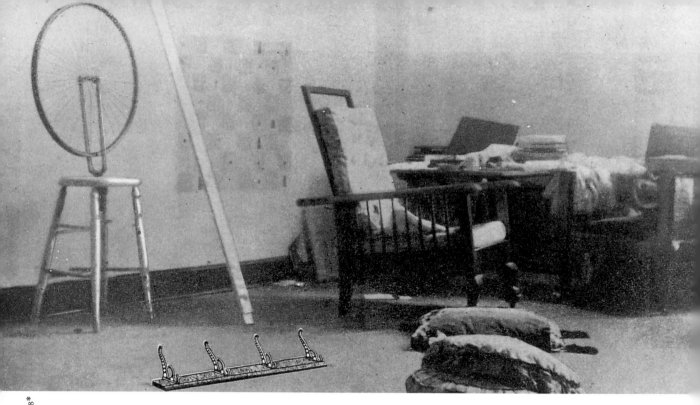

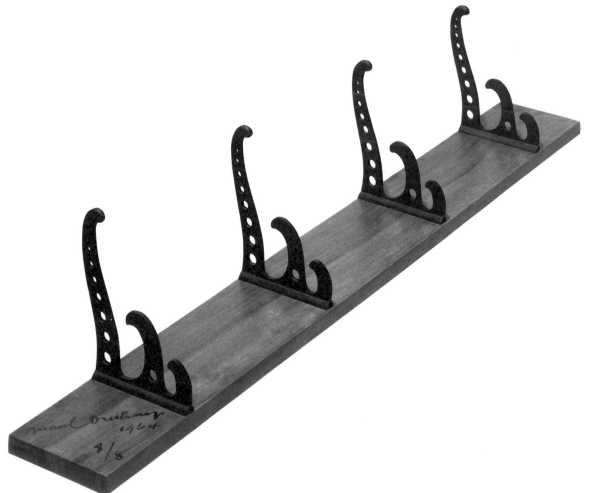

Here Nothing, always Nothing

EXEUNT INDEPENDENT ARTISTS

Close of the Exibition at Grand Central Palace as Independently Pictured by L. M. Glackens

WE are privileged in being able to print these exclusive pictures of Closing Day at the exhibition of the Society of Independent Artists, which brings to an end its long run at the Grand Central Palace to-day. Our [artis]t, Mr. L. M. Glackens, was allowed carte blanche in the exhibition and was [affor]ded especial facilities for research work, owing to the happy coincidence of [his b]eing brother to the president of the society, Mr. W. L. Glackens. Thanks to [his in]fluence in this quarter, he is able to claim the distinction of being the first white man (outside of the committee) to penetrate into the fastnesses of this display of modern art and to emerge alive with several of its secrets clasped tightly to his bosom. Of course, there were many of the exhibits which had no secrets, but those were so patent to the average visitor that it is not necessary to deal with them here. On this page will be seen only those features of modern art which have double, or even triple, meanings, and which would otherwise have escaped the dull perception of the layman.

CameraWork, published by **Stieglitz** since 1903, ceases publication after fifty issues.

Nord–Sud, a review with **Dadaist tendencies**, is published in Paris; includes contributions from Apollinaire, Reverdy, Max Jacob, Breton, Soupault, and Aragon.

C.G. Jung publishes Psychology of the Unconscious.

BEATRICE WOOD, UN PEUT [sic] D'EAU DANS DU SAVON (A LITTLE WATER IN SOME SOAP), 1917 (1977 REPLICA)

The first Pulitzer Prizes are awarded.

In New York City, the Original Dixieland Jass Band makes the first recordings,
a new form of music distribution allowing for a mass cultural reception of jazz.

Spreading beyond New Orleans, the Dixieland sound is all the rage.

The first Sunday baseball game is played in New York's Polo Grounds between the Giants
and the Cincinnati Reds. Manager John McGraw and Christy Mathewson
are arrested for violating New York's **blue laws**.

JULY

Race riots in East St. Louis. Between twenty and seventy-five African-Americans are reported killed.

Under Tzara's direction, the first issue of *Dada* is published in Zurich. The last of seven issues appears in March 1920.

JULY 5

The US Post Office finds an issue of the *The Masses*, edited by Max Eastman, "unmailable under the (Espionage) Act of June 15, 1917." In August, the Post Office forbids the mailing of another issue. *The Masses* folds within the year. Eastman goes on to edit the journal *Liberator*.

JULY 28

Duchamp has his thirtieth birthday party at the Stettheimers' Tarrytown summer home. The scene is commemorated in Florine Stettheimer's *La Fête à Duchamp*.

AUGUST

In New York, Duchamp produces the single issue of *Rongwrong*, which includes contributions from Carl Van Vechten, Allen Norton, and Helen Freeman. Originally intended as *Wrong Wrong*, its title is the result of a printer's error. Picabia, editor of the rival magazine *391*, challenges Roché to a chess match to decide which periodical will continue publishing. Roché loses and *Rongwrong* is finished. The game's thirty-four moves are recorded and published in *Rongwrong*.

BÉATRICE WOOD, BÉATRICE ET SES DOUZES ENFANTS! (BEATRICE AND HER TWELVE CHILDREN!), C. 1917

Henrie Waste's (a.k.a. Ettie Stettheimer) *Philosophy* is published by Longman's, Green and Co.

At age seventy-two, Sarah Bernhardt tours America for the last time.

Second *Others* anthology published by Alfred A. Knopf.

T.S. Eliot's *Prufrock and Other Observations* is published.

Katherine Dreier meets Henri-Pierre Roché, who assists with her collecting activities.

ELLE
Béa

ENNUIE DIMANCHE

LUI, LA PLAGE, LA CHARMANTE DANSEUSE...
Isadora!

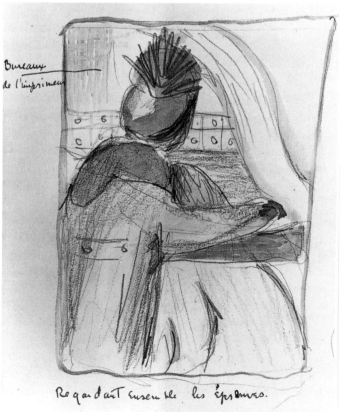

Bureaux
de l'imprimeur

Regardant ensemble les épreuves.

AUGUST 23
Private bathing is forbidden in Berlin to conserve water and coal.

FALL
American soldiers are being transported to France at the rate of 50,000 per month; in all, more than two million soldiers make the voyage.

OCTOBER
Picabia leaves New York for Switzerland; he never returns.

OCTOBER 15
Mata Hari, the enchanting Dutch dancer, is found guilty of espionage and is executed in France. She is said to have turned over sensitive information to the Germans that she garnered during intimate relations with a number of Allied officers.

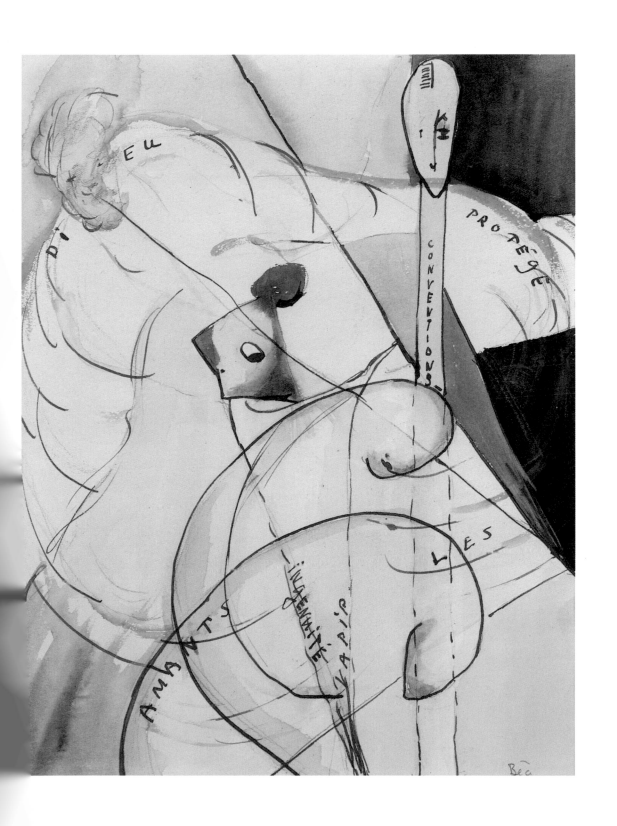

FRANCIS PICABIA, PAROLES, 1917–19

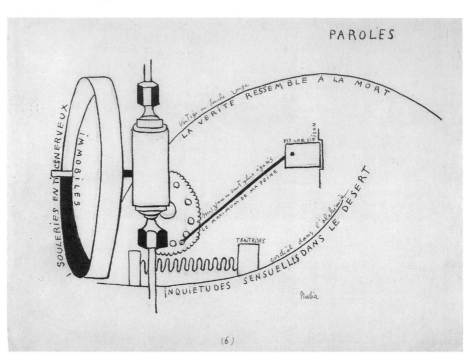

FRANCIS PICABIA, VERTU (VIRTUE), c. 1917

Upton Sinclair's *King Coal.*

First four issues of *391* are published in Barcelona by Picabia.

Numbers 5, 6, and 7 are published in New York.

In all, nineteen issues are published.

OCTOBER 27
American troops arrive at the front-line trenches for the first time near Nancy, France. Gas masks are standard issue equipment for US troops at the front.

NOVEMBER 7
Bolsheviks seize power in the virtually bloodless October Revolution—so-named because Russians used the older, Julian calendar.

DECEMBER 1
US protests Russian armistice proposal.

DECEMBER 16
Russia breaks with Triple Entente to sign armistice with Germany and its allies. Russian dead are said to number 3.7 million.

AMÉRICAINE

Francis Picabia, AMÉRICAINE (AMERICAN), cover, 391, July 1917

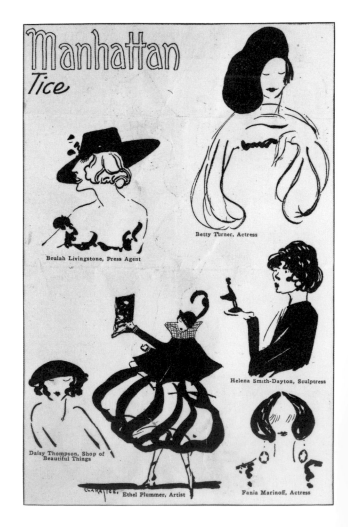

JANUARY

Shortly after New Year's, Arthur Cravan and Mina Loy marry in Mexico City.

Club Dada is formed in Berlin. Schwitters' application to join is rejected by Huelsenbeck.

President Wilson presents his Fourteen Points, a proposal for a peace settlement.

JANUARY 16

President Wilson orders all industries not involved in food production to remain closed on Mondays. Theaters are allowed to stay open.

19**18**

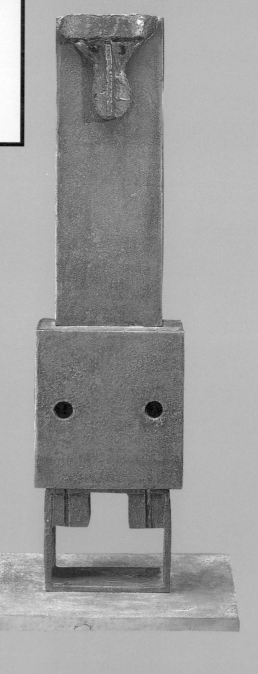

MAN RAY, BY ITSELF I, 1918 (1966 REPLICA)

FEBRUARY

Having abandoned painting more than four years earlier, Duchamp returns to it for a final encore, his oil on canvas *Tu m'*, painted at the request of Katherine Dreier. The 10-foot-wide painting is self-reflexive, summarizing his prior works. It is placed above Dreier's bookcase in her apartment at 135 Central Park West. Duchamp hires a professional sign painter to paint the pointing finger, itself a familiar advertising trope, which is prominently signed "A. Klang"; Yvonne Crotti also paints part of the composition. Duchamp: "...summarizing one's works in a painting is not a very attractive form of activity." The title evokes the French expression, "tu m'ennuis"—"you bore me."

FEBRUARY 29

Picabia arrives in Lucerne, recovering from alcoholism.

MARCH

Due to a shortage of men, women march in the St. Patrick's Day Parade.

MARCH 26

Breakfasting with Roché over scrambled eggs, tea, and grapefruit, Duchamp states that nothing new has been written since Mallarmé's "Un coup de dés jamais n'abolira le hasard" and that nothing new has been created in music since Debussy.

SPRING

Modern Gallery closes in New York.

APRIL 1

Daylight Savings Time is inaugurated to conserve fuel for US business.

APRIL 14

Charlie Chaplin's *A Dog's Life* is released.

The Arensbergs' salon is reduced to one or two evenings per week.
Arp, Janco, and Giacometti form the Zurich club,
Das neue Leben (The New Life).
Berlin Dada is formed. Members include: Johannes Baader, George Grosz,
Raoul Hausmann, Hannah Höch, Richard Huelsenbeck,
John Heartfield, Wieland Herzfelde, and Franz Jung.
Socialist Eugene V. Debs is found guilty of violating the 1917 Espionage Act.
Frank O. King creates the popular comic strip *Gasoline Alley*.
Grosz, Herzfelde, and Heartfield join Communist Party in Berlin.

APRIL 18
Hugo Ball writes in his diary: "Perhaps the art which we are seeking is the solomonic key that will open all mysteries. Dadaism—a mask play, a burst of laughter? And behind it, a synthesis of the romantic, dandyistic and— daemonistic theories of the 19th century."

APRIL 21
The German aviator Manfred von Richthofen, known as the "Red Baron," is shot down and killed in the battle of the Somme after a flying career that reportedly included the downing of eighty Allied aircraft in less than two years.

The French are encouraged to eat horsemeat by the Minister of Provisions.

APRIL 30
American troops are gassed in France. During May, 15,000 gas shells are reportedly dropped by Germans into American trenches.

MAY 5
German mines are discovered off Delaware Bay.

MAY 9
"Exterminator" wins The Kentucky Derby.

MAY 24
284,114 women register to vote in New York City.

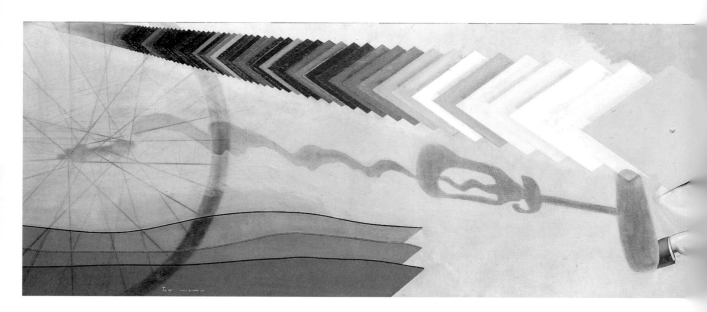

Ingmar Bergman, Swedish film director, is born.

In Cologne, Max Ernst, Johannes Baargeld, and Hans Arp lead Dada activities.

Upon reading copies of Zurich *Dada* journal,

Aragon, Breton, Éluard, and Philippe Soupault become interested in Dada.

The New York Philharmonic Society bans works by living German composers.

Aragon receives the *Croix de Guerre* for evacuating wounded under fire.

Under the patronage of Gertrude Vanderbilt Whitney, the **Whitney Studio Club**,

an artists' club/exhibition space, is opened at 147 West Fourth Street.

Providing an ideology that would later be seized upon by National Socialists, Oswald Spengler publishes

Decline of the West, which calls for the end of "decadent" Weimar democracy.

D.W. Griffith's *Hearts of the World*, a war story starring Lillian Gish, Robert Harron, and Dorothy Gish, opens.

Under the influence of Futurist compositions,
Hausmann, Grosz, Heartfield, and others
develop a new **typography** that
reflects the mechanics
of disjunction
and rupture.

JUNE

Baroness Elsa von Freytag-Loringhoven publishes the poem "Love—Chemical Relationship," which is inspired by Duchamp's unfinished *Large Glass* and dedicated to the artist in *The Little Review*.

JUNE 9

Georgia O'Keeffe arrives in New York with Paul Strand. She becomes romantically involved with Stieglitz later in the year.

JUNE 20

X-ray expert Dr. Eugene Caldwell dies in New York of X-ray burns.

JUNE 29

US war costs $13.8 billion for the fiscal year.

JULY 9

"What Is Dadaism?" appears in the *New York Tribune*, one of the first American notices of Dada; it is a rehash of a previously published article in the *Kölnische Zeitung*.

JULY 16

Lexington Avenue subway line opens.

Bolshevik revolutionaries reportedly execute Czar Nicholas II and his heir, Alexis, ending three centuries of Romanov rule. The Empress Alexandra, their four daughters, and several servants are also reported to have been shot to death in Siberia.

JULY 19

Baseball is ruled a non-essential occupation by US Secretary Baker; baseball players can now be drafted.

JULY 23

Duchamp makes a miniature version of *Nude Descending a Staircase* for Carrie Stettheimer's dollhouse; it is a birthday gift.

Tzara reads his "Manifeste Dada 1918" during the *Soirée Tristan Tzara* in Zurich. It is later published in *Dada 3*, with the collaboration of Picabia.

MARCEL DUCHAMP, TU M', 1918

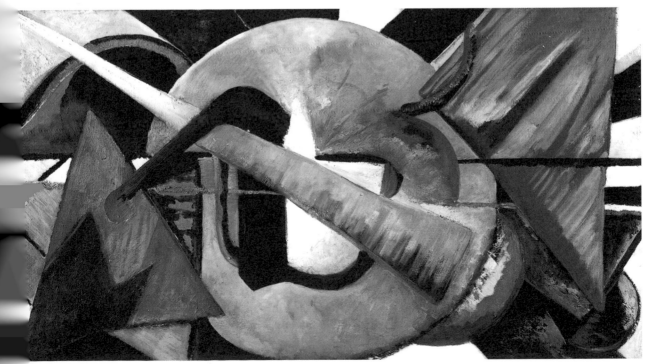

KATHERINE S. DREIER, ABSTRACT PORTRAIT OF MARCEL DUCHAMP, 1918

AUGUST 13
Duchamp sails on the SS *Crofton Hall* to Buenos Aires with *Sculpture for Traveling*, his notes for *Large Glass*, and Yvonne Crotti, the wife of his ex-studio mate, Jean Crotti. (Jean Crotti is involved with Suzanne Duchamp, Marcel's sister, whom he marries in 1919.) Before departing, Duchamp writes to Picabia, who is in Switzerland, that in New York, "everything has changed and [there are] fewer ways of enjoying oneself."

AUGUST 15
US breaks diplomatic ties with Russia after Bolsheviks arrest French and British diplomats, and sends 7,000 Marines to Vladivostok to aid the anti-Bolshevik forces.

AUGUST 18
Katherine Dreier, following Duchamp, travels to Buenos Aires; there she writes *Five Months in the Argentine from a Woman's Point of View*.

AUGUST 25
The motion picture industry is declared an "essential industry" by the US War Industries Board.

SEPTEMBER
Left-hander Babe Ruth leads the Boston Red Sox to a World Series victory over the Chicago Cubs.

SEPTEMBER 18
Arthur Cravan, unable to persuade Jack Johnson to come to Mexico, fights Black Diamond Jim Smith and is knocked out in the second round.

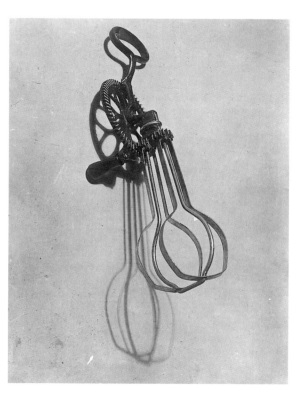

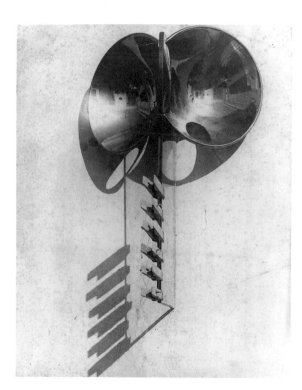

The *New York Times* begins **home delivery.**
In New York, a new method for producing **color motion pictures** is demonstrated by Leon Forrest Douglass.
Controversy is still stirring in America over the psychoanalytic ideas of Freud and Jung.
Vicente Blasco Ibañez's novel, *The Four Horsemen of the Apocalypse*, is a best-seller.
Knute Rockne becomes head football coach at Notre Dame.
Photomontage is developed by John Heartfield and George Grosz, Berlin Dadaists; in a disputed claim, Hausmann insists that he has discovered photomontage while vacationing in the island of Usedom with Hannah Höch.
Regular airmail service is inaugurated between New York and Washington, D.C.
The first US airmail stamp is issued.
In New York, Man Ray continues work on Aerographs, which are produced with an air gun.
"I was planning something entirely new, I had no need of an easel, brushes, and the other paraphernalia of the traditional painter. The inspiration came from my office, where I had installed an airbrush outfit with air-pump and instruments to speed some of the work which involved the laying down of large areas of color."
The first gasoline pipeline begins, a 40-mile line between Salt Creek and Casper, Wyoming.

FALL

In Mexico City, Arthur Cravan tries to establish a boxing academy; his wife, Mina Loy, pregnant with their child, sails for Buenos Aires (where Duchamp and others are). Although expected to follow, Cravan is never heard from again. His mysterious disappearance perpetuates his legendary status in literary circles.

OCTOBER 7

Raymond Duchamp-Villon, artist and brother of Marcel Duchamp, dies.

OCTOBER 13

Morton Livingston Schamberg dies of the "Spanish flu," a worldwide influenza epidemic that kills 25–50 million.

OCTOBER 14

Of the four million US troops sent to Europe, approximately 50,000 are reported dead, a loss vastly smaller than that suffered by European nationals.

NOVEMBER 9

Spiro Agnew, vice-president who resigned under Richard Nixon, is born.

Kaiser Wilhelm II abdicates and Karl Liebknecht, leader of the Spartacus party (the German Communist Party), declares the birth of the "free socialist republic of Germany"

Guillaume Apollinaire dies. Memorial statements by Tzara and Picabia are published in *Dada 3* (December 1919).

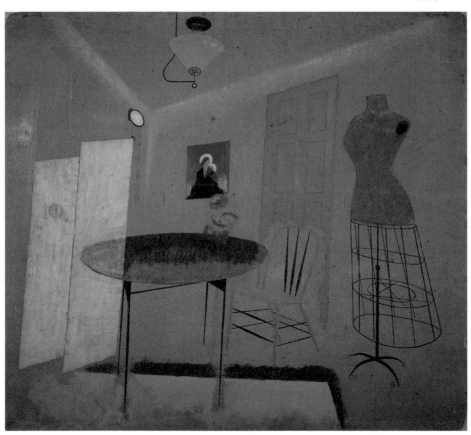

MAN RAY, STILL LIFE + ROOM INTERIOR, 1918

In Palestine, the British army decisively defeats the Turks, taking Haifa and Nazareth.

In New York, the African-American 367th Infantry is awarded colors by the Union League.

Most labor unions still refuse to admit women. 91% of all female employees in New York receive less than equal pay for equal work

US deaths from influenza epidemic exceed war casualties suffered by US soldiers.

Total cost of World War I among all the belligerents is more than $232 trillion during combat years.

Daily war expenditures (all nations): $164.5 million.

Charlie Chaplin appears in *A Dog's Life* and *Shoulder Arms*.

The collapse of the Hapsburg Empire gives rise to the birth of four nations: Austria, Hungary, Czechoslovakia, and a Kingdom of Slovinia, Serbia, and Croatia.

Mexican government nationalizes oil fields.

NOVEMBER 11
Armistice is signed at
11:01 a.m. Four million
soldiers and six million
civilians have been killed
in the four-year world
war.

NOVEMBER 24
In New York, Enrico
Caruso makes his film
debut in *My Cousin*.

DECEMBER 1
US occupation of
Germany begins.

DECEMBER 7
Spartacists in Berlin call
for revolution.

DECEMBER 10
Max Planck wins Nobel
Prize in physics for his
"quantum" theory, which
revolutionized the under-
standing of the nature of
energy.

DECEMBER 21
Kurt Waldheim, future
UN Secretary-General
and Austrian President,
is born.

DECEMBER 25
Spartacist revolt in
Berlin.

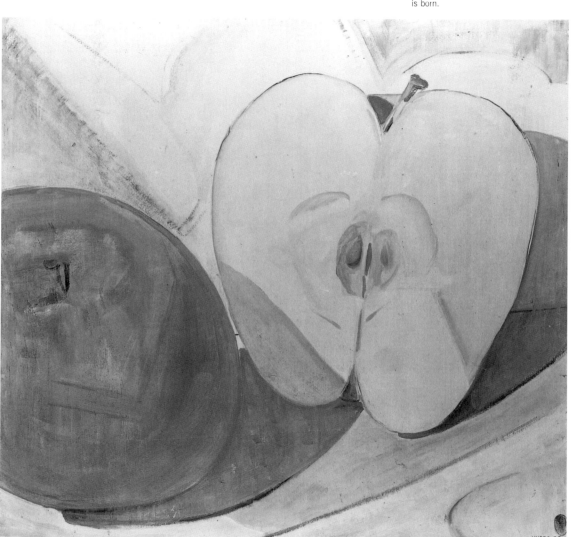

JOHN R. COVERT, HYDRO CELL, 1918

US Post Office burns five hundred copies of *The Little Review* containing
installments of James Joyce's *Ulysses*, which is banned in the United States until 1933.
Irving Berlin's *Yip Yip Yaphank* opens in New York.
Reflecting the growth of cooperative buildings in the first two
decades of the 20th century, the Hotel des Artistes,
designed by George Mort Pollard, opens on West 67th Street,
just down the street from the Arensbergs.
US population is 103.5 million.

JANUARY
Picabia and Tzara meet in Zurich; it is the first significant contact between New York and Zurich Dada.

JANUARY 15
Karl Liebknecht and Rosa Luxemburg, German Communist leaders, are murdered while in the custody of the Freikorps. Luxemburg is beaten by a mob, shot in the head, and her body is dumped in a canal. Uprising is over.

JANUARY 16
Tzara holds a conference on abstract art in Zurich.

JANUARY 21
35,000 mostly female dressmakers strike in New York City, demanding a 44-hour work week.

German munitions maker Krupp begins armament production for US under terms of armistice.

JANUARY 25
The world's largest hotel, the 2,200-room Pennsylvania, opens in New York on Seventh Avenue.

Allies adopt a plan for League of Nations.

FEBRUARY-MARCH
Emphasizing an alternative distribution of art, Max Ernst and Johannes Baargeld sell the journal *Der Ventilator* at factory gates in Cologne. British Occupation Forces ban publication when it reaches a circulation of 20,000.

1919

JOHN R. COVERT, EX ACT, 1919

John Reed is tried for sedition in connection with articles published in *The Mass*
While awaiting trial, he writes *Ten Days That Shook the World*.
Roseland Ballroom, an up-market dance hall, opens at 1658 Broadway (near 51st street), hosting jazz bands.

FEBRUARY 5
William S. Burroughs, author of *Naked Lunch*, is born.

FEBRUARY 14
International delegations at Versailles agree to create the League of Nations proposed by President Wilson.

FEBRUARY 15
Wieland Herzfelde edits *Jedermann sein eigener Fussball*, distributing 7,600 copies on Berlin streets before it is banned by the police and he is arrested.

MARCH
Man Ray publishes the sole issue of the pseudo-anarchist periodical *TNT*; contributors include Philippe Soupault, Charles Sheeler, Duchamp, and Arensberg, who contributes a poem, "Vacuum Tires: A Formula for the Digestion of Figments."

Due to a shortage of raw materials, beer supplies shrink and dry up completely in some markets.

Inaugural issue of *Littérature*, the Paris review and important Dada organ, is edited by Aragon, Breton, and Soupault (last issue, June 1924).

Barricades in the Berlin streets; Ministry of Defense troops fight Berlin workers, who had been called upon to strike by the Communist Party. 1,500 revolutionaries are killed and 10,000 wounded.

JOHN R. COVERT, BRASS BAND, 1919

Havelock Ellis, *The Philosophy of Conflict.*

Satie writes *Socrates*, music set to three dialogues by Plato.

Pound resigns as foreign editor of *The Little Review.*

First international airmail flight from Vancouver to Seattle.

MARCH 13
Britain announces that
German U-boats are to
be sold and proceeds
distributed among the
Allies.

MARCH 23
Benito Mussolini forms
the party *Fiasco di
Combattimento*, leading
Italy toward Fascism.

FRANCIS PICABIA, L'ENFANT CARBURETOR (THE CHILD CARBURETOR), C. 1919

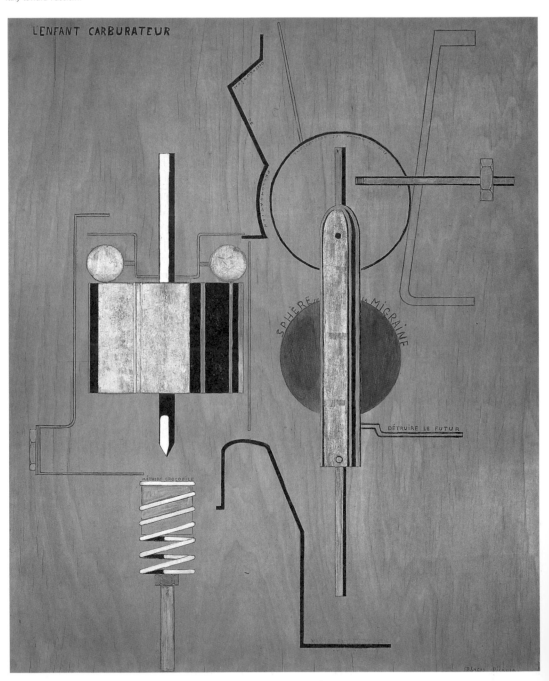

Rudolph Steiner, *The Essential Points of the Social Question.*
The large well-illustrated broadsheet, which became the typical tabloid format, is introduced by *The Daily News* in New York
and widely copied, changing the face of 20th-century newspapers.

MARCH 29
British astronomers witnessing solar eclipse off the coast of West Africa verify Einstein's General Theory of Relativity. The latter is subsequently hailed as "one of the greatest, perhaps the greatest achievements of human thought."

MARCH 31
Pictures of Kaiser Wilhelm are banned in Prussian schools.

APRIL 10
Emiliano Zapata, leader of Mexican rebels and agrarian folk hero, is killed by government troops.

APRIL 12
First concert of New Symphony Orchestra, of which Varèse is musical director, at Carnegie Hall. On the bill is Bach followed by Bartók's *Deux images*, Alfredo Casella's *Notte di maggio*, Debussy's *Gigue*, and Gabriel Dupont's *Le chant de la destinée*. Critics dislike the music's dissonance and cacophony. The directors of the New Symphony Orchestra ask Varèse to moderate future performances; instead, he resigns.

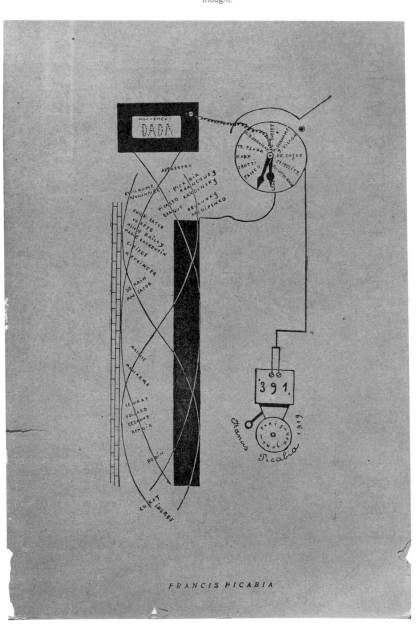

FRANCIS PICABIA

Franz Kafka publishes *In the Penal Colony*.

Marcus Garvey founds the shipping line Black Star to spearhead his "Back to Africa" movement.

First issue of *Die Pleite* is edited by Wieland Herzfelde (last issue, 1924).

Stravinsky's *Le chant du rossignol* is first performed in Geneva with Walter Serner shouting, "Viva Dada."

APRIL 13
Price of gasoline reaches 75¢ per gallon in Britain.

APRIL 14
In Paris, Allies demand $23 billion in reparations from Germany.

APRIL 17
United Artists film company is formed by Charlie Chaplin, D.W. Griffith, Mary Pickford, and Douglas Fairbanks.

APRIL 21
500,000 reported to have died of influenza in Belgian Congo during the war years.

APRIL 25
The Bauhaus (1919-28) is founded by Walter Gropius in Weimar.

APRIL 27
Motion picture censorship agreed to by the National Association of the Motion Picture Industry.

MAN RAY, LA VOLIÈRE (THE AVIARY), 1919

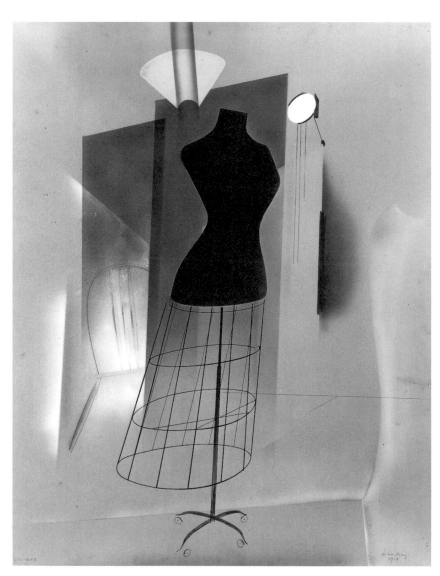

Californian Oliver Smith develops the mechanical rabbit, marking the start of modern greyhound racing.
Oil magnate John D. Rockefeller spearheads universalist American philanthropy, giving away over $100 million this year. Half goes to the General Education Board and half to the Rockefeller Foundation.
Thomas H. Morgan, *The Physical Basis of Heredity*.
Duchamp, when asked whether he thought World War I had an impact on the development of the arts, replies: "I don't weigh potatoes with shit."
Upton Sinclair's *Jimmy Higgins*.
Fritz Lang's *Half Caste*.

APRIL 30
Sixteen packages containing dynamite bombs are reportedly found in the New York Post Office. Authorities claim they are part of nationwide plot by "Reds" to celebrate May Day by assassinating public officials, including Supreme Court Justice Oliver Wendell Holmes, Postmaster-General Burleson, and Attorney General A. Mitchell Palmer.

MAY 1
Approximately four hundred soldiers, sailors, and marines celebrate May Day by raiding the newspaper office of the Socialist *New York Call*, beating the editors and damaging the premises.

MAY 7
New York State Governor Alfred E. Smith signs bill prohibiting the display of red flags.

JUNE
Allen Norton, co-editor of *Rogue*, publishes the poem "Walter's Room," about Arensberg's salon, in the June issue of *The Quill*.

*The *** room
Which Walter conceived
one day
Instead of walking with
Pitts in the Park
Or celebrating Sex on
the Avenue*

*Where people who lived
in glass houses
Threw stones connubially
at one another;
And the super pictures
on the walls
Had intercourse with the
poems that were
never written...*

*Where I first saw Time in
the Nude;
Where I met Mme.
Picabia;
Where Christ would have
had to sit down
And Moses might have
been born with propriety.*

Admiration of the Orchestrelle for the Cinematograph

MAN RAY. ADMIRATION OF THE ORCHESTRELLE FOR THE CINEMATOGRAPH, 1919

MARCEL DUCHAMP, 50CC OF PARIS AIR, 1919 (1949 REPLICA)

A.D. Juilliard bequeaths $20 million
to endow Juilliard School of Music in New York.

First issue of *Der Dada*, edited by Hausmann,
Grosz, and Heartfield in Berlin (last issue, April 192

TNT, MARCH 1919

JUNE 9
US troops are "asked" by Nicaraguan government to send troops to "protect" the country from Costa Rica.

JUNE 17
New York State establishes first written test for driver's license.

JUNE 28
Five years after Sarajevo gunfire triggered world war, the Germans sign peace treaty in the Hall of Mirrors at Versailles. German representatives are reportedly humiliated when forced to use a separate entrance and exit to the hall. John Maynard Keynes, British delegate to the conference, later publishes *The Economic Consequences of Peace*, arguing that the flawed treaty could wreak economic havoc in Germany.

The New York Times lists 176 plays as having been performed in Manhattan in the previous season.

JULY
Duchamp sails to Paris from Argentina. Staying with Picabia, he is in contact with the Dada group—including Breton—gathering at the Café Certá.

JULY 1
Daily airmail service begins between New York and Chicago.

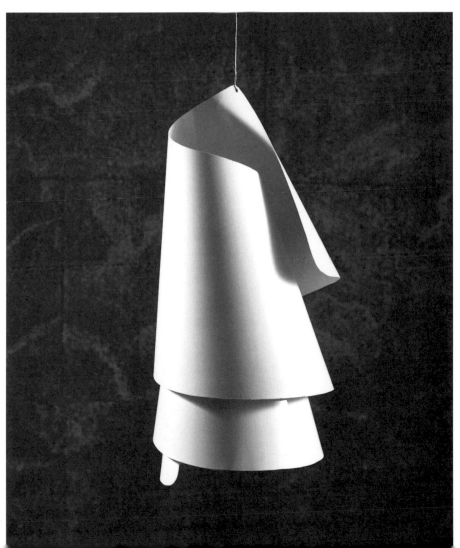

MAN RAY, LAMPSHADE, 1919 (1959 REPLICA)

19**19** *121*

JULY 4

Jack Dempsey defeats Jesse Willard to become world heavyweight champion.

JULY 17

30,000 cigarmakers strike in New York City.

JULY 30

Race riots in Chicago.

AUGUST

Katherine Dreier travels in Europe, meeting many artists and poets—partly through the connections and generosity of her friend Marcel Duchamp—including Archipenko, Brancusi and Ernst. Meeting Ernst and Baargeld in Cologne at their Dada show, she is among the first Americans to see a Dada exhibition. Impressed, she makes efforts to organize a New York show of their work, but is denied an export license by the British occupation authorities in Cologne.

AUGUST 31

The American Communist Party is founded in Chicago.

SEPTEMBER 3

Louise Arensberg, Roché, and Wood go to see the Houdini film *The Grim Game*, featuring an actual accidental aircraft collision.

SEPTEMBER 9

Boston police officers go on strike, leaving a major American city lawless and riotous. Governor Calvin Coolidge issues edict to replace the striking policemen. After Coolidge rejects a plea by AFL President Gompers to allow the policemen to return to work, President Wilson sends Coolidge a telegram congratulating him on his reelection victory and offering support for his law and order policy: "There is no right to strike against the public safety by anybody, anywhere, anytime."

MAN RAY, AEROGRAPH OR UNTITLED, 1919

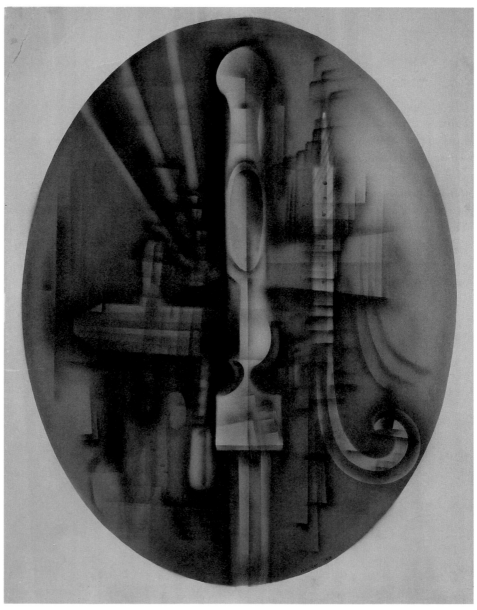

Here Nothing, always Nothing

MAN RAY, SEGUIDILLA, 1919

In Abrams v. United States, the Supreme Court upholds conviction of five
New York City Russians, including Mollie Steimer and Jacob Abrams,
who are associated with the anarchist publication *Der Shturm*.
They are imprisoned under the Espionage Act of 1917 for distributing circulars criticizing capitalism, American intervention
in Bolshevik Russia, and the character of President Wilson.

President Wilson wins Nobel Peace Prize.

The antiwar film directed by Abel Gance, *J'Accuse*, opens and is well received.

NOVEMBER 17
Man Ray's third and last one-artist exhibition opens at the Daniel Gallery. His most comprehensive show to date, it features work produced over the past six years. Exhibited for the first time are his Aerographs (paintings produced with an airbrush).

DECEMBER
Duchamp pencils his now infamous mustache and goatee over a reproduction of the *Mona Lisa*, calling it *Gioconda (L.H.O.O.Q.)*. The letters, when pronounced in French, sound like "Elle a chaud au cul"— "she's got a hot ass." Duchamp's gesture is publicized through the work's "reproduction" on the cover of *391* in 1920.

DECEMBER 2
First Dada World Congress opens at the Grande Salle des Eaux Vives in Geneva; attended by, among others, Stravinsky and Archipenko.

DECEMBER 3
Henry Clay Frick, steel magnate, millionaire, art collector, and staunch anti-unionist, dies.

DECEMBER 30
French birth rates reportedly double since start of the year.

LATE DECEMBER
Duchamp returns to new York, bringing Arensberg a souvenir from Paris: *50cc of Paris Air*, a pharmacist's glass ampule drained of its serum and resealed, containing 50cc of air. Duchamp later recalled: "I thought of it as a present for Arensberg, who had everything money could buy."

Baroness Elsa von Freytag-Loringhoven, PORTRAIT OF MARCEL DUCHAMP, c. 1919

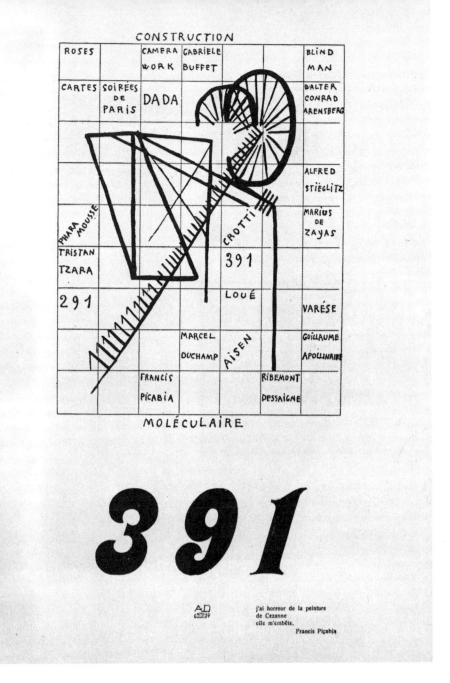

In a campaign to combat the spread of Communism and leftist organizations, members of Congress meet with motion picture executives to discuss the important propagandistic role film and the film industry can play to "do all that is within its power to up build and strengthen the spirit of Americanism."

American railroad lines total 265,000 miles.

Carl Sandburg wins Pulitzer Prize for *Corn Huskers*.

JANUARY 2
Palmer Raids conducted by Attorney General A. Mitchell Palmer begin. More than four thousand suspected "subversives" are arrested, including the feminist and anarchist Emma Goldman and Alexander Berkman; both are deported without trial.

JANUARY 5
Radio Corporation of America is formed to broadcast worldwide.

JANUARY 16
Amendment to the US Constitution prohibiting the consumption of alcohol takes effect.

JANUARY 17
Tzara, "awaited like a messiah," returns to Paris, welcomed by the *Littérature* group.

JANUARY 20
Federico Fellini, the Italian film director, is born.

JANUARY 23
Littérature introduces the Dada manifestation to Paris, organizing the first Friday gathering, *Première vendredi de Littérature*, at the Palais des Fêtes. Widely attended, it draws André Salmon, Max Jacob, Luis Aragon, André Breton, Paul Éluard, Jean Cocteau, and Tristan Tzara among others. Tzara reads a newspaper article aloud accompanied by Éluard hammering on bells, which renders Tzara's speech incomprehensible.

Huelsenbeck publishes *Almanach Dada* in Berlin, wherein he proclaims: "In the countries of the Allies, including the United States, Dada has been victorious."

The "ink-blot" test invented by psychiatrist Herman Rorschach.

US Census reports show New York is largest city, with 5.6 million inhabitants. Chicago, Philadelphia, and Los Angeles follow.

Tommy gun inventor, Ret. Officer John J. Thompson, receives patent for his submachine gun.

Reported homicides in New York City per 100,000: 1916-20, 4.9; 1921-25, 5.4

H.G. Wells, *The Outline of History*.

First American broadcasting station is opened in Pittsburgh by Westinghouse Company.

Freud's *Beyond the Pleasure Principle*, a reformulation of his drive theory, especially the machinations of the death drive.

Duchamp invents his first motored optical machine, *Rotary Glass Plates (Precision Optics)*.

MAN RAY, L'INQUIÉTUDE, 1920

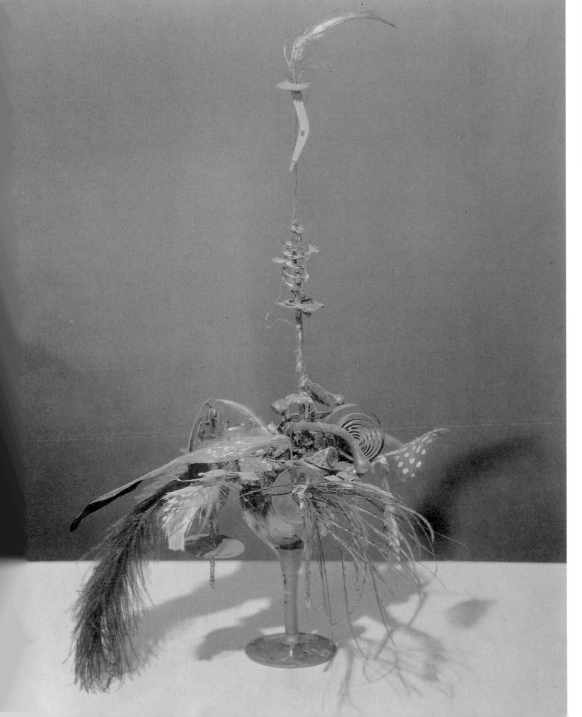

FEBRUARY 5

Second Dada manifestation in Paris at the Salon des Indépendants includes thirty-eight performers reading manifestos. Organizers had spuriously informed the newspapers that Charlie Chaplin would be participating.

MARCH 13

Pro-monarchist Wolfgang Kapp and German troops attempt a coup, staining the streets of Berlin with blood. A Communist-led strike helps defeat the coup.

MARCH 27

A Dada Manifestion at Salle Berlioz, Maison de l'Oeuvre in Paris, celebrates the twenty-fifth anniversary of the premiere of Alfred Jarry's *Ubu Roi*, the scatological drama inspirational to Dada's negative aesthetics. Audience members bring musical instruments to interrupt the manifestation as anti-Dada protesters in the balcony drop copies of *Non*, vilifying the Dadaists as lunatics. The event was so successful, Tzara would later claim, that there were three spectators for every seat and that 1,200 spectators were turned away.

CHARLES SHEELER, BARONESS ELSA'S PORTRAIT OF MARCEL DUCHAMP, c. 1920

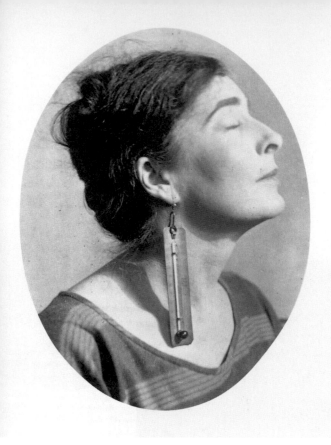

MAN RAY, PORTRAIT (MINA LOY), 1920
MAN RAY, NEW YORK OR EXPORT COMMODITY, 1920

Boston Red Sox sell Babe Ruth
to the New York Yankees for $125,000.
While Man Ray is photographing Duchamp's
Rotating Demisphere (Precision Optics),
one of the spinning glass blades of the
optical apparatus flies off and narrowly misses him.
In a gesture aimed at rejecting the contemporary identity of the "artist," he adopts the occupational title "engineer."
Between 1910 and 1920, the population of New York City
increases by almost one million to 5,620,048.
Wieland Herzfelde's *Die Pleite* is banned in Berlin.
Coco Chanel introduces the chemise dress, characteristically loose, low-waisted, and without a restrictive corset.
Almost forty percent of New York's population is foreign-born.
Upton Sinclair, *100%, the Story of a Patriot.*

SPRING

Steichen writes to Stieglitz from France about Dada and Picabia's *391*: "Dada or Dadaism & '391' is the vehicle of expression. It is the last word in modernism, as vapid and empty as international diplomacy but unlike the latter is *frankly and openly* an expression of contempt for the public. The public enjoys it and is *willing to* pay for its enjoyment. It is part of the hollow empty laugh which is supposed to stand for gaiety & amusement in Europe today. It is smart to be gay. It is the heaviest clumsiest gaiety I have ever beheld. It reeks with sham and is a *lie* on the face of itself. It is cheap perfume used to quell the stench of seven million rotting bodies because the stench might interfere with money making. Money takes precedence over everything."

Tzara invites Arensberg to contribute to *Littérature*. In response, Arensberg warns Tzara—who is considering a trip to New York—about the probable American reception of his Dada activities: "I can't tell you how happy America would be to have you transplant the center of the world. I should not know how, however, to answer you as to the form of hospitality which the guardians of free speech would extend you....I look forward with impatience to seeing in the flesh the spirit of Dada."

APRIL

Police close Dada exhibition at Bauhaus in Cologne. After the police find the most objectionable work in the show is actually the Dürer engraving *Adam and Eve* (as incorporated into one of Max Ernst's sculptures) the exhibition is reopened in May. In another of Ernst's works, the artist includes a hatchet so that exhibition-goers can destroy it.

APRIL 25

Picabia and Tzara publish the first issue of *Cannibale* (the second is published on May 25), the journal which, according to Picabia, was founded in New York, first printed in Barcelona, and published in Zurich. Contributors include "the collaboration of all the Dadaists in the world." The second issue includes an announcement for the Société Anonyme's "First Exhibition of Modern Art," and Breton's poem, "Psst," which consists of a list of the twenty Bretons in the Paris telephone book.

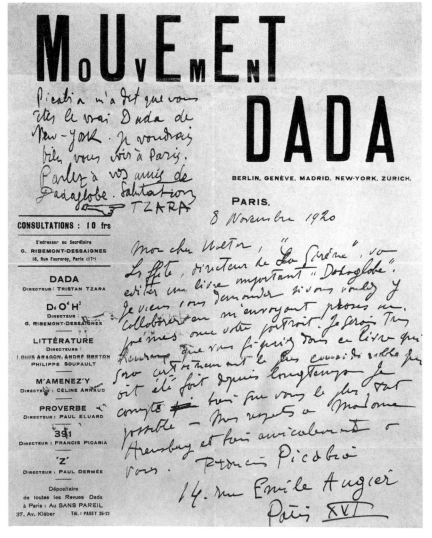

Irish nationalists led by Sinn Feiners riot in the streets of Belfast in protest of British rule.

One of the first modern detective stories, *The Cask* by F. Wils Crofts, is published.

Charlie Chaplin's *The Kid*.

MAN RAY, DUST BREEDING, 1920

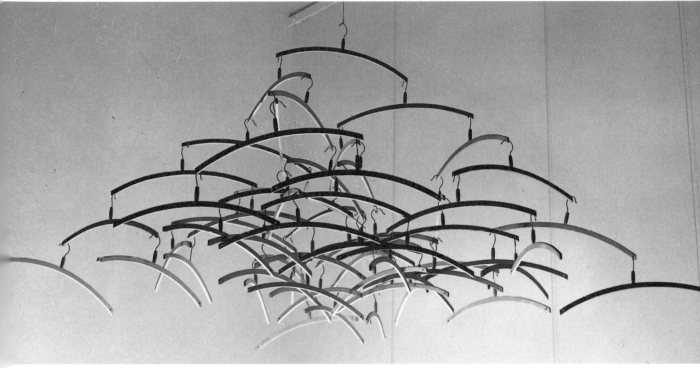

Joan of Arc (1412-1431) is canonized by Pope Benedict XV almost five hundred years after her death.

Sherwood Anderson's *Poor White.*

Mamie Smith records *Crazy Blues,* a hybrid of jazz, blues, and vaudeville,
which establishes a market for black jazz and blues recordings often referred to as "race records."

Clothing prices and hemlines rise; short skirts become fashionable.

After following Duchamp to Buenos Aires in neutral Argentina a year earlier,
Katherine Dreier publishes *Five Months in the Argentine: From a Woman's Point of View* in New York.

Number of licensed motor vehicles in the US: 8,890,000;
in Great Britain: 663,000.

League of Nations proposed by Woodrow Wilson is formed
even as the US Senate votes against joining.

In a celebrated case of anti-Communist hysteria, **Sacco and Vanzetti**
are arrested and convicted of murder on highly questionable evidence.
Despite international efforts, they are executed
on August 23, 1927.

APRIL 29

The Société Anonyme, Inc., founded by Duchamp, Man Ray, and Katherine Dreier, is established at 19 East 47th Street, across the street from the Ritz Hotel. The first museum in America dedicated exclusively to modern art, the Société also contains a vast library of international Dada publications, an archive that documents New York Dada's contemporaneous dialogue with European Dada formations. "Société Anonyme" is the French equivalent of "Incorporated" (the superfluous "Inc." is added by New York State). Dreier had initially wanted to name the

organization "The Modern Ark—A Private Museum." The Société closes in 1939 after eighty-four exhibitions; its collection ultimately goes to the Yale University Art Gallery.

APRIL 30

First exhibition at the Société Anonyme opens with works by Brancusi, Duchamp, Picabia, Man Ray, Schamberg, Stella, Van Gogh, and Villon.

MAY

Littérature, no. 20, is published as *Vingt-trois manifestes du mouvement dada*; it includes the manifesto published under Walter Arensberg's name, "Dada est américain." This manifesto establishes Arensberg's reputation in Europe as a spokesman for New York Dada. According to Arensberg, however, he was not its author. Apparently, he wrote only the manifesto's title—intended to be the manifesto itself—and nothing else.

MAY 10

Katherine Dreier writes Gabrielle Buffet-Picabia asking her to contact Tzara and find out "how much he would charge to send us a monthly public letter with short telegraphic sentences, telling us about the general happenings and the exhibition pertaining to the modern movement in Europe."

MAN RAY, INSTALLATION VIEW OF THE SOCIÉTÉ ANONYME GALLERIES, 1920

MAY 26

Festival Dada draws huge crowds at the Salle Gaveau in Paris and many are disappointed because Dadaists do not fulfill the program's promise that "all the Dadaists will have their hair cut on stage." Tzara recalls much later: "For the first time in the history of the world, people threw at us not only eggs, vegetables, and pennies, but beef-steaks as well. It was a very great success. The public was extremely Dadaist. We had already said that the true dadaists were against Dada."

JUNE 24

The First International Dada Fair in Berlin (through August 5) exhibits 174 objects, among them John Heartfield's effigy of a German officer with a stuffed pig's head and a variety of printed signs with such slogans as "Art is dead! Long Live Tatlin's Machine Art!" and "Dada is political." Picabia is one of the few non-Germans included in the show. Katherine Dreier arranges to exhibit some of these works at the Société Anonyme in what the Berlin exhibi-tion catalogue notes will be the first Dada exhibition in America. Ultimately this show doesn't transpire, for German officials declare the works too controver-sial for export.

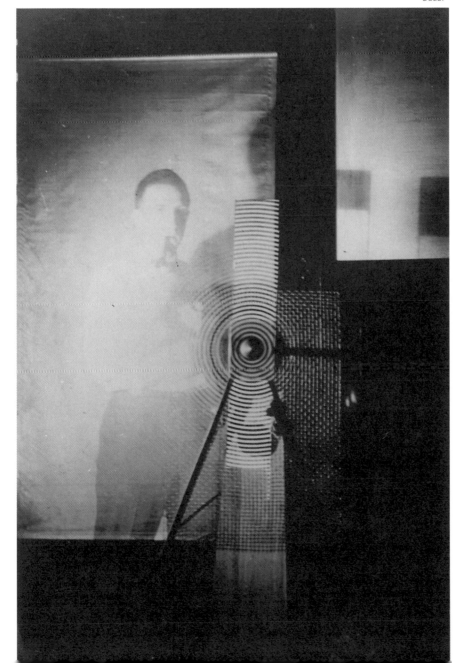

MAN RAY, MARCEL DUCHAMP WITH ROTARY GLASS PLATES MACHINE (IN MOTION), 1920

JULY
Critic John Rodker writes in *The Little Review* (July-August): "Paris has had *Dada* for five years, and we have had Elsa von Freytag-Loringhoven for quite two years. But great minds think alike and great natural truths force themselves into cognition at vastly separated spots. In Elsa von Freytag-Loringhoven Paris is mystically united with New York…The movement should capture America like a prairie fire."

AUGUST
Arensbergs travel to Los Angeles, where they will move in 1921, putting an end to the soirées at their New York salon.

AUGUST 26
Women gain right to vote nationally as 19th amendment to the Constitution is ratified. Women are excluded from the ceremonial signing in Washington.

AUGUST 29
Jazz legend Charlie Parker is born.

SEPTEMBER 28
Eight members of the Chicago White Sox, including "Shoeless" Joe Jackson, are indicted for conspiring with gamblers to throw the 1919 World Series.

OCTOBER
One million coal miners strike in Great Britain.

OCTOBER 19
A New York judge rules that membership in the Communist Party is sufficient grounds for deportation.

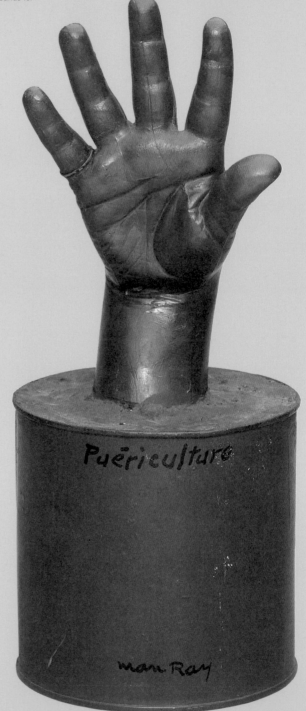

Man Ray, PUÉRICULTURE or RÊVE/PUÉRICULTURE (DREAM/CHILDCARE), 1920

Obscenity charges
are brought against the editors of *The Little Review*, Margaret Anderson and Jane Heap, and the Washington Square Bookshop for serializing and distributing Joyce's *Ulysses*.

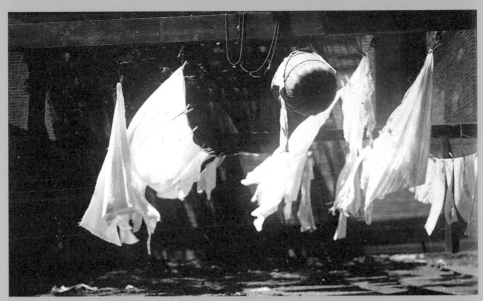

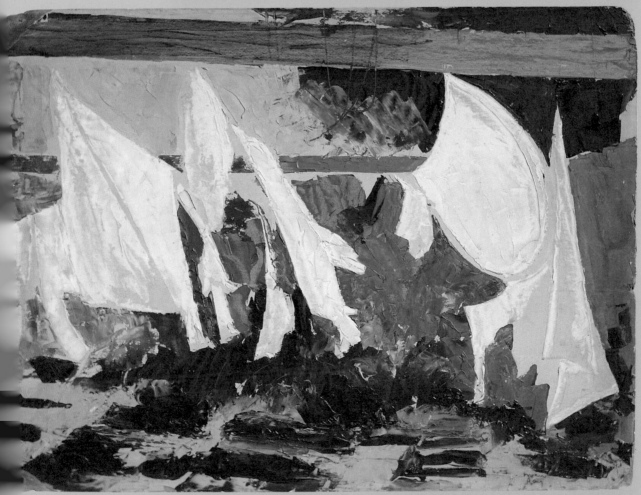

Gotham Book Mart, founded by Ida Frances Steloff, opens at 128 West 45th Street. It becomes one of New York's most important defenders of modern literature.

Ezra Pound becomes foreign correspondent for *Dial* (until 1923).

In baseball, the first of the Negro Leagues, known as the Negro National League, is established.

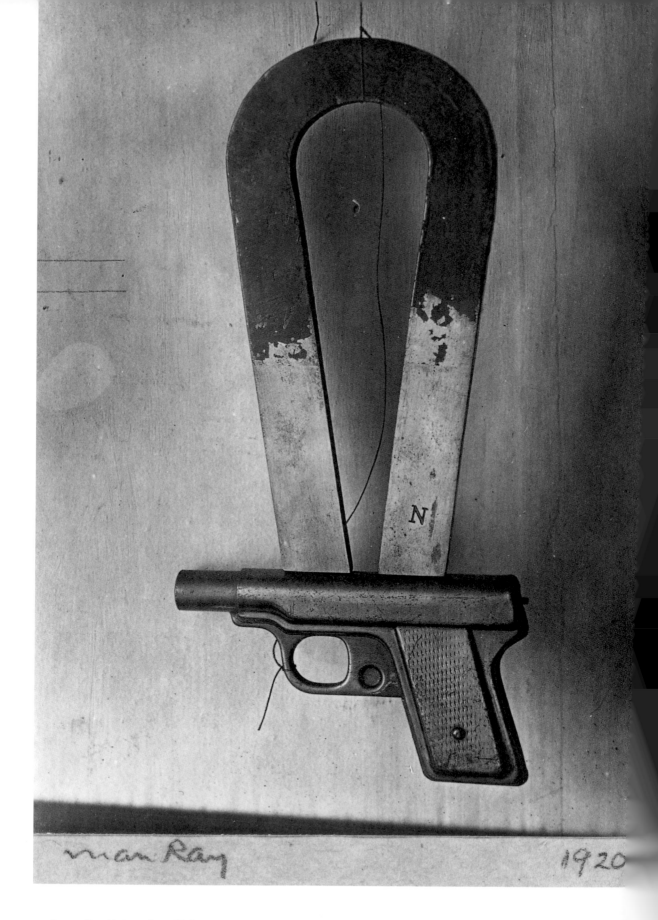

OCTOBER 23
Andrew Carnegie's
Pittsburgh estate
valued at more than
$23 million.

OCTOBER 25
King Alexander I of
Greece dies after having
been bitten by his pet
monkey.

NOVEMBER
F.S. Flint publishes "The
Younger French Poets" in
the London publication
The Chapbook. It is a
lengthy article that takes
Dada seriously and
reproduces many primary
Dada tracts. A digestible
guidepost making sense
of Dada senselessness,
it is seized upon by the
popular press and
regurgitated in the subse-
quent popular reception
of Dada.

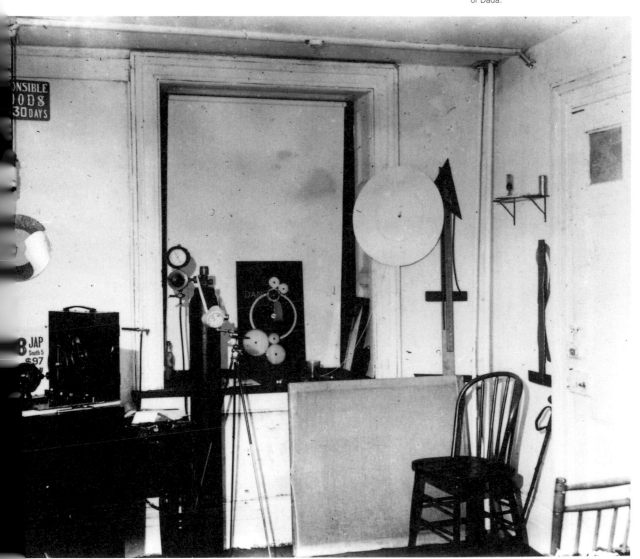

MAN RAY, STUDIO-BASEMENT 8TH ST., N.Y., 1920

Charles Sheeler becomes associated with the de Zayas Gallery.

Fighting on the streets of Dresden between the Reichswehr and German workers kills sixty.

Oskar Kokoschka writes an article protesting the damage done to an artwork in the Dresden Gemäldegalerie.

He suggests that political fights take place at a safe distance from works of art.

Grosz and Heartfield respond with "Der Kunstlump," in *Die Aktion*.

Alfred Adler, *The Practice and Theory of Individual Psychology*.

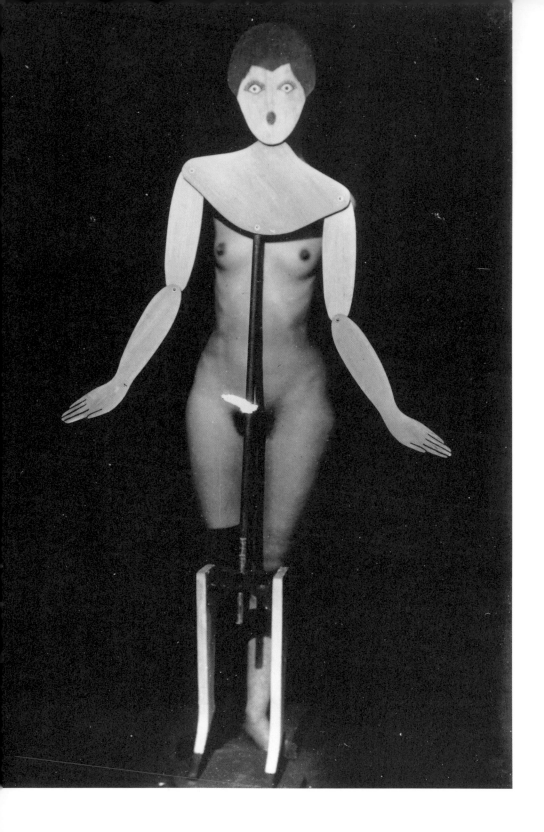

MAN RAY, PORTMANTEAU, 1920

NOVEMBER 1
For the first time in America, Schwitters exhibits collages at the Société Anonyme (through December 15)

NOVEMBER 3
Duchamp resigns as president of the Société Anonyme and is elected chairman of the Exhibition Committee. Katherine Dreier becomes president and Marsden Hartley is named secretary.

NOVEMBER 7
Eugene V. Debs, Socialist leader, is charged with espionage and imprisoned.

NOVEMBER 8
Picabia writes Arensberg on MoUvEmEnT DADA stationery, requesting a contribution to *Dadaglobe*, an anthology of Dada writings that is never published. A postscript is appended by Tzara: "*Picabia m'a dit que vous êtes le vrai Dada de New York*" ("Picabia told me that you are the real Dada of New York"). The cities listed under the MoUvEmEnT DADA stationery are: Berlin, Geneva, Madrid, New York, and Zurich.

DECEMBER
Baroness Elsa von Freytag-Loringhoven reviews William Carlos Williams, first book, *Kora in Hell*, in *The Little Review*, no. 3; after the two subsequently meet, the baroness—who is not known for her graciousness—offers to give the poet syphilis.

JOSEPH STELLA, COLLAGE, NUMBER 21, c. 1920

Coal production:
United States: 645 million tons
Great Britain: 229 million tons
Germany: 107 million tons

Oil production:
United States: 443 million barrels
Mexico: 163 million barrels
Russia: 25 million barrels

Eugene O'Neill's first Broadway play, *Beyond the Horizon*, opens and wins the Pulitzer Prize.

pyjama toujours bleu
comme certaine difficulté à suivre la conversation
buste de Tolstoï football
l'inconfort des meubles esthétiques
annonce la réminiscence
confesseur athlète
Jiardino Guardi

N'EXISTE PAS

jusqu'à la ressemblance

idéoplastie

PÔLE TEMPÉRÉ

H. P.
R.

fa bémol faux

l'œil slave sucrant la tasse à thé
déblaye les conceptions courage
araignée

M. D.

sous un parasol

je ne joue qu'en do

à Saint-Cucufa J. C. je ne joue qu'en fa

au Colorado

je ne joue qu'en sol

KODAK

matricule 10872-B.

Fr. 2.50

la chaleur d'une pipe allumée
et le froid du verre sur la peau

étaient tout un climat

In an early use of photography for the discovery of asteroids,
Germany astronomer Max Wolf renders visible what is referred to as the "true structure" of the Milky Way.
Soviets and Poles sign armistice, recognizing Polish independence.
Franz Kafka, *A Country Doctor.*
United States population as reported by the US Census: 117,823,165.
World population: 1,811,000,000.

Dada manifesto, "DADA soulève TOUT," which had been distributed January 12 at a protest against Marinetti in Paris, is reprinted in *The Little Review* (January-March). Contributors to this issue also include Margaret Anderson, Elsa von Freytag-Loringhoven, Sherwood Anderson, Louis Aragon, and Philippe Soupault.

JANUARY 22

Duchamp writes Picabia and Germaine Everling in Paris, asking them to ask Tzara—generally referred to in the press as the "father" of Dada— "permission" to publish a Dada publication. The irony and contradiction of this request was not lost on Duchamp: "At last I took care of the sale of some Dadas from 391 and some books. Enclosed find a check for a few sales—Man Ray was in charge of selling these last few days and we did better—I hope to send you another check as big as this one soon. Man Ray and one of our friends Bessie Breuer are going to publish a New York Dada—Could you be kind enough to ask Tzara to write a short authorization allowing us to print what would appear in the magazine? Here Nothing, always Nothing, very Dada...."

1921

Nearly 20,000 businesses reportedly fail during the year; wages are cut 10 to 25 percent.

Charlie Chaplin's *The Idle Class* opens.

Game theory, the mathematical analysis of conflict using games as models, is proposed by Emile Borel.

Demuth travels to Paris.

Eight million women are reportedly employed in the United States: 37 percent are secretaries.

Tuberculosis vaccine is developed by Albert Calmette and Camille Guérin.

Ludwig Wittgenstein, *Logico-Philosophicus.*

Ezra Pound, *Poems 1918-1921.*

British archaeologists Howard Carter and George Herbert uncover the tomb of Tutankhamen; unlike most tombs, it has not been looted.

First regular radio broadcasts by KDKA, Pittsburgh.

The same year, Graham McNamee announces the **first radio broadcast of a baseball game** from the Polo Ground

292 J. Doucet,

MERDELAMERDELAMERDELAMERDELAMERDELAMER

de l'a merique !

Cher Tzara — dada cannot live in New York.
All New York is dada, and will not tolerate a
rival, — will not notice dada. It is true
that no efforts to make it public have been
made, beyond the placing of your and our
dadas in the bookshops, but there is no
one here to work for it, and no money
to be taken in for it, or donated to it. So
dada in New York must remain a secret.

 No additional sales have been made of
the consignment you sent to "Société Anonyme".
The "anonyme" itself does not sell anything.

MAN RAY, LETTER TO TRISTAN TZARA, N.D.

JANUARY 24
Allies open discussion on German reparations. Reported total: almost $56 million, not including 12 1/2 percent tax demanded on German exports.

JANUARY 29
"'Dada' Will Get You If You Don't Watch Out; It Is on the Way Here," an article by Margery Rex, appears in *The Evening Journal*; it is the first major American newspaper article to acknowledge the New York presence of Dada. In it, Duchamp defines Dada: "Dada is nothing....It is very contradictory. Anything that seems wrong is right for a true Dadaist. As soon as a thing is produced they are against its publication. It is destructive, does not produce, and yet in just that way it is constructive." Man Ray: "It consists largely of negations."

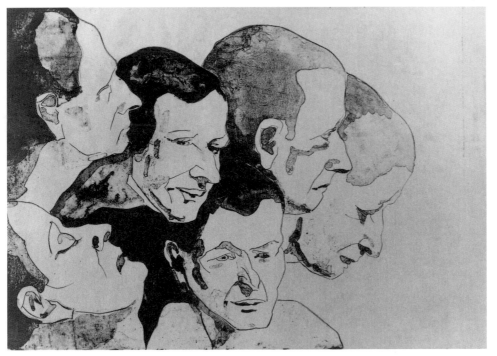

GEORGE BIDDLE, THE BARONESS ELSA VON FREYTAG-LORINGHOVEN, 1921

Varèse completes his major symphony, *Amériques: Americas, New Worlds*, which incorporates **New York street sounds** and noises, a gesture important to the development of conceptually based music in the 20th century.

"I could hear all the river sounds, the lovely foghorns, the shrill peremptory whistles, the whole wonderful river symphony which moved me more than anything ever had."

Amériques would not be performed until 1926.

Edith Wharton wins Pulitzer Prize for *The Age of Innocence*.

Albert Einstein lectures on his General Theory of Relativity in New York.

Virginia Woolf, *Monday or Tuesday*.

FEBRUARY 3
Tzara writes to Man Ray on MoUvEmEnT DADA stationery requesting a contribution to *Dadaglobe*, the anthology he is preparing.

FEBRUARY 6
Critic Kenneth Burke's article "Dadaism Is France's Latest Literary Fad" appears in the *New York Tribune*: "This is simply the logical fulfillment of the art tendencies in France since the end of the last century. For individualism, in its final analysis, means expressing one's self. In 1919, then, the world discovered the end of all possible thought. After Dada and Einstein, we have nothing left but food and the theaters."

ALFRED STIEGLITZ, PORTRAIT OF DOROTHY TRUE, 1919

FEBRUARY 8
Duchamp writes to
Picabia, Germaine
Everling, and Tzara in
Paris: "My ambition is to
be a professional chess
player."

FEBRUARY 17
Nine million automobiles
are on the roads in the
US.

MARCH 6
Sudbury, Pennsylvania,
police chief issues an
order requiring women
to wear skirts at least 4
inches below the knee.

MARCH 22
Germany refuses to
make first 1 billion mark
reparation payment.
French and Belgian
troops occupy parts of
the country.

MARCH 31
With coal miners on
strike, Great Britain
declares a state of emer-
gency.

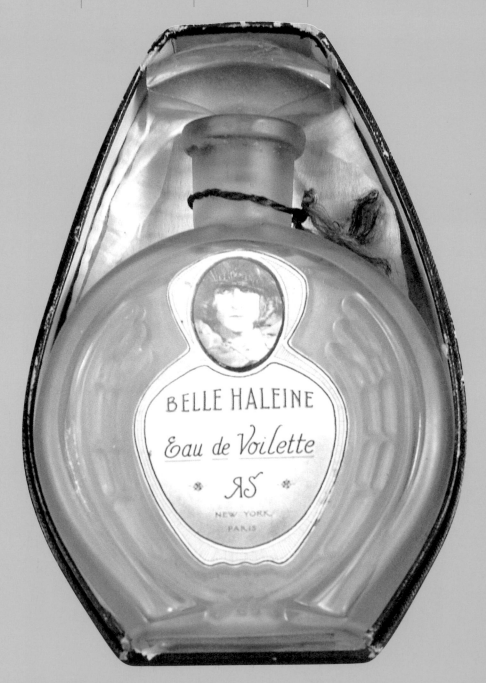

MARCEL DUCHAMP, BELLE HALEINE, EAU DE VOILETTE, 1921

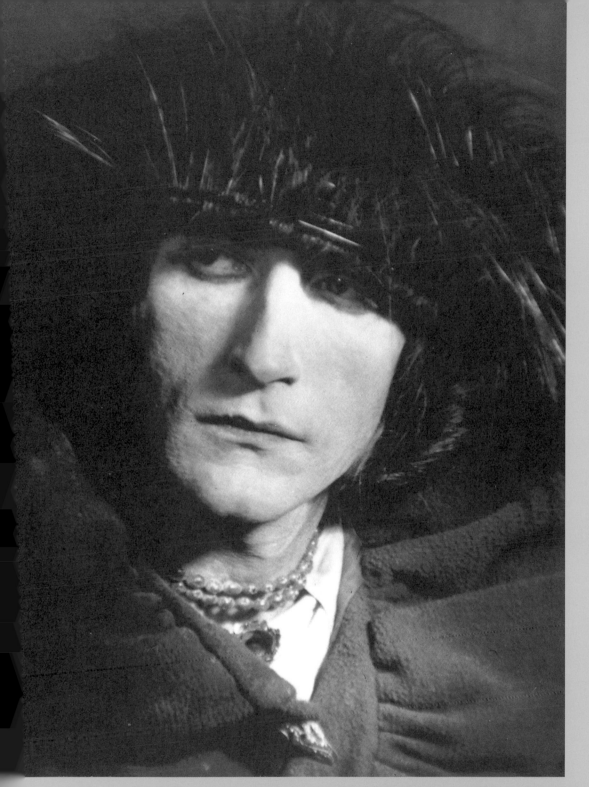

MAN RAY, ROSE SÉLAVY, 1921 (1970 PRINT)

Insulin, a substance used to combat diabetes, is first isolated.

Rafael Sabatini's *Scaramouche* is a best-seller.

Marsden Hartley publishes *Adventures in the Arts*, which includes the chapter "The Importance of Being Dada."

Hartley: "Remembering always that Dada means hobby-horse, you have at last the invitation to make merry for once in our new and unprecedented experience over the subject of ART with its now reduced front letter.

Dadaism offers the first joyous dogma I have encountered which has been invented for the release and true freedom of art."

Albert Einstein wins Nobel Prize for physics for discovering the photoelectric effect in 1905;

no mention is made of the **Theory of Relativity**.

APRIL

In New York, Duchamp and Man Ray publish the sole issue of *New York Dada*, the only publication to officially represent the Dada movement in America. Man Ray: "Aside from the cover which Duchamp designed, he left the rest of the make-up to me, as well as the choice of the contents. Tristan Tzara, one of the founders of Dadaism, sent us a mock authorization from Paris, which we translated. I picked material at random—a poem by the painter Marsden Hartley, a caricature by a newspaper cartoonist, Goldberg, some banal slogans, Stieglitz gave us a photograph of a woman's leg in a too-tight shoe; I added a few equivocal photographs from my own files. Most of the material was unsigned to express our contempt for credits and merits. The distribution was just as haphazard and the paper attracted very little attention. There was only one issue. The effort was as futile as trying to grow lilies in the desert."

Tzara's "authorization" asserts his (disputed) claim that the word "Dada" was a chance discovery in a dictionary: "Night was upon us when a green hand placed its ugliness on the page of Larousse—pointing very precisely to Dada—my choice was made."

Poet Hart Crane had caught wind of *New York Dada* before its publication and wrote to his friend Matthew Josephson (January 14, 1921): "I hear 'New York' has gone mad about 'Dada' and that a most exotic and worthless review is being concocted by Man Ray and Duchamp, billets in a bag printed backwards, on rubber deluxe, etc. What next!...I like the way the discovery [of the baroness] has suddenly been made that she has all along been, unconsciously, a Dadaist. I cannot figure out just what Dadaism is beyond an insane jumble of the four winds, the six senses, and plum pudding. But if the Baroness is to be a keystone for it—then I think I can possibly know when it is coming and avoid it."

APRIL 1

An April Fool's Day symposium advertised as "do you want to know what a dada is?" takes place at the Société Anonyme. Admission is 50 cents. It is held in conjunction with the Société's exhibition—its eighth to date—of works by Schwitters, Campendonk, Klee, Molzahn, Tour Donas, and Stuckenberg which is billed as a Dada exhibition. An unnamed reviewer in *American Art News* (April 2) is unimpressed: "The Dada philosophy is the sickest, most paralyzing and most destructive thing that has ever originated in the brain of man.... because they believe in the utter futility of everything, Dadaists write lunatic verse and paint meaningless pictures as jibes at the rest of mankind, which they hold in contempt. The more inexplicable the verse and pictures are, and the more exasperated the public gets, the better pleased the Dadaists are."

"Dada" Will Get You if You Don't Watch Out; It Is on the Way Here

Paris Has Capitulated to New Literary Movement; London Laughs, but Will Probably Be Next Victim, and New York's Surrender Is Just Matter of Time.

This is a "dada poem" by M. Louis Aragon, who, according to the Chapbook, "Tantalizes you with half said things":

MYSTICAL CHARLIE.
"The lift still went down breathlessly
"and the staircase still went up
"That lady does not hear the speeches
"she is a fake
"and I who was already thinking of making
"love to her
"Oh the clerk
"so comical with his mustache and his
"artificial eyebrows
"He shouted when I pulled them
"Strange
"What do I see That noble foreign lady
"Sir I am not a light woman
"How isn't he ugly
"Happily we
"have pigskin bags
"hard-wearing
"This one
"Twenty dollars
"It holds a thousand
"It's always the same system
"No restraint
"or logic
"a bad theme."

BY MARGERY REX.

What is Dada?
Who are the Dadaists?
Where?—But at least that is possible to explain—they are in Paris. They are taken very seriously in that city even if the rumors which have trickled over to London have caused howls of derision. And Dada is coming to New York.

At the top is shown a cubist painting, "Nude Descending a Stairway," by Marcel Duchamp. Beneath it at the extreme right is one of the pictorial forms which is Dadaism. What can it mean, do you suppose?

Portrait de TRISTAN TZARA
FRANCIS PICABIA

Not an astronomical chart, but merely Monsieur Picabia's portrait of Tzara, whose personality is such, we are assured, that it perspires from the very joys of poetry he writes.

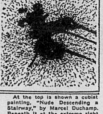

Dada is a literary movement. It has attacked Paris with lunacies, jibes and insulting ironies, but Paris has nevertheless capitulated to Dada. New York has sympathetic souls awaiting Dada.

The younger French poets go in for Dada. Dada came in to being in the Cabaret Voltaire in Zurich in 1916. Its founder was Tristan Tzara, said to be a Rumanian. He is now at the head of the band of Dadaists who live in Paris.

One of Tzara's first Dadaistic performances was the reciting of one of his onomatopoeic poems to the accompaniment of an electric bell of eight-inch calibre, according to an account written by Mr. Aldous Huxley.

Founder Explains What It Means.

"Dada means nothing," said Tzara, as he is quoted in the November Chapbook. "If I shout:
"Ideal, ideal, ideal
"Knowledge, knowledge, knowledge
"Boomboom, boomboom, boomboom.
"I have set down exactly enough progress, law, morality and all the other fine qualities which so many intelligent people have discussed in so many books, to come finally to this, that, after all, such one has danced according to his own personal boomboom, and that so far as he is concerned, his boomboom is right: satisfaction of a sickly curiosity; private bell for inexplicable needs; bath; pecuniary difficulties; stomach with repercussion on life—
"If everybody is right and if all pills are not pink, let us try for once not to be right. People think they can explain rationally, by thought, what they write. But it is very relative—
What does it mean? Want is Dada? The Isle de Paris is far away. But it was necessary to find someone on the Isle de Manhattan to throw light upon Dada.

Comment of New York Artists.

At the Societe Anonyme, at No. 19 East Forty-seventh street, moderns of the moderns, in painting, foregather. There I found Miss Katharine Dreier, director of the Societe; Marcel Duchamp, who painted the famous "Nude Descending the Staircase"; Joseph Stella, modern painter, and Man Ray, sculptor.

"Dada is irony," said Miss Dreier. "That is, its basic idea."
"Dada is nothing," said M. Duchamp. "For instance the Dadaists say that everything is good, nothing is bad; nothing is interesting, nothing is important."
"It is a general movement in Paris, relating rather to literature than to painting," M. Duchamp went on. "It is very contradictory.
"Anything that seems wrong is right for a true Dadaist. As soon as a thing is produced they are against its production.
"It is destructive, does not produce, and yet is just that way it is constructive, do you see?"
Joseph Stella broke in with a wave of his expressive hands. He had just finished his lecture on modern art.

"Dada means having a good time—the theatre, the dance, the dinner. But it is a movement that does away with everything that has always been taken seriously. To poke fun at, to break down, to laugh at, that is Dadaism."

"Dada is a state of mind," explained Man Ray, sculptor. "It consists largely of negations. It is the tail of every other movement—

Cubism, Futurism, Simultanism, the last being closely related."

Declares It Is Also Disgust.

But Tzara, who is Dada himself, says that Dada is also disgust.

"Every product of disgust capable of becoming a negation of the family is Dada—abolition of all hierarchy and social equation set up by our valets—Dada; abolition of the memory; Dada; abolition of the prophets; Dada; abolition of the future; Dada; liberty; Dada.

"Liberty: DADA DADA DADA, howling of irritated colors, interweaving of contraries and of all the contradictions, of grotesques, of inconsequences: LIFE."

Nonsense, with or without meaning, we learn, is Dada. Zulu yells, according to Mr. Flint of the Chapbook, special fondnesses, simulated imbecility, incoherent tumbles of words, and occasionally poetry—is Dada.

M Francis Picabia, famous for many things, contributes this immortal bit of verse to the magazine mentioned:

"Dada smells of nothing, it is nothing, nothing.
"It is like your hopes: nothing.
"Like your paradise: nothing.
"Like your idols: nothing.
"Like your politicians: nothing.
"Like your artists: nothing.
"Like your religion: nothing."

No Prizes for Solutions.

No prizes, laments Mr. Flint, are offered for solutions of these bits of literature.

The Dadaists may be amusing themselves at the expense of the public, Mr. Flint warns, and they certainly know what they are doing in any case, he says, without letting us share the joke. Their ultimate object seems to be to discredit all the works of the mind.

As soon as any part or parcel of Dada becomes intelligible, some poets flee from it. Sense should be left to children, they feel. It saddens these poets to find sense in modern poetry.

More ironical and less Dadaistic, we are told, is verse by M. Paul Morand, who, according to the Chapbook, is a poet to be watched (?).

"Glorious day,
"The British Ambassador returns on foot from the Quai d'Orsay.
"Like England
He is bounded below by gaiters of white chalk and above
By a chimney stack.
"In order not to spoil the success of the day for him the wounded

are going to promise not to suffer any more."

Wouldn't This Make You Weep? But now for your real uncompromising Dada—M. Pierre Albert-Birot:

"Pour Dada.
"AN AN AN AN AN AN AN AN
"AN AN AN
1111 1 1
"POUH-POUH POUH-POUH RRA
si si si
"lrrrrr oum oum
"AN AN AN AN
"aaa aaaa aaa tainn
"UI 11111
"HA HA HA HA HAA HA HA."

Like Ethel Monticue, in the "Young Visiters," we blush or faint at this "mystic words," yet without wishing to wound the sensitive and unintelligible soul of any of the visiting Dadaists we have heard this very identical verse issuing from the apartment next door at about 3 a. m. The young man uttering the words is less formal and less starched, especially at this time of night, than perhaps might be the Dadaist who originally proclaimed the poem from a platform. In common justice to our readers, we must state his attire is informal indeed.

He might be, called a Simultanist also. Along with his cryptic song he beats a measure with his fist on the forehead of none other than his wiry father, pastmaster in Dadaism, himself, but unappreciative of its vocal aspects at this late hour. Indeed, he is actually held by his frantic father—we mean his DADA—and is also known to accompany his choral measures with movements of his feet.

Unreasonable, yes; but that is the essence of Dadaism.

"Dadaism will only continue to exist by ceasing to be," says J. E. Blanche.

"Painting had already begun to tear down the past—why not literature?" asked M. Duchamp. "But then I am in favor of Dada very much myself."

You Must and You Mustn't,

Paris is more serious, says the Chapbook, and in one of its reviews it prints the following:

"Madame Rachild has written an article on Dada. She has proved you must not write articles about Dada.

"Monsieur Georges Courteline spoke of DADA for an hour at Comœdia: He said that you must not speak of DADA.

"Monsieur Fernand Divoire never says DADA. He says 'the hobby horse' party.

"If you must speak of DADA, you must speak of DADA.

"If you must not speak of DADA, you must still speak of DADA.

The next step, after a cursory examination of Dadaism would seem to be a reactionary call for home and Mamaism, with all due respect, or rather all respect due, to the founder of DADA.

APRIL 7
In Plymouth, Massachusetts, Plymouth Rock is moved to a brick building for security purposes.

APRIL 9
US troops "intervene" in fighting in Guatemala.

APRIL 11
First sports radio broadcast, a boxing match.

APRIL 12
Ford Motor Co. produces a million cars per year, a return to the prewar production rate.

APRIL 24
In an unsigned article in the *New York Herald*, Henry McBride reviews Duchamp and Man Ray's periodical, *New York Dada*. Citing Duchamp as "a genuine dadaist, if not the first and original one," McBride discusses the artist's cover design: "They say in Europe, you know, that we are all dadas over here, and the countless repetition of the word upon the title page may be M. Duchamp's sly allusion to that fact."

APRIL 27
José Capablanca defeats Emanuel Lasker in the World Chess Championship in Havana.

APRIL 30
De Zayas Gallery closes in New York. Last exhibition is of paintings and watercolors by Arthur B. Davies.

Elsa
Baroness
von
Freytag
Loring-
hoven

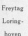

DON'T MISS
Kurt Schwitters and other
ANONYMPHS at the
SOCIÉTÉ ANONYME, INC.
19 East 47th Street, New York

trumpets and drums.
YOURS WITH DEVOTION

CUT OUT DADYNAMIC STUFF!

WATCH YOUR STEP!

25c

KEEP SMILING

dadaphoto

EYE-COVER ART-COVER CORSET-COVER
AUTHORIZATION

NEW YORK DADA:

You ask for authorization to name your personal Dada. But Dada belongs to everybody. I know excellent people who have the name Dada. Mr. Jean Dada; Mr. Gaston de Dada; Fr. Pirahis's dog is called Zizi de Dada; in G. Ribemond-Dessaignes's play, the pope is likewise named Zizi de Dada. I could cite dozens of examples. Dada belongs to everybody. Like the idea of God or of the tooth-brush. There are people who are very dada, more dada; there are dadas everywhere, all over and in every individual. Like God and the tooth-brush (an excellent invention, by the way).

Dada is a new type; a mixture of man, naphthaline, sponge, animal made of elastin and beefsteak, prepared with soap for cleaning the brain. Good teeth are the making of the stomach and beautiful teeth are the making of a charming smile. Halebstäsch of ancient oil and injection of rubber.

There is nothing abnormal about my choice of Dada for the name of my review. In Switzerland I was in the company of friends and was hunting the dictionary for a word appropriate to the sonorities of all languages. Night was upon us when a green hand placed its ugliness on the page of Larousse—pointing very precisely to Dada—my choice was made. I lit a cigarette and drank a demitasse.

For Dada was to my nothing and to lead to no explanation of this offshoot of relationship which is not a dispute nor a scholié but rather a constellation of individuals and of free facets.

Dada visited before us (the Holy Virgin) but one cannot deny its ineptical power to add to this absurdity existing spiral and impulses of penetration and diversity that characterizes its present form.

There is nothing more incomprehensible than Dada.

Nothing more indefinable.

With the best will in the world I cannot tell you what I think of it. The journalists who say that Dada is a protest are right, but it is a pretext for something I do not know.

Dada has penetrated into every hamlet; Dada is the best paying concern of the day.

Therefore, Madam, be on your guard and realize that a really dada product is a different thing from a glossy label.

Dada abolishes "unknown." No unisex do not exist in words but only in some atrophied brains whose cells are too jammed. Dada is an anti-"asiano" means. The simple meshism that serves as sign for deaf-mutes are quite adequate to express the four or five mysteries we have discovered within 7 or 8,000 years. Dada offers all kinds of advantages. Dada will soon be able to boast of having shown people that to say "right" instead of "left" is neither less nor less logical, that not 2763 — 3/4; that "fool" is a merit; that yes — no etc. Strong in-fluences are making themselves felt in politics, in commerce, in language. The whole world and what's in it has slid to the left along with us. Dada has inserted its syringe into hot bread, to speak allegorically into language. Little by little (large by large) it destroys it. Everything collapses with logic. And we shall see certain liberties we constantly take in the sphere of sentiment, social life, morals, once more become normal standards. These liberties no longer will be looked upon as crime, but as fiches.

I will close with a little international song. Order from the publishing house "La Sirène" 7 rue Pasquier, Paris, Danaglobe, the work of dadas from all over the world. Tell your booksellers that this book will soon be out of print. You will have many agreeable surprises.

Read Dadaglobe if you have trouble. Dadaglobe is in press. Here are some of its collaborators:

Paul Citroen (Amsterdam); Baader Dadasudolez; R. Hausmann; W. Hearn-field; H. Hoech; R. Hucbenbeck; G. Grosz; Fried Hardy Worm (Berlin); Clément Pansaers (Bruxelles); Max Robber (Calcutta); Jacques Edwards (Chili); Bairgeld, Arnauds s, Oalsgudalsen, Max Ernst, F. Hunbrich (Cologne); K. Schwitters (Hannover); J. K. Bonset (Leyden); Guillermo de Torre (Madrid); Gino Gutmnelli, E. Baochi, A. Fiozzi (Mantoue); Kreneitsh (Moscou); A. Vagts (Munich); W. C. Arizmberg, Gabrielle Buffet, Marcel Duchamp; Adon Lacroix; Baroness v. Loringhoven; Man Ray; Joseph Stella; E. Varese; A. Stieglitz, M. Hartley; C. Kahler (New York); Louis Aragon; G. Brauner; André Breton; M. Buffet; S. Charchoune; J. Crotti; Suzanne Duchamp; Paul Eluard, Benjamin Peret; Francis Picabia; G. Ribemont-Dessaignes; J. Rigaut, Soubeyran; Ph. Soupault, Tristan Tzara (Paris); Melchior Vischer (Prague); L. Evola (Rome); Arp; S. Taeuber (Zurich).

The incalculable number of pages of reproductions and of text is a guaranty of the success of the book. Articles of luxury, of prime necessity, articles indispensable to hygiene and to the heart, toilet articles of an intimate nature.

Such, Madame, are we proper for Dadaglobey for you need look no further than to the use of articles prepared without Dada to account for the fact that the skin of your heart is chapped; that the air prevents renewal of your intelligence is cracking; also for the presence of those tiny wrinkles all imperceptible but nevertheless distressing.

All this and much else in Dadaglobe.

TRISTAN TZARA.

VENTILATION

On the question of proper ventilation opinions radically differ. It seems impossible to please all. It is our aim, however, to cater to the wishes of the majority. The conductor of this vehicle will gladly be governed accordingly. Your cooperation will be appreciated. DADATAXI, Limited.

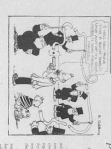

R. Guldboek.

PUG DEEBS MAKE
SOCIETY BOW

MAY 3
"Exposition Dada, Max Ernst," the first Paris exhibition of Ernst's collages, opens at Au Sans Pareil.

MAY 11
Germany unconditionally accepts Allied reparation demands.

MAY 14
Italian Fascists win twenty-nine seats in Parliament.

MAY 19
Congress sets first national quotas to regulate immigration.

MAY 24
Erik Satie's *Le piège de Méduse*, composed in 1913, is first performed in Paris at the Théâtre Michel. It is billed as a "musical one-act comedy" in which a mechanical monkey dances.

JUNE 1
More than eighty die in race riot in Tulsa.

JUNE 6
Last major Dada exhibition (through June 30) "Salon Dada Exposition Internationale," at Galerie Montaigne in Paris. Duchamp declines to participate, but Man Ray is represented by two photographs.

JUNE 8
Man Ray writes to Tristan Tzara: "Dada cannot live in New York. All New York is dada, and will not tolerate a rival, will not notice dada. It is true that no efforts to make it public have been made, beyond the placing of your and our dadas in the bookshops, but there is no one here to work for it, and no money to be taken in for it, or donated to it. So dada in New York must remain a secret."

JUNE 30
As of this date, 800,000 immigrants had arrived since the previous June.

JULY
Picabia publishes a special number of *391*, *Le Pilhaou-Thibaou*, contesting Tzara's claim to have invented the word "Dada."

JULY 1
Heavyweight champion Jack Dempsey knocks out French boxer Georges Carpentier in the fourth round, breaking the latter's thumb and spraining his jaw. Duchamp, listening to the fight on a transatlantic radio broadcast in France, loses all his bets.

Stuart Davis, Cigarette Papers, 1921

Enrico Caruso, the leading tenor of his time, dies in Naples after contracting pleurisy in New York.

He had made more than 160 records for the Victor Talking Machine Company.

The Magnetic Fields, a collection of **automatic writings**, is edited by Breton and Soupault.

President Harding commutes Eugene V. Debs' ten-year prison sentence.

American art collector Collis Huntington buys Gainsborough's *Blue Boy* and Reynolds' portrait of Mrs. Siddons for £200,000.

JULY 10
Boxer Jake La Motta born in New York City.

JULY 14
Man Ray, disillusioned with the lack of support for his work in New York, sails on the *Savoie* for Paris, where he stays, with the exception of a few trips, for the next nineteen years.

JULY 24
Sheeler and Strand's nine-minute film *Manhatta*, featuring rapid cuts of New York images, debuts at the Rialto Theatre on Broadway. Some stills are later featured in *Vanity Fair* (April 1922) while Tzara is acting as the magazine's European correspondent.

JULY 27
German Minister of Education proposes that English replace French as a compulsory language in German schools.

SEPTEMBER
Breton interviews Freud in Vienna. The two maintain a correspondence until some time after Breton publishes *The Communicating Vessels* (1932), in which he notes that the sexual motifs that Freud uncovers in others' dreams are conspicuously absent in the analysis of his own; Freud would deny the charge.

FALL
Walter Arensberg publishes *The Cryptography of Dante*, a quasi-psychoanalytic, crypto-linguistic exegesis of *The Divine Comedy* claiming to have discovered the method for decoding the work's secret meanings; among the unraveled subtexts are Dante's supposed reunification with his mother, whom he lost young. Most significant, however, is Arensberg's engagement with word-play and the sometimes sexual underbelly of cryptic structures—a preoccupation shared by his friend Duchamp, among others. The cryptographic structures Arensberg decoded include the simple pun, the acrostic, the anagram, and the anagrammatic acrostic. Arensberg's cryptography is ridiculed by the press; *The Evening Journal* predicts that it "promises to become the foremost literary scandal of modern times."

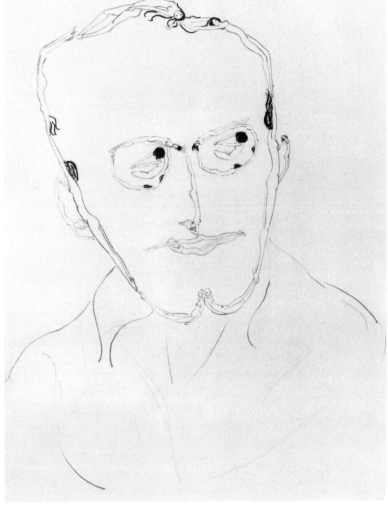

CLARA TICE, PORTRAIT OF FRANK CROWNINSHIELD, c. 1921

Schwitters hears Hausmann recite his sound poem, *FMSBW*, which has a profound impact on him.

British Broadcasting Company is founded in London.

Population in 1921:

USSR: 136 million

United States: 107 million

Great Britain: 42.5 million

Germany: 60 million

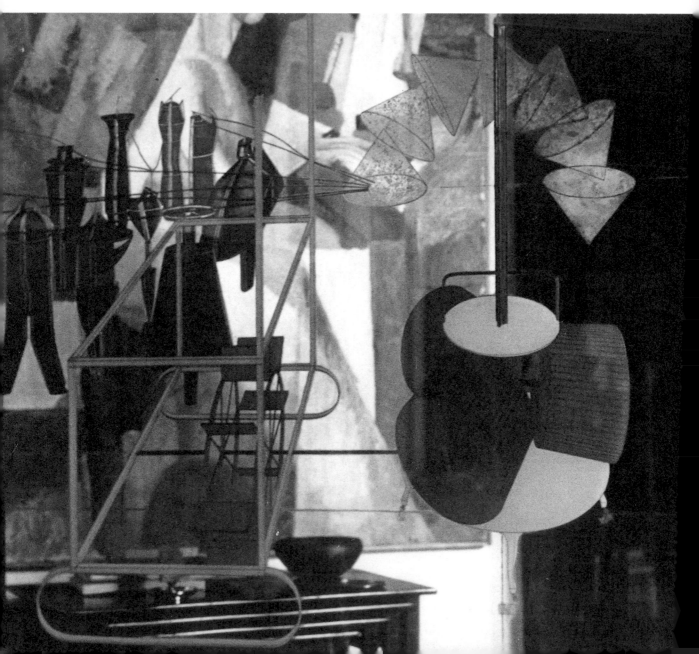

CHARLES DEMUTH, BUSINESS, 1921

Anatole France wins the Nobel Prize in literature.

Sherwood Anderson, *The Triumph of the Egg*.

John Dos Passos, *Three Soldiers*. John Heartfield designs dustjacket
for the second German edition, published by Malik Verlag in 1929.

New York State passes law granting a state commissioner the discretion to censor dances.

Eugene O'Neill, *Anna Christie*.

MoUvEmEnT

DADA

TZARA
12, rue de Boulainvilliers
Paris (16e)

BERLIN, GENÈVE, MADRID, NEW-YORK, ZURICH.

PARIS, *3 Février 1921*

Cher Monsieur Man Ray,
Je vous remercie au nom de
tous les Dadas pour votre
envoi (Dadaglobe). Malheureusement
Dada littéraire américain n'est
pas assez représenté (Merci pour
les pages de Mmes Adon Lacroix et
V. Loringhoven). Dans Dadaglobe
il y aura une grande partie
documentaire, qui contiendra
surtout des articles de journaux
parus dans le monde entier.
Je vous serais fort obligé si
vous vouliez m'envoyer les
articles sur DADA ayant déjà

CONSULTATIONS : 10 frs

S'adresser au Secrétaire
G. RIBEMONT-DESSAIGNES
18, Rue Fourcroy, Paris (17e)

DADA
DIRECTEUR : TRISTAN TZARA

D₄O⁴H²
DIRECTEUR :
G. RIBEMONT-DESSAIGNES

LITTÉRATURE
DIRECTEURS :
LOUIS ARAGON, ANDRÉ BRETON
PHILIPPE SOUPAULT

M'AMENEZ'Y
DIRECTEUR : CÉLINE ARNAUD

PROVERBE
DIRECTEUR : PAUL ELUARD

391
DIRECTEUR : FRANCIS PICABIA

'Z'
DIRECTEUR : PAUL DERMÉE

Dépositaire
de toutes les Revues Dada
à Paris : Au SANS PAREIL
37, Av. Kléber Tél. : PASSY 25-22

Luigi Pirandello, *Sei personnagi in cerca d'autore (Six Characters in Search of an Author).*
D.H. Lawrence, *Women in Love.*
Walter Benjamin's "Critique of Violence" is published in the
Archiv für Sozialwissenschaft und Sozialpolitik (1920-21).

OCTOBER 2
New York Yankee Babe Ruth hits his fifty-ninth and final home run of the season.

OCTOBER 13
New York Giants beat the Yankees at the Polo Grounds, winning the World Series.

NOVEMBER 3
Striking milk truck drivers dump thousands of gallons of milk onto the streets of New York.

NOVEMBER 7
Mussolini names himself "Il Duce," the leader of Italy's National Fascist Party.

In Versailles, trial of Henri Desire Landri begins; he is accused of killing and cooking eight women.

NOVEMBER 14
The German Expressionist film *The Cabinet of Dr. Caligari*, directed by Robert Wiene, opens in Paris.

DECEMBER
Man Ray exhibits for the first time in Europe at the Librairies Six in Paris. He makes *Gift,* a found-iron object to which he glued tacks, during a meeting with Erik Satie. *Gift* is included in the exhibition. Catalogue includes texts by Aragon, Arp, Éluard, Ernst, Ribemont-Dessaignes, Soupault, and Tzara.

DECEMBER 5
Sinn Fein and Lloyd George agree to make southern Ireland a Free State. Northern Ireland remains under British rule.

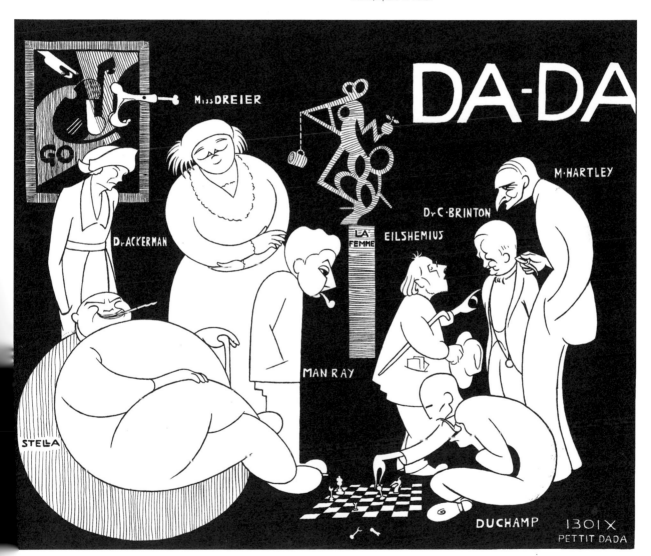

RICHARD BOIX, DA-DA (NEW YORK DADA GROUP), 1921

The State of Missouri reports a 100 percent increase in the divorce rate since 1896.

Tarzan of the Apes, starring actual **jungle animals**, opens on Broadway in New York.

President Harding signs the Willis-Campbell Act, forbidding doctors from prescribing beer for medicinal purposes.

JANUARY

Duchamp returns to New York, where he later opens a fabric-dyeing shop with artist Leon Hartl. Duchamp: "I am a business man. He [Hartl] dyes and I keep the books. If we are successful, we don't know what we'll do." The business bankrupts within six months.

After Germany fails to make war reparations payments, 100,000 French and Belgian soldiers occupy the Ruhr.

JANUARY–APRIL

Breton tries to organize Congrés International pour la Détermination des Directives de l'Esprit Moderne "to establish new directives for the modern mind." Eventually, Tzara breaks with Breton, who then claims that Tzara has stolen credit for the 1918 manifesto actually written, he says, by Walter Serner. Breton also charges that Tzara is not the father of Dada. These personal attacks punctuate the dissolution of the Paris Dada group. Breton's Congress is unrealized, as is the latent potential of Paris Dada.

1922

George Grosz breaks with Dada.

Coco Chanel introduces Chanel No. 5 perfume.

First radio commercials. Radio station WEAF is first to use advertisements to pay for broadcasting.

The popular film star and comedian Roscoe C. "Fatty" Arbuckle is acquitted by a San Francisco jury after one minute of deliberations.

He was accused of raping and murdering the actress Virginia Rappe.

He is nonetheless fired by Paramount and his films are withdrawn by distributors.

Louis "Satchmo" Armstrong leaves New Orleans to join Joe "King" Oliver's seven-piece jazz band in Chicago.

The Cotton Club, the Harlem nightclub reputedly frequented by denizens of the underworld, opens at 142nd Street and Lenox Avenue.

Blacks are admitted generally only as performers.

Joseph Stella travels to Italy.

In 1922, 12 percent of American films are produced in New York, 84 percent in Hollywood.

Ford Motor Company buys Lincoln Motor Company for $8 million.

In New York, the invention of film that also records sound is announced by Lee De Forest.

JANUARY 2
Value of German mark plummets to 7,260 per dollar.

JANUARY 13
Before a New York crowd, Gene Tunney triumphs over Battling Levinsky, becoming light-heavyweight champion.

JANUARY 31
In Germany, the cost of living jumps 73.7 percent from the previous year.

FEBRUARY
Vanity Fair publishes Edmund Wilson's article on Dada, "The Aesthetic Upheaval in France." In its July issue, Tzara authors "Some Memoirs of Dadaism," the first of four articles he would contribute.

FEBRUARY 2
Hollywood director William Desmond Taylor is found murdered in Los Angeles, a bullet through his heart.

FEBRUARY 5
First issue of *Reader's Digest* is published in New York by Lila Acheson and her husband, DeWitt Wallace. "How to Keep Young Mentally" is the title of the first article.

FEBRUARY 7
The man referred to in the American press as the Chippewa Indian, reportedly the world's oldest living person, dies at the age of 137.

FEBRUARY 9
According to the US World War Foreign Debt Commission, Britain owes $4 billion; France, $3 billion; Italy, $1.6 billion.

CHARLES DEMUTH, SPRING, C. 1921

In Paris, Man Ray publishes an album of Rayographs—cameraless photographs—titled *Les champs délicieux*.

Tzara writes the preface.

Murnau's *Nosferatu*, starring Max Schreck, opens in Germany.

Great Britain and the United States reach agreement on a treaty mandating British rule in Palestine.

The Vatican objects, arguing that the creation of a Jewish home in Palestine threatens religious equality.

FEBRUARY 17
France rejects baseball as an Olympic sport for the 1924 games.

FEBRUARY 25
Picabia turns his back on Dada, attacking Breton's Congress of Paris and most of his formerly close Dada friends in *La Pomme de Pins (The Pinecone)*.

MARCH
A new series of the magazine *Littérature* appears under the editorship of Breton. Although many Dadaists still contribute, the journal begins to transform itself from a Dada caterpillar into a Surrealist butterfly (last issue, June 1924).

MOVEMENT AND MASS
A view of Broadway through the balustrade on the roof of the Empire Building, contrasting the flickering liveliness of movement in the street with the static architecture

THE MOVING STREET (Below)
The Church Street elevated railway, as seen from the Empire Building. A study in the relation between movement of the street and the stability of the buildings

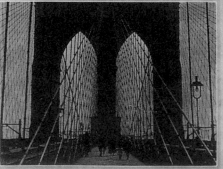

STEEL STRUCTURE
Showing the relation of structural masses to the spaces made by the open sky as it appears above and behind the steel design

MECHANICAL MONOTONY
The Equitable Building, in which the photographers were interested in the monotonous repetition of windows and other utilitarian details, which give so forceful a sense of the vast scale and mechanical precision of the skyscraper

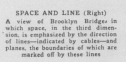

Charles Sheeler is well known as one of our modern painters; Paul Strand is a master in photography, a tireless experimenter in the possibilities of the camera. The interest of these two artists did not lie in presenting places of value to the sightseer but rather in expressing certain phases of New York through dynamic patterns

SPACE AND LINE (Right)
A view of Brooklyn Bridge in which space, in the third dimension, is emphasized by the direction of lines—indicated by cables—and planes, the boundaries of which are marked by these lines

160

Manhattan—"The Proud and Passionate City"
Two American Artists Interpret the Spirit of Modern New York Photographically in Terms of Line and Mass

MARCH 23
Annapolis admits Emile Treville Holley, its first African-American since the Civil War.

MARCH 24
The Ku Klux Klan holds mass initiations in Tulsa, Oklahoma.

MARCH 29
US Census reports that 11 percent of the population cannot speak English.

MARCH 31
Striking US coal miners number 600,000.

MARCH 31
700 French killed or wounded in Mouleuya Valley, Morocco, by "rebel" ambush. Number of Moroccan casualties is unknown.

SPRING
Elsa von Freytag-Loringhoven, described by some as the personification of New York Dada, becomes the center of a small literary controversy. Harriet Monroe writes in *Poetry*: "The trouble is *The Little Review* never knows when to stop. Just now it is headed straight for Dada; but we could forgive even that if it would drop Elsa von Freytag-Loringhoven on the way." In its spring issue, *The Little Review* defends the baroness: She "is the first American Dada....When she is dada she is the only one living anywhere who dresses dada, loves dada, lives dada."

APRIL 2
Charlie Chaplin's *Pay Day* debuts in New York.

APRIL 4-16
Together with other Paris Dadaists, Breton leads a mock trial of the writer Maurice Barrès, who had been wartime president of the League of Patriots, in the Salle des Société Savantes. With Breton presiding as judge, Tzara participates as a witness, and at a moment of high drama, Picabia walks out, breaking with Dada.

The Hollywood Bowl, the amphitheater seating thousands, opens for California entertainment-seekers.

T.S. Eliot publishes *The Waste Land*.

Reports declare that vitamin D cures rickets.

First British Broadcasting (BBC) broadcast.

APRIL 17
Waikiki sunbathers are ordered to wear clothing by the city of Honolulu.

MAY 5
Shakespeare folio sells in New York for $9,500.

MAY 22
In his article "Why Dada?" in *The Century Magazine*, Sheldon Cheney belatedly predicts a Dada invasion for New York: "There is to be a Dada invasion of America. In fact, it is here in little already. There has been published the first issue of 'New York Dada,' less clever than its European models, and only feebly nonsensical, but a beginning....But we are likely to witness a mushroom growth of Dada journals and Dada activities."

MAY 23
Irish Free State declares Sinn Fein illegal in six counties.

MAY 26
Because of an outburst during a New York-Washington game, Babe Ruth is stripped of his title as Yankee captain.

Federal Narcotics Board is established.

JUNE
First issue of *Transbordeur Dada*, edited by Serge Charchoune in Paris (last issue, 1949).

AUGUST 3
First radio sound effect on WGY, Schenectady, New York: two wooden blocks clapped together imitate the sound of one door.

ARTHUR G. DOVE, GEAR, c. 1922

The American cocktail becomes popular in Europe.

Maidenform, manufacturers of undergarments, is formed by dressmakers Ida and William Rosenthal. Their most important invention is the Maiden Form Brassiere, the first uplifting brassiere, which radically transforms the shape of femininity in the 20th century.

Communist Party is formed in China, meeting for the first time in a Shanghai girls' school. Mao Tse-tung, schoolteacher and library assistant, attends.

Hemlines fall in Paris as full-length skirts are now à la mode.

Emily Post publishes *Etiquette*.

AUGUST 15
German government offers to pay one quarter of the total reparations demanded by the Allies.

AUGUST 17
The largest dance hall in the world, Cover Hall, opens in New York.

AUGUST 29
Versailles, palace to French kings and more recently the site of the armistice signing, is reported to be seriously threatened by a mushroom fungus.

SEPTEMBER
Duchamp proposes to Tzara—whom he had referred to in another context as the "traveling salesman" of Dada—that the word "Dada" be marketed internationally as an insignia cast in silver, gold, and platinum to "be worn as a bracelet, badge, cuff links or tie pin....The act of buying this insignia would consecrate the buyer as Dada...the insignia would protect against certain maladies, against life's multiple troubles, something like those Little Pink Pills which cure everything.... *Nothing* of 'artistic' literature about it, just straight medicine, a universal panacea, a fetish in a sense: if you have a toothache, go to your dentist and ask him if he is Dada...." The insignia would sell for $1 or its equivalent and be accompanied by a "short prospectus (about three pages, and in every language)"; Duchamp's modest proposal was never realized.

Mamie Smith records the jazz tune "Da Da Strain," which is quickly followed up by five subsequent recordings of the song during the next six months. In the 1953 Dada retrospective at Sidney Janis, Duchamp, the exhibition's organizer, includes New Orleans Rhythm Kings' version of "Da Da Strain" among the twenty-seven items constituting the New York Dada section.

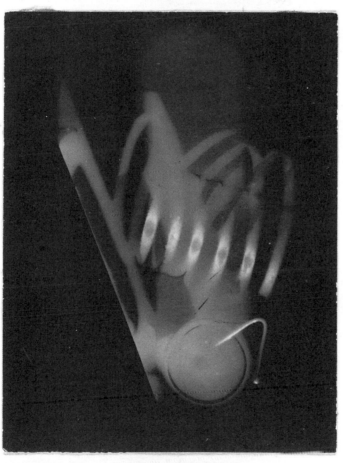

F₴ORROSE
SEL A VIE

Rayograph

Silent film star Lillian Gish stars in *Orphans of the Storm*, set during the French Revolution.

Marsden Hartley publishes first book of verse in Paris.

Despite the row between Picabia and Breton, the two men travel together to Barcelona, where Picabia exhibits at Galerie Dalmau and Breton lectures.

MAN RAY. F₴ORROSE SEL À VIE, 1922

OCTOBER 8
Giants beat the Yankees in five World Series games at the Polo Grounds.

OCTOBER 23
Hyperinflation in Germany as bread prices double in one month; internationally, the mark is quickly becoming virtually worthless. Public baths close to save on coal.

OCTOBER 24
British ship captains caught violating US Prohibition laws argue that British law requires the transport of five quarts of brandy in case of illness.

OCTOBER 30
Mussolini, accompanied by 40,000 black-shirted Fascists, marches on Rome in a bloodless revolution that makes him dictator.

MARCEL DUCHAMP, SOME FRENCH MODERNS SAYS MCBRIDE, 1922

In New York, Duchamp designs Henry McBride's collection of art criticism,

Some French Moderns Says, McBride.

It is illustrated with Charles Sheeler's photographs of artworks and

published by the Société Anonyme;

the design is copyrighted by Rrose Sélavy.

NOVEMBER 4
The Postmaster General
in New York requires that
all homes receiving mail
have a mailbox.

NOVEMBER 7
Jacob Gimbel, New York
department store
founder, dies.

NOVEMBER 29
José Capablanca, the
Cuban chess master,
plays twenty-four simul-
taneous games, defeating
Duchamp and nineteen
others at the Marshall
Chess Club in New York.

DECEMBER
Although the death of
Dada is widely reported,
it continues to provoke
publicity and popular
attention. Critic William
A. Drake in *Poet Lore*
(December): "For Dada,
whatever else may be
said of it, can never be
accused of having hid-
den its light. As a press-
agent feat, the mere
thought of the promi-
nence given the move-
ment for four years…is
enough to make any
ambitious journalist bite
his nails in chagrin."

"Can a Photograph Have
the Significance of Art?"
by Marcel Duchamp is
published in
Manuscripts.

(man Ray Collection)

The Non-Dada.

affectueusement Rrose

Photo by Joe Costa of the New York World

MARCEL DUCHAMP, THE NON-DADA, 1922

F. Scott Fitzgerald, *Tales of the Jazz Age*.
Mahatma Gandhi sentenced
to six years in prison for civil disobedience,
referred to by British authorities as "sedition."
Tourneur's film, *Last of the Mohicans*.
Sinclair Lewis publishes his second novel, *Babbitt*.
Congress of the Constructivists meets in Weimar. Participants include Theo van Doesberg,
Tzara, and Arp as well as El Lissitzky, Richter, and Moholy-Nagy.
Eugene O'Neill wins Pulitzer Prize for *Anna Christie*.
Irving Berlin composes "April Showers."
Walter Arensberg publishes *The Cryptography of Shakespeare: Part I*, a crypto-linguistic interpretation
of the bard's works, arguing, among other things, that Francis Bacon was the actual author.
Volume II is never published. Duchamp on Arensberg's cryptography:
"It was the conviction of a man at play. Arensberg twisted words
to make them say
what he wanted."

After *The Little Review* (Fall 1922) dedicates an entire issue to him, Joseph Stella receives his first one-artist exhibition at the Société Anonyme, which includes his epic *New York Interpreted*. The glowing reception inspires more than one critic to hail Stella as "one of the great American artists of today." *New York Interpreted* hangs today in The Newark Museum, New Jersey.

Schwitters publishes *Holland-Dada*, which is the first issue of the review *Merz*.

FEBRUARY 8

Dada's death notice is served in the American press by the critic Vincent O'Sullivan, whose article "Dada Is Dead" appears in the New York journal *The Freeman*: "Sirs: In a vaudeville show given in Paris lately it occurred to the producers to have a funeral procession of the enterprises that had died during the year. So they passed across the stage, one by one, lugubriously, while the musicians played a dead march. Among them was our old friend 'Dada.' Which proves two things: 1) that Dada has become known to the general public; 2) that Dada is really dead....There are some Americans in Paris, the middle-aged men I have spoken of, who still believe that Dada is alive. Nobody else does. These Americans will doubtless continue to speak for some time yet of Dada as a living thing. Don't believe them. Dada is dead."

1923

Man Ray produces *Le retour à la raison*, a Dada film.

In a testimony to the vast and sometimes indecipherable impact Duchamp exerts on 20th-century art, Charles Demuth exclaims that *Nude Descending a Staircase* is the "strongest influence" on his recent work.

Nikolai Tarabukin, *From the Easel to the Machine*.

Under the pseudonym Henrie Waste, Ettie Stettheimer publishes her second and final novel, *Love Days*, in which her intimacies with Marcel Duchamp and Elie Nadelman are explored through fiction.

Max Ernst and Paul Éluard collaborate on two books,

Les malheurs des immortels **and** *Répétitions*.

FLORINE STETTHEIMER, PORTRAIT OF DUCHAMP, 1923

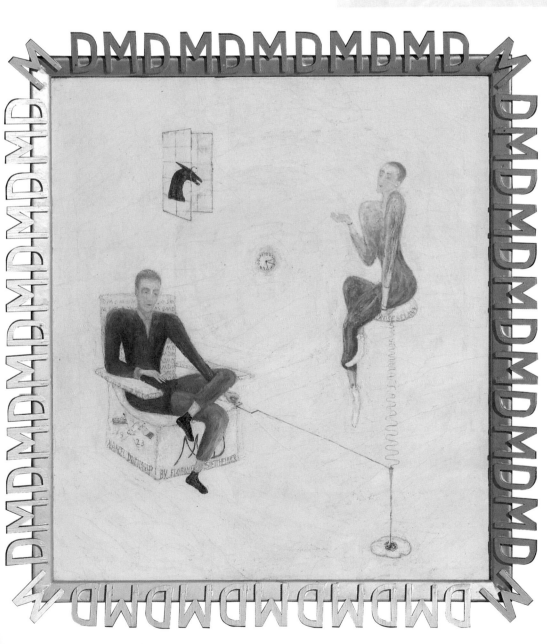

FLORINE STETTHEIMER, PORTRAIT OF MARCEL DUCHAMP, c. 1923

FEBRUARY 10
Having allowed *Large Glass* to be delivered, incomplete, to Katherine Dreier, Duchamp leaves New York. Arriving on the *Noordam* in Rotterdam, he travels on to Paris, where, except for three brief trips to New York, he will remain for the next twenty years.

MARCH
Lenin suffers his second stroke since November. Loss of speech and paralysis force him to resign—a fateful twist that alters the face of Soviet Communism. At his death in January 1924, he leaves a political testament advocating the removal of Joseph Stalin as party secretary-general; Stalin nonetheless succeeds him.

MARCH 26
Sarah Bernhardt, the legendary actress, dies.

APRIL
Although Baroness Elsa von Freytag-Loringhoven once offered to give syphilis to William Carlos Williams, the poet still gives her the needed money to sail to her native Germany on the *SS Yorck*; she does not return.

APRIL 18
Yankee Stadium opens to a crowd of 74,200.

JULY 7
The second night of a Dada session, "Soirée du coeur à barbe" ("Soirée of the Bearded Heart") at the Théâtre Michel, Paris. Films by Man Ray and Hans Richter, music by Satie, Stravinsky, and a performance of Tzara's *Coeur à gaz*. Breton, arriving with Aragon and Péret, instigates a fight that turns into a riot and police action is taken; Pierre de Massot's arm is broken. Duchamp's absence is as conspicuous as the public rift between Tzara and Breton.

AUGUST 2
President Warren G. Harding, aged fifty-seven, dies in office; he is succeeded by Calvin Coolidge.

SEPTEMBER 1
In a disaster of epic proportions, a massive earthquake and fire destroys most of Tokyo, killing hundreds of thousands and leaving millions homeless. Thousands are reported to have gone insane; martial law is declared in Tokyo.

SEPTEMBER 4
The spanking machine is proposed for use against first-time offenders in Winnipeg.

Katherine Dreier publishes
Western Art and the New Era.
On the relationship between high and low, Dada and popular culture, she remarks:
"One is constantly being asked in America, what is Dadaism?
One might say in response that almost any form of our modern advertisements,
which are essentially American and original, is some form of natural Dadaism in our country.
As an illustration the advertisement of a young woman with attached hands,
made out of paper, supposedly ironing with a real iron, is pure Dadaism.
Where the Jazz band in our country has almost obliterated music, one gets an expression of Dadaism.
Charlie Chaplin through his feet, is a pure expression on the stage.
We in America often appear natural-born Dadaists as regards art,
without possessing the constructive side. Therefore it seems doubtful whether an intellectual Dadaism
would ever secure a foothold in America, with its intellectual constructive side
as an undercurrent."
The US film industry becomes big business as $750 million are invested in 1923.
Marathon couples dancing, or "dancing until you drop,"
becomes the rage across the United States.
William Butler Yeats wins Nobel Prize for Literature.
The television is first developed by John Logie Baird.
The first transatlantic radio broadcast between New York and London.
World Chess League is formed at The Hague.
Sigmund Freud, *The Ego and the Id.*
Deferring to the wishes of American tourists,
Paris restaurants begin to draw color lines.
For $2,000, Katherine Dreier acquires
Duchamp's *Large Glass* from the Arensbergs,
who are now settled in California.

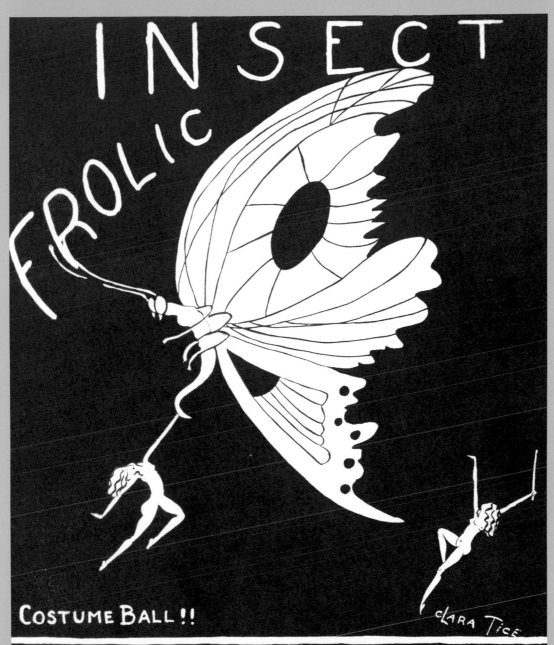

INSECT FROLIC

COSTUME BALL !!

CLARA TICE

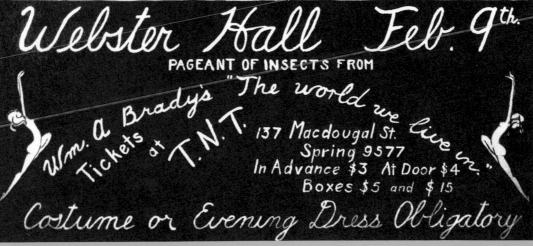

Webster Hall Feb. 9th.

PAGEANT OF INSECTS FROM

Wm. A. Brady's "The world we live in."
Tickets at T.N.T.
137 Macdougal St.
Spring 9577
In Advance $3 At Door $4
Boxes $5 and $15

Costume or Evening Dress Obligatory

CLARA TICE, INSECT FROLIC, 1923

SEPTEMBER 14
Jack Dempsey defeats Luis Firpo before a crowd of 82,000 at the Polo Grounds.

SEPTEMBER 27
German President Friedrich Ebert declares martial law.

AUTUMN
Among the few writers who understand and share the emphatic anti-retinal emphasis of Duchamp's Dada is G. Ribemont-Dessaignes, who writes in *The Little Review* (Autumn-Winter): "Sight is the lowest sense, so low that it should simply be worn under the sole of one's boot. It is the enemy of poets....the Dada painters have broken with sight. They paint or design as if they did not see. This thanks to the dexterity of Dada....This is all I know of the eyes of Dada, excuse me for not being an occultist."

OCTOBER 15
In an all-New York World Series, the Yankees defeat the Giants in the sixth game at the Polo Grounds.

NOVEMBER 5
New York City removes height restrictions for new buildings along Fifth Avenue, allowing the skyscrapers to rise even higher.

NOVEMBER 12
Days after his failed Beer Hall Putsch in Munich, Adolf Hitler is arrested at a Bavarian villa belonging to former New York art dealer and Harvard graduate, Ernest "Putzi" Hanfstaengel.

After receiving anti-Semitic death threats, Albert Einstein flees Berlin.

NOVEMBER 15
A pound of sugar reaches 250 billion marks in Germany.

DECEMBER 28
Gustave Eiffel, engineer of the Eiffel Tower, once the tallest man-made structure in the world, dies at ninety-one.

JOHN R. COVERT, FROM WORD TO OBJECT, 1923

JOHN R. COVERT: WILL INTELLECT SENSATION EMOTION, 1920–23

Parisian women are reported to use two pounds of face powder per year.

John Covert abandons painting to become a salesman for the
Arensberg crucible company in Pittsburgh.

The song "Yes, We Have No Bananas" is so popular that it is sung more than "The Star Spangled Banner."

Charlie Chaplin appears in *The Pilgrim.*

Walter Benjamin's essay "The Task of the Translator"
accompanies his introduction to Baudelaire's *Tableaux parisiens.*

New York Prohibition Enforcement Act
is repealed.

JANUARY
The first Winter Olympics are held in Chamonix, France.

JANUARY 1
"No new activity in Paris, so far as I know," Duchamp writes Ettie Stettheimer on New Year's Day, referring to the virtual absence of Dada, which is soon subsumed by Surrealism.

JANUARY 13
Three days after being knocked out, bantamweight boxer Frankie Jerome dies.

JANUARY 21
Lenin, who had once lived across the street from Hugo Ball's Dada Cabaret during his Zurich exile, dies. His body is laid in a marble tomb near the Kremlin.

FEBRUARY 28
US troops occupy Honduras in the name of protecting American interests.

MARCH 31
Duchamp in Monaco writes to Jacques Doucet, reporting that he has been playing chess, challenging chance at the roulette wheel, and losing "like a novice"; he is more successful over time, however, as he changes his strategy: "I play without placing a stake."

APRIL 2
New York City Transit Commissioner Harkness announces a campaign to prohibit advertising in the subways.

1924

The first monograph on Man Ray, by Georges Ribemont-Dessaignes, is published in Paris.
Breton publishes first manifesto of Surrealism
(*Manifeste du surréalisme*). Borrowing the term
"surrealism" from Apollinaire, who had subtitled his 1917 play *Les mamélles de Tirésias a drame surréaliste*,
Breton writes: "Surrealism, subst. Pure psychic automatism, by which it is intended to express,
verbally, in writing or by other means,
the real process of thought.
It is thought's dictation, all exercise of reason
and every esthetic or moral preoccupation being absent."
Duchamp creates *Monte Carlo Bond (Obligations pour la roulette de Monte-Carlo)*, the issue from a company
in which Rrose Sélavy is listed as president and Duchamp as administrator.
Attempting to challenge Mallarmé's famous mantra, "a throw of the die never abolishes chance,"
Duchamp tries to beat the odds at the roulette table by utilizing the precision logic of chess.
In all, thirty bonds are to be issued promising a return of 20 percent for the prospective buyer/collector.
The photograph on the bond of Duchamp with his face and hair lathered in soap is by Man Ray.
Stock held in the **Ford Motor Co**. valued at almost $1 billion.
Tzara publishes *Sept Manifestes Dada* with illustrations by Picabia.
Women's hair styling: the bobbed cut becomes ubiquitous across the country.
Arthur Dove creates his first collages.
The gas chamber, developed as a more "humane" form of execution,
is used for the first time at Nevada State Prison.
The Nazis later adapted gas for organized genocide during World War II.
Psychoanalyst Otto Rank publishes *The Trauma of Birth* in Paris and New York.
Picabia ridicules the Surrealists in the final issue of *391*.
Buster Keaton's *The Navigator*.
Fernand Léger's abstract film *Ballet mécanique*.
2.5 million radios are in use in the US.
Australian anthropologist Raymond Dart discovers a fossilized skull of a species he names
Australopithecus africanus, positing it as the "missing link" between humans and apes.
Erich von Stroheim's silent film *Greed*

MAY 26
Japanese government protests the barring of Japanese immigrants to America. The American Legion and AFL justify this special exclusion, arguing that "the Japanese are unassimilable; their culture is too different."

JUNE 2
Native Americans are granted full US citizenship.

JULY
Max Ernst travels to Asia, meeting Paul and Gala Éluard in Saigon.

JULY 12
Duchamp, invited at the last minute, plays chess for the French team in the first chess Olympiad, which coincides with the Olympic games being held in Paris. Duchamp loses his first game to Chepurov of Finland and his second game to Victor Kahn of Russia, but he does manage to win later games in the tournament.

SEPTEMBER
Although virtually absent in any manifest form in New York, Dada remains a menace. Waldo Frank in his "Seriousness and Dada," published in *Magazine of the Arts:* "A healthy reaction to our world must of course be the contrary of Dada: it must be ordered and serious and thorough. Dada worked well in overmature Europe. We, by analogue, must be fundamental, formal. That indeed is the proper mood of youth."

DECEMBER
Benjamin Péret and Pierre Naville found and edit the review *La Révolution Surréaliste*; contributors to the first issue include Boiffard, Éluard, Breton, Péret, Aragon, Reverdy, and Soupault. The declaration on the cover suggests a turning away from a Dada sensibility toward an increasingly political emphasis: "We must work toward a new declaration of the rights of man."

DECEMBER 4
Picabia's Dada ballet *Relâche*, with music by Erik Satie, is performed in Paris, the opening having been delayed a week. During the intermission, *Entr'acte,* a film by René Clair and Picabia, is screened; the music, also by Satie, is the first ever written for film. Duchamp and Brogna Perlmuttenn appear nude on stage, posing as a frozen tableau of Adam and Eve. The audience is forewarned to bring dark glasses and earplugs.

JULIETTE ROCHE

LA MINÉRALISATION DE

DUDLEY CRAVING MAC ADAM

PARIS
IMPRIMERIE CROUTZET ET DEPOST
70, RUE DE BONDY, 70

1924

The Surrealists publish the pamphlet *Un cadavre,* attacking Anatole France, who had just died. Outraged by this, newspapers hurl invectives at the Surrealists.

J. Edgar Hoover is named Director of the Bureau of Investigation, which becomes the FBI in 1935.

Aragon publishes *Une vague des rêves,* a summary of hypnosis experiments that had begun in 1922.

At the Paris Olympics, the Spaniard Ricardo Zamora, a.k.a. "The Great Zamora"— considered the world's greatest soccer goalkeeper—allows a ball kicked to him by his own teammate to slip into his own net in the last minute of play; it is the only score of the game, deciding Italy's victory over Spain, which is knocked out of competition. Zamora cries openly.

Thomas Mann publishes *The Magic Mountain.*

Kleenex, the original disposable paper handkerchief (first known as Celluwipes) is introduced by Kimberly-Clark.

Following up on its quota restrictions on immigrants in 1921, Congress acts again to limit immigration, reducing the number of legal immigrants to 164,677 1,197,892 entered during the last year of unrestricted immigration).

JANUARY 8
Stravinsky, arriving in New York for the first time, debuts at the New York Philharmonic.

FEBRUARY 21
The New Yorker, founded by Harold Ross, publishes its first issue.

MARCH 30
Rudolph Steiner, Austrian founder of theosophy, dies.

APRIL
In the third issue of *La Révolution Surréaliste*, Pierre Narville declares, "there is no such thing as Surrealist painting." Breton responds in the fourth issue with the first installment of *Le Surréalisme et la peinture*.

MAY 19
Malcolm Little, later black militant Malcolm X, is born.

JULY 20
Frantz Fanon, author of *Black Skin White Masks*, is born.

JULY 21
In a sensational trial, John Scopes is found guilty in Tennessee for teaching Darwinian evolution. The successful prosecuting lawyer, William Jennings Bryan, dies five days later.

1925

Charlie Chaplin's *The Gold Rush* opens in the US.

Eisenstein's second film, *Potemkin*, opens.

The Surrealist game *cadavre exquis* ("exquisite corpse") is developed; it consists of collaborative drawing on a folded sheet of paper.

Franz Kafka's *The Trial* is published posthumously.

Max Ernst develops the automatic drawing technique known as *frottage* ("rubbings").

The Vienna Psychoanalytic Institute is founded.

The Charleston becomes the latest dance craze to sweep America; it is first popularized by a South Carolina "all-Negro review" appearing in New York in 1923.

Josephine Baker, appearing in "The Negro Review," becomes a star in Paris.

Buster Keaton's *Go West.*

Duchamp creates *Rotating Demisphere (Precision Optics)*, a detail of which is reproduced on the cover of *The Little Revi*

20 million automobiles are registered in the US.

John Dos Passos, *Manhattan Transfer.*

F. Scott Fitzgerald, *The Great Gatsby.*

René Clair's film *The Ghost of Moulin Rouge.*

Marcel Mauss publishes *Essai sur le don, forme archaïque de l'échange (The Gift).*

AUGUST 8
40,000 white-robed
Ku Klux Klansmen march
on Washington, D.C.;
200,000 spectators look
on.

SEPTEMBER 10
In Duchamp's sixth-place
finish in the French
chess championship, his
50 percent score merits
the title "Maître de la
Fédération Française des
Échecs."

OCTOBER 8
A record $125,000 is
paid for a seat on the
New York Stock
Exchange.

OCTOBER 21
Paul Klee's first one-artist
exhibition in Paris
opens, with thirty-nine
watercolors, at the
Galerie Vavin-Raspail.

NOVEMBER 14
"Exposition, la peinture
surréaliste" opens in
Paris at the Galerie
Pierre. It is the first group
exhibition of Surrealist
painting, including works
by Arp, de Chirico, Ernst,
Klee, Masson, Miró.

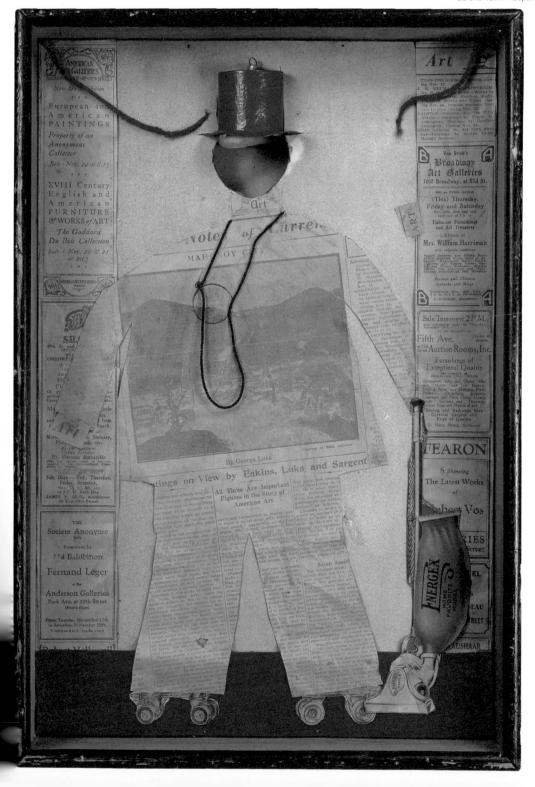

ARTHUR G. DOVE, THE CRITIC, 1925

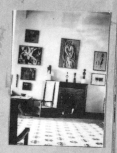

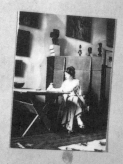

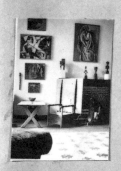

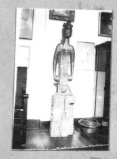

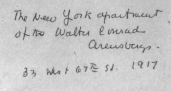

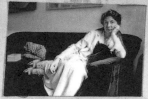

The New York apartment
of the Walter Conrad
Arensberg.
33 West 67ᵗʰ St. 1917

Louise "Lou."

MIDNIGHT *at the* ARENSBERGS':
A READYMADE CONVERSATION

Imagine an evening in the Arensbergs' apartment. The following fabricated conversation has been created to suggest the subjects the New York Dada circle discussed, using the vocabulary of the day.
Your surrogate ear—Walter Arensberg's fictitious nephew visiting from Pittsburgh—wanders through the Arensbergs' large studio room, listening attentively. The dialogue is drawn from directly quoted sources and from extrapolation.
The physical layout of the apartment is accurate, all of the speaking characters were guests there, and everything discussed really happened. Annotations describe the sources, places, events, and people mentioned, in order to provide a historical framework for the fabricated talk.

Louise Arensberg (1879-1953) and Walter Arensberg (1878-1954)

During a five-year period—from 1914 through 1919—Walter and Louise Arensberg assembled one of the earliest and most important collections of modern art in America. Although they both grew up in relatively wealthy families (Walter's father was part owner of a successful crucible company in Pittsburgh, and Louise was the only daughter of John Edward Stevens, owner and manager of the Stevens Textile Mill in Ludlow, Massachusetts), little in their respective cultural backgrounds forecasts this unwavering commitment to modern art.

Walter Arensberg attended Harvard University, where he majored in English literature and was graduated with honors in 1900. After considering a career in journalism, he eventually decided to become a poet, an avocation that began when he was still in high school. In 1907 he married Louise Stevens, the sister of a former classmate. They lived in Boston for the next seven years, Louise devoting her time to the theater and music (she played the piano and sang), while Walter continued to write poetry (much of it influenced by late nineteenth-century French Symbolist writers). Although they had made a few relatively modest acquisitions during their years in Boston—mostly prints by artists influenced by Impressionism—in 1913 they saw the Armory Show and purchased several works from it, whereupon their conversion to modern art was immediate and complete.

In 1914, the Arensbergs moved from Boston to New York City, purchasing a large duplex apartment at 33 West 67th Street. Almost immediately, they began to acquire modern paintings and sculpture, which they displayed throughout the various rooms of their new home, positioning the largest and most impressive works in the main studio. It was this room that hosted some of the most important artistic gatherings of the decade, for in the very period when they were most active as collectors, the Arensbergs opened their apartment to almost nightly parties, informal sessions consisting of food, drink, and lively conversation. These meetings represented America's first modern artistic salon.

Initially, these gatherings were composed primarily of young writers: Alfred Kreymborg, Donald Evans, Allen and Louise Norton, Wallace Stevens, Carl Van Vechten, William Carlos Williams, and others. Eventually, when the Arensbergs became known for their collection, they were joined by some of the most important American and European artists of their generation: Marcel Duchamp, Francis Picabia, Man Ray, Albert Gleizes, Juliette Roche, Jean and Yvonne Crotti, Edgard Varèse, Beatrice Wood, Clara Tice, Charles Sheeler, Morton Livingston Schamberg, Charles Demuth, John Covert, Joseph Stella, Florine Stettheimer, Katherine Dreier, Mina Loy, Arthur Cravan, the Baroness Elsa von Freytag-Loringhoven, and others (referred to collectively as the Arensberg Circle). "The Arensbergs collected not only art," as a friend once recalled, "but the artists as well."

The Arensbergs moved to California in the early 1920s. In the meantime, most of the European artists who had attended their salon returned home. For the next thirty years, however, the Arensbergs continued to add important modern paintings and sculpture to their collection, relying in large measure on the advice and guidance they received through correspondence with Duchamp, who had returned to Paris in 1923. By 1950, when their collection was donated to the Philadelphia Museum of Art, the Arensbergs had acquired some forty works by Duchamp, seventeen sculptures by Brancusi, fifteen drawings and paintings by Picasso, eight Braques, and one of the most important collections of Pre-Columbian art assembled in this century.

Although the Arensbergs' collection of modern art will remain their most enduring legacy, the artistic salon they maintained in New York during the second decade of this century was an equally important contribution to the history of American modernism, providing an ideal environment for the formation of New York's first avant-garde.

—*Francis M. Naumann*

CHARLES SHEELER, LIVING ROOM OF NEW YORK APARTMENT OF LOUISE AND WALTER ARENSBERG, 1919

SOUTHEAST CORNER

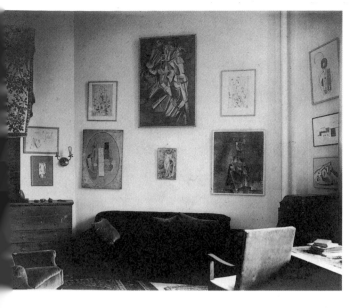

SECTION OF EAST WALL

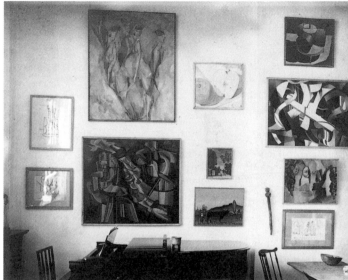

SOUTH WALL

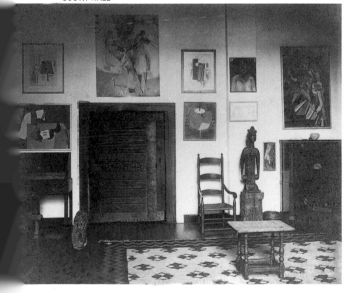

SECTION OF EAST WALL

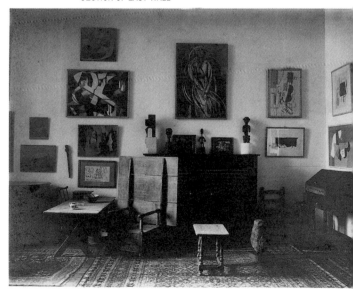

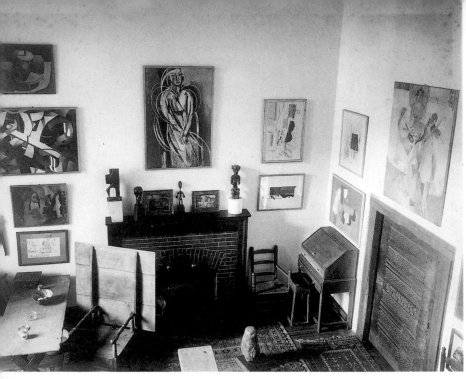

TIME: END OF JANUARY 1917, 11:45 P.M.
PLACE: THE ARENSBERGS' STUDIO, 33 WEST 67TH STREET, APARTMENT 2FE.

Walter Arensberg's visiting Nephew enters the apartment after an evening at the Metropolitan Opera.
He removes his overcoat and Kuppenheimer hat and straightens his dark evening suit, hoping that his attire
is appropriate for the evening. He walks into a generous, two-story duplex studio room.
The floors are covered with worn Oriental rugs and the room is furnished with groupings of American antique furniture,
but most striking are the soaring, white, 17-foot-high walls, filled with modernist paintings by Henri Matisse,
Marcel Duchamp, Francis Picabia, Morton Schamberg, Joseph Stella, Charles Sheeler, and others.
Directly ahead the Nephew sees a brick fireplace, over which hangs Matisse's **Mlle. Yvonne Landsberg** *of 1914.*
Gazing at the painting with a pained expression on her face is Beatrice Wood
(wearing a Paris dress purchased by her mother, with a band of ribbon across her forehead).
She is accompanied by a tall figure in a dark suit, Henri-Pierre Roché.[1]

This fabricated conversation depended on the sources cited in notes. I want to especially thank Francis Naumann for encouraging me to use this form as a way of evoking the topics of conversation at the Arensbergs. I also thank for their comments Beatrice Wood (on the atmosphere at the Arensbergs), Naomi Sawelson-Gorse (on Louise Arensberg), Carolyn Burke (on Mina Loy), Emile Bedriomo (on French slang), and Allan Knee (on crafting dialogue).

1
Henri-Pierre Roché (1879–1959) did many things: he was a French diplomat in the United States during World War I; an art dealer for such modernists as Brancusi; a scout for the collection of John Quinn; and he wrote *Jules et Jim* and *Victor*, which includes characters based on the Arensberg circle.

BEATRICE WOOD

I have been staring at that painting for an hour, and I'm trying to imagine what Walter sees there. I think it is the ugliest thing in this whole room, and I must agree with the critic who called Matisse "the Apostle of the Ugly."[2] That outlandish woman with the white streaks around her body. I can't tell whether they are puffed sleeves or wings or daggers.[3]

Walter Arensberg approaches in a rumpled suit; he is giving an art tour to two Hungarian-born vaudevillians, the Dolly Sisters, Roszika and Jenny.

WALTER ARENSBERG
(*pointing at the Matisse painting*):

When I walked into the Montross Gallery last year, I told Walter Pach that I saw radiation coming from her.[4] Emanations of an energy that are more real than a human body. By being abstracted she becomes eternal, a Mademoiselle who will always remain a mademoiselle.

(*He wipes a stray lock of hair from his forehead and takes a drag on his Murad cigarette.*)

HENRI-PIERRE ROCHÉ

She may be abstract and she may be eternal, and she may *even* be a Mademoiselle, but she is certainly no *jeune fille*. And what are her hands doing there, covering her *petite femme*?[5] Why such quivering?

JENNY DOLLY:

Walter, is this what they call Futurism? Making a woman with holes for eyes?

ROSZIKA DOLLY: No, Jenny, it's called Cubism!

JENNY DOLLY: Perhaps, Roszika, we should just be safe and call it the new art!

ROSZIKA DOLLY: Safe! My dear, it's all revolution![6]

BEATRICE WOOD
(*an expression slowly dawning on her face*):

Finally I think I can see her!
The Mademoiselle.
Out of all those angular lines
she comes,
a creature of beauty![7]

2
"Matisse at Montross," *The American Art News*, 13 (January 23, 1915), p. 2.

3
Beatrice Wood, *I Shock Myself* (Ojai, California: Dillingham Press, 1985), p. 28.

4
Arensberg bought the painting from an exhibition at the Montross Gallery, organized by Walter Pach in 1915. Pach (1883–1956) was an artist and art critic, important in the 1910s especially for facilitating the showing of European artists in New York (through his involvement with the Armory Show and with such galleries as the Montross).

5
Petite femme is a reference to female sexual organs. See note 43 below.

6
Futurism, Cubism, new art, and revolution were all buzzwords for modern art.

7
Wood, *I Shock Myself*, p. 28.

Beatrice Wood (b.1893)

Having spent the early years of her life in San Francisco and then New York, Beatrice Wood moved to Paris with her mother at the age of seven. For the remainder of her formative years, she would shuttle back and forth between Europe and America, studying at private schools. From a young age, she knew she wanted to escape her wealthy, conservative family's lifestyle in favor of a bohemian one. She took art classes at the Académie Julian in Paris and rented a studio for a brief time in Giverny. After turning to theater and dance in Europe, she made her stage debut in New York, where she had relocated in 1916.

Wood's introduction to Henri-Pierre Roché and Marcel Duchamp in New York had a great impact on the direction of her career. Both men encouraged her to renew her artistic endeavors, Duchamp giving her a key to his studio so she would have a place to work. His studio was in the same building as the Arensbergs' apartment, and before long Wood was spending nearly every evening in the company of the collectors and their circle of friends. Duchamp published one of her drawings in *Rogue* magazine, encouraged her to join and exhibit with the Society of Independent Artists, where her work caused quite a stir, and copublished *The Blind Man* magazine with her and Roché. At Duchamp's urging, she experimented with drawing directly from her unconscious. Her drawings often depicted gatherings of the Dadaists, including chess games, parties, and salons at the Arensbergs. These drawings, along with her diaries, recorded the exciting events of those years.

With the exception of two years spent in Montreal, Wood remained in New York until 1928, then moved to California, where the Arensbergs had relocated. Although she continued to create drawings, she devoted herself primarily to ceramics after 1930. More than sixty years of study and production as a ceramist have won her international renown in that field. She continues to live and work in California to this day, the last surviving member of the New York Dada group.

—*Lauren Ross*

Unable to see a creature of beauty and feeling a little baffled, the Nephew edges to the left,
toward a Steinway grand piano, situated beneath two paintings by Marcel Duchamp.[8]
Baroness Elsa von Freytag-Loringhoven has backed Wallace Stevens against the curve of the piano frame.
She is dressed in a bolero jacket and kilt, her head shaved; she gazes up at Duchamp's paintings and mutters.

BARONESS:	Marcel, Marcel, I love you like Hell, Marcel. (*She touches the collar of Stevens' brown tweed suit.*) Although he loves me, he would never even touch the hem of my red oilskin slicker. Something of the dynamic warmth—electrically!—would be dissipated. You see![9]

WALLACE STEVENS (*edging away*):	Oh. Yes. (*He mentally notes, "How glad I am to live in Hartford," and vows never to travel below 14th Street.*)

BARONESS:	I have only one god. In attendance or not. And that is *passion*.[10] Marcel is the man I *want*. He is *real*. You are phantoms.[11]

The Nephew shudders, fingers his tie, and turns left toward the couch,
where Louise Arensberg and Louise Norton are talking together.[12]

LOUISE ARENSBERG (*her flat-chested figure in a dark dress appointed with a lace jabot and a wolf collar, wearing angular jeweled earrings and elaborate button shoes*):	I could never manage your style, Louise, nor your scent.

LOUISE NORTON (*wearing a loose-fitting dress with a low bodice*):	I had rather be judged by my scents than my suits.[13] And I always believe that one should wear a hat—in so much as imagination is more than decoration, which is nearer kin to Don Quixote than to the dandy.[14]

LOUISE ARENSBERG:	Are you inspired by Clara Tice? I hear she attracts the most attention at the Pagan Routs.[15] With her *radiator* costume.

LOUISE NORTON:	Clara was the first to bob her hair, *before* Irene Castle. "I hate those cootie cage coiffure effects," Clara said the other day. "They make the hair look like it had been combed with an egg beater."[16] So Clara advocates convenience, rolled-up stockings, and short dresses with straight tailored lines. But here I must part company with her. A woman maintains the illusion of beauty through strenuous artifice. It curves the lips and curves are lovelier than straight lines.[17] Yes, brains and ability can attract a man, but Oh! the importance of *fanfreluches!*[18]

8
The paintings are *Portrait (Dulcinea)* (1911) and *The King and Queen Surrounded by Swift Nudes* (1912).

9
Baroness Elsa von Freytag-Loringhoven, in George Biddle, *American Artist's Story* (Boston: Little, Brown, 1939), p. 138.

10
Baroness von Freytag-Loringhoven, quoted in Francis M. Naumann, *New York Dada 1915–23* (New York: Harry N. Abrams, 1994), p. 170.

11
Ibid., pp. 170, 172, 173.

12
Louise Arensberg (1879–1953) came from a wealthy New England family and was devoted to both music and art; although Walter was the initiator of the collection, there were reportedly only two occasions on which the Arensbergs disagreed. Louise Norton (1890–1990) was an editor of *Rogue*, a fashion columnist for the magazine (using the name Dame Rogue), a poet, and a translator; after her marriage to Allen Norton, she married Edgard Varèse in 1921.

13
Dame Rogue (Louise Norton), "Philosophic Fashions: Good Smells and Bad," *Rogue*, May 1, 1915, p. 15. She favored scents promoted by the Natura Company.

14
Dame Rogue (Louise Norton), "Philosophic functions: Hats Lusitania," *Rogue*, June 15, 1915, p. 18.

18
Dame Rogue (Louise Norton), "Philosophic Fashions: The Importance of Being Dressed," *Rogue*, July 15, 1915, p. 13.

16
Clara Tice, quoted in "'Greenwich Village Queen' Here Decries Beauty That Is Purchased," *Saint Louis Star*, June 9, 1921.

17
Dame Rogue (Louise Norton), "Philosophic Fashions: Fashions in Figures, Circumbendibus," *Rogue*, September 15, 1915, p. 12.

Hall (119 East 11th Street), using such themes as "Arabian Nights," the "Red Revel," the "Futurist Ball." Most people came in costume, and Clara Tice was especially known for her radiator costume.

15
Pagan Routs were the beginning of the Greenwich Village costume ball fad, first suggested by Floyd Dell in 1914 as a way of raising money for *The Masses* and for the Liberal Club. Many other balls followed, so that they became a virtual Greenwich Village industry, invariably held at Webster

Baroness Elsa von Freytag-Loringhoven (1874–1927)

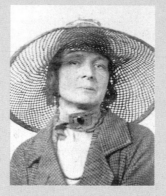

Born Elsa Ploetz in a small town in Germany, the future "mother of Dada" rejected her bourgeois family at an early age. At eighteen she ran away from home to live in Berlin with an aunt, who eventually threw her out. She studied acting and supported herself by working as a chorus girl. An affair with an artist introduced her into a circle of artists and writers, and her interest in the arts flourished, leading her to take an apprenticeship in applied arts in Berlin. She married, but soon grew bored and ran off with a longtime lover to the United States, settling in Kentucky in 1909. This relationship did not last more than a year, and after a stint in the theater in Cincinnati, Elsa moved to New York in 1913. There she met and married Leopold von Freytag-Loringhoven, a German baron ten years her junior. They spent only a short time together before the baron, while attempting to travel to Germany, was captured by the French. After four years imprisonment, he committed suicide, leaving Elsa an impoverished widow.

Despite her title, the baroness lived in squalor for the remainder of her life, sometimes homeless, frequently shoplifting. She became a well-known and easily recognized presence in Greenwich Village, walking around in outrageous outfits that might include a coal scuttle strapped to her head, a hat decorated with gilded vegetables, postage stamps affixed to her face, an electric taillight on the bustle of her dress, or a birdcage—containing a live bird—hanging from her neck. Her behavior was as colorful as her dress and often got her into trouble. She was arrested several times for public nudity and was frequently thrown out of social gatherings for off-color or insulting remarks.

During the ten years the baroness lived in New York, she befriended many artists, at first by posing for them (her enthusiastic willingness to pose nude made her a sought-after model). Her circle grew to include writers such as William Carlos Williams, and some of her prolific poetry was published in *The Little Review*. The few formal works of art she produced were mostly portraits of artists she admired. The object of her greatest affection was Duchamp, for whom she felt an intense, almost obsessive, passion. She believed Duchamp to be a consummate artist whose followers paled in comparison, and shared his love of the readymade object, collecting hundreds of items found on the streets of New York. As an expression of her affection, she penned the following poem: "Marcel, Marcel, I love you like Hell, Marcel." Although Duchamp did not return her amorous feelings, he remained her friend for many years, and there can be little doubt that they delighted in each other's irreverence. In a collaboration with Man Ray, Duchamp made the baroness the subject of a film with the accurately descriptive title *The Baroness Shaves Her Pubic Hair*.

In 1923, the baroness decided to return to Germany. She was greatly disappointed with what she discovered there after her long absence. She was unable to return to America, however, and remained in Europe until her death four years later. Her departure from New York City undoubtedly contributed to the dissolution of the Dada movement, as she was considered a key figure of the group. As proclaimed in *The Little Review* in 1922, she was "the first American dada…she is the only one living anywhere who dresses dada, loves dada, lives dada."

—*L.R.*

LOUISE ARENSBERG: It's almost midnight, just in time to bring our guests their desserts.

LOUISE NORTON: In time to bring our guests their just desserts.

(Louise Arensberg exits to the kitchen.)

The Nephew seeks company in the center of the room where, standing on a large Oriental rug,
are a cluster of recent émigrés to New York, including Edgard Varèse, Mina Loy, Arthur Cravan, Marcel Duchamp,
Joseph Stella, and Henri-Pierre Roché accompanied by Beatrice Wood.

MINA LOY

(attired in a beige dress of her own design, her black hair twisted in a chignon, wearing a mosaic brooch and candelabra earrings in which a dragonfly is encased in amber):

I can't say which I prefer. Lunch downstairs at the Brevoort, on checkered tablecloths, with a view of the Village bohemians. Or perfectly served blue-point oysters upstairs, with the white cloths and the old waiters.[19] And all the French soldiers in their sky-blue uniforms! Perhaps they will inspire new fashions.[20]

MARCEL DUCHAMP:

Mina, you and beautiful clothes. *On peut dire, "Madame, vous avez un joli caleçon de satin." On ne peut dire, "Madame vous avez un sale con de catin."*[21] Or perhaps Cubism is the new fashion. Cubism could almost be a prophet of the war, as Rousseau was of the French Revolution, for the war will produce a severe, direct art.[22]

EDGARD VARÈSE

(leaning on a cane):[23]

The war! We left to escape it but we can't stop talking about it. Dame Rogue says that all war is silly and it's just arithmetic that causes all the problems between nations. Patriotism is the vice of the ages.[24]

BEATRICE WOOD:

Imagine all those people killed by airplanes! In masses! That is what is new in this war! All those young men gone! What a loss to humanity!

BARONESS

(muttering as she walks through the group):

Humanity! I wouldn't lift my leg for humanity.[25]

19
The Brevoort (Fifth Avenue and Eighth Street) was French in style and cuisine, and attracted both flush bohemians and expatriates. The other restaurant that attracted French expatriates was the Lafayette (University Place and 9th Street).

20
Mina Loy designed clothes and hoped to partly support herself in New York with her fashion drawings.

21
Duchamp's verbal play, for which he was well-known, can be translated as "One may say, 'Madame, you have pretty satin panties.' One may not say, 'Madame, you have a dirty whorish cunt'"; Mina Loy, "Colossus," quoted in Carolyn Burke, *Becoming Modern: The Life of Mina Loy* (New York: Farrar, Straus and Giroux, 1996), p. 218.

22
Marcel Duchamp, in his first published interview in the United States, *New York Tribune*, September 12, 1915.

24
Dame Rogue (Louise Norton), *Rogue*, May 15, 1915, p. 4.

25
Baroness Elsa von Freytag-Loringhoven, in Naumann, *New York Dada 1915–23*, p. 169.

23
Edgard Varèse was using a cane because he had been hit by an automobile in 1916. It was while visiting him in the hospital that Beatrice Wood met Marcel Duchamp and was introduced to the Arensberg circle.

Marius de Zayas (1880–1961)

Born in Veracruz, Mexico, to a prominent family, Marius de Zayas drew caricatures for his father's two newspapers as well as for the leading paper of Mexico City. Forced by political turmoil to leave Mexico, the de Zayas family relocated to New York City in 1907. In New York, the artist took a job at *The Evening World*, portraying the members of the local art world and society in caricatures. These clever drawings quickly captured the attention of Alfred Stieglitz, prompting the gallery owner to organize the very first exhibitions of de Zayas' work at 291 in 1909 and 1910.

During the second exhibition, de Zayas moved to Paris, remaining there for a year. It was here that he first encountered the work of the European avant-garde and met members of the city's intellectual circles, including Gertrude Stein and Guillaume Apollinaire. De Zayas regularly wrote to Stieglitz in New York, telling him of the exciting new work he was seeing, particularly that of the Cubists. During this time, and again on a second trip to France in 1914, de Zayas acted as a European liaison to Stieglitz, helping to organize exhibitions of modern art, including the first showing of Picasso in America.

Influenced by the radical artwork and literary innovations to which he had been exposed, de Zayas' caricatures drifted away from their traditional newspaper style. Instead of illustrating his subjects with a physical likeness, he portrayed them with mathematical equations, geometric shapes, and abstract designs. This new mode of representation was designed to convey the sitter's emotional and psychological state. These portraits comprised the artist's third exhibition at 291—which would also be his last—and were reproduced in the pages of the eponymous magazine. They undoubtedly served as inspiration to the other artists in the Dada circle, who took up their own varied forms of abstract portraiture.

De Zayas abandoned caricature after 1916. Although his production as an artist waned, his enthusiasm for presenting the work of other members of the avant-garde grew. Throughout the teens, he published articles in such experimental publications as *Camera Work* and *291*, and he helped to edit the latter. He co-authored *A Study of the Modern Evolution of Plastic Form* (1913) with Paul Haviland and wrote *African Negro Art: Its Influence on Modern Art* (1916). De Zayas served as an artistic consultant to many members of the art world, and opened two galleries in New York: the Modern Gallery (in 1915) and the De Zayas Gallery (in 1919). In the twenties, he continued to advise on exhibitions in both Europe and America. Subsequently he turned to painting and, years later, to other media, including writing, filmmaking, and music. He settled in Connecticut in the 1940s and remained there until his death in 1961.

—*L.R.*

HENRI-PIERRE ROCHÉ: But the atmosphere at the Brevoort doesn't remind me of the war. It just takes me back to Paris. I haven't seen it for three months. The Vichy Celestin on the bar, the sound of French conversations, the talk of anarchy, of Mallarmé. And always *tout va bien*.[26] I forget for a moment that I am not in Montparnasse.

EDGARD VARÈSE: I can understand the desire to be elsewhere. I migrated to this city to find open horizons, to expand freedom. But these American sportsman types, *mon dieu*. That *grin*. It is as unvarying as their conversation. One-syllable words, no irony, and always the Dollar.[27]

ARTHUR CRAVAN
(his towering, muscled frame straining against his tweed suit and vest): Ah yes, the American gentleman. I recognize the type. He keeps change jingling in his pocket, parts his hair in the middle, chews tobacco, and greets you by touching his index finger to the brim of his hat. To be or not to be...American.[28]

HENRI-PIERRE ROCHÉ: Americans have those things that Walt Whitman championed— confidence, generosity, and optimism.[29] But it's a little simple-minded. They watch the war newsreels and cheer them as if the war is a football match! It's all the same to them.[30]

MARCEL DUCHAMP
(a deadpan expression on his face, wearing a simple jacket, loose black bowtie, and a white shirt with a rolled collar): The machines and the skyscrapers attract me. I wish I could have my studio in New York's highest turret and look out and drink the American cocktails. After six months here I realized, Ah well, they don't allow mere people to live in their towers. I even once planned to turn the Woolworth Building into a readymade.[31] *Cela n'a pas d'importance.*

EDGARD VARÈSE: For me New York is the symphony of the river. The steamers' foghorns, the lapping of the waves, the sounds of the garbage tugs. And the shrill sirens and klaxons along Broadway. It moves me more than anything I heard in Europe.[32] The music that ought to be living and vibrating at this moment needs a new means of expression, and only science can infuse it with youthful sap.

26
Drawn from Juliette Roche's visual poem, *Brevoort*, 1917, reproduced in *Demi Cercle*, 1920, illustrated in Naumann, *New York Dada 1915–23*, p. 98.

27
Varèse to Mme. Kaufman, February 29, 1916; quoted in Louise Varèse, *Looking-Glass Diary* (New York: W.W. Norton and Co., 1972), p. 122.

28
Adapted from Fabian Lloyd (Arthur Cravan), "To Be or Not to Be...American," *L'Écho des Sports*, June 10, 1909.

29
Henri-Pierre Roché, "How New York Did Strike Me," 1924, quoted in Carlton Lake and Linda Ashton, eds., *Henri-Pierre Roché: An Introduction* (Austin: Humanities Research Center, University of Texas, 1991), pp. 72–73.

30
Henri-Pierre Roché, *Victor*; quoted in Naumann, *New York Dada*, p. 110.

31
In January 1916, Duchamp wrote himself the following note: "find inscription for Woolworth Bldg. as readymade."

32
Edgard Varèse, quoted in program notes to *Varèse: Amériques, Nocturnal Ecuatorial* (Vanguard Classic, compact disc, 1991).

Man Ray (1890–1976)

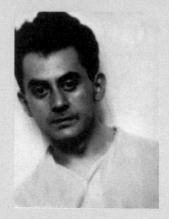

Born Emmanuel Radnitzky in Philadelphia, Man Ray moved with his family to Brooklyn at the age of seven and, in 1908, upon graduation from high school, to Manhattan. For several years he took classes at the Ferrer Center in Harlem, the National Academy of Design, and the Art Students League, while supporting himself as an architectural draftsman. The 1913 Armory Show as well as exhibitions at 291 made him familiar with developments in European and American modernism. Man Ray felt a far greater affinity with the work being produced in Europe, and later stated that he would have moved overseas had World War I not prevented his departure. In 1913, he moved to Ridgefield, New Jersey, where he formed part of an artists' colony of painters and writers. For two years there, he painted in a Cubist style. 1915 was a pivotal year in his life: his first one-artist show opened at the Daniel Gallery; he moved back to New York City; he took up photography; and he met Marcel Duchamp.

From 1915 until 1921, Man Ray lived and worked in New York, experimenting not only with painting and photography, but with collage, airbrush, assemblage, filmmaking, and object sculpture. A true innovator, his style defies categorization, but shows the influence of the machinist aesthetic. During this time, he mingled with artists at the Arensbergs and showed his work again at the Daniel Gallery and at the Forum Exhibition. In 1920, he met Katherine Dreier, helped name and run the Société Anonyme, and gave a controversial lecture on art at one of its symposia the following year.

Throughout the 1920s, the friendship between Man Ray and Duchamp flourished. They shared the same concern with art as an intellectual exercise liberated from the restrictions of established schools. They collaborated on several projects, including the publication of the only issue of *New York Dada* in 1921. In later years, Man Ray nevertheless denied that a Dada movement had ever existed in New York. Always disappointed with the art of his countrymen, he claimed that Americans were incapable of grasping the radical principles of Dada. This may be one reason why he followed Duchamp to Paris and settled there in 1921.

Man Ray remained in Paris for the next twenty years, becoming an active participant first in the Parisian Dada movement and later in Surrealism. He was able to support himself through portrait and fashion photography, the work for which he is best known today. In 1940, World War II forced him to return to America. He lived in Hollywood until 1951, then went back to Paris, where he remained until his death.

—*L.R.*

Marcel Duchamp (1887–1968)

Marcel Duchamp and his siblings, Jacques Villon, Raymond Duchamp-Villon, and Suzanne Duchamp, all pursued careers in art. Marcel left his parents' home in Normandy to study in Paris at the Académie Julian (1904–05), after which he contributed humorist drawings to a number of Parisian periodicals. Beginning in 1909, Duchamp exhibited his paintings, which were influenced first by the Impressionists, then Cézanne, and later by Cubists such as Jean Metzinger and Fernand Léger. Although he knew and associated with many of these artists, Duchamp's work was unique in its conflation of different styles, such as his celebrated *Nude Descending a Staircase* (1912), a painting that has been described as "Cubo-Futurist." This work triggered an explosive reaction from the art world when it was seen at the Armory Show of 1913, and launched the celebrity that continues to surround Duchamp's name to this day.

Duchamp moved to New York in 1915 and soon became acquainted with every artist in the Arensberg circle. His gracious manner, good looks, wit, and charm attracted many. He was known for his irreverent manner and colorful acts, whether shaving a star shape into his hair or posing as Rrose Sélavy, his fictitious feminine alter ego. The combination of his unique artwork and intriguing persona had an enormous effect on those around him. Despite his reluctance to ally himself with any one movement or style, Duchamp served as the very hub of the Dada circle.

Duchamp's oeuvre is singular in its radical experimentation and rejection of artistic convention. While in France, he conceived and executed assemblages of ordinary objects, including his first *Bicycle Wheel* (1913). Once in New York, he coined the term "readymade" for the found objects he transformed into works of art simply by declaring them as such. These latter pieces, including the infamous *Fountain* (1917), forever altered the definition of art. Duchamp's philosophy of advocating intellectual over purely visual (what he called "retinal") concerns and his focus on the conceptual meaning of his work were also controversial at the time.

Although Duchamp took several excursions to Europe and South America between 1915 and 1923, New York City served as his home. In 1923, having left the *Large Glass* uncompleted, he abandoned making art for chess, a game which he also considered an art form. That same year he returned to France, where he remained until 1942, when he moved back to New York. He died there twenty-six years later, leaving an unparalleled legacy to the art of this century.

—*L.R.*

Joseph Stella (1877–1946)

Born in a mountain village outside of Naples, Joseph Stella came to the United States in 1896 at the age of nineteen. His arrival in New York was a momentous event for the young man. He enrolled first at the Art Students League and then at the New York School of Art, where he studied under William Merritt Chase. Like many early twentieth-century artists living in New York, he took to depicting the realities of urban life, including poverty and squalor. Throughout Stella's years in America, he maintained a close alliance with his fellow Italian immigrants, who were trying to assimilate to urban life.

Two excursions outside of New York were catalysts for Stella's artistic development in the years following his arrival. A trip to Paris in 1912 introduced the artist to modernism, particularly Fauvism, Cubism, and Futurism. Upon his return from Europe, Stella abandoned his academic style. Three of his new Futurist canvases were included in the Armory Show the following year. His inclusion in group exhibitions thereafter led critics to declare him among the most daring of artists. By 1915, when Stella met Duchamp and Picabia, he had established himself as an important force in American modernism. A trip to Pittsburgh and Bethlehem, Pennsylvania, in 1918 introduced Stella to the industrial factories and grain elevators of the American landscape. These forms, along with the towering structures of New York City, became the subjects of his paintings. As Stella later wrote, "Steel and electricity had created a new world." It was in this same year, 1918, that he began his now famous depictions of the Brooklyn Bridge.

Throughout the late teens and early twenties, Stella maintained close associations with members of the Dada group, frequenting the home of the Arensbergs, who had purchased his work. In 1920, he joined the Société Anonyme, through which he exhibited as well as lectured on his work. His works on glass and collages may have been influenced by his Dada friends and colleagues. Stella was a colorful and vociferous participant in their gatherings. He shared the Dadaists' combination of sophisticated worldliness and nose-thumbing irreverence. As Edgard Varèse remarked, "He was in some ways so refined, so delicate...and then he could be so vulgar, obscene...he was a paradox...."

Stella became an American citizen in 1923, but he spent his remaining years traveling extensively throughout Europe, Africa, and the Caribbean, although he periodically returned to New York. From the mid-twenties until his death in 1946, his subject matter and artistic style went through several metamorphoses. He held fast to a belief, first developed during the Dada period, in the absolute freedom of the artist to disregard schools, trends, and all inhibitions for the bliss of self-expression.

—L.R.

Clara Tice (1888–1973)

Born in Elmira, New York, Clara Tice moved with her family to New York City at the turn of the century. There she studied art under Robert Henri. Her work was included in the first Independents Exhibition of 1910, which she helped to organize. Five years later, she received public attention after the Society for the Suppression of Vice tried to censor some of her nudes. This directly led to her first one-artist exhibition that same year, which featured more than 250 paintings and drawings. Her work was included in many group exhibitions and at least seven one-artist exhibitions during her lifetime.

Tice is best known for drawings in a characteristic linear style, most often of female nudes, butterflies, and dogs. These clearly delineated forms made her a successful illustrator for books, periodicals, and newspapers, such as the *The New York Times*, the *Globe*, and the *Sun*. She also designed posters and invitations for balls and other fetes, created sets for the theater, and produced window displays for such department stores as Saks Fifth Avenue. Although a regular illustrator for the high-profile *Vanity Fair* from 1915 to 1921, she also contributed to such underground publications as *Rogue*.

Tice was a recognizable fixture in Greenwich Village, where she lived for many years. She moved to Connecticut later in life, but eventually returned to New York City. She continued her prolific creation of paintings and drawings until her death at the age of eighty-four.

—L.R.

JOSEPH STELLA: Don't forget Coney Island or the Brooklyn Bridge. *That* is America. Glittering lights and tawdry colors. The steely orchestra of modern constructions.[33] True art reflects what is going on now. We cannot live on crumbs of the past![34]

ARTHUR CRAVAN: New York! New York! I would like to inhabit you.[35] I just arrived two weeks ago and I nominate as your great countryman: Jack Johnson. What a boxer! After Poe, Whitman, Emerson, he is the most glorious American. If there is a revolution here I shall fight to have him enthroned as King of the United States.[36]

Louise Arensberg enters, pushing a trolley filled with chocolate eclairs and rice pudding, trailed by Charles Demuth, Katherine Dreier, and Jean Crotti. The Nephew follows the food and takes a small plateful. He notices in the corner a chess game between psychologist Elmer Ernest Southard and Allen Norton, who is composing a poem about the gathering, which he will later publish as "Walter's Room."

ALLEN NORTON
(composing "Walter's Room" between moves of the chess game):
Where people who lived in glass houses
Threw stones connubially at one another;
And the super pictures on the walls
Had intercourse with the poems that were never written.[37]

HENRI-PIERRE ROCHÉ: It must be midnight, one could time a clock by Louise. Always the admirable hostess, always the inevitable rice pudding.

MINA LOY: A perfect dear who, however, just cannot acquire the knack of misbehaving.[38]

LOUISE ARENSBERG: We must have *something* to sop up all the liquor. Between Walter and Marcel we keep the local liquor merchant in business.

MARCEL DUCHAMP: If I didn't drink so much alcohol I would have committed suicide long ago![39] *Cela n'a pas d'importance.*

HENRI-PIERRE ROCHÉ
(mischievously):
Louise, can you please help my young friend, Beatrice, to understand this statue by my friend Brancusi? *(He points to* Princesse X, *with its obvious phallic shape.)*[40]

33
Stella on the Brooklyn Bridge, *Transition*, 16–17 (June 1929), pp. 86–88.

34
Joseph Stella, "The New Art," *Trend*, 5 (June 1913), p. 395.

35
Arthur Cravan, *Maintenant*, 1 (1912). Although Cravan arrived in New York on January 13, 1917, he probably did not become part of the Arensberg circle until April.

36
Arthur Cravan, in "Arthur Cravan vs. Jack Johnson," *The Soil*, 1, no. 4 (April 1917), pp. 161–62.

37
This and subsequent segments of Norton's poem are from "Walter's Room," *Quill*, 5 (June 1919), p. 20.

38
Loy, in Burke, *Becoming Modern*, p. 217.

39
From Juliette Roche-Gleizes, "Souvenirs," unpublished memoirs, quoted in Naumann, *New York Dada*, p. 47.

40
The phallic shape of Brancusi's sculpture was commented on by critics, and Charles Demuth used it to witty effect in his 1930 illustration for Robert McAlmon's story "Distinguished Air."

Florine Stettheimer (1871–1944)

Florine Stettheimer was born into a wealthy and eccentric family in Rochester, New York. Her father abandoned the family, and her brother and one of her sisters married and established their own lives. However, Florine, her sisters Carrie and Ettie, and their mother formed an inseparable quartet. The daughters were educated exclusively by private tutors, first in the United States and then in Europe, where the four women lived from 1900 until the outset of World War I. Florine took to art, studying painting under Kenyon Cox and Robert Henri at the Art Students League in New York, as well as under various painters in Germany. Upon settling in New York, the four shared a luxurious apartment on the Upper West Side, only nine blocks from the Arensbergs. Like the Arensbergs, the Stettheimers often entertained, hosting salons for many prominent artists, writers, and thinkers of the day, including Duchamp and Picabia.

Florine painted throughout her life, and her canvases reflect the grandeur and ceremony of the carefully constructed environment in which she lived. She depicted her personal experience, which included the glamour and excitement of New York, the lush fields and gardens of the outlying areas, and the members of the circle in which she traveled. Her artistic style was as sumptuous and posh as her subject matter: delicate figures, abundant floral arrangements, and fancy soirees, all painted with swirling flourishes in pastel and candied colors. In her portraits she followed the Dada practice of using objects to elucidate the subject's personality, attributes, and psychological state. She played with the laws of time and space by sometimes having her figures float in ethereal ways, warping the linear occurrence of events, or depicting a person more than once in the same canvas. She often constructed special frames for her paintings to extend their subjects beyond the borders of the canvas.

In 1916, Stettheimer had her first one-artist show at the Knoedler Gallery in New York. The show was a critical disaster and not a single work sold. This experience so devastated her that she vowed never to exhibit or part with her work again. Although she allowed an occasional work to be included in group exhibitions, and eventually renounced her desire to be buried with her paintings, she remained very attached to her creations. Because she did not have to rely on sales to support herself, Stettheimer was able to avoid pressures from the commercial art world. Her fierce independence and disregard of artistic trends was shared by many of the Dada artists.

All four Stettheimer women remained in New York City until their deaths. Florine enjoyed a long and productive painting career until she died of cancer in 1944.

—L.R.

LOUISE ARENSBERG
(blushing):

I find it most helpful to decipher her anatomy. The polished bronze is so reflective you may miss parts of her face—see here. I see the neck here, what a long neck! And her round delicate shoulders.[41]

CHARLES DEMUTH
(dressed in a black suit with a plum scarf and hand-clocked French lisle socks):

Hmm. Lovely. But it reminds me more of something I saw the other night at the Lafayette Baths.[42]

HENRI-PIERRE ROCHÉ: *Le petit oiseau, le petit homme.*[43]

JEAN CROTTI: Not so *petit* this one. *On dirait une grosse pine.* [43A]

The Nephew blushes but summons up a knowing smile as he edges toward his Uncle Walter, who continues giving his art tour to the Dolly sisters. He points to Duchamp's In Advance of the Broken Arm.

WALTER ARENSBERG: Here we have what Marcel calls a readymade.

KATHERINE DREIER
(her blonde hair piled atop her head, corseted, wearing the dress of a clubwoman):

Only you, Marcel, would have the spiritual sensitiveness to find *this* shovel. The key to the spiritual world beyond us. The prophet—it is *you*, Marcel.

WILLIAM CARLOS WILLIAMS
(approaching, reticently):[44]

I just want to tell you, Monsieur Duchamp, that I have looked at your works a great deal and I *like* them.

MARCEL DUCHAMP
(pauses, looks Williams evenly in the eye): Do you?

WILLIAM CARLOS WILLIAMS
(looking humiliated, sighing, to himself): You're all so damned sophisticated.[45]

HENRI-PIERRE ROCHÉ: Marcel, *you* are our victorious one, our young Napoleon, like Alexander the Great as a young man, like the Hermes of Praxiteles.[46]

MARCEL DUCHAMP: Come now. It's only a snow shovel that I found in a hardware store on Columbus Avenue.

41
When asked about Brancusi's sculpture, Louise Arensberg was known to ignore its phallic appearance by treating it as a portrait with identifiable anatomical features.

42
The Lafayette Baths was a sexual gathering place for men, raided by the police in 1916, and the subject of several homoerotic paintings by Charles Demuth, beginning in 1916.

43
Le petit oiseau (literally "the little bird") is a childish expression for penis; *petit homme* and *petit femme* were Roché's favored words for male and female sex organs (Francis Naumann noted this on examining Roché's journals at the Harry Ransom Humanities Research Center, University of Texas, Austin).

43A.
Translation: "It looks like a big cock."

44
William Carlos Williams (1883-1963) was a prominent poet who emphasized the importance of writing in the American language; he came into the Arensberg circle via the little magazine *Others* (1915–19), initially financed by Walter Arensberg and edited by Alfred Kreymborg.

45
This incident is recounted in William Carlos Williams, *The Autobiography of William Carlos Williams* (New York: Random House, 1951), p. 137.

46
Roché compared Duchamp to all these figures. Roché called Duchamp Victor (informalized to Totor; thus on the cover of the second issue of *The Blind Man* there appears above the title: P [for Pierre] B [for Beatrice] T [for Totor]) and in 1957 wrote a *roman à clef* about Duchamp, called *Victor*.

Charles Demuth (1883-1935)

Charles Demuth was born and raised in Lancaster, Pennsylvania, studying at local schools and with private tutors until he left home for Philadelphia. There he studied at the Drexel Institute (1901-07) and the Pennsylvania Academy of the Fine Arts (1905-11). During his studies, he made several trips to Europe, including a two-year stay in Paris between 1912 and 1914, where he attended the Académies Julian, Moderne, and Colarossi. In Paris he met such figures as Gertrude Stein and Alice Toklas and, upon returning to the United States, Eugene O'Neill. Through contacts such as these, Demuth created many book illustrations and maintained close connections with the literary and theater worlds throughout his career.

From 1915 until his death, Demuth divided his time between New York and Lancaster, and his work reflected both locations in subject matter and imagery. In New York, he was surrounded by such cosmopolitan figures as Duchamp and Picabia, and his work was showcased in multiple exhibitions at the Charles Daniel Gallery and at Alfred Stieglitz's galleries, including 291, Intimate Gallery, and An American Place. Scenes of New York nightlife, including cafés, clubs, and vaudeville, made their way into his work. In Lancaster, he depicted the factories and grain elevators of that industrial town. His landscapes, whether city or country, contained architectural forms that reflected the explosion of technology and industry in the United States, executed in a style that combined European Cubism and Futurism with decidedly American abstraction.

Although Demuth was a central figure in the so-called Stieglitz circle, he was in contact with the Dadaists and acknowledged their influence. Beginning in 1923, he created a series of portraits that represent their subjects with objects, letters, and sometimes numbers, related to the portraits by de Zayas and Picabia. Demuth indicated that he intended to do such a portrait of his good friend Duchamp, but never executed it. He traveled with Albert Gleizes, owned photographs by Man Ray, and once said of Duchamp, "a great painter. The big glass thing, I think, is still the great picture of our time." He also gave some of his works witty and ironic titles in the style of the Dadaists.

Because of the wealth of his family and the positive reception of his work, Demuth was always financially comfortable. He did not enjoy good health, however, starting with a childhood accident that forced him to walk with a cane for the rest of his life. He developed severe diabetes in 1921 and later tuberculosis, which greatly slowed what previously had been prolific artistic production. After years of chronic illness, he died in his bedroom in Lancaster in 1935.

—L.R.

KATHERINE DREIER: The average eye is too untrained to notice a difference in snow shovels. This one ended in being just the *right* snow shovel.[47]

47
Katherine Dreier, *Western Art and the New Era* (New York: Brentano's, 1923), pp. 70–71.

MARCEL DUCHAMP: *Cela n'a pas d'importance.*

WALTER ARENSBERG: People arc always asking me to explain the *Nude Descending a Staircase.*

JENNY DOLLY: An explosion in a shingle factory!

ROSZIKA DOLLY: An orderly heap of broken violins!

JENNY DOLLY: A lot of disused golf clubs![48]

48
All of these were published descriptions of *Nude Descending a Staircase.*

ALLEN NORTON
(his head popping up from the chess game with Elmer Ernest Southard):
Walter's Room.
Where I saw Time in the Nude.[49]

49
Norton, "Walter's Room," p. 20.

MARCEL DUCHAMP: It is idle to explain it. I do *not* explain it. It is, after all, the fourth dimension.[50] *Cela n'a pas d'importance.*

50
Duchamp, in Elmer Ernest Southard's "Mlle. De L'escalier," 1916, in Frederick Gay, *The Open Mind: Elmer Ernest Southard 1876–1920* (Chicago: Normandie House, 1938), p. 316.

KATHERINE DREIER: It is a rare combination, Marcel, to have originality of so high a grade as yours, combined with such strength of character and spiritual sensitiveness.[51] That is the guarantee of your real bigness.[52] *(She tentatively places a heavy hand on his shoulder.)*

51
Dreier to Marcel Duchamp, April 13, 1917, quoted in Naumann, *New York Dada*, p. 156.

52
Dreier to William Glackens, April 26, 1917, quoted in Naumann, *New York Dada*, p. 157.

ELMER ERNEST SOUTHARD[53]
(who rises from his chess game with Allen Norton to take over the discussion):
Cubism represents the approach to beauty though ugliness. True beauty can come through the insane and through the psychopathic. And thus, perhaps, Marcel, you are a schizophrenic in your art. But as you say, *Cela n'a pas d'importance.* I have developed my scheme for the Ecstasies of Experience and I have found four distinct and logical types. They move up from the Religious and the Amorous to the Inventive, and at the peak is the Artistic. It is through the Artistic that you have found the door to the greater emotional experiences of life.[54] But there you are, an artist, and me an alienist. What do we know of life? We are both hopeless analysts.[55]

53
Neuropathologist Elmer Ernest Southard (1876–1920) knew Walter Arensberg at Harvard, where he was a master at chess. In his study of the mind, Southard posited that artists could be analyzed on the basis of the shapes they painted. At the Arensbergs he enjoyed analyzing dreams.

55
From "Mlle. De L'Escalier," in Gay, *The Open Mind*, p. 316.

54
Based on Southard's theories developed in the late 1910s, described in Gay, *The Open Mind*, pp. 248–49.

Francis Picabia (1879–1953)

Born in Paris to a Spanish father and French mother, Francis Picabia studied at the École des Beaux-Arts and the École des Arts Décoratifs. He took an early interest in Impressionism, furthered by studying under Pissarro in 1898, and later in Neo-Impressionism and Fauvism. After being introduced to Cubism, his work took on a more structured and volumetric appearance. This new work was presented in New York in 1913 both at the Armory Show and at his first one-artist exhibition, mounted by Alfred Stieglitz at 291. Picabia's trip to New York that year must have made quite an impact because in 1915, while serving with the French Army in Havana, he deserted and settled in New York.

In New York, Picabia reestablished previous associations with Stieglitz, Marius de Zayas, and Marcel Duchamp and met other artists at the home of the Arensbergs. These associations, combined with the aesthetic of the technologically advanced city, led to the development of Picabia's machinist style. Wheels, gears, spark plugs, cameras, light bulbs, and pistols became subject matter and inspiration. Picabia believed that New Yorkers were best equipped to relate to his machine-influenced style: "The Spirit of New York is so elusive, so magnificent and so tremendously atmospheric—while the city in itself is so concrete...You New Yorkers can readily understand me...Your New York is the Cubist, Futurist City: with its architecture, its life, its spirit, it expresses modern thought...Since everything here is so extraordinarily modern, you will understand the sketches and studies I have done since I arrived in New York, because they express the spirit of New York as I see it...."

Picabia's work was reproduced in the pages of *291* and *Camera Work* and exhibited at de Zayas' Modern Gallery. Critics writing on Dada seemed to single out Picabia for the greatest amount of commentary, and images of his work made the newspapers. Picabia enjoyed his high profile and enthusiastically granted interviews, often speaking out in a controversial manner. He viewed art as an avenue for the exchange of ideas, and communication. The influence of his work on American artists, including members of the Dada and Stieglitz circles and the Precisionists, is immeasurable.

Picabia also played a key role in transmitting the discourse of Dada to the movement's international capitals. He published *391*, which continued the work of Stieglitz's *291*, first in Barcelona and New York in 1916–17 and then in Zurich in 1919. He collaborated with Tristan Tzara, the father of the Dada movement in Europe, and was active in Dada affairs in Paris after his return to that city in 1919. Disagreements among the members of the group eventually led to the dissolution of Dada, and Picabia relocated to the south of France in the mid-1920s. About twenty years later, he returned to Paris, where he lived out the remainder of his life. He continued to paint throughout these years, although his style went through radical transformations.

—*L.R.*

Jean Crotti (1878–1958)

Born in the French-speaking part of Switzerland, Jean Crotti first studied art at the Schule für dekorative Künste in Munich in 1896. A brief apprenticeship with a theater set designer in Marseilles in 1900 was followed by a year of study at the Académie Julian in Paris. In the early years of the century, Crotti's paintings revealed the influence of the Neo-Impressionists and the Fauves and, beginning around 1911, that of the Cubists. Although Crotti continued to live and work in Paris for many years, he later expressed great dissatisfaction with this period of his life and artistic production.

Crotti moved to New York City to escape the war in 1915 and soon met Duchamp and Picabia, who had arrived that same year. Crotti and Duchamp shared a studio and attended the Arensberg salon together, and it wasn't long before Crotti's great admiration for his friend manifested itself in his work. In what he later described as a second birth, Crotti began making work unlike anything he had previously produced. He branched out from painting and began to fabricate constructions of metal, glass, and found objects. Notable among these is a now-lost portrait of Duchamp in wire and glass (1915)—materials inspired by his association with Duchamp. Twenty-two of these new pieces were presented at the Montross Gallery in 1916 in a group show of the works of Crotti, Duchamp, Albert Gleizes, and Jean Metzinger. The controversial exhibition sparked a critical response that ranged from horror to celebration.

In 1916, Crotti returned to Paris and fell in love with Duchamp's sister, Suzanne, and in 1919 they were married. Crotti and his new wife, also an artist, remained in Paris and maintained frequent contact with Duchamp, receiving periodic updates on his work. They also spent much time with Picabia, who returned to Paris in 1919. Although Crotti and Suzanne Duchamp remained in touch with the Dadaists in Paris, they did not proclaim themselves part of the movement until 1921, when they signed a Dada manifesto and officially participated in Dada events.

Soon afterwards, however, Crotti turned away from Dada in favor of Tabu, an artistic/philosophical movement that he founded in an effort to address such elusive concepts as mystery and infinity. Although his work took a new direction, it was born of Dada's freedom and irreverence, to which Crotti made a short-lived but passionate contribution.

—L.R.

John Covert (1882–1960)

The painter John Covert was by all accounts an introverted and sensitive man. Raised in Pittsburgh, most of his childhood was spent alone with his father; his mother was institutionalized with a nervous disorder shortly after his birth, and his younger brother died when he was seven. In high school, Covert showed more of a penchant for mathematics than art, but in 1908 or 1909, he went to Munich and studied painting at the Akademie der bildenden Künste until 1912. He then settled in Paris for two years, exhibiting at the Salon of the Société des Artistes Français in 1914, but had no contact with French avant-garde circles, perhaps due to his introverted nature. "I didn't get to know a modern artist, or see a modern show, or even meet the Steins. It's incredible, I must have lived in armor." In 1914, the outbreak of World War I forced Covert to leave Paris; after a brief stay in Pittsburgh, where he exhibited his work for the second time, he moved to New York City in 1915.

Covert received his first exposure to the avant-garde in New York through his cousin Walter Arensberg, who introduced him to the members of the Dada circle. He was quickly absorbed into this group, and became a co-founder and secretary of the Society of Independent Artists in 1917. The innovations of the Dadaists forced him to reevaluate his own work, which seemed academic and staid in comparison. By 1919, he was making paintings in his mature style: a conflation of Cubism, machinist forms, and his longtime interest in mathematics and geometry. These unique works had three-dimensional objects such as wood, tacks, and string affixed directly to the canvas. His unusual use of materials was praised by the critic Henry McBride after Covert's first and only one-artist show at the de Zayas Gallery in 1920, although subsequent critical attention was rare. His work was shown the following year at the Pennsylvania Academy of the Fine Arts and the galleries of the Société Anonyme.

In 1921, the Arensbergs moved to Los Angeles, and many of the Dadaists, including Duchamp, Covert's close friend, left for Europe. The dissolution of the Dada circle had a devastating effect on Covert, who had grown dependent on the Dadaists' emotional and financial support. In 1923, he petitioned many wealthy collectors for patronage, but to no avail. In August of that year, he abandoned painting and took a job working for his cousin Frank Arensberg at the Vesuvius Crucible Company near Pittsburgh. Although Covert did not produce any more work, he did see his paintings included in a few exhibitions during the remaining years of his life.

—L.R.

The Nephew, afraid that he is in over his head, seeks company beneath a balcony, where Alfred Kreymborg, Mina Loy, and
William Carlos Williams are reminiscing about last month's production of Kreymborg's Lima Beans,
which co-starred Loy and Williams and was produced by the Provincetown Players.[56]
(Kreymborg is wearing baggy pants, a coffee-stained shirt, a whimsically patterned bowtie and a thick-lensed pince-nez
on a knotted black cord. Williams steals glances at the pale skin at the nape of Loy's neck.)

MINA LOY: I think our *Lima Beans* was lovely. But I'm afraid, Alfred, that your stylized verse is too fantastic for the Provincetown Players.

ALFRED KREYMBORG: I counted sixteen curtain calls! And only twelve of them were for your décolletage.

MINA LOY: But the modernity of the Provincetown Players goes no further than an up-to-the-minute fad. Like Freudism's new parlor game, psyching each other. Or making schoolboy jokes about modern art. Or the New Relations or the Higher Sex or varietism.[57]

WILLIAM CARLOS WILLIAMS: I believe, Mina, that the term this week is Psychic Harmony.

MINA LOY: Harmony between the sexes is unimaginable. The only point at which the interests of the sexes merge is the sexual embrace.[58] *(She glances at Arthur Cravan with a mixture of doubt and longing as he catches her eye.)* Before I sailed here I wrote Carl Van Vechten, "Do you think there is a man in America I *could* love?"[59] That one for instance *(nodding at Cravan, who stands with an impassive stare)*, who could fall in love with *that*? He looks respectable and square. Does that marble stare suggest a Grecian statue—or a farmer? Or a husband?[60] But of course, the advantages of marriage are too ridiculously ample compared to all other trades.[61] Before long, I expect, the Provincetown Players will do a play about the New Woman. What is it they call them down at the Liberal Club, Heterodites?[62]

WILLIAM CARLOS WILLIAMS: I understand from the *New York Evening Sun* that it is *you*, Mina, you who exemplifies the Modern Woman. As the reporter put it, "This woman is half way through the door into Tomorrow."[63]

56
Lima Beans by Alfred Kreymborg, opened at the Provincetown Players on December 1, 1916. Alfred Kreymborg (1883–1966) was a poet, best known as the editor of several little magazines: *Glebe* (1913–14), *Others* (1915–19), and *Broom*. He came into the Arensberg circle via *Others*, which was financed by Walter Arensberg.

57
These were subjects for early plays produced by the Provincetown Players. (Susan Glaspell's *Suppressed Desires* was a comedy about psychoanalysis, Wilbur Daniel Steele's *Change Your Style* satirized modern art, Neith Boyce's *Enemies* was a two-character play about modern relationships.) The terms for relationships were coined during the 1910s and were widely in use in Greenwich Village.

58
Mina Loy, "Feminist Manifesto," in Loy, *The Last Lunar Baedeker*, ed. Roger C. Conover (Highlands, North Carolina: The Jargon Society, 1982), p. 269.

59
Mina Loy to Carl Van Vechten, quoted in Naumann, *New York Dada*, p. 166.

60
Although Mina Loy initially rejected Arthur Cravan's advances, she fell in love with him a few months later, married him in 1919, and remained with him until he disappeared in Mexico that same year. A decade later, when *The Little Review's* "Confession-Questionnaire" asked, "What has been the happiest moment of your life?" Loy responded, "Every

63
The article that identified Mina Loy as the Modern Woman was "Do You Strive to Capture the Symbols of Your Reactions? If Not You Are Quite Old-Fashioned," *New York Evening Sun*, February 17, 1917.

dances, lectures, informal theater, art exhibitions, playing poker, and hanging out by the electric pianola were common activities. Heterodites is a reference to the Heterodoxy Club, founded in 1912, as a gathering place for women who espoused feminism.

61
Loy, "Feminist Manifesto," p. 270.

62
The Liberal Club moved to 137 MacDougal Street in November 1913 and called itself "A Meeting Place for Those Interested in New Ideas." Formal discussions,

moment I spent with Arthur Cravan." To "Your unhappiest?" Loy responded, "The rest of the time." Quotations drawn from Loy's "Colossus," as edited by Roger C. Conover, in Rudolf E. Kuenzli, *New York Dada* (New York: Willis Locker & Owen, 1986), p. 104.

Morton Livingston Schamberg (1881–1918)

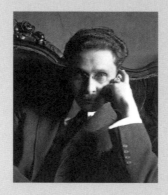

Born and raised in Philadelphia, Morton Schamberg received a degree in architecture from the University of Pennsylvania before taking up painting at the Pennsylvania Academy of the Fine Arts under William Merritt Chase. Between 1903 and 1906, Schamberg accompanied Chase on class trips to Holland, England, and Spain. After his studies, Schamberg returned to Europe to live and work in Paris from 1906 to 1907. The following year he took an extended trip to France and Italy, spending much of his time with Charles Sheeler, his friend and former classmate at the Pennsylvania Academy. Schamberg returned to Philadelphia in 1910 with a passion for modernism. There he helped introduce the avant-garde to America by publishing articles and organizing exhibitions.

Schamberg's travels in Europe piqued his interest in the luminosity of Impressionism and later in early Renaissance precision. Contact with the Steins and their circle in Paris exposed him to the work of Picasso, Braque, Matisse, and the Fauves. The influence of his European contemporaries and of the work displayed at the 1913 Armory Show found their way into Schamberg's paintings, which went through several stages of development. At various times, Schamberg experimented with the loose brushstrokes of the Impressionists, the intense colors of the Fauves, and the fractured structures of Cubism. Beginning in 1915, he turned to machinist imagery, executed with great precision. This transformation may have been influenced by the machinist works of Picabia and Duchamp and the paintings and photographs of Sheeler, with whom he kept in close contact. Schamberg's own interest in photography and his friendship with Paul Strand also may have played a role.

Schamberg's mature compositions show machines or machine parts, enlarged to fill the canvas. With the exception of *Telephone* (1916), the subjects of these works are not recognizable objects; although the forms were copied from actual machinery, Schamberg abstracted them into structures of flat, geometric shapes. These structures betray the artist's early interest in architecture. Schamberg also maintained a taste for vivid colors, hence his acid yellow and turquoise blue palette.

Schamberg executed approximately thirty pastels and fewer than five paintings with machinist imagery over a three-year period. In 1918, an outbreak of influenza in Philadelphia claimed Schamberg's life, cutting short the career of this promising American Dadaist.

—*L.R.*

MINA LOY: We modern women will have to leave off looking to men to find out what we are *not*. As conditions are at present constituted we have the choice between Parasitism, Prostitution, or Negation. As a beginning I suggest the unconditional surgical destruction of virginity at puberty. So much for the man-made bogey of virtue.[64]

BEATRICE WOOD: Yes, yes. One goes through life with the idea of virginity, instead of sleeping with men when they have the desire. The more we exist outside the system, the more creative we are.[65]

Alfred Kreymborg drops his pince-nez.

ALFRED KREYMBORG *(fumbling for words):* The more important question is: can the Provincetown Players do plays that are modern in *style*? Hmmm. It was lovely last month to beat time with my pencil so you got the rhythms of *vers libre*. Against Zorach's checkered backdrop. It looked like a *Rogue* cover.[66]

MINA LOY: Farewell dear *Rogue*! "The cigarette of literature" and a necessary evil.[67] Will we see your likes again?

ALFRED KREYMBORG: As for really modern theater, I think that we'll have to wait until the free-versers write the plays instead of the Greenwich Villagers. Perhaps they love too much their bohemian stage set, their little green window boxes and their orange and black decor. I was in the Samovar the other night and Bobby Edwards sang a new verse to that never-ending song of his.[68] You could barely hear him over his ukelele, but the song stuck in my mind because it was so true

(Kreymborg sings):

Way down south in Greenwich Village
Came a bunch of Uptown swillage
Folks from Lenox subway stations
Come with lurid expectations[69]

64
Adapted from Loy, "Feminist Manifesto," pp. 269–71.

65
Wood, *I Shock Myself*, p. 35, originally published in *Pour Toi*.

66
Rogue had a checkered cover, and the set designed by William Zorach consisted of checkerboard screens.

67
Rogue was published in two runs, from March 1915 to September 1915, and in three issues in a larger format, from September 1916 to December 1916. Its motto was "The cigarette of literature" and William Reedy of the *St. Louis Mirror* called it "a necessary evil."

68
The Samovar, 148 West 4th Street, run by Nanni Bailey, served as the unofficial meeting place of the Provincetown Players and inspired the verse, "Samovars twinkle, ukeleles tinkle, Villagers drinkel." Bobby Edwards was known as the Village troubadour, and he exemplified the breed of eccentric marketers of the Village's bohemian ethos, along with Guido Bruno and Tiny Tim.

69
From Bobby Edwards' *The Village Epic*, of which many verses were composed and sung in Village tearooms. The first verses were improvised at Polly's, the first of the Village tearooms, c. 1914.

Katherine Dreier (1877–1952)

Katherine Dreier was born into a family of wealthy German immigrants living in Brooklyn, New York. For generations her family had emphasized the importance of philanthropy and work in the community, a philosophy that drove her tireless patronage of art. Although she painted, it was as a collector, writer, and exhibition organizer that Dreier made her greatest contribution to the world of art.

Dreier was exposed to European movements in art through extensive travel and her study of painting in Paris, London, and Munich. Her work was included in the Armory Show of 1913, an exhibition that heightened her awareness of the avant-garde and its chilly critical reception in America. Committed to the advocacy of this new art, she became involved with the Society of Independent Artists in 1916. It was through her efforts with this organization that she became acquainted with the Arensbergs and their circle, most notably Marcel Duchamp. For the remainder of her life, Dreier maintained a close friendship with Duchamp, all the while purchasing and championing his art—including his last painting (*Tu m'*, 1918), which Dreier commissioned for her library.

Dreier enlisted Duchamp—who in turn recruited Man Ray—to help found an organization that would promote modernism in America. The result was the Société Anonyme, established in 1920. The organization built an art collection and sponsored lectures and exhibitions, the largest of which was held at The Brooklyn Museum in 1926-27. Until its dissolution in 1951, the Société Anonyme promoted many modernist movements, including Dadaism, Cubism, Futurism, Constructivism, and Russian Expressionism.

Despite Dreier's association with Dadaism, she possessed much more traditional views on art than most people within the Dada circle. Her reading of Dada differed from those who produced it; specifically, she was resistant to the Dada rejection of formal aesthetics. This is evidenced in her book *Western Art and the New Era* (1923), wherein she criticizes Dada for failing to adhere to more traditional uses of media. In their conceptual concerns, she believed, "their message belongs more to the art of literature than painting." During the early 1920s, Dreier began to steer away from Dadaism and become increasingly interested in the abstractions and teachings of Kandinsky, to which she would remain committed for the rest of her life.

—*L.R.*

WILLIAM CARLOS WILLIAMS: Just last week Marcel Duchamp and his friends climbed to the top of the Washington Arch and declared the Village "a Free Republic, Independent of Uptown."[70] But I fear the Village has instead become a Republic of Tearooms, Dependent on Uptown.[71]

The Nephew, realizing that he is perhaps regarded as one of the Uptown swillage, loosens his tie and heads toward the piano, where a group is earnestly discussing the system of juried art exhibitions. Among the discussants are Walter Arensberg, Walter Pach, and art critic Henry McBride.

WALTER PACH
(twisting his long waxed mustache): That show at the Academy of Design puts the nail in the coffin—the salon jury system is dead. Not even the *members* go!

HENRY McBRIDE[72]
(wearing a tailored Bond Street suit that fits his tall, erect frame): The Academy's show is so tepid that not a ripple can be detected on the intellectual life of the city. Perhaps the Academicians should be compelled by law to go to their own show or else resign and become Independents.[73] How is the planning coming along?

WALTER PACH: John Quinn drafted the legal papers last month, Gertrude Vanderbilt Whitney has just joined us, and we sent out announcements two weeks ago. Envelopes are coming back with the *oddest* postmarks.

HENRY McBRIDE: Young artists have been enfranchised. History is in the making. Breathe deeply of the air. Does not there seem to be already more ozone?[74]

WALTER ARENSBERG: Will this be like the Armory Show? Walter, you and Arthur B. Davies and Walt Kuhn did a fine job, yes. But it can hardly be counted an experiment in democracy

WALTER PACH: Well, there *are* limits. As John Quinn says, we don't want "democracy run riot."[75]

70
On January 23, 1917, Duchamp, John Sloan, and four others climbed a secret stairway within the Washington Arch and declared Greenwich Village independent.

71
Pioneered in 1913 by Polly's, bohemian tearooms had by 1917 become a widespread fad. They provided a chief means of employment for Village residents and, along with the Village costume balls, a vehicle for extracting money from uptown visitors.

72
Henry McBride (1867–1962) began writing art criticism for the *New York Sun* around the time of the Armory Show and became the critic most consistently supportive of modern art. He also served as the art critic for *The Dial* (under the stewardship of Scofield Thayer and Marianne Moore) and editor of *Creative Art*.

73
Henry McBride, *New York Sun*, January 21, 1917.

74
Ibid.

75
John Quinn, draft for a circular for the Société Anonyme; quoted in Steven Watson, *Strange Bedfellows: The First American Avant-Garde* (New York: Abbeville Press, 1991), p. 312.

Juliette Roche (1884–1980)

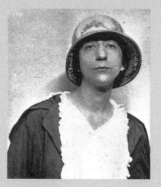

Born the daughter of a wealthy and powerful member of the French government, Juliette Roche studied art in Paris at the Académie Ranson and under several painters, including Odilon Redon. During the years just before World War I, she moved easily in Parisian artistic and literary circles. One of the many figures she befriended was Albert Gleizes, the well-known Cubist painter. In 1914, Gleizes was drafted into the French army and stationed at Toul. The two artists corresponded frequently and fell in love. Roche's father used his influence to get Gleizes an honorable discharge. In 1915, Gleizes and Roche were married and set sail for New York City on their honeymoon.

Arriving in the port of New York was a momentous event which the couple recorded—Gleizes through his art and Roche in her extensive journals. In an interview for the *New York Tribune* printed one month after their arrival, Roche declared, "Your city is beautiful! The lights, electric signs, most nourishing to artists....We are greatly inspired to work here." The couple was met almost immediately after their arrival by Duchamp, who introduced them into the Arensberg circle by hosting a gala dinner in their honor at the Brevoort Hotel. According to Roche's journals, this event was attended by the Arensbergs, Man Ray, Joseph Stella, and the Stettheimer sisters, among others.

It may have been this evening, or other subsequent evenings like it, that inspired Roche in 1917 to create a visual poem entitled *Brevoort*. This Dadaesque poem presents bits of overheard conversations in French and English, arranged on the page to form geometric shapes. These phrases, taken out of context, are nonsensical, yet reflect the topics discussed among the members of the avant-garde. The work shows the influence of Cubism's fragmentation of form as well as Dada abstracted portraits, which combined images with mathematical equations or objects to portray a personality.

After about a year, Roche and Gleizes began to feel that New York was not living up to their expectations. The technology which had captivated Roche upon her arrival now seemed threatening, and led her to write a long narrative entitled "The Mineralization of Dudley Craving Mac Adam" in 1918. The title character of this fable is an amalgam of people Roche met in New York, including Duchamp and Arensberg. Mac Adam wanders the streets of Manhattan, encountering bizarre sights and sounds which eventually drive him insane. The story concludes when he returns to his room and commits suicide by swallowing a key, causing his whole body to turn to metal.

Roche and her husband left the "mineralizing" effects of the city for the more rustic suburb of Pelham, New York. Roche's longing for a more pastoral existence is evident in her paintings of 1915-19, romantic scenes of carefree figures romping in idyllic settings. Pelham was apparently not satisfactory for the couple, as they returned to Paris in 1919. In 1920, Roche gathered her poetic writings and published them in a book, *Demi Cercle.* She continued to paint, maintaining a studio in the south of France until her death in 1980 at the age of ninety-eight.

—*L.R.*

WALTER ARENSBERG: Why not? Perhaps our simple rule—six dollars to exhibit two paintings—can be the tie between American artists and European artists. No more commercial tricks. Perhaps new audiences will vindicate our principle.

HENRY McBRIDE: The principle of "No jury, no prizes" will not be vindicated by an uproarious excitement upon the part of the public over the affair, nor by impressive gate receipts and picture sales. It will be vindicated by only one thing, the future.[76]

WALTER PACH
(dismissively): Of course, but where does *taste* come in?
Do we want the future to see us as a random attic, full of junk?
In the name of freedom we might find ourselves exhibiting
family portraits and birdbaths and millinery dummies
and batik panels and artificial flower arrangements.[77]

WALTER ARENSBERG: Or the kitchen sink!

MARCEL DUCHAMP
(with a secret smile): Or perhaps something for the bathroom.

At this point, the Nephew brightens up, feeling that he has understood something from the party.
He ventures his first words of the evening:

THE NEPHEW: *Cela*
n'a pas
d'importance!

76
Henry McBride, *New York Sun*, April 15, 1917.

77
All of these, except the kitchen sink, were among the twelve hundred works shown at the "First Annual Exhibition of the Society of Independents," which opened April 10, 1917, at the Grand Central Palace.

Stuart Davis (1894–1964)

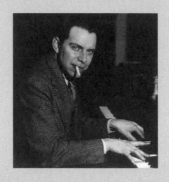

Stuart Davis, whose parents were both artists, took to art at a young age and studied under Robert Henri in New York early in the century. In 1913 John Sloan, Davis' mentor, encouraged him to submit his work to *The Masses.* For three years, he produced illustrations, including covers, for the politically liberal magazine. Although Davis' art, as well as his social and political beliefs, were initially shaped by the Ashcan painters, his work underwent a transformation after the 1913 Armory Show, where he was one of the youngest artists to be included. The avant-garde art he saw there eventually led him to experiment with Cubism and collage techniques. Soon after, he developed an interest in avant-garde poets such as Guillaume Apollinaire and William Carlos Williams, whose writing Davis characterized as "clash and sequence."

In the early twenties, Davis created a series of works on paper which were inspired by the machinist works of Picabia. He was preoccupied with structures such as the elevated trains and buildings of urban New York. "Modern art," he wrote, "is a reflection of the advance of modern industrial technology...the most important, in fact the only important part of the subject matter of modern art [is] the materialistic esthetic corresponding to modern industrial technology..."

Davis' experiments in collage were very likely influenced by Man Ray and Joseph Stella, who were taking the technique far beyond the precedents set by Picasso and Braque in France. These New York artists, led by Duchamp's example, presented items such as tin cans and crumpled papers as collaged works of art. Davis expressed his admiration for the Dada act of giving intellectual and aesthetic precedence to found objects. The Dadaists' irreverent and radical experimentation with materials and forms led Davis to ask, "Is it possible that [they] are operating on the aesthetic emotion as a surgeon does on a diseased organ?"

In 1929, Davis returned from a nine-month stay in Paris and began to look at New York with renewed interest. His mature style of flat planes of color and pulsing lines was greatly influenced by the energy of urban life. He enjoyed a long and illustrious career, spending most of the remainder of his life in New York, where he died in 1964.

—L.R.

Arthur G. Dove (1880–1946)

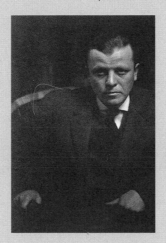

Born in upstate New York, Arthur Dove began painting at the age of nine. While at Cornell University, studying law according to his father's wishes, he received his first formal instruction in art. His love for painting soon turned into full-time devotion and upon graduation he moved to New York, becoming a successful illustrator for magazines such as *The Saturday Evening Post*. In 1907, he went to France, where he encountered the art of Matisse and Cézanne, which would greatly influence his mature style. After returning to New York, Dove was noticed by Stieglitz, who exhibited his work on many occasions, beginning with his first one-artist show in 1912. Dove became a permanent fixture in Stieglitz's stable of artists. The two would remain friends and mutual champions for more than thirty years. Dove also showed at the Forum Exhibition in 1916 and at the Independents Exhibition in 1917.

Although best known for his paintings and pastels, between 1924 and 1928 Dove produced assemblages. These works went beyond collage in their use of found objects, including chicken bones and fur, unusual elements that compelled Katherine Dreier in 1926 to describe him as "the only American Dadaist." Although not all these constructions were satirical, some possess a Dada-like humor which extends beyond their materials, including parody of the art establishment. Dove also produced abstracted portraits in assemblage, after those by de Zayas, Picabia, and others. Having attended the Arensberg salon and exhibitions at 291, he was undoubtedly familiar with the work produced by those artists. Stieglitz, quick to recognize the Dada quality of Dove's constructions, exclaimed, "Wait until Duchamp sees them!"

Despite Dove's associations with the New York art world, he lived elsewhere for most of his life. From 1910 until his death, he alternated between living on farms, boats, and at yacht clubs in New York State and Connecticut, all the while supplementing his income by farming and fishing. Not surprisingly, the majority of Dove's work reflects the forms of nature which surrounded and sustained him.

—*L.R.*

ANARCHY, POLITICS, *and* DADA

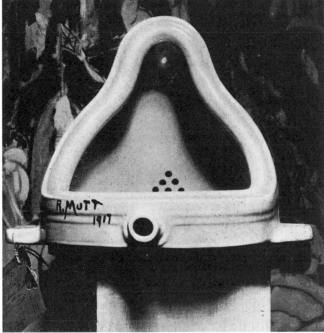

ALFRED STIEGLITZ, MARCEL DUCHAMP, FOUNTAIN, 1917

This article is dedicated to Paul Avrich, whose singular struggle to preserve the scattered and neglected documents of the early twentieth-century anarchist movement in Russia and America is only matched by his impeccable scholarship; he has pointed the way for those of us who follow.

1
Benjamin R. Tucker, *Benj. R. Tucker's Unique Catalogue of Advanced Literature: The Literature That Makes for Egoism in Philosophy, Anarchism in Politics, Iconoclasm in Art* (New York: Benjamin R. Tucker Bookshop, 1906). Stirner's book, *Der Einzige und sein Eigentum,* was originally published in 1845 and Tucker's English edition came out in 1907 (see note 19 below). On Stirner's life and career, see John Henry Mackay, *Max Stirner: Sein Leben und sein Werk* (Berlin: Schuster und Loeffler, 1898). On Tucker, see James J. Martin, *Men Against the State* (Colorado Springs, Colorado: Ralph Myles Publishers, 1963), pp. 202–78.

2
William A. Camfield, *Marcel Duchamp: Fountain* (Houston: The Menil Collection, 1989), chap. 1.

3
I would argue that Alfred Stieglitz paid homage to this idea in his photograph of Duchamp's *Fountain*, which he positioned in front of *The Warriors* (1913) by Marsden Hartley. The suggestion of a continuum between the Dadaists' revolt and earlier rebellions in the name of individualism could not be more explicit. The image was reproduced in the Dada magazine *The Blind Man,* 2 (May 1917) as "The Exhibit Refused by the Independents."

4
Manuel Komroff, "Art Notes," *New York Call,* December 6, 1914, p. 5.

5
H. Wayne Morgan, *Keepers of Culture: The Art-Thought of Kenyon Cox, Royal Cortissoz, and Frank Jewett Mather, Jr.* (Kent, Ohio: Kent State University Press, 1986), pp. 1–11.

6
Ibid., p. 49.

7
Constance H. Schwartz, "The Exhibition at Macbeth Gallery," in Constance H. Schwartz, *The Shock of Modernism in America,* exh. cat. (Roslyn Harbor, New York: Nassau County Museum of Art, 1984), pp. 49–51.

8
Robert Henri, "An Ideal Exhibition Scheme—The Official One a Failure," *Arts and Decoration,* 5 (December 1914), pp. 49–52, 76.

9
George Bellows, "Jury Duty," *The Masses,* 6 (April 1915), p. 10.

10
I am citing the Society's "Certificate of Incorporation." See Francis M. Naumann, *New York Dada 1915–23* (New York: Harry N. Abrams, 1994), p. 176.

11
Camfield, *Marcel Duchamp: Fountain,* p. 18.

"Egoism in Philosophy, Anarchism in Politics, Iconoclasm in Art": so the well-known American anarchist and individualist Benjamin Tucker, editor of the journal *Liberty* and publisher of the English edition of Max Stirner's anarchist manifesto, *The Ego and His Own,* summed up his ideology in 1906. Just over a decade later, in 1917, Marcel Duchamp's *Fountain* (p. 90) pushed "iconoclasm in art" to extremes that had been unimaginable in 1906.[1] In a single gesture, Duchamp broke with European modernism and all previous Western artistic traditions, creating a public scandal in the process.[2] But where we mark a break there is also a continuum. Prior to 1917, American anarchists carried out a sustained attack on artistic conventions and restrictive institutions in the name of unfettered artistic expression, which they equated with individual liberation. New York Dada took up this cause, revolting against "art" itself. This is the key to the politics of New York Dada: anarchist individualism forged an indivisible link between artistic innovation and art's negation.[3]

In 1914, the anarchist painter Manuel Komroff, reflecting on the flowering of American modernism in the wake of the 1913 Armory Show, wrote: "The Independent School of Art has not grown overnight, nor can its result be traced to the international exhibition. It has been a steady development from the Robert Henri style to its present day individualistic attitude."[4] Komroff had a point. It was Henri who, more than any other, worked to undermine the artistic establishment in America in the name of freedom of expression. At the turn of the century, a handful of academic art institutions, supported by juried shows and a phalanx of well-placed art critics, championed the notion of ideal beauty and high moral content in painting, while disparaging all other tendencies.[5] Kenyon Cox's *An Eclogue* (1890) epitomized the conservative ideal—clear and legible, with a classical theme garbed in allegory, his "pastoral dialogue" spoke to a select audience.[6]

Contrast this with Henri's rough, expressive portrait of a young working-class girl, *Cori Looking over the Back of a Chair* (1907). No wonder Henri encountered stiff resistance to his work and that of his students. Intransigence was so pronounced that in 1908 he and seven other like-minded artists decided to mount the first independent art exhibition in America, without president or jury, to challenge academic authority.[7] The success of this show, followed by the large "Independents" exhibition of 1910 and the famous Armory Show of 1913, inspired Henri to call for a permanent artist-organized exhibition space, free of juries and open to all, in 1914.[8] He was seconded by George Bellows, his most talented student, who condemned establishment art juries in the press and contributed a satirical sketch to the leftist magazine *The Masses,* which mocked the smug, clublike atmosphere of the mainstream art world.[9]

The rebels knew that innovative art could find a ready audience: all artists lacked was a venue to support that art. The formation of the Society of Independent Artists in 1916, with nominal exhibition fees and a mandate to "afford American and foreign artists an opportunity to exhibit their work independent of a jury," met this need.[10] The inaugural Society of Independents exhibition in April 1917 was intended as a showpiece for artists beholden to no juried aesthetic or institution. Fittingly, the Society's directorship brought together pre-Armory Show "independents"—William Glackens, Bellows, Rockwell Kent, and Maurice Prendergast—with the Dadaists and their supporters—Duchamp, Francis Picabia, Walter Pach, Katherine Dreier, Walter Arensberg, Morton Livingston Schamberg, John Covert, Man Ray, and Joseph Stella.[11]

What, then, were the *politics* of artistic individualism? Examining conservative criticism during these years, we find artistic independence persistently identified with "anarchy" and "revolution." The exhibitors of 1908 were labeled "revolutionists."[12] The Independents of 1910 were called "insurgents, anarchists, socialists, all the opponents to any form of government, to any method of discipline"; and the Armory Show moderns were pilloried as "anarchic hordes" intent on "disrupt[ing] and destroy[ing], not only art, but literature and society, too."[13]

In fact, conservative objections echoed artists' assertions. Henri, himself an anarchist, was quick to draw equations between freedom of expression in the arts and freedom from all forms of authority. Anarchist artists and critics, including Bellows, Emma Goldman, Margaret Anderson, Hippolyte Havel, Carl Zigrosser, Bayard Boyesen, Benjamin de Casseres, Man Ray, Adolf Wolff, Hutchins Hapgood, Komroff, Leonard Abbott, and others, made the same claim.[14] Reading art anarchically, they turned individualism in the arts, initially embodied in Henri's realism and eventually in the whole range of modernism, into a radical political praxis, liberating (and destroying) a hitherto sacrosanct sphere of cultural authoritarianism.[15]

Enter New York Dada. In early April 1917, Duchamp, intent on testing the Society of Independents' respect for an open forum, submitted *Fountain* for inclusion in its upcoming exhibition under the name "R. Mutt." Bellows protested vigorously, declaring that if *Fountain* were shown the Society would have to accept anything, even "horse manure glued to a canvas."[16] Against the censorship of art "in principle," the anarchist Bellows reverted to treating the controversial "art

12
William Innes Homer, *Robert Henri and His Circle* (Ithaca, New York: Cornell University Press, 1969), p. 145.

13
On the criticism of the 1910 Independents, see Homer, *Robert Henri and His Circle*, p. 154. Criticism of the Armory Show is discussed in Milton W. Brown, *The Story of the Armory Show*, 2nd ed. (New York: Abbeville Press, 1988), p. 167.

14
I will be discussing the art and art criticism of these and other anarchists in my Ph.D. dissertation, "The Culture of Revolt: Art and Anarchism in America, 1908–1920."

15
Indeed, on the eve of meeting Duchamp in the spring of 1915, Man Ray gave his rebellious artistic sensibility a decidedly ribald, Dadaistic turn. That winter he produced an ephemeral publication—*The Ridgefield Gazook*—which opened with a drawing of two copulating grasshoppers and went on to satirize anarchist Manuel Komroff's "Art

16
Bellows' objections were later recorded by Beatrice Wood. See Beatrice Wood, *I Shock Myself: The Autobiography of Beatrice Wood* (San Francisco: Chronicle Books, 1988), p. 29.

several other humor-oriented Man Ray productions from 1915–16, notably his *Self-Portrait* of 1916, have come to be viewed as "proto-Dadaist." See Paul Avrich, *The Modern School Movement: Anarchism and Education in the United States* (Princeton: Princeton University Press, 1980), pp. 159–60; and Naumann, *New York Dada 1915–23*, pp. 10, 76–83.

sheet: Adolf Wolff ("Adolf Lupo"), who later collaborated with Man Ray to produce the Dadaist magazine *TNT* (1919); Man Ray's companion, the *vers libre* poet Adon Lacroix ("Adon La"); Hippolyte Havel ("Hipp O'Havel"); and the Czech anarchist poet Joseph Kucera ("Mac Cucera"). All these people—Man Ray included—were part of New York's anarchist milieu. *The Ridgefield Gazook* and

Notes" with the heading "Art Motes" and a masturbatory ink splotch signed "Kumoff." The same publication featured a poem-illustration commemorating Arthur Caron, Charles Berg, and Carl Hanson, three New York anarchists who blew themselves up while preparing a bomb that was intended for John D. Rockefeller, Jr. Four other anarchists appeared in Man Ray's

17
Ibid.

18
Anonymous, "His Art Too
Crude for Independents,"
New York Herald, April 14,
1917, p. 6. Punning on
functionality, Duchamp posi-
tioned the urinal in such a
way that it could function
both as urinal and fountain,
though one would have
been ill-advised to try it out.

19
Stirner argued that the ego's
sole concern was "the self-
realization of values from
himself": hence the state,
which imposed moral and
societal values on the indi-
vidual, was the ego's
implacable enemy. So were
all forms of abstract thought,
divorced as they were from
the individual's corporal
being. He closes his book
with the statement: "Every
higher essence above me,
be it God, be it man, weak-
ens the feeling of my
uniqueness, and pales only
before the sun of this con-
sciousness....All things are
nothing to me." See Max
Stirner, *The Ego and His
Own*, trans. Steven T.
Byington (New York:
Benjamin R. Tucker
Bookshop, 1907), pp. 361,
366.

object" as merely a urinal, labeling it indecent.[17] The majority of the Society's directors agreed:
"The *Fountain* may be a very useful object in its place, but its place is not an art exhibition, and it is,
by no definition, a work of art."[18]

The irony is poignant: Duchamp's *Fountain* did depart from previous artistic standards, but
so had the work of Henri, Bellows, and many others over the past decade. Duchamp simply extend-
ed the artists' individualist revolt to a realm most were unprepared to confront, namely, the insti-
tution of "art" as such. What is more, Duchamp's motivations for doing so sprang from the same
source—anarchism—that had driven his iconoclastic predecessors.

In *The Ego and His Own*, Max Stirner condemned subservience to metaphysical concepts and
social norms, arguing they must be usurped by the will of each unique, self-determining, value-
creating ego.[19] Duchamp read Stirner's book in the summer of 1912, an event which marked his
"complete liberation."[20] Liberation from what, we may ask? Firstly, from the Bergsonian meta-
physics of Cubism and paintings such as the *Nude Descending a Staircase No. 2* (1912) (p. 35).[21] Duchamp
never painted another Cubist work; instead he became increasingly preoccupied with conceptual
productions that subordinated metaphysical and social norms, values, and dictates to the caprice
of his personality. In *Three Standard Stoppages* (1913–14), for example, he replaced the "standard"
meter with a series of measures devoid of purpose, measures he decided upon arbitrarily, accord-
ing to "chance."[22] This work, Duchamp tells us, was directly inspired by Stirner.[23] In like fashion,
The Bride Stripped Bare by Her Bachelors, Even (Large Glass) (1915–23) (p. 50) fused myriad references to

20
Francis M. Naumann,
"Marcel Duchamp: A
Reconciliation of Opposites,"
in Rudolf E. Kuenzli and
Francis M. Naumann, eds.,
*Marcel Duchamp: Artist of
the Century* (Cambridge,
Massachusetts: The MIT
Press, 1989), pp. 29–30.
Francis Picabia also read
Stirner's book; see Gabrielle
Buffet-Picabia, *Aircs*

abstraites (Geneva: Pierre
Cailler, 1957), p. 20. Two
French translations of *Der
Einzige und sein Eigentum*
were published at the turn
of the century, the first in
1900 and the second in
1910; see Hélène Strub,
ed., *L'Anarchisme:
Catalogue de livres et
brochures des XIX et XX
siècles* (Paris: K.G. Staur,
1993), pp. 265–66.

21
The foundation of Cubism in
Bergsonian metaphysics is
discussed in Mark Antliff,
*Inventing Bergson: Cultural
Politics and the Parisian
Avant-Garde* (Princeton:
Princeton University Press,
1993), pp. 39–66.

22
Naumann, "Marcel
Duchamp: A Reconciliation
of Opposites," p. 30.

23
Ibid., p. 29.

metaphysics, mathematics, and Duchamp's own sexual obsessions into a singularly imaginative statement, both "egoistic" and enigmatic.[24]

The American readymades, such as *In Advance of the Broken Arm* (1915) (p. 51) and *Fountain*, pursued the same end. Here Duchamp undermined the metaphysical aesthetics and socially imposed conventions that defined "art," replacing painting and sculpture with mass-produced objects devoid of aesthetic deliberation and any trace of the creative process. The readymades were his Stirnerite revolt against the rules "art" imposed on the individual. Negating the productive role of the artist and the very idea of aesthetic judgment, Duchamp brought the entire edifice of "art" crashing down, much to the consternation of American art critics, who, already bemused by the nonproductive role of the "artist," furtively searched for qualities of "beauty" that would at least make the act of choosing "artistic."[25]

Look again at the infamous anti-art gestures of New York Dada, such as Man Ray's photograph *Homme (Man)* (1918) (p. 108) and Morton Livingston Schamberg and Baroness Elsa von Freytag-Loringhoven's outlandish *God* (c. 1917) (p.86). These objects remain, poised on the edge of affirmation and negation, as anarchy's supreme triumph—over aesthetics, social conventions, and "art" itself. To paraphrase Benjamin Tucker, "Egoism in philosophy led to artistic iconoclasm," a development complemented in the political realm by the New York Dadaists' shared contempt for capitalism, war, and patriotism; but that is another story.[26]

24
Jerrold Seigel, *The Private Worlds of Marcel Duchamp: Desire, Liberation, and the Self in Modern Culture* (Berkeley and Los Angeles: University of California Press, 1995), pp. 86-114.

25
In an interview with Nixola Greeley-Smith for *The Evening World*, Jean Crotti played with these notions, declaring to his incredulous interviewer that "as an artist I consider that shovel [*In Advance of the Broken Arm*] the most beautiful object I have ever seen"; see Nixola Greeley-Smith, "Cubist Depicts Love in Brass and Glass; 'More Art in Rubbers Than in Pretty Girl,'" *New York Evening World*, April 4, 1916, p. 3. When Bellows objected to *Fountain*, Walter Arensberg made an ironic appeal to his sense of aesthetics, announcing that "a lovely form has been revealed"; see Wood, *I Shock Myself*, p. 29. Duchamp himself insisted that the choice of a

26
I will be discussing this dimension of New York Dada in my dissertation.

qualitative feature that set the artist apart from others. See also the discussion of Jean Metzinger's Cubist painting *Le goûter* (1911) and the elitist role of "taste" in the Bergsonian Cubists' aesthetic in Mark Antliff, *Inventing Bergson*, pp. 42, 44–46.

readymade was "always based on visual indifference and, at the same time, on the total absence of good and bad taste"; see Pierre Cabanne, *Dialogues with Marcel Duchamp* (New York: The Viking Press, 1971), p. 48. Here Duchamp underlined that the readymade was a rejection of Bergsonian Cubism, which glorified "taste" as the

dAdAmAgs

STUART DAVIS, GAR SPARKS, HENRY GLINTENCAMP, BLA!, BRUNO'S WEEKLY, 1916*

The great charm of Dada is that you know it's there but you can't quite put your finger on it. Historically, most of Dada in New York is subsumed into a category called "proto-Dada," but when the goofy word finally shows its face here, in the 1921 magazine *New York Dada*, it is to declare, in Tristan Tzara's pronouncement, that God and my toothbrush are Dada, and New Yorkers can be Dada too, if they are not already; which is to say that proto-Dada could be Dada. This "authorization" having been duly dispensed, the hard core of New York Dada (Marcel Duchamp and Man Ray) takes its leave for Paris. Hello, I must be going.

In New York, as in other cultural centers, the avant-garde wanted a revolution, which became modernism. They breached the traditional rules, the frames of artistic reference, on the grounds that modernity had changed them (people and rules both). But the Dada spirit within the avant-garde would not be content with breaking the frame once; it took a more skeptical position and questioned framing itself. Dada was something of a coach and trainer for the avant-garde, upbraiding it for backsliding or getting lazy. As Demuth wrote in *The Blind Man* (no. 2, May 1917), "Most stop and get a style/ When they stop they make a convention..../The going just keep going." When we discern in the innumerable avant-garde movements and gestures of the day an inkling of the permanent revolution, with its humor and abandon, we are watching the birth of Dada, even as it laughs itself out of existence.

This appearance/disappearance act of Dada was especially well-suited to the little magazines that sprang up as perhaps the major life-support system of the avant-garde. As periodicals, they could criticize or mock a cultural event while its effects were still reverberating or respond to a recently delivered criticism. Even if one of the primary intentions of the little magazines was to print unusual or even shocking new work, the editors could quickly find themselves embroiled in the sort of controversies which became Dada's stock in trade, if not its *raison d'être*. The humorous counterattacks, even against itself, became so much a defining aspect of Dada that the movement (and, inconsistently, it did become a movement) could not survive without it. An interesting example of provocation is the very first issue of *Rogue*, March 15, 1915. There the editors offer Gertrude Stein's "Aux Galeries Lafayette": "One, one, one, one, there are many of them. There are very many of them. There are many of them. Each one of them is one. Each one is one...." This is not about shopping (though it is not an accident that so much in *Rogue* revolves around women's purchases). Stein is working out the degree zero of the artist's consumption of words, repeating the pronoun in minimalist combinations, scooping the meaning out of reference. A marvelous (and graciously short) text in which words begin to argue against their assigned meanings: four *ones* are no longer just *one*, yet after repeated *there are many of thems*, *them* become all the same, that is to say, one! Then, at the end of this issue of *Rogue*, and as if in anticipation of outrage, the editor threatens to "publish Miss Gertrude Stein's History of a Family which is nine volumes of five hundred pages each." In this manner Stein, *Rogue*, and its potential critics are, all three, happily mistreated.[1]

Also high on the list of special attributes of the "littles" was the ability, in part born of necessity, to have unrelated materials in confrontation or juxtaposition. Serious journals into the beginning of the twentieth century continued to look like books—unbroken pages of prose (often

1
In fact, Stein was repeating herself repeating; the same experimentation with "one" had appeared in her "Picasso," printed in a special number of Stieglitz's *Camera Work* for August 1912.

only distinguished by print in two columns), with occasional illustrations. The intelligent journal thus maintained its distance from journalism, but the littles split the difference, acted fast, thrived on short but intense contributions, and multiplied the cultural relations, giving the page over to modernity's ever-shifting horizons.

A most remarkable example of these multiple impressions, or simultaneities, is *Bla!*, a broadside announcing itself as a journal and exhibiting a triple superimposition of handwriting over drawing over printed text. We know very little about *Bla!*, would not even know of its existence except for a reproduction of its single page in Guido Bruno's Greenwich Village *Bruno's Weekly* for February 5, 1916. *Bla!* may have taken shape when three artists at Polly's Restaurant defaced a news column about the Ballets Russes, then in New York; that would not touch us. But publishing it declared a new status for graffiti and the layering of disparate media.[2]

The double-page spread in the littles served a similar if less extreme purpose; it was a privileged site for the avant-garde's battles, the more so for Dada. The reader is made to break concentration or if possible redouble it; to think in two directions or more, to think in complementary directions or even opposite ones. The pages move from being transparent, sequential text to a *place* where things are happening (just what, might actually be less important). The reader starts on the left, goes to the right, but now back and forth, even diagonally; is brought to question the tradition of left as starting point; and may be made to jump high and low, culturally. It is, of course, difficult for us today to get a feel for how bewildering this may have been in 1915; these pages gave us our first training.

2
The authors, Stuart Davis, Gar Sparks, and Henry Glintencamp, were about to break with *The Masses* editorial board, but I see no clear reference to the journal or its other contributors. Glintencamp fled to Mexico that summer because *The Masses* was being prosecuted for publishing one of his drawings. Also that summer, Davis painted his first canvases of simultaneous scenes; William Carlos Williams used one of the sketches as a frontispiece for his Dadaesque *Kora in Hell*. In 1921, Davis started a magazine called SHIT. See Paul Mariani, *William Carlos Williams: A New World Naked* (New York: McGraw-Hill, 1981), p. 181.

A modest example, in terms of layout, is a double page from *Rogue* for August 15, 1915. Mina Loy's now well-known "Virgins Plus Curtains Minus Dots" is a smoldering feminist poem, but full of blank spaces and aggressive ellipses. Its hard edges were unreadable to nineteenth-century eyes. It faces Clara Tice's seemingly offhand *Virgin Minus Verse,* a sketch of a young lady clearly relieved to be corsetless, relaxing into her own bodily freedom. Obviously the double page is planned, coming at female constraints from two arts at once. In Loy, men's flesh "wanders at will," so why not women's, which already "throbs to the night" behind a door bolted by "somebody who was never a virgin"? In contrast, Tice's virgin doesn't bother to argue, but just luxuriates before us, bravely enacting a body theater her mother never contemplated staging.

Now compare the spectacular double page by Marius de Zayas and Picabia for the November 1915 issue of *291*. Obviously many new sorts of decisions have been taken, though it is my sense of it that these pages are themselves, in part, a response to the Loy/Tice spread (only one issue of *291* separates the two productions). Of course, while the women are writing about women, the men are writing about *them*. The "psychotype" and "machine" are joined at the bottom by "ELLE" and "VOILÀ ELLE," which I take to be their titles.[3] Text and image are thoroughly cryptic, which gives the reader-viewer the sense of watching the two men talking to each other, via all sorts of personal allusions (we note they are both speaking French). De Zayas' scattered lines have been seen as "denounc[ing] the woman as an unintelligent creature wholly consumed by carnal desires."[4] I read more readily praise of a woman not suckered by grandiloquent intellectualism, an idea more inter-

3
Traditionally, *FEMME! (WOMAN)* at the top of the page is considered to be the title; however, *ELLE* appears over de Zayas' name, next to Picabia's name and title. Also, while *ELLE* stands alone, *FEMME* is integrated into the syntax of the text. To put the title at the bottom emphasizes the image aspect of the "text."

4
William A. Camfield, *Francis Picabia,* exh. cat. (New York: The Solomon Guggenheim Museum, 1970), p. 24. Later commentators have espoused Camfield's interpretation.

esting to Dada than the other alternative. The same sentiment, sometimes in the same terms, can be found in Mina Loy's poem in *Rogue* for May 1, 1915. In "One O'Clock at Night," she drifts off during a male harangue: "Beautiful half-hour of being a mere woman/ The animal woman/…/Indifferent to cerebral gymnastics." I also note that what typographically appear to be the final words of de Zayas' "picture"—"absence absolue de cilice" ("complete lack of hair shirt")— nicely describes the Tice/Loy corsetless woman: no virgins, no verse, and no images will agree to guilty self-punishment.[5]

Picabia's drawing for VOILÀ ELLE continues to puzzle us. I don't see the gun other commentators have discerned, and I definitely don't see the wires from the dial at upper right as being connected to the "gun"; they seem to be very clearly connected to a butterfly valve on the pipe at lower left. What we do have is a machine which has gotten so complex in controlling his/her throttle that he/she has lost all power (gas, juice?). This is familiar territory for Picabia (Duchamp called it "L'esprit automobile du señor Picabia").[6] His cars are only human; that is what makes them Dada.

The main innovation of this double page in *291* is typographical. Tzara's early issues of *Dada* are not nearly as advanced, not even his third number, which remains more linear. The freedom of typography and layout in this period is almost entirely the work of the little magazines. The widespread commercial adoption of linotype technology had, quite recently, relegated traditional printing presses and their cases upon cases of beautiful type to the garbage heap of history, to be salvaged by out-of-work printers and typesetters going into business for themselves.[7] Many of the littles, along with slim volumes of avant-garde verse or fiction, are reported in memoirs as having been printed by some "redical" [sic] or anarchist printer: from Sonia Delaunay and Cendrars' *Transsibérien* of 1913, through Kreymborg's *Others* in 1916 (printed by "Mr. Liberty" without profit, at $23 an issue), to the *Cabaret Voltaire* and *Dada*, both printed by the anarchist Julius Heuberger, sent to prison during the production of *Dada*, nos. 4-5.[8] The modern artists were actually exploiting an older technology, but, with the help of radicalized craftsmen-printers, they were able to explore possibilities that the newer machines, better suited to mass production, were poised to eliminate.

De Zayas' page has to be composed, even conceived *at the printer's*. The littles epitomize the moment in modernist culture when the creator actually laid hands on the technology (in New York, this clearly followed from the avant-garde's esteem for Stieglitz the photographer, first to "create" with a machine). There could be play with size within the line, or within the word; then with the distinctive character of typefaces; then with the direction of the line; then, why print parallel lines? Image and type might be mixed, as in "Mental Reactions" by de Zayas and Agnes Ernst Meyer for *291*, no. 2, or Katharine N. Rhoades, de Zayas, and Meyer's "Woman" for *291*, no. 3 (p. 269); or type would *be* the image, as in de Zayas' ELLE (or FEMME). Picabia's badly machined car parts are matched, in de Zayas, to exuberant, unruly fonts. The games with lettering may be the more disturbing of the two to our language-trained minds; refigured type reconceives our words, and what had been a transparent medium is now "twenty six beautiful and exotic shapes which can slink or lurk, stand erect or be flattened…," "living things squirming on the page."[9] The body of the letter had gained in presence, was eroticized, told the history of representation, made ideas smile at us.

5
The corset was much discussed at this time; see the introduction to Francis M. Naumann, *New York Dada 1915–23* (New York: Harry N. Abrams, 1994). In the previous issue of *291*, Picabia had pictured a corset supplying electricity to the spark plug in "De Zayas! De Zayas!" While that may or may not liberate women, the reference to Xenophon in "De Zayas! De Zayas!" does free someone: "je suis venu sur les rivages du Pont-Euxin," which refers to the Greek army in disastrous retreat finally seeing the Black Sea, implies some homecoming or seeing the light in New York. But for Picabia or de Zayas?

6
Duchamp, signing Marcel Douxami ("sweetfriend") in *Rongwrong* (one issue, 1917).

7
For the transformation to linotype technology and related issues, Lewis Blackwell, *Twentieth Century Type* (New York: Rizzoli, 1992).

8
For Heuberger and *Dada*, see Dawn Ades et al., *Dada and Surrealism Reviewed*, exh. cat. (London: Arts Council of Great Britain, 1978), p. 59.

9
Arthur Cohen, "The Typographic Revolution: Antecedents and Legacy of Dada Graphic Design," in Stephen Foster and Rudolf Kuenzli, eds., *Dada Spectrum: Dialectics of Revolt* (Iowa City: University of Iowa Press; and Madison, Wisconsin: Coda Press, 1979), p. 88.

Or, instead of redrawing content, lettering could stand at a critical distance from it. An unusually elegant example is Picabia's presentation of a text by Gleizes, in *391*, no. 5, for June 1917.[10] The text, espousing a theoretical position on modern painting which Picabia certainly did not share, is laid out in classical fashion, like a throwback to well-established periodicals, but in a typeface so arch and crowded it can hardly be read.[11] Picabia's own mechanomorphic drawings neatly contrast with the text, fore and aft: "Cônes" is a jibe at Gleizes' narrowly conceived cube, and perhaps also refers to the two Cone sisters, collectors and friends of the Steins; "Nain" (French for "dwarf") makes little of Gleizes' stature as a theoretician.

One last special domain of the little mag that must be mentioned is the way it foregrounded the popular arts. The little is, again, a privileged site, because of its spirit of confrontation, and the liberation of typography. In terms of confrontation no one went further than Robert Coady in his five issues of *The Soil* (1916—17). He matched, on facing pages, a renowned artist and a thirteen-year-old, a monument and a steam hammer, Morgan Russell's *Cosmic Synchromy* and an egg by "A. Chicken," and, most attractively, Stanton Macdonald-Wright's *Organization 5* with the display window of a hat store. In *The Soil*, one read about vaudeville, boxing, the movies, swimmers, Toto the clown, Nick Carter, dressmaking. Arthur Cravan began to take over these pages, as poet and reporter at first, but then as a boxer. But even without Cravan's help, Coady was blunt; beneath his double spreads he reiterated: which is the monument? which has movement? which has the energy?[12]

In terms of typography, the popular arts had already preceded the avant-garde in the dra-

10
Picabia began *391* in Barcelona after leaving New York in 1916. He returned to New York the following year, and nos. 5, 6, and 7 were published there during the summer of 1917. The run of *391* has been reprinted, with an introduction by Michel Sanouillet (Paris: Le Terrain Vague, 1960).

11
Ades, *Dada and Surrealism Reviewed*, p. 141. Ades notes that this Globe Gothic sans serif was soon abandoned because of its poor readability. Ades is particularly attentive to typographical matters in various Dada productions.

12
In his last issue, Coady reviewed the New York Independents' show of 1917 somewhat in the manner of Cravan's scandalous review of an earlier Paris Salon des Indépendants (1914). Still, Coady was trying to evaluate the work, whereas Cravan was frankly insulting and even obscene.

matic mixing of typefaces. Before Delaunay/Cendrars, before Marinetti, before Mallarmé's throw of the dice, there had been advertising posters all over Paris walls, then on the city's corner Morris columns, which advertised current entertainments. Consumerism's early attempts to put its products into artful language were, for the avant-garde, both terribly amusing and yet illustrative of a modern functionalism which made high art begin to look superfluous. The second *The Blind Man* (May 1917) represents a whole number of Dada strands: response to scandal, advertising-style layout, a defense of machined objects, and, in addition, an assault on the idea of authorship and creativity. While this "death of the author" was already implicit in "machined" artwork, Duchamp's found objects were the point of entry for unsigned popular or commercial "culture" into the towers of "art." While Duchamp did not intend his *Fountain* (p. 90) to be art, it was, and is, our art-gaze that was affected; the famous urinal is a Dada Buddha.

The finale of Dada in New York is the one issue of, appropriately enough, *New York Dada* (April 1921) (p. 150). It is saturated with popular and commercial culture. The cover itself is very French, in the simple elegance of its upside-down typewriter face turned into a sort of wallpaper pattern, and its perfume joke on a French dessert ("Belle Hélène," with a further embedded pun, "poire," or pear, being colloquial for "face").[13] The inside double page offers a confrontation between Paris Dada and New York Dada, both drenched in "low" culture. On the left comes Tzara's Parisian manifesto: you too can be, will be Dada. His "metaphors" tell us that our daily, commercialized behavior may be more of a help than a hindrance. On the New York right, Rube Goldberg's famous cartoon carries the Dada day with its deadpan absurdity. This confrontation prompts a distinction: a spontaneous, or natural Dada could shoot around corners, just do it; Tzara's Dada often only existed in his declaration that it existed. Most of the fresh air, or "Ventilation," that Dada wanted to contribute came inside the manifesto, instead of in works the manifesto announced. (Typically, Tzara's *Dadaglobe*, announced here, never appeared.)

New York Dada effectively sapped high culture by detouring the droll aspects of popular culture: dress ball as boxing match, physics as cartoon, the baroness as circus showman, philosophy as "corset-cover." The French contingent was fascinated by popular New York, by its pervasiveness and its democratic lack of reverence. The irrational possibilities of the machine, master product of utilitarian good sense, were particularly seductive: crooked gun, flipped typewriter, double-exposure photograph. All three French Dadas—Roché, Duchamp, and Picabia—went out to Rockaway Beach in 1917, where each sat for his trick-mirror photo. One, one, one photo made many of them, each "né sans mère." Each man is cloned into five, sitting around a table contemplating himself. Each shows one of them seen from five different vantages in a single photo. But obviously many New Yorkers had already done this, including one natural Dadaist who nicely trumped Dada: Chico Marx had simultaneously beaten and lost to himself at cards in his version, about eight years earlier.[14]

Dada meant to take the measure of preposterous pretensions, but with an instrument on which you couldn't read any gradations, a gauge that would stay gleefully broken. Thus Groucho testing the pulse of his favorite American matron: Either my watch is stopped or this woman is dead. Neither was true, yet both watchmaking and matrons seemed to suffer a setback. The little Dada magazines performed a similar diagnosis; their pages were unreasonably alive with the death of stale culture.

13
"Poire" as face has a strong resonance in French art because of Charles Philipon's caricature of King Louis-Philippe for *Charivari*, January 17, 1834, "the most famous and influential caricature of the first half of the nineteenth century"; see Kirk Varnedoe and Adam Gopnik, *High & Low: Modern Art and Popular Culture*, exh. cat. (New York: The Museum of Modern Art, 1991), pp. 115–16.

14
See Naumann, *New York Dada 1915–23*, pp. 48, 68, and 110, for the photographs of Roché, Duchamp, and Picabia. Rockaway Beach is not identified in the photos. I am assuming the photos were taken in Rockaway because the Chico Marx photo was. See Groucho Marx and Richard J. Anobile, *The Marx Brothers Scrapbook* (New York: Harper, 1973), p. 32. Many thanks to Jesse Bochner for discovering this photo.

Unknown Photographer, MULTIPLE PHOTOGRAPH OF CHICO MARX, c.1909*

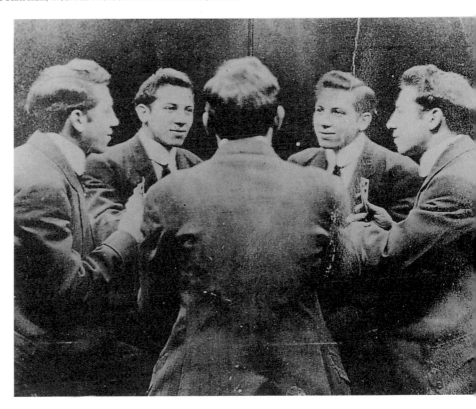

ABRAHAM A. DAVIDSON

The EUROPEAN ART INVASION

BARONESS ELSA VON FREYTAG-LORINGHOVEN, PORTRAIT OF MARCEL DUCHAMP, c. 1919

That very multifaceted approach known as "modernism" was thriving in American art well before 1915. One may mention, among many other examples, the nonobjective paintings of Arthur G. Dove of 1910 and his subsequent biomorphic stylizations; the nonobjective paintings, even before 1910, of the Chicago engineer Manierre Dawson; Max Weber's tilting and breaking up of New York's tall buildings; John Marin's color splashes that evoke, nearly nonobjectively, the landscape about Weehawken, New Jersey; and Abraham Walkowitz's piling up of New York's buildings one atop the other and his paintings and drawings of coiled lines and intermeshed shapes.

But there were certain things the American modernists were not prepared to do before 1915, things they would not have thought of doing. These included the affixing of nontraditional materials, such as string, paper, upholstery tacks, pieces of wood, to a two-dimensional surface; the display of manufactured products, sometimes in combination with other such products, as "authentic" sculptures; the ascription of human characteristics to nonhuman objects; and the establishment of seemingly nonsensical connections between image and title. Beginning in 1915, there also developed a sense of alienation from academicism and nineteenth-century American traditionalism in general. This attitude is dramatically revealed in one of Dove's collages of the 1920s. *The Critic* (1925) (p. 175), made of cardboard, newspaper clippings, and magazine cutouts, along with a cord and velvet material, is meant to represent the aggressive debunker of all modernism, Royal Cortissoz.[1] The figure, made up of newspaper reviews of the traditional painters Thomas Eakins, John Singer Sargent, and George Luks, is formally top-hatted, wears a monocle about his neck, and moves unsteadily on roller skates as he scoops up dirt in his vacuum cleaner.

What happened to make these artists reject traditionalism in the ways they did? More than any other factor, it was the influx of Europeans, whose art and attitudes served as catalysts for change. Arriving in New York from Germany in 1913 was Baroness Elsa von Freytag-Loringhoven; and from France, in the spring of 1915, Marcel Duchamp and Francis Picabia; also arriving from France, in September 1915, were Jean Crotti, Albert Gleizes, and Gleizes' wife, the artist Juliette Roche.[2] More interesting than Dove's demonstrated dislike of academicism was the split within this European modernist contingent. Gleizes remained a committed Cubist, depicting such engineering marvels as *Brooklyn Bridge* (1915), while Crotti went beyond painted canvases to constructions of glass and other materials. His *Les forces mécaniques de l'amour en mouvement* (*The Mechanical Forces of Love in Movement*) (1916) (p. 64), a kind of precursor to Duchamp's *The Bride Stripped Bare by Her Bachelors, Even* (*Large Glass*) (1915–23) (p. 50), proved too much for Gleizes, who objected to the provocativeness of this and other Crotti titles.[3] It was a construction with flattened forms, consisting of metal tubing, wires, and balloons, affixed to glass, and Crotti provided an elaborate explanation.[4]

Most often, what Americans took from the Europeans was an idea, an approach rather than specific forms or aspects of a style. Duchamp's large construction, *Large Glass*, alluded through its machine forms to the attempted seduction of the female animus in the upper part by the male animus in the lower. In a series of machine portraits, meant to portray specific people, Picabia endowed his machines with human attributes. In his "portrait" drawing of Stieglitz, he attached to the camera a prominent bellows, deflated like a limp phallus, hinting at the photographer's impotence as an arbiter of modernism.[5] John Covert profited from the Europeans' anthropomor-

1
For the identification of the figure as Cortissoz, see, among others, Ann Lee Morgan, *Arthur Dove: Life and Work, with a Catalogue Raisonné* (Newark: University of Delaware Press, 1984), p. 50.

2
Others who came at this time were the collector, diplomat, author, and man-about-town Henri-Pierre Roché and the composer Edgard Varèse. Although they were closely associated with the Arensberg circle (Roché had an affair with Louise Arensberg), they did not directly influence the course of visual arts here. But it is noteworthy that Roché wrote the guidelines for the Society of Independent Artists. Varèse was avant-garde in his composition of music and a champion of Debussy before it was fashionable.

3
Nixola Greeley-Smith, "Cubist Depicts Love in Brass and Glass; 'More Art in Rubbers Than in Pretty Girl!'" *The Evening World*, April 4, 1916, p. 3.

5
Dickran Tashjian, *Skyscraper Primitives: Dada and the American Avant-Garde, 1910–1925* (Middletown, Connecticut: Wesleyan University Press, 1975), p. 38.

asked whether the shapes of the balloons had significance, whether love was necessarily round, he replied: "It is round because I wish it. Another artist might see it in squares."

4
Ibid. Crotti said that the red balloon, the smallest, indicated "love"; the blue balloon, the next in size, "the ideal"; and the green balloon, the largest, "green for hope." "Farther to the right," he explained, "I have indicated the extent to which love may carry human beings by suggesting an aeroplane." He did not wish to be too doctrinaire about his piece. When

6
Michael Klein, "The Art of
John Covert," Ph.D. diss.
(New York: Columbia
University, 1971), p. 73.

7
The baroness walked about
Greenwich Village with her
skull shaved and painted
purple, with postage stamps
affixed to her cheeks, and
with a birdcage containing
a live canary tied about
her neck.

phism, though in his painting of two apples he used his own distinctive imagery. Yet in referring to part of the human anatomy through indirect allusion rather than through clear-cut representation, Covert's work relates to that of the Europeans. *Hydro Cell* (1918) (p. 113), the title of the painting, is a play on the medical term "hydrocele," which designates the accumulation of fluid in the scrotum,[6] and loose apples have something of the appearance of that anatomical part full of fluid. Such cleverness and obliquity follow Duchamp and Picabia, as when Duchamp named his readymade shovel *In Advance of the Broken Arm* (1915) (p. 51).

In her bizarre behavior, Baroness von Freytag-Loringhoven set a standard for shocking "decent" folk—as the Arensberg group did with their art.[7] But her art was significant in its use of unconventional materials, as in her *Portrait of Marcel Duchamp* (c. 1919), in which the bicycle wheel to the right (a clear reference to the readymade) is made of wood and the "pipe" in the grimacing mouth of straw. At this time, Americans, too, were using unconventional materials on flat surfaces: Covert used string in his *Brass Band* (1919), upholstery tacks in *Time* (1919), and wooden dowels in *Vocalization* (1919); Beatrice Wood, actual soap in *Un peut* [sic] *d'eau dans du savon (A Little Water in Some Soap)* (1917) (p.95); Stuart Davis, packing paper for his jazz musician in *Itlksez* (1921) (a nonsensical word, but a phonetic spelling of "it looks easy"); and Joseph Stella, wrappers and other papers, which made up entire works.

The baroness was enamored with Duchamp, and this must at least in part account for her collaboration with Morton Livingston Schamberg in making *God* (c. 1917), an assemblage consist-

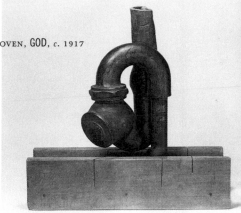

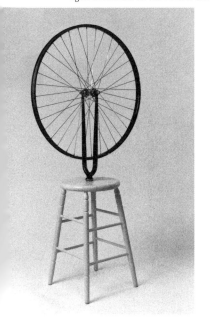

ing of a cast-iron plumbing trap set in a wooden miter box.[8] *God* clearly reflects the influence of Duchamp's earlier readymades, such as *Bicycle Wheel* (1913), *In Advance of the Broken Arm* (1915), and *Fountain* (1917) (p. 90), even if it does not share their totemic look. The strange title, which has never been adequately explained, argues for the influence of Duchamp's own clever and oblique naming of works.

The baroness made no more assemblages, and Schamberg died in the great influenza epidemic of 1918, about a year after *God* was assembled. But Man Ray (born Emmanuel Radnitzky), the most persistent American Dadaist of the period, made many assemblages. He had been taken with Duchamp's ideas from the time the Frenchman visited him late in 1915 in Ridgefield, New Jersey, and they kept in continuous contact through the decade, and beyond 1921, when they both left for Paris. Man Ray's assemblages include *New York* or *Export Commodity* (1920) (p. 128), a glass olive jar containing a vertical column of ball bearings that resembles a tall New York office building; *Obstruction* (1920) (p. 131), a constellation of clothes hangers, dangling so densely that you can't see through them clearly; and *Catherine Barometer* (1920), made of a washboard, tube, and color chart, a work which manages to evoke something of the imperiousness which Katherine Dreier, the art patron and occasional painter, must have radiated; the artist described her as "a large, blonde woman with an air of authority."[9]

I find especially fascinating those rare instances when a specific formal element of a European work was taken over by an American. When this happened, the intonation changed.

8
Francis Naumann believes that it was the baroness who came up with the idea for the assemblage and with the title; see Naumann, *New York Dada 1915–23* (New York: Harry N. Abrams, 1994), p. 128.

9
Man Ray, *Self Portrait* (Boston: Little, Brown and Company, 1963), p. 89.

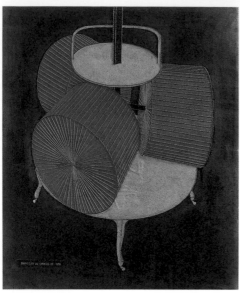

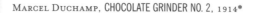

10
Klein, "The Art of John
Covert," pp. 101–02, 105.

Covert, for his *Brass Band*, appropriated the patterning and the curved sections Duchamp used for his *Chocolate Grinder, No. 2* (1914), which eventually became incorporated within *Large Glass*. Covert replaced Duchamp's thread with string, and intermeshed the three distinct sections of the Frenchman's implement. The allusion now was to the brass instruments of a musical ensemble, as well as to the metal braces on the sides of drums,[10] and not at all to the sexual fantasy as played out by Duchamp's mythical, animistic mechanical entities.

Also based on the *Chocolate Grinder, No. 2* is Man Ray's painting *Percolator* (1917), where the artist, like Duchamp, was struck by the stark isolation of the mechanical object. There may be a sexual implication in the rigidly upright vertical pole, but Man Ray did not conceive of a complex sexual interplay among things, as did Duchamp. Man Ray's several figures joined at the waist at the top of *The Rope Dancer Accompanies Herself with Her Shadows* (1916) (p. 79) are meant to suggest a single figure occupying various positions through the passage of time. It was an idea that may well have come to him from Duchamp's versions of *Nude Descending a Staircase* (1912) (p. 35), which had been on view at the 1913 Armory Show. The paintings share elaborate titles and, in both cases, these titles are prominently inscribed directly on the canvas surface. But Man Ray's intonation differs from Duchamp's depiction of the process of motion. The tininess of the figures in Man Ray's painting, the brightness of the colors, the festive occasion of the vaudeville performance, and the tightrope walker who inspired the painting removes the entire image from Duchamp's single-minded concern with motion. Nor do we have in Man Ray the disturbing conflation of human and mechan-

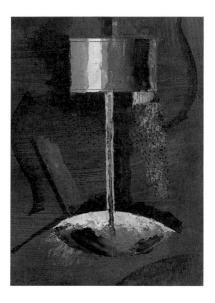

ical movement that we find in Duchamp.

In these examples, and in general, we see that the Americans' approach was different from that of these European invaders who inspired it in the first place. The Americans were not quite as Dadaist, or, put better, they were Dadaist in a different way—without the aura of disillusionment. The differences become a little more evident when we consider how the Americans regarded Dadaism. Katherine Dreier saw the basic idea of it as "irony," while Joseph Stella ventured that "Dada means having a good time—the theater, the dance, the dinner. But it is a movement that does away with everything that has always been taken seriously. To poke fun at, to break down, to laugh at, that is Dadaism."[11] Marsden Hartley echoed this view in his *Adventures in the Arts*: "A Dadaist is one who finds no one thing more important than any other thing, and so I turn away from my place in the scheme from free expressionist to dada-ist with the easy grace that becomes any self-respecting humorist."[12]

It is not that the Americans were wrong. It is that they were only partially right. The fun was there, the put-down was there, and they were appreciated as such. But there was a deadly seriousness to the European attitude, especially concerning the human resemblance—physical and behavioral—to machines, which the Americans did not fully grasp. It is not accidental that the assemblages were more mincing than the readymades, that there were no elaborate constructions like those of Crotti and Duchamp, which functioned as theaters of mechanical-human activities. In the end, the Americans were more direct and a little more innocent—before their involvement in a world war and an economic depression.

11
"'Dada' Will Get You If You Don't Watch Out; It Is on the Way Here," *New York Evening Journal*, January 29, 1921.

12
Marsden Hartley, *Adventures in the Arts* (New York: Boni and Liveright, 1921), p. 248.

LINDA DALRYMPLE HENDERSON

Reflections OF AND/OR ON MARCEL DUCHAMP'S *Large Glass*

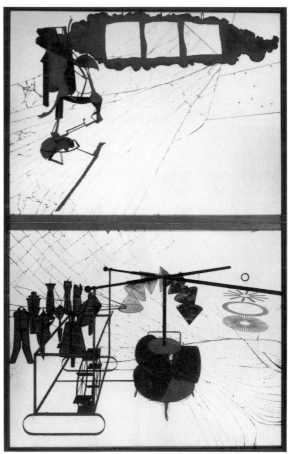

MARCEL DUCHAMP, THE BRIDE STRIPPED BARE BY HER BACHELORS, EVEN (LARGE GLASS), 1915–23*

Marcel Duchamp's adoption of glass and such materials as lead wire and lead foil for *The Bride Stripped Bare by Her Bachelors, Even (Large Glass)* (1915–23) was one of the means by which he defined his artistic practice in opposition to the Cubism of pre–World War I Paris. These media and a style of execution based on mechanical drawing represented for Duchamp a critique of the métier of painting and, in particular, the emphasis on the sensitive touch and elevated taste of the Cubist painter, celebrated in texts such as Albert Gleizes and Jean Metzinger's *Du Cubisme* of 1912.[1] However, just as in 1911 Duchamp himself had adopted certain visual characteristics of Cubism, such as transparency, in order to identify himself with the Cubist avant-garde, in New York the decision by young artists to work on glass now signaled their association with the new avant-garde represented by Duchamp and Francis Picabia. Indeed, the varying responses of younger artists to Duchamp's *Large Glass* serve as an effective barometer of how well those around the French artist understood his project.

Determined to "put painting once again at the service of the mind,"[2] Duchamp had begun in later 1912 to make hundreds of notes for *Large Glass*, although his actual execution of the work began only after he arrived in New York in June 1915. In one of his notes, Duchamp referred to a "playful physics"[3] in *Large Glass*, and like his models Alfred Jarry and Raymond Roussel, he was ever alert to possibilities for humor (particularly wordplay and both visual and functional punning) as he looked to science and technology. There, too, he found a rich store of sexually suggestive language and analogues for human sexual physiology with which to construct his mechanical commentary on the sexual quest of the Bachelors for the Bride above, who remains forever out of their reach. Duchamp utilized geometry as well as science to establish the basic opposition in the *Glass*: that of a biomechanical Bride existing in an etherial, four-dimensional space—free of gravity and measure—versus a purely mechanical Bachelor Apparatus set in a three-dimensional perspective construction and further constrained by gravity, measure, and the laws of mechanics.[4]

When Duchamp arrived in New York, he bore with him not only notes and drawings but also a small study on glass for the Bachelors, the *Nine Malic Molds* (1914–1915) (p. 44), which would have provided striking visual evidence of his new approach to art. Duchamp elucidated his philosophy in interviews during the fall of 1915, in which he praised the "scientific spirit" of Seurat and emphasized the need for an art that would be "still more abstract, more cold, more scientific."[5] As interviewer Alfred Kreymborg observed, "'Pure' is his favorite monosyllable."[6] Although the red *Nine Malic Molds* were painted in oil on the back of the glass ("vermillion unrelieved by a change of shade," according to Kreymborg),[7] Duchamp had hoped to avoid the use of oil paint as much as possible in his new "painting of precision."[8] He speculated in his notes on a variety of alternative media, including acid to etch the glass or a photosensitive emulsion to effect a photographic transfer of an image, although in the end these plans proved unworkable.[9] Likewise, Duchamp's use of lead wire applied to the back of the glass panels of the *Malic Molds* and the *Glass* itself created a new kind of depersonalized line, "precise and not so controlled by your hand," as he explained later.[10]

Yet many of the materials Duchamp employed, such as lead wire, also had specific scientific or technological associations, most often with electricity: lead wire, for example, was standardly used in French households to create fuses. Indeed, rather than the artist's studio, Duchamp often turned to the scientific laboratory for models for his activity. Of the many aspects of science and

1
The present essay is drawn in part from Linda D. Henderson, *Duchamp in Context: Science and Technology in the "Large Glass" and Related Works* (Princeton: Princeton University Press, forthcoming), where many of the issues raised here are discussed and documented in full. On Duchamp's reaction against *Du Cubisme* and its strongly Bergsonian stance, see chaps. 5, 6, and 13.

2
Duchamp, as quoted in James Johnson Sweeney, "Eleven Europeans in America," *The Museum of Modern Art Bulletin*, 13 (1946), p. 20.

3
See Duchamp, in Michel Sanouillet and Elmer Peterson, eds., *Salt Seller: The Writings of Marcel Duchamp* (New York: Oxford University Press, 1973), p. 49.

4
For an abbreviated treatment of these issues, see Linda D. Henderson, "Etherial Bride and Mechanical Bachelors: Science and Allegory in Marcel Duchamp's 'Large Glass,'" *Configurations: A Journal of Literature, Science, and Technology*, 4 (Winter 1996), pp. 91 120.

5
Duchamp, as quoted in "A Complete Reversal of Opinions by Marcel Duchamp, Iconoclast," *Arts and Decoration*, 5 (September 1915), p. 428.

6
Alfred Kreymborg, "Why Marcel Duchamps [sic] Calls Hash a Picture," *Boston Evening Transcript*, September 18, 1915, p. 12.

7
Ibid.

10
Quoted in Naumann, "*The Bride Stripped Bare*," p. 37.

9
Duchamp described his etching experiment in an unpublished interview with Sidney, Harriet, and Carroll Janis (1953), quoted in Francis M. Naumann, "*The Bride Stripped Bare by Her Bachelors, Even* and Related Works on Glass by Marcel Duchamp," *Glass*, no. 60 (Fall 1995), p. 37. For Duchamp's speculation on photographic transfer, see *Salt Seller*, pp. 38, 76, 82–83.

8
Duchamp, in *Salt Seller*, p. 30, and Paul Matisse, ed., *Marcel Duchamp: Notes* (Paris: Centre Georges Pompidou, 1980), notes 68, 77.

technology he explored, electricity and electromagnetism emerge as central to *Large Glass*, "a paint-ing *of frequency*,"[11] in which the Bride communicates with and controls the Bachelors below by means of the Hertzian waves of wireless telegraphy. In Duchamp's words, "the connections. will be. *elec-trical*, and will express the stripping: an alternating process. Short circuit if necessary—."[12] Clearly, the potentially sexual overtones of much electrical terminology made it a rich resource for the iconoclastic humor in the *Large Glass*.

Based on more than three years of research and creative invention on Duchamp's part, the complex and multivalent *Large Glass* transcends the Dada movement as such. Nonetheless, the *Glass* served as a powerful stimulus and liberating force for the younger artists who emerged in the con-text of the Arensberg circle and New York Dada. Of the three artists who produced works on glass in New York—Jean Crotti, Joseph Stella, and Man Ray—Crotti was most closely acquainted with Duchamp's project. This is hardly surprising, since Crotti, who would marry Duchamp's sister Suzanne in 1919, shared Duchamp's New York studio for a time in late 1915—early 1916.[13] The two were interviewed, along with Picabia and Gleizes, who had also resettled in New York, in a 1915 *New York Tribune* article, "French Artists Spur on an American Art." Crotti's comments make clear that he had absorbed certain of Duchamp's basic views, including his rejection of Cubism: "My work is quite the reverse of M. Gleizes's," Crotti declared, emphasizing that "I do not attempt to portray anything but ideas."[14] Indeed, Crotti's extant works on glass from this period, *Les forces mécaniques de l'amour en mouvement (The Mechanical Forces of Love in Movement)* (1916), *The Clown* (1916), *Composition with*

11
Duchamp, in *Salt Seller*, p. 25; on this theme, see Henderson, *Duchamp in Context*, chap. 8.

12
Duchamp, in *Salt Seller*, p. 39.

13
For Crotti's activity in New York and his relation-ship to Suzanne Duchamp, see William A. Camfield and Jean-Hubert Martin, *Tabu Dada: Jean Crotti and Suzanne Duchamp, 1915–1922*, exh. cat. (Bern: Kunsthalle Bern, 1983).

14
Crotti, as quoted in "French Artists Spur on an American Art," *New York Tribune*, October 24, 1915, sect. 4, p. 2.

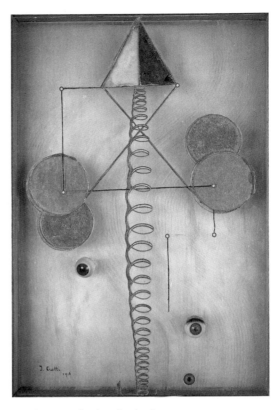

JEAN CROTTI, THE CLOWN, 1916

Square (1916), and *Solution de continuité (Interruption)* (c. 1916) (p. 65), reveal not only that he had adopted Duchamp's technique of wire and other materials applied to glass, but that he, along with Picabia, understood more than others certain of the thematic "ideas" behind *Large Glass*.

Les forces mécaniques de l'amour en mouvement (The Mechanical Forces of Love in Movement) was constructed as a shallow shadow box, with paint, lead wire, and metal tubing applied to the back of the glass. Crotti's visual language at this point still utilized abstract areas of color, in the tradition of his own Orphist-oriented paintings, as well as an overt color symbolism that contrasted with Duchamp's subtle rethinking of color.[15] Nonetheless, during an interview with Nixola Greeley-Smith, Crotti used an electric light bulb behind the glass to illuminate specific areas as he explained their symbolism. According to Greeley-Smith's account:

> The light was behind the red balloon. "Love," said the artist, then came a larger balloon. "Blue, the ideal," M. Crotti explained..."Green for hope," added the painter. "Farther to the right I have indicated the extent to which love may carry human beings away by suggesting an aeroplane."..."The brass indicates machinery, energy, power."[16]

When asked if he believed in love, Crotti replied,

> "In the sense of the strong, natural attraction of the sexes I believe in love, but not in the sense of pretty-pretty sentiment....My picture does not undertake to express sentimental love. It is love in the most primitive sense."[17]

15
For Duchamp's notes on color, see *Salt Seller*, pp. 79–83.

16
Crotti, as quoted in Nixola Greeley-Smith, "Cubist Depicts Love in Brass and Glass; 'More Art in Rubbers than in Pretty Girl!'" *The Evening World*, April 4, 1916, p. 3.

17
Ibid.

Crotti's commentary provides a curious blend of the technological with a "primitive," unsentimental conception of love and sexuality which suggests a text that undoubtedly had been critical for Duchamp's early work on the *Large Glass* project in Paris as well. Remy de Gourmont's 1903 *Physique de l'amour: Essai sur l'instinct sexuel*, which was in its tenth edition by 1912, combined an overview of "primitive" sexual activity from species to species with frequent mechanical metaphors. "Love is profoundly animal; therein lies its beauty," he asserts near the beginning of *Physique de l'amour*.[18] Readily shifting from the animal world to the mechanical, Gourmont subsequently argues in a discussion of parthenogenesis: "The female appears to be everything; without the male, she is nothing. She is the machine and has to be wound up to go; the male is merely the key."[19] Gourmont also introduced a theme that underlies paintings such as Picabia's *Machine tournez vite (Machine Turn Quickly)* of c. 1916–18 (p. 62): "They [the sexual organs] are rigorously made the one for the other, and the accord in this case must be not only harmonic, but mechanical and mathematical. They are gears that must fit one in the other with exactitude...."[20] Moreover, the title Gourmont uses for his six chapters surveying copulation techniques from crustaceans and insects to humans, "The Mechanism of Love," provides a suggestive prototype for Crotti's title *The Mechanical Forces of Love* and could also serve well as a subtitle for the *Large Glass*.

Paul Haviland's elaboration in *291* of a theory of mechanical sexuality (i.e., man "has made his human ideal machinomorphic") stands as another reflection of the prevalence in this period of human-machine metaphors, often with sexual overtones like those of Gourmont.[21] Electricity

18
Remy de Gourmont, *Physique de l'amour: Essai sur l'instinct sexuel*, 30th ed. (Paris: Mercure de France, 1924), p. 13. See also Remy de Gourmont, *The Natural Philosophy of Love*, trans. Ezra Pound (New York: Boni and Liveright, 1922; New York: Willey Book Co., 1940), p. 6.

19
Gourmont, *Physique de l'amour*, p. 29; *The Natural Philosophy of Love*, p. 16.

20
Gourmont, *Physique de l'amour*, pp. 77–78; *The Natural Philosophy of Love*, p. 46.

21
See Paul Haviland, statement in *291*, nos. 7–8 (September-October 1915). In addition to the presence of such metaphors in the writings of Jarry and Roussel, F.T. Marinetti, for example, treated automobiles as anthropomorphic objects of desire in his 1909 "The Founding and Manifesto of Futurism."

often played a role in such analogies, as in Villiers de l'Isle-Adam's 1886 novel *L'Ève future*, where the fictional Thomas Edison declares that "modern love...from the standpoint of physical science is a question of equilibrium between a magnet and an electricity."[22] As noted above, electricity and electromagnetism were central to the scenario of Duchamp's *Large Glass*, and Crotti reflects that view when he points out to Nixola Greeley-Smith that the brass in *The Mechanical Forces of Love in Movement* signifies "energy" and "power" as well as machinery. Crotti's subsequent works would develop a more clearly mechanomorphic figure style, and electricity would often play a role in those works. In his 1916 painting *Virginity in Displacement*, for example, a spidery line, electrical connections, and sparklike forms suggest the flow of electrical current from one part of his machine-virgin to another.[23]

One of Crotti's other works on glass, *The Clown*, includes the spiral form that Duchamp himself used at times as a sign for electrical activity.[24] Yet in this case, and in another work on glass, *Solution de continuité*, Crotti seems to have responded specifically to the *Large Glass* project. Central to Duchamp's scenario for communication between the Bride and the Bachelors was the "Juggler of Gravity," who was to have been placed opposite the Bride at the right side of her realm. Drawn by Duchamp in one of his notes as centered on a spiraling coil, the Juggler was to carry out a kind of balance-preserving dance on the garment of the Bride at the horizon line, registering the tugging on the garment by the never-executed *Boxing Match* immediately below.[25] (Duchamp exhibited his drawing *Boxing Match*, with its clockwork gears and detailed description of the mechanism's operation, at the Bourgeois Gallery in April 1916.) The intermediary figure of the Juggler would thus be a sensitive register of the Bachelors' stripping activity at the same time that he carried on a wave-borne dialogue with the Bride herself. Jean Suquet has suggested that *The Clown* may well be Crotti's response to Duchamp's central character, and indeed he does seem to "juggle" colored symbols for "love" and the "ideal" akin to those in *The Mechanical Forces of Love in Movement*.[26]

In Duchamp's commentary on the "electrical connections" between the Bride and the Bachelors, he had emphasized that "in spite of this cooler, there is no *discontinuity [pas de solution de continuité]* between the bach. machine and the Bride."[27] "Solution de continuité" is translated as break or discontinuity, and Crotti's adoption of the term as a title for another work on glass may well derive from Duchamp's usage. Crotti adds the word "wrong" and his organic, spermlike, and central egglike forms as well as forceps suggest that any sexual discontinuity will be overcome. The birth evoked by the forceps may also refer to what Crotti later termed his second birth "by auto-procreation and self-delivery without umbilical cord,"[28] an event he associated with the climactic, liberating effect of his encounter with the art of Duchamp and Picabia in 1915.

Both *The Clown* and *Solution de continuité* are also constructed on the shadow box model. Indeed, within the space of *The Clown*, Crotti suspended three glass eyeballs of the type he had used in his constructed *Portrait of Marcel Duchamp (Sculpture Made to Measure)* (1915) (p. 276) (now lost) and had depicted as well in the related drawing *Portrait of Marcel Duchamp* (1915) (p. 48). Glass eyeballs became symbolically charged objects for Crotti: he associated them with an ability to perceive the invisible and later talked of "his" glass eyes as linked by an "ultra-sensitive wire" to "an induction coil generating force, light and heat," which was itself connected to a "small apparatus receiving and emit-

22
Villiers de l'Isle-Adam, *L'Ève future* (1886; Paris: Jean-Jacques Pauvert, 1960), p. 153.

23
Reproduced in Camfield and Martin, *Tabu Dada*, p. 95.

24
See, for example, the drawing *Milky Way* (*Salt Seller*, p. 37). Such spiral imagery was common in textbooks on electricity, specifically, in circuit diagrams, and Crotti employed it in other works as well (see Camfield and Martin, *Tabu Dada*, pp. 107–08). Picabia also adopted the use of spiraling wires in works such as *Totalisateur*, 1921–22.

25
On the Juggler of Gravity, see *Salt Seller*, p. 65; *Marcel Duchamp: Notes*, notes 55, 68, 77, 91, 137, 141, 149–53.

26
Jean Suquet, *Le Grand Verre rêvé* (Paris: Aubier, 1991), pp. 154–55.

27
Duchamp, in *Salt Seller*, p. 39.

28
Quoted in Camfield and Martin, *Tabu Dada*, p. 82; see also Camfield's discussion, p. 12.

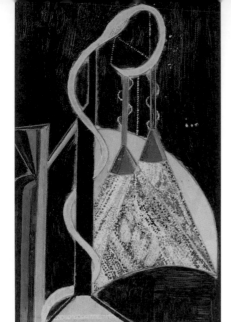

29
Ibid.

30
Kreymborg, "Why Marcel Duchamps [sic] Calls Hash a Picture," p. 12.

31
See Linda D. Henderson, "X-Rays and the Quest for Invisible Reality in the Art of Kupka, Duchamp, and the Cubists," *Art Journal*, 47 (Winter 1988), pp. 323–40.

32
Duchamp, in James Johnson Sweeney," A Conversation with Marcel Duchamp," 1956, in *Salt Seller*, pp. 130, 136.

33
Gourmont, *Physique de l'amour*, pp. 143–48; *The Natural Philosophy of Love*, pp. 87–90.

ting vital waves."[29] Crotti made literal the metaphorical discussions of the new art common to critics such as Kreymborg, who had concluded from his interview with Duchamp: "It is with Duchamp's work as with that of others in the modern repertory of painting, music, poetry, you require a new pair of eyes, a new pair of ears, a new set of senses and emotions to give each his due."[30] Here glass eyeballs become signs for the visionary powers of the artist, able to perceive invisible realities, such as the fourth dimension or the ranges of electromagnetic waves beyond human sense perception (e.g., X-rays and Hertzian waves).[31]

Crotti's use of the phrase "sur mesure" or "made to measure" in his portrait of Duchamp of 1915 presages a theme he would explore in his remaining work on glass of 1916, *Composition with Square*. Here Crotti comes closest to Duchamp's alternatives to oil paint, including tinfoil and sequins as well as wire. In addition, Duchamp's adoption of mechanical drawing as his model for a "completely *dry* drawing" with "no taste in it"[32] is signaled here by the triangular draftsman's "square" as well as the geometrical construction of the weblike motif in the background. Yet since Crotti's symbolic red, blue, and green circles, as well as the black triangular forms at the bottom, all echo *The Mechanical Forces of Love in Movement*, it is tempting to believe that there may also be a sexual commentary in the work. Gourmont had noted the female spider's habit of devouring her mate, and Crotti's arrangement seems to suggest that love, hope, and the ideal are all caught in the web that fills the composition.[33] In addition, the tinfoil Crotti employed had specific electrical associations: arranged in layers alternating with plates of glass, tinfoil was standardly used to create the

electrical condensers whose production of sparks was essential to the wireless, "spark" telegraphy central to Duchamp's *Large Glass* narrative.

In *Composition with Square*, Crotti explored most fully the possibilities of new, non-art materials, incorporating only small areas of paint. The juxtaposition of such a Crotti work with Joseph Stella's paintings on glass of 1916–17 points up how different Stella's works are from those of Crotti and from Duchamp's *Large Glass*. Although Stella became a close personal friend of Duchamp, his roots in the Futurist Divisionism of artists such as Gino Severini and his love of color prevented him from embracing Duchamp's ascetic denial of painting.[34] In contrast to Duchamp, who declared of the *Glass*, "There are no colors in the *coloration of a surface* sense,"[35] Stella found in glass painting the opportunity to create sensuous patterns of color. *Man in Elevated (Train)* (1918) (p. 262) and *Chinatown* (1917), with their forms outlined in wire and infilled with high-keyed color, are like modernist stained-glass windows. Their style derives from the flat, geometrical facets Stella had first established in his 1913–14 series *Battle of Lights, Coney Island*.

While *Man in Elevated (Train)* actually incorporates a collaged piece of newspaper, Stella's painting *Prestidigitator* (1916) is the boldest of the three works in its conception. Although the prominent sexual themes in the works of Duchamp, Picabia, and Crotti are absent, Stella adopts a mechanical iconography, focusing on the hanging lamps in use in this period. Who is the prestidigitator, or sleight-of-hand artist, whom Stella celebrates here? It may well be the painter himself, who is able to reveal the color hidden within the white light that streams down from the two lamps. Unlike the areas of stippled, Divisionist color that occur across the surface of the *Coney Island* paintings as well as *Man in Elevated (Train)* and *Chinatown*, Stella here carefully contains the dots of color within the shafts of light. Just as Picasso had done in works of 1914, Stella playfully uses Divisionist dots to embody rays of light, celebrating the range of visible light within the electromagnetic spectrum, in contrast to the invisible waves that preoccupied Duchamp and Crotti.[36] The nimble hands and fingers (i.e., digits) of the sleight-of-hand performer are the source of the term "prestidigitator," and Stella, in effect, digitizes and makes visible the colors composing white light.

Of the artists around Duchamp, Man Ray understood the broader implications of his endeavor most fully. Although he produced only one major work on glass, the 1920 *Danger/Dancer* or *L'Impossibilité* (p. 280), much of his own activity paralleled Duchamp's pursuit of a depersonalized means of art making beyond painterly touch. It was Man Ray who suggested to Duchamp, as he laboriously scraped silver from the area of the Oculist Witnesses in *Large Glass*, that "there might be a photographic process that would expedite matters," to which Duchamp replied, "Yes, perhaps in the future photography would replace all art."[37] In Man Ray's own photography practice, glass negatives functioned as the automatic, impersonal registrations that were a goal for Duchamp as he contemplated translating the Bride's image to the glass via photography. Indeed, the younger artist's 1920 photograph of *Dust Breeding* (p. 130) on *Large Glass* documents Duchamp's conception of *Glass* as a kind of indexical registering apparatus, on which dust was allowed to gather for six months in order to produce the coloration of the semicircular Sieves above the Chocolate Grinder. Likewise, Man Ray's use of an airbrush beginning in 1919 must have appealed to

34
On Stella, see Barbara Haskell, *Joseph Stella*, exh. cat. (New York: Whitney Museum of American Art, 1994), pp. 38–46.

35
Duchamp, in *Marcel Duchamp: Notes*, note 136.

36
See, for example, Picasso's 1914 *Pipe and Sheet of Music* (The Museum of Fine Arts, Houston).

37
Duchamp and Man Ray, as quoted in Man Ray, *Self-Portrait* (Boston: Little, Brown and Co., 1988), p. 73.

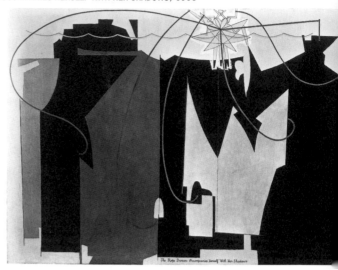

Duchamp: here was a precision technique for applying paint that completely removed the touch of the artist.

While Crotti's works on glass had explored mechanical sexuality, Man Ray's *Danger/Dancer* is the only one of the New York glass works considered here that combines sexually oriented machine imagery with a highly precise mode of execution as well as verbal punning on the model of the extensive wordplay basic to Duchamp's *Large Glass* project. Man Ray later traced his inspiration for the painting to the "gyrations of a Spanish dancer" he had seen.[38] Those movements, however, are translated into an image of woman as a composite of gears, a theme that had been present in Duchamp's conception of the Bride's "desire-gears"[39] as well as in Gourmont's discussion of sexual interaction in terms of gears and Picabia's illustration of that idea in paintings such as *Machine tournez vite*, which is usually credited as a direct model for *Danger/Dancer*. Yet Man Ray creates an "impossibility" by intermeshing three gear wheels, which are then locked in place and cannot move; further, he varies the size of the gear teeth at the top of the inner circle, creating another mechanic's nightmare, somewhat akin to Duchamp's playful commentary on "standard" measures in the three differently defined meter variations of his *Three Standard Stoppages* (1913–14) (p. 213). There is a clear "danger" threatening this dancer's mobility, and Man Ray creates our double reading of the word by adding a slight suggestion of a G's extension to the C in DANCER. Duchamp's notes for *Large Glass* are filled with similar kinds of wordplays, most often homonyms or near-

38
Man Ray, *Self-Portrait*, p. 79.

39
For the Bride's "desire-gears," see Duchamp, in *Salt Seller*, pp. 42–43.

homonyms on the model of Roussel's *Impressions d'Afrique*.[40] Thus, for example, in a play on the word taste (*goût*), Duchamp created an elaborate scenario involving various forms of *gouttes* (drops) in the Bachelor Apparatus; his readymade *Bottle Rack* is also an *égouttoir*, literally a "de-dropper," but also a "de-taster."[41]

Man Ray's most direct iconographical response to *Large Glass* had been his 1916 oil painting on canvas, *The Rope Dancer Accompanies Herself with Her Shadows*, which suspended a Dancer/Bride above her "shadows" and ropes that echo the Bachelors/Nine Malic Molds connected by their Capillary Tubes.[42] However, he may also have been following Duchamp's lead when in 1918 he began to select or create objects to which he gave sexual identities, such as his *Man* (an eggbeater) and *Woman* (a combination of flashbulb reflectors and a row of clothespins). In this case, his model would have been Duchamp's readymades, which the artist described as vehicles for "unloading ideas,"[43] and which seem to have functioned as surrogate objects for ideas or elements from *Large Glass*. Duchamp made such associations manifest in his miniature museum of his works, the 1941 *Box in a Valise*, where *50cc of Paris Air* (1919) (p. 120), *Traveller's Folding Item* (1916), and *Fountain* (1917) (p. 90) parallel, respectively, the Bride, the mid-section of the *Glass* (identified with her garment), and the Bachelors. In the wake of Duchamp's selection of readymade counterparts to the Bride, such as the *Hat Rack* (1916) and a free-swinging chimney ventilator (now lost), Man Ray's decision to suspend *Danger/Dancer* in his studio window above his phallic 1918 assemblage *By Itself I* (p. 104) might be read as an analogue to the Bride-above-Bachelor arrangement of *Large Glass*.[44]

Man Ray's installation would have been a fitting tribute to Duchamp, whose radical rethinking of the nature of art had had such a powerful effect upon the artists around him in New York. Although of the group, Crotti had been the most immediate eyewitness to the birth of the *Large Glass*, the language of technology and electricity remained central to his oeuvre only into the early 1920s in the context of "Tabu Dada," the quasi-mystical variant on Dada he established with Suzanne Duchamp.[45] Stella's course had been altered less radically by his friendship with Duchamp, and he soon moved on to painting romantic encounters with technology, such as his *Brooklyn Bridge* series, begun in 1919; when he utilized glass as a support in later works, his subjects were flowers or other organic forms.[46]

In the end, it was Man Ray whose approach to art making remained closest in spirit to Duchamp and who would become involved with both Paris Dada and the Surrealist movement that followed. In 1920, the same year he photographed *Danger/Dancer* in his window as well as the process of dust "breeding" on *Large Glass*, Man Ray survived a dangerous encounter with another of Duchamp's works on glass, *Rotary Glass Plates (Precision Optics)* (p. 133). Having built a machine powered by electricity, Duchamp was exploring the optical effects created by its spinning glass blades, when one blade flew off the apparatus, nearly decapitating Man Ray, who was photographing the scene.[47] It was a harrowing experience, according to Man Ray's account, but one that hardly affected what would become a lifelong friendship between these two individuals, united by wit, iconoclasm, and steadfast commitment to "the development of ideas" in art.[48]

40
For a sampling of Roussel's homonyms, see Jennifer Gough-Cooper and Jacques Caumont, "Ephemerides on and about Marcel Duchamp and Rrose Sélavy, 1887–1968," in Pontus Hulten, ed., *Marcel Duchamp: Work and Life* (Cambridge: The MIT Press, 1993), entry for June 10, 1912.

41
Hulten first suggested this reading of the *Bottle Rack*, ibid., p. 16.

42
On the relation of the two works, see, for example, Francis M. Naumann, "Man Ray, Early Paintings 1913–1916: Theory and Practice in the Art of Two Dimensions," *Artforum*, 20 (May 1982), pp. 41–42. Like Duchamp's *Juggler of Gravity*, Man Ray's "rope dancer" was an equilibrist.

43
Duchamp, as quoted in Otto Hahn, "Passport No. G255300," *Art and Artists*, 1 (July 1966), p. 10.

44
For the lost ventilator he titled *Pulled at Four Pins*, see Arturo Schwarz, *The Complete Works of Marcel Duchamp*, 2nd rev. ed. (New York: Harry N. Abrams, 1970), cat. no. 232. On the early readymades as surrogate vehicles for ideas from the *Large Glass* project, see Henderson, *Duchamp in Context*, chap. 13.

45
On this subject, see Camfield and Martin, *Tabu Dada*, and, particularly, the chronology's overview of Crotti's later artistic activity.

46
On these works, as well as the collages with which Stella experimented in the 1920s and 1930s, see Haskell, *Joseph Stella*.

47
See Man Ray, *Self-Portrait*, p. 62.

48
Ibid., p. 270.

AMELIA JONES

EROS, *That's Life,* *the* OR **BARONESS'** PENIS

MAN RAY, ROSE SÉLAVY, 1921

In his 1918 Dada Manifesto, Tristan Tzara stated the sources of "Dadaist disgust": "Morality is an injection of chocolate into the veins of all men.... I proclaim the opposition of all cosmic faculties to [sentimentality,] this gonorrhea of a putrid sun issued from the factories of all philosophical thought.... Every product of disgust capable of becoming a negation of the family is Dada."[1] The Dadaists were antagonistic toward what they perceived as the loss of European cultural vitality (through the "putrid sun" of sentimentality in prewar art) and the hypocritical bourgeois morality and family values that had supported the nationalism culminating in World War I.[2] Conversely, in Hugo Ball's words, Dada was to "drive...toward the in-dwelling, all-connecting life nerve," reconnecting art with the class and national conflicts informing life in the world.[3]

While Dada has, for the most part, been institutionalized as "art," it has also been privileged for its attempt to explode the boundaries separating the aesthetic from life itself, reversing the nineteenth-century romanticism of Charles Baudelaire's "art for art's sake."[4] The aspect of Dada that interests me here is its opening up of artistic production to the vicissitudes of reception, such that the process of making meaning is itself marked as a political act. I will suggest that it was in New York that Dada, before it knew itself as such, challenged bourgeois morality in the most aggressive way through the opening of art to the erotic exchange of interpretation, in particular via the *sexualization* or *eroticization* of the subjects and objects of art. Per Marcel Duchamp's well-known pun, "eros, that's life,"[5] the New York Dadaists—in particular Duchamp himself—eroticized "everyday life"; they charged the art making and viewing processes with an eroticism that necessarily exposed the invested and thus politicized aspects of meaning and value production.[6] This erotic politicization, enacted most powerfully through dramatic self-performances, worked in explosive antagonism to the veiled bourgeois moralism, utopian formalism, and romantic sentimentalism that had reigned previously in the European art world.

The New York Dada artists who enacted the sexualization of "everyday life" through performances of themselves signaled the incursion not only of war but of commodity culture itself into bourgeois life in the Western world at the beginning of the twentieth century. In particular, the Baroness Elsa von Freytag-Loringhoven's bizarre, sexually ambiguous self-performances in the streets of New York and Duchamp's masquerade as a woman ("Rrose Sélavy") in the well-known series of photographs are dramatic *performances* of Dada.[7] As such, I argue that these artists' confusion of gender and overt sexualizations of the artist/viewer relationship challenged post-Enlightenment subjectivity and aesthetics far more pointedly than did Dadaist paintings and drawings, which only partially addressed the divisions that privileged art as separate from life in the nineteenth-century romantic imagination.

1
Tristan Tzara, "Dada Manifesto 1918," reprinted in Charles Harrison and Paul Wood, eds., *Art in Theory 1900–1990: An Anthology of Changing Ideas* (Oxford and Cambridge, Massachusetts: Blackwell Publishers, 1992), pp. 252–53.

2
These sentiments were particularly strong among the German Dadaists. As German Dadaist Richard Huelsenbeck argued, the war revealed German Expressionism to be a "large-scale swindle" mobilized on the part of Germany to legitimate the nationalist warmongering policies that led up to the war: "art (including culture, spirit, athletic club)...is a large-scale swindle. And this,...most especially in Germany, where the most absurd idolatry of all sorts of divinities is beaten into the child in order that the grown man and taxpayer should automatically fall on his knees when, in the interest of the state or some smaller gang of thieves, he receives the order to worship some 'great spirit.' I maintain again and again: the whole spirit business is a vulgar utilitarian swindle. In this war the Germans...strove to justify themselves at home and abroad with Goethe and Schiller. Culture can be designated solemnly and with complete naïvety as the national spirit become form, but also it can be characterized as a compensatory phenomenon, an obeisance to an invisible judge, as vernal for the conscience"; Huelsenbeck, "En Avant Dada: A History of Dadaism" (1920), reprinted in Robert Motherwell, ed., *The Dada Painters and Poets; An Anthology*, 2nd ed. (Cambridge, Massachusetts, and London: Harvard University Press, 1981), p. 43.

tions of this figure as early as 1921; see Naumann, *New York Dada 1915–23*, p. 228. All Duchamp's subsequent articulations of Sélavy after this point (in writings and other pieces) thus recontextualize the photographs; further, at least one of the best-known versions of the photograph was given to Sam White in 1924 and signed by Duchamp, "lovingly Rrose Sélavy, alias Marcel Duchamp" (this photograph is now in the collection of the Philadelphia Museum of Art).

aesthetic value must remain disinterested in relation to their objects. I expand on this activation of spectatorial desire in relation to body art in my book *Body Art/Performing the Subject* (University of Minnesota Press, forthcoming).

7
While Francis Naumann argues that these photographs of Duchamp should *not* be labeled "Rrose Sélavy" since, strictly speaking, they were completed before Duchamp adopted this particularly modified version of "Rose," I feel it ultimately makes more sense to label them as such since "Rrose" basically replaced "Rose" in Duchamp's conceptualiza-

5
From the self-adopted feminine name, Rrose Sélavy; I discuss Rrose Sélavy at length in my book *Postmodernism and the En-Gendering of Marcel Duchamp* (New York and Cambridge, England: Cambridge University Press, 1994); see especially chapter 5, "The Ambivalence of Rrose Sélavy and the (Male) Artist as 'Only the Mother of the Work.'"

6
This emphasis on the investments of interpretation radically challenges the traditional, loosely Kantian, connoisseurial basis of art historical value judgments. In Kantian terms, interpreters of

3
Hugo Ball, "Dada Fragments" (1916–17), in Motherwell, *The Dada Painters and Poets*, p. 54.

4
This has been substantiated by Dada's subsequent institutionalization in textbooks and museums, beginning with Alfred H. Barr's 1936 exhibition "Fantastic Art, Dada, Surrealism" at The Museum of Modern Art, New York, and including Motherwell's excellent anthology cited above and Francis Naumann's comprehensive *New York Dada 1915–23* (New York: Harry N. Abrams, 1994).

Francis Picabia, *Voilà Elle (Here She Is)*, 1915 (p. 57): Here she is, an incomplete tubular machine: "she" is simply the HOLE of the target, whose reaction to the shot wad of fire from the gun initiates her own continual penetration. Marius de Zayas, *Femme!* 1915 (p. 57): A Woman! comprised of a man's anxious desires. Her sassy arm proclaims its debt to its male author—"I see...how she loves to be a straight line traced by a mechanical hand"; she is, naturally, "harebrained" (her "cerebral atrophy" a function of her brute physicality), and her Dadaism is articulated through male desire: she "exists only in the exaggeration of her *jouissances* [orgasmic pleasures] and in the consciousness of possession....I see her only in pleasure."

The eroticizing thrust of New York Dada arose in relation to a number of interrelated forces. In New York, Dada was largely a French importation, inspired primarily by the enigmatic erotic-aesthetic energies of Marcel Duchamp and the bluntly sexual mechanomorphic strategies of French-Spanish-Cuban expatriate Francis Picabia. Along with French artist Jean Crotti and Arthur Cravan, an English pugilist-writer-magazine impresario (and nephew of Oscar Wilde), these artists left an increasingly barren Parisian art scene and a Europe torn asunder by war to come to the "New World."[8] Escaping World War I, the male immigrant artists generally saw New York City as a site of renewal for their artistic (or, as the case may be, anti-artistic) impulses. Europe was perceived as a wasteland, both in terms of its literal devastation and of the very attitudes of nationalism that had led to war—attitudes that many artists perceived in terms of an anti-individualism damaging to artistic creation. In Europe, stated painter Albert Gleizes in 1915, "[t]he individual is being crushed or welded into a vast instrument to be swayed by the despots who control all destiny there today."[9]

Gleizes' observations mask a more specific set of concerns: clearly World War I traumatized European *masculinity* in particular (a masculinity already weakened by the mushrooming bureaucracy of the increasingly alienating capitalist regime). As Klaus Theweleit has suggested, the very nationalism endemic to the war and its aftermath (including the rise of fascism in Germany) was itself a masculinizing reaction against the perceived "feminization" of culture by the commodification of everyday life. Masculinity during this period took its armored, militaristic shape in opposition to the threatening flows of capitalism, themselves metaphorized through the bodies of Jews, women, and communists.[10]

As I have argued at length elsewhere in relation to Rrose Sélavy, during this period commodity culture itself became associated with femininity, with women the primary consumers in an expanding market economy and female bodies the purveyors of commercial value in advertisements. As a result, broad anxieties about the collapse of individualism, and the corresponding threat to masculinity, were often articulated by male artists and by popular culture in relation to the gender-ambiguous figure of the New Woman or *garçonne* ("boy-girl").[11] The dangerous, even masculinized eroticism of the New Woman marked the collapse of the "separate spheres" that had kept "proper" women out of the public arena in nineteenth-century Europe.[12]

8
"If only America would realize," Duchamp opined, "that the art of Europe is finished—dead, and that America is the country of the art of the future." Duchamp in "The Nude-Descending-a-Staircase Man Surveys Us," *New York Tribune*, September 12, 1915, section 4, p. 2. Or, as Picabia put it, "The war has killed the art of the Continent entirely"; cited in "French Artists Spur on an American Art," *New York Tribune*, October 24, 1915, reprinted in *Dada/Surrealism*, no. 14 (1985), p. 131.

9
Cited in "French Artists Spur on an American Art," p. 130. Gleizes, who was far more conservative aesthetically than Duchamp or Picabia, had come to the US during the war.

10
See Klaus Theweleit's monumental *Male Fantasies*, vols. 1 and 2, Stephen Conway, Erica Carter, and Chris Turner, trans. (Minneapolis: University of Minnesota Press, 1987, 1989).

11
See Jones, "Rrose Sélavy in Context: The New Woman, The Advertisement, and the Photographed Woman as Fetishized Commodity," in *Postmodernism and the En-Gendering of Marcel Duchamp*, pp. 160–73.

12
Prostitutes were the only women who roamed the streets unescorted or purveyed their own "business" activities outside the home.

Given the threat imposed by women engaging freely in the public realm (or, for that matter, by woman-as-flow), it is perhaps not surprising that cultural representations labored to re-contain recalcitrant femininity. In the case of New York Dada, the (largely male) artists' antagonism toward bourgeois culture was articulated primarily in terms of mechanical tropes that encoded the anxieties of this threatened masculinity in relation to American industrial capitalism. Furthermore, this encoding had a particular resonance in terms of gender: while critics could claim a masculinizing function for the shift of culture from a decadent, depleted Europe to the "virile" field of America (with one critic remarking that "[t]his shifting of field from Europe to America implies a ceaseless alertness which proves art virile and assertive"[13]), New York Dadaists such as Picabia articulated the forms of the Americanized machine as explicitly *feminine*.[14] The New Woman bore the attributes of both women (she was, after all, anatomically female) and men (she was threateningly independent, sexually in charge, even—perhaps—a lesbian, and so doubly dangerous to the heterosexual masculine matrix of sexual difference). The Americanized New Woman, mapped into the feminized machine image, figured the threat of American industrial capitalism to European masculinity (or, in some cases, such as Duchamp's *Large Glass* (p. 50), strategically exacerbated it).[15]

> Marcel Duchamp, *The Bride Stripped Bare by Her Bachelors, Even (Large Glass)*, 1915–23:
> a huge mechanized "portrait" of the impossibility of consummation, the breakdown
> of gender relations, and heterosexual erotic exchange. The Bride, puffed up,
> waiting, exhaling her wistful, milky cloud above the strict horizon line dividing her
> definitively from the bachelors (this line is also the clothes stripped off in the
> haste to consummate). Aided by the chugging wheel of the gliding water mill-chariot,
> and the flaccid mechanics of the coffee grinder, the bachelors stand, sadly, in
> "uniforms and liveries" (hackneyed ex-soldiers hoping to cop a feel or a look), spewing
> impotent and "illuminating" love gas through the sieves. The gas dazzles downward
> into liquid ("splash!") then upward through the oculist witnesses, who look
> on, providing a transfer point for the subject- object relations of the *Mariée* and
> the *Célibataires* (the two sides of the self as well as of the self-other dyad).

Duchamp's *Large Glass* explores rather than represses the ambivalence that structures the engagements and clanking "flows" of industrial-erotic energies, an ambivalence that threatens always to rupture their clear path to "production" (which utopically seeks to replace the mess of procreation). While Duchamp mapped capitalism's dangerous freeing of libidinal flows and gender boundaries, Picabia and Man Ray rather faithfully traced the anxious lines of a projected female body/machine-as-container-of-the-uncontrollable-(feminine)-flows-of-commodity-culture: the iron-bodied "Catherine" of Man Ray's *Catherine Barometer* (1920), with her impotent phallic thrust, defuses the "feminization" of culture during the Victorian and subsequent periods;[16] Picabia's mechanical "girl born without a mother" images both replace women's role in procreation with a model of God-like creation and ensure that the "girl" will be around for the whims of the remaining world of men.[17]

13
Words of the anonymous author in "French Artists Spur on an American Art," p. 129. Paradoxically, the European artist-immigrants to New York touted the United States—which was beginning to emerge as the world center of industrial capitalism—as more nurturing of a masculinized individualism. Thus, Picabia perspicaciously observed that American culture epitomized the next stage of industrialism—far beyond the lingering archaisms of European culture. In his words, American culture inspired him to see that "the genius of the modern world is machinery....perhaps the very soul [of human life]"; ibid., p. 131.

14
This point and much of the following section is indebted to Caroline Jones' excellent article, "The Sex of the Machine: Mechanized Bodies in Early Modernism," unpublished paper, 1995. See also Nancy Ring, "New York Dada and the Crisis of Masculinity: Man Ray, Francis Picabia, and Marcel Duchamp in the United States, 1913–1921," Ph.D. diss. (Evanston, Illinois: Northwestern University, 1991). On the alignment of the threatening woman with the machine (which can then be destroyed) see Andreas Huyssen's discussion of Fritz Lang's *Metropolis* (1926) in "The Vamp and the Machine," in *After the Great Divide: Modernism, Mass Culture, Postmodernism* (Bloomington: Indiana University Press, 1986), pp. 65–81.

15
This threat is made clear by a French journalist's account from 1925: "The innocent young thing of yesterday...has given way to the *garçonne* of today....Add to this sports, movies, dancing, cars, the unhealthy

17
See Picabia's c. 1916–18 gouache *Fille née sans mère (Girl Born Without a Mother)* and his 1918 book of drawings and poems, *Poèmes et dessins de la fille née sans mère* (reprint, Paris: Éditions Allia, 1992). Note especially the poems "Polygamie," with its "vagin printanier" ("vernal vagina"); "égoïste," with its "Américaines" (New Women?); and "Hermaphrodisme," with its visible sperm, oviduct, and sexual apparatus.

16
On this Victorian-era feminization of culture specifically in the US context, see Ann Douglas, *The Feminization of American Culture* (New York: Anchor Press/Doubleday, 1988).

most intelligent woman in the world today, the only one that always knows what she wants, and therefore always gets it"; from "The Nude-Descending-a-Staircase-Man Surveys Us," p. 2.

need to be always on the move—this entire Americanization of old Europe, and you will have the secret to the complete upheaval of people and things"; M. Numa Sadoul, writing in *Progrés Civique*, June 13, 1925, p. 840; cited by Jones, "The Sex of the Machine," pp. 21–22, who develops this point at length. Duchamp put a more positive spin on this dynamic, commenting in a 1915 interview that "[t]he American woman is the

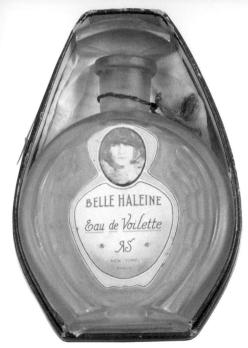

Man Ray's Dadaist objects are violently ambivalent on a conceptual-ideological level
(if also aesthetically rather clumsy); tellingly, they conflate gender politics and
the complex politics of commodity culture.

Man Ray, *New York* or *Export Commodity*, 1920 (p. 128): metal ball bearings in glass
olive jar. Domestic container filled with hard, ungiving metal spheres (paradoxically,
these little turgid balls grease the machinery, making it flow; here, they clog the
orifice of the phallic jar). Stuffed jar-olives, pistons thrusting in and out—New York
itself as a commodity (feminized) to be exported as so much cultural "stuff" to
reinvigorate the European spirit.

Man Ray, *Homme (Man)* (also known as *La Femme*), 1918 (p. 108): open, penetrable cage
of thin metal whose purpose—beating eggs (chicken ova, unfertilized)—is domestic. Yet,
hanging downward from its gears and handle, it's saclike (doubled: two sacs) and vaguely
phallic. Man Ray couldn't decide on its "gender."[18]

18
See also Man Ray's
Woman, 1918, a strip of
glass seemingly held togeth-
er by clothespins (vicious
projectiles in shadow), every
housewife's favorite tool for
hanging. Two concave light
reflectors—receptacles that
also throw back what they
receive—leak light through
two blind but "seeing" holes.

Finally, how radical are these objects and pictures that pretend to destroy the aesthetic and its bour-
geois pretensions? to join art irrevocably to life itself? Displayed and honored as objects of visual
and contemplative pleasures (connoisseur's delights), the objects inform New York Dada, a
"movement" constructed more or less retrospectively by European Dadaists and their followers,
which itself becomes a greased wheel in the machine of commodity culture that is art history and

Man Ray, Baroness Elsa von Freytag-Loringhoven, 1920

its institutions. Perhaps the best lesson, taught by the *maître* Duchamp, is that in fact there is *no way out* of the circuits of desire that capitalism puts into play. One might as well celebrate the "feminization" of subjectivity—its opening to gendered and sexualized flows—that patriarchy fears as a consequence of the commodification of everyday life.

Duchamp, in fact, served as desired object for many of the artists now joined as New York Dadaists. In the US, as a slim, sophisticated-seeming French artist with his finger on the pulse of Parisian avant-gardism, Duchamp—in his own quiet way—triumphed. Both as an object of artistic-spectatorial art-historical desire and as a performer of (from an American point of view) an extraordinarily unconventional "masculinity," Duchamp challenged the structures of the art world—profoundly.[19] Through his very life-as-art, and art-works-as-life, he demonstrated art making and art interpretation to be components in a circuit of erotically invested desires, with meaning itself contingent on the sexually inflected exchange between the subjects and objects of art. While it was Freud who remarked that the struggle for meaning between subjects-objects is necessarily an "erotic" exchange ("we [know] none but sexual objects"[20]), it was Duchamp who extrapolated this in terms of the process by which art comes to have meaning. As he stated in his well-known speech of 1957, "The Creative Act," the phenomenon "which prompts the spectator to react critically to the work of art....is comparable to a transference from the artist to the spectator in the form of an esthetic osmosis...."[21]

21
Duchamp, "The Creative Act" (1957), in Michel Sanouillet and Elmer Peterson, eds., *The Writings of Marcel Duchamp* (New York: Oxford University Press, 1973), p. 139.

20
Freud, "The Dynamics of Transference" (1912), in Phillip Rieff, ed. *Therapy and Technique* (New York: Collier Books, 1963), pp. 114, 112.

19
Duchamp's desirability is confirmed not only through the obsessive references to his work and persona in art historical accounts of contemporary art but also through his appeal to other artists, including many women. He was the subject-object of numerous portraits by female artist admirers: several portraits by the baroness and Florine Stettheimer, including the latter's elaborate play on the mutable engendering of Marcel/Rrose; an abstract portrait by Dreier; and a number of charming drawings by Beatrice Wood. I discuss Stettheimer's piece at some length in *Postmodernism and the En-Gendering of Marcel Duchamp*, pp. 119–20.

Duchamp—"exotic" import from the French avant-garde—portrays himself in a
complex array of gendered and obliquely eroticized subjectivities, the most
famous of which is fixed in the group of photographs
taken by Man Ray, soon thereafter to join the
discursive field Duchamp labeled "Rrose Sélavy."

Marcel Duchamp and Man Ray, *Rrose Sélavy* images, and cover of *New York Dada*,
c. 1920-21: the man-woman *Rrose Sélavy*, Duchamp's performance as a bourgeois female
(New Woman? garçonne?), object of male-female desires, flamboyant transgressor
of masculine fears of the New Woman. Pictured on the (imaginary) commercial
product, "Belle Haleine" ("beautiful breath") perfume and, in turn, on the premiere
issue of New York Dada, she gives value (through her celebrity appeal) to both
"products." She is also multiply fetishized: photographic image as fetish;
woman-as-image as fetish; woman-as-commodity as fetish; perfume-magazine as
commodity fetish; Duchamp-author as fetish; New York Dada as art historical fetish, etc.—
in an endless exchange of values of the most mutable kind.[22] The art-making-viewing
system is itself marked as an economically and erotically based system of
exchange. We are made subjects of, drawn into, Duchamp's engendering play
of himself as subject and object of art.[23]

Along with Duchamp, the baroness—a quintessential New Woman who was fiercely independent of her bourgeois German family and masculine in her lack of "feminine" shame and her writerly and performative self-confidence—unhinged the European masculinity that sought to confirm itself elsewhere.[24] The baroness, a maverick writer with a wicked crush on Duchamp, performed herself in dramatically unglued personifications: she moved throughout the city with shaved and painted scalp, headdresses made of birdcages and wastepaper baskets, celluloid curtain rings as bracelets, assorted tea balls attached to her bust, spoons to her hat, a taillight to her bustle.[25] The baroness's fixation on Duchamp ("Marcel is the *man* I want"[26]) marks her perception of their compatibility as artistic transgressors: both *performed* Dada in the deepest way.

Rather than *representing* Dada concepts—such as the eroticized woman-as-machine of Picabia's numerous drawings and paintings—the baroness lived them. Not incidentally, in 1922 she was identified as the embodiment of Dada itself: "the first American dada...she is the only one living anywhere who dresses dada, loves dada, lives dada."[27] Given the baroness' perhaps too total identification with the anti-aesthetic boundary-breaking nonsense of Dada, it is grotesquely fitting that, while Picabia, Man Ray, Crotti, and the others went on to more or less successful careers making objects (with Duchamp reserving himself for posterity,)[28] the baroness could only self-destruct—dying at the early age of fifty-three after returning to Europe in the 1920s and living in abject poverty for several years. Performing herself across boundaries—as penniless woman-for-sale, New Woman-artist, mannish lover-of-Duchamp, outlandishly androgynous streetwalker, a proud feminist dependent on male support[29]—she became increasingly unbounded and ultimately "disap-

22
Jones, *Postmodernism and the Engendering of Marcel Duchamp*, pp. 164–68, for a more extensive discussion of this dynamic of fetishization, which is indebted to the work of Abigail Solomon-Godeau.

23
As I discuss at length in my forthcoming *Body Art/Performing the Subject*, the continuing significance of Duchamp's self-engendering gesture for what we now call postmodernism is abundantly clear. See Andy Warhol, *For Rrose Sélavy and Belle Haleine* (1973), in which, wearing a showman's striped jacket and a huge Afro wig, this decidedly queer artist sits on bleachers surrounded by a bevy of showgirls (or are they "men" in drag?); reprod. in Kynaston McShine and Anne d'Harnoncourt, *Marcel Duchamp*, exh. cat. (New York: The Museum of Modern Art; Philadelphia: Philadelphia Museum of Art, 1973), p. 227.

24
Born in northern Germany in 1874, Elsa von Freytag-Loringhoven ran away from home at the age of eighteen to live on her own. See her autobiography, *Baroness Elsa*, Paul I. Hjartarson and Douglas O. Spettigue, eds. ([Canada]: Oberon Press, 1992). I am grateful to Naomi Sawelson-Gorse for sharing this source with me.

25
These descriptions are drawn from Robert Reiss, "'My Baroness': Elsa von Freytag-Loringhoven,"

Dada/Surrealism, no. 14 (1985), p. 86; Naumann, *New York Dada 1915–23*, p. 169; and *Baroness Elsa*, pp. 9–10.

26
Cited in Naumann, *New York Dada 1915–23*, p. 172.

27
Ibid., p. 168, from J[ane] H[eap], "Dada," *The Little Review* (Spring 1922), p. 46.

28
Duchamp slowed his production of art works drastically after the Dada period. I discuss his "silence" and the way in which it increased his mystique for the American art world in

Postmodernism and the En-Gendering of Marcel Duchamp; see especially "Duchamp's 'Indifference' and Duchamp's 'Silence,'" pp. 66–69.

29
In her autobiography she writes, "my feminine pride demanded of me to find a lover to provide for me," *Baroness Elsa*, p. 53.

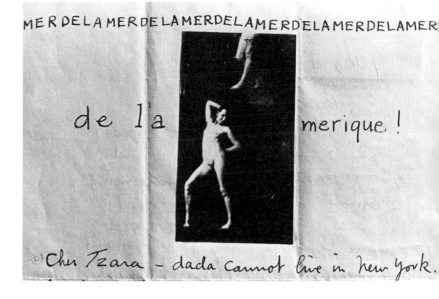

MER DE LA MER DE LA MER DE LA MER DE LA MER DE LA MER

de l'a merique !

Cher Tzara — dada cannot live in new york.

pearcd," a victim of, in her words, "my own honest love nature—and my unfitness to deal with the world—*unprotected*."[30]

30
Ibid., p. 69.

 Man Ray, *Letter to Tristan Tzara*, showing photograph of the baroness, 1921: the anatomically female body bared shamelessly, crotch shaved, arms defiantly splayed for maximal viewing effect, legs strongly planted and firm. Here, she's Man's letter "A" of "*l'Amérique*," the *garçonne* who seems American (because of her scary independence?) even though she's not. The baroness' body (her performed self) *signifies* Americanness/Dada/the stripping bare of the bride of capitalism; through this body-self she took the ultimate risk of riding the almost invisible line between subject and object, woman as artist and woman as object (body as commodity).

As Francis Naumann has discovered, the baroness made a plaster cast of a penis that she used to shock all the "old maids" she met.[31] One could argue that this fake penis signaled her adoption of phallic attributes (as New Woman), but also that she marked the penis as *transportable* rather than as a fixed, biologically determined guarantor of phallic privilege.[32] It was for this transgression as well, perhaps, that the baroness, who violently transgressed conventional notions of Euro-American femininity, had to disappear: for, even within Dada itself, such a blatant symbolization of the continuing (if threatened) privilege of the male artist could not be allowed. It was imperative that the New Woman, per Picabia, be contained within the anxiety-reducing mechanomorphic forms of

31
Naumann, *New York Dada 1915–23*, p. 173.

32
On the penis as transferable attribute, see Judith Butler, "The Lesbian Phallus and the Morphological Imaginary," in *Bodies That Matter: On the Discursive Limits of 'Sex'* (New York: Routledge, 1993), pp. 57–91.

CHARLES DEMUTH, TURKISH BATH, 1916*

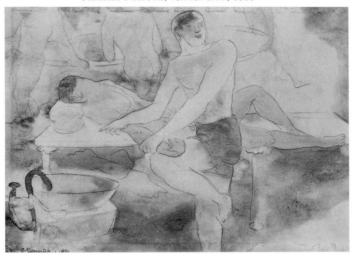

the facetious machine image, not parading freely through the streets wielding a penis clearly disat-tached from its conventional role as guarantor of male privilege.

The baroness' performative (rather than biological) penis, along with Marcel's erotically invested *garçonne*-esque eros/Rrose-as-commodity, were the ultimate weapons against the bour-geois norms that Dada in general is thought of as radically antagonizing. There were, however, other penises that were equally disturbing to the anxious masculinity seeking to reconfirm its bor-ders during this period, confirming that this masculinity took its shape not only through its oth-ering of femininity but also through its opposition to the homosexual. Penises not erected in the direction of heterosexual penetration thus also deeply challenged the assumptions embedded in conceptions of artistic creation at this time.

Two "misfits," one a slightly crazed German immigrant, flaunting her ambiguous
yet voracious sexuality and her anomalous subjectivity (as woman-model-artist/writer),
the other a homosexual man forced by art history into the heterosexualizing/heterosexist
male model of the modernist artist, presented objects that inscribed sexualities
profoundly disruptive to the structures of art production and reception that were left
undisturbed by much Dada work. Charles Demuth, who frequented nightclubs
with the always congenial party-goer Duchamp, dressed the part of a dandy-aesthete and
admired Oscar Wilde and des Esseintes, the aesthetically saturated and hedonistic hero
of Huysmans' novel *À rebours* (1884). Providing a link between the nineteenth-century

decadents and the erotically inclined, but generally heterosexist and often patriarchal New York Dadaists, Demuth played out his sexual desires in tender, erotic watercolors. These have been largely erased from historical accounts of New York Dada, even when Demuth, a marginal Dada at best, is included in such histories.[33]

Baroness Elsa von Freytag-Loringhoven, *God*, c. 1917 (in a photograph by Morton Schamberg):[34] here the penis-phallus, ultimate signifier for the transcendent ruler of all, is contorted into a pretzel of plumbing (the site, after all, where resides the detritus of the basest of human functions). Brilliantly turning the tables on the woman-as-machine trope, the piece insists on the link between industrialism and masculinity (yet there's that sensuous, feminine curve to these pipes...).[35]

Charles Demuth, *Turkish Bath*, 1916: a narrative, illustrative version of forbidden contortions of the heterosexual matrix of "proper" sexual difference, the image (with its febrile line and puckered paper patches of scrumptious flesh) is gloriously steeped in male-to-male desires. Playing on the long tradition (à la Ingres) of the exotic female-other presented in titillating, lesbianized contexts for heterosexual, European, male viewing pleasure, Demuth—like the baroness, like Duchamp—turns the bourgeois morality that continues to plague much of Dada ass-backwards.

Finally, then, the merging of art and life is at least momentarily achieved—through a polymorphous eroticization that has been remarked upon but largely downplayed in art historical accounts of the period.[36] There are at least two interesting lessons provided by such an investigation of the sexualized explorations of New York Dada: first, that of the resistance of art history to accommodating the most extreme (and, notably, least commodifiable) examples of the avant-garde into its normalizing narratives; second, that of the intense challenges provided by artists who *performed* rather than *illustrated* the sexualization of modern subjectivity in capitalism. Taking the lesson provided by the mutability of the baroness' penis and Duchamp's "femininity," we might begin to rethink the ways in which these most extreme sexualizations of the artistic subject have permeated contemporary artistic practice—and what *this* means in terms of the historical linkages between the global disruptions and explosive incursions of capitalism in the teens and twenties and those of the 1960s and beyond.

33
Demuth's homoerotic watercolors have been dealt with to some extent in relation to his own career; see Barbara Haskell, *Charles Demuth*, exh. cat. (New York: Whitney Museum of American Art, 1987), and Jonathan Weinberg's important book, *Speaking for Vice: Homosexuality in the Art of Charles Demuth, Marsden Hartley, and the First American Avant-Garde* (New Haven and London: Yale University Press, 1993); much of the foregoing description of Demuth comes from Weinberg's account. However, texts on New York Dada tend not to discuss these images at any length, focusing instead on Demuth's less provocative imagery.

34
The attribution of this piece has been debated. I accept here Francis Naumann's typically thorough attribution of the piece to the baroness, with Schamberg responsible for the well-known photograph of the piece.

35
We might productively compare this to Duchamp's 1917 *Fountain*, which presents the obverse of the baroness' impossibly looped yet still rigid phallus—a urinal shaped like a womb, ready to embrace the "piss" ejaculate of every male passerby, yet, turned sideways, unable to drain it away.

36
In *Postmodernism and the En-Gendering of Marcel Duchamp*, I discuss the way in which American accounts of Duchamp, who became an insistent presence in discussions of postmodernism from the 1960s through the 1980s, generally ignored Rrose Sélavy and even downplayed the *Large Glass*, focusing instead on the institutional critique of the readymades. Aside from Francis Naumann's thorough accounts, the baroness has been marginalized in the histories of New York Dada. And, as noted above, Demuth's homoerotic imagery has been excised from all accounts of New York Dada, even when he is included as a member of the movement.

The oBJECT CAUGHT *by the* HEEL

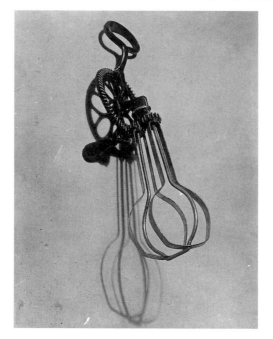 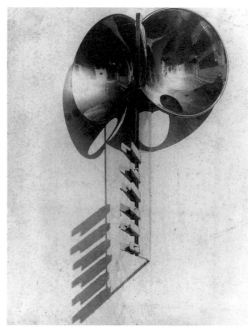

left: MAN RAY, HOMME (MAN), 1918; *right:* MAN RAY, FEMME (WOMAN), 1918

If we agree (but perhaps some of us won't) that the section of New York Dada devoted to photography has only one real photographer-member in it—and his name is Man Ray—then we will have to go the next step and admit to the rarity of the phenomenon altogether, since the photographs Man Ray actually executed before leaving New York for Paris in July 1921, can be counted on the fingers of both hands.[1] Leaving aside the photographs he made for Duchamp, like *Dust Breeding* (1920) (p. 130), and possibly *Shadows of Readymades* (1918) (p. 109), or the various portraits and interior shots he executed, his own Dada photographs are: *Homme (Man)* (1918), *Femme (Woman)* (1918), *The Enigma of Isidore Ducasse* (1920), *Portmanteau (dadaphoto)* (1920) (p. 138), *8th Street* (1920), *Compass* (1920) (p. 136), *New York (Transatlantique)* (1920) (p. 2), *Moving Sculpture* (1920) (p. 135), and the 1920 untitled shot of a woman with a cigarette in her mouth taken at a radically oblique angle so that most of the image consists of a cascade of her hair.[2]

To try to broaden the category by adding the photograph Morton Schamberg took of his and Baroness Elsa von Freytag-Loringhoven's readymade/sculpture *God*, or the one Stieglitz shot of Duchamp's readymade *Fountain* (1917) (p. 9) is not really to build anything very significant about a genuine Dadaist photographic practice, but merely to focus on the fact that certain photographers made photos of the work of others, and certain artists made photos of their own. Nor is it likely to get us very far in hypothesizing what might be meant by a Dada photograph, New York or otherwise.

Instead I'd like to begin with the fact that Man Ray's first two such objects—*Homme (Man)* and *Femme (Woman)*—stake their photographic interest on the relation between a readymade and its shadow. For in each of these works, the "point" is a kind of exfoliation of the physical object into the virtual space of its flattened, wall-bound reflection, where, redoubled by means of cast shadow, it functions to reinterpret the mass-produced object—eggbeater on the one hand and photographer's lamps and drying paraphernalia on the other. Which means that Man Ray has here entered the discourse on the readymade, then very active within New York Dada circles, to produce a photographic variation on it of a particular kind. And this means, further, I would claim, that so-called New York Dada photography cannot be thought of apart from the contemporary deployment of the readymade across the whole gamut of work devoted to it, primarily at the hands of Duchamp and Picabia.

For the readymades existed in various forms and in several media. They came: 1) as real objects, often signed and titled (such as Duchamp's *Fountain*); 2) also in the form of such objects put in circulation because they were photographed and published (Stieglitz's photograph of Duchamp's *Fountain* published in *The Blind Man* [May 1917]); 3) as well as in the published form of the mechanomorph, which presented a readymade either in its graphic version by means of the highly impersonal technique of industrial drawing (as in Picabia's *Ici, c'est ici Stieglitz/Foi et amour [Here, This Is Stieglitz/Faith and Love]* (p. 56) or *Voilà Haviland [Here is Haviland]* (p. 52) [both 1915]) or its photographic version (as in Picabia's *Américaine [American]* (p. 101), the cover of *391* [July 1917]); and 4) in the form of disembodied shadows—as in the trace of a group of readymades cast on the wall (*Shadows of Readymades* made for Duchamp in 1918 possibly by Man Ray) or cast on a canvas (Duchamp's *Tu m'* [1918]) (p. 106).

1
Francis Naumann has added Alfred Stieglitz' *Spiritual America* (the photograph of a gelding's genitals) and his 1921 photomontage reproduced in *New York Dada* to this group. The latter is a sandwich print of a portrait of Dorothy True and an advertising photograph of a stockinged leg. It is hard for me to see this as constituting anything like a real Dada practice on Stieglitz' part.

2
Mina Loy's portrait (*Portrait [Mina Loy]* [1920]) leaves it open whether this should count among the few Dada photographs, or is another of the group of portraits.

3
Various scholars emphasize
cast shadow as evidence of
Duchamp's concern with
"things-in-themselves" exist-
ing in a world beyond the
conditions of three dimen-
sions, for example, Linda
Dalrymple Henderson,
The Fourth Dimension and
Non-Euclidian Geometry in
Modern Art (Princeton, New
Jersey: Princeton University
Press, 1983), pp. 157–158.
For a different view see
my "Notes on the Index,"
in The Originality of the
Avant-Garde (Cambridge,
Massachusetts: MIT Press,
1983).

If we set the last of the possibilities aside for a moment, since Duchamp's attitude toward cast shadow forms its own special point of controversy,[3] we see that the readymade's discursive form is that of the commodity-in-circulation, which is to say an exploitation of the commodity's own eco-nomic condition as an object of exchange now redoubled by its location in the pages of a magazine and thus ready for dissemination within the world of high culture. Indeed it is as a peculiarly place-less and shadowless object, quite isolated from any context, that Duchamp presents his *Chocolate Grinder* on the cover of *The Blind Man* (May 1917) or Picabia stages the spark-plug rendition of *Portrait d'une jeune fille américaine dans l'état de nudité* (*Portrait of a Young American Girl in a State of Nudity*) (p. 52) in the pages of *291* (July 1915). The readymade's logic is thus articulated as several interrelated corollar-ies of mechanical production: 1) at the level of the subject, the readymade strips away the unique-ness of the individual (as in Picabia's mechanomorphic portraits or Duchamp's *Oculist Witnesses* [1920]), replacing it with a more robotic conception of personhood; 2) at the level of production, the readymade's industrial condition involves a depersonalization and "de-skilling" of the image, which can lead equally in the direction of the real object, of the photograph of the object, or of the industrial drawing of the object—both photograph and commercial rendering seen as paired mechanical options; and 3) at the level of the logic of dissemination, the readymade is under-stood—and presented—as a "token," a depthless sign of equivalence within a system of pure exchange.

The aspect of photography exploited by this complex is, then, its condition as a multiple (and thus itself a form of "token") as well as a view of it as automating the production of the work of art, the fruit of the marriage—as Paul Haviland wrote in the September 1915 issue of *291*—of man and the machine. Haviland's characterization is thus a celebration of the photograph as itself a form of readymade, or an object of pure exchange-value.

Although all of Man Ray's Dada photographs bear on the condition of the readymade, his own insistence on the inclusion of cast shadows radically alters the interpretation of the photo-graph's relation to the mechanical object. For the cast shadow, as a form of index, firmly glues the object to the place at which it was when it cast its shadow, producing the indissolubility of cause and effect, the shadow firmly catching the object by its heel, as it were. And in so dramatizing this cap-ture of the object by its context, the shadow enacts the photograph's own condition as index, as a photo-mechanically produced form of trace: always taken at a certain angle and under certain lighting conditions, it is the document of a relation between photographer and object that forced each to be present to the other in an actual moment of time. The very opposite of a circuit of exchange, this sense of being rooted to the spot at which an event occurred opens onto what Walter Benjamin had seen as the most ancient of art's possible conditions—that of cult value—or Barthes had called the precondition of the photograph as "punctum," the undeniable fact that "that-has-been."[4]

4
See Roland Barthes,
Camera Lucida,
trans. Richard Howard
(New York: Hill and Wang,
1989), p. 96.

It might be argued that Man Ray's fixation on cast shadow itself derived from Duchamp's since the two earliest photographs date from the moment in 1918 when Duchamp was painting *Tu m'* and producing *Shadows of Readymades*, in which Man Ray may have collaborated. But aside from Man Ray's relation to shadow having very little to do with anything we might call Duchamp's con-cern with n-dimensional projection, his own interest in cast shadow dates from 1916, when he

made *The Rope Dancer Accompanies Herself with Her Shadows* (p. 79), having picked up fallen scraps of cut paper from the floor, because he saw them as the shadows cast there by an imagined tightrope walker dancing above his head.[5] And in this account, although it relates to painting and not to photography, we have the experience of a spot that marks the intersection of two trajectories mutually present to one another: the observer's point of view and the shadow's projection from the object.

To understand the photograph as the imprint left by an object, in a process that turns that object into the residue of an event, is of course to write a general description of the rayograph, which Man Ray would begin to make the year after he arrived in Paris, which is to say in 1922. But this notion of traces and residues and events was already being sketched out in the small collection of New York photographs between 1918 and 1920. In each, the event of the photograph is nakedly dependent upon point of view, some of them radically oblique, as when the ashtray's container in *New York (Transatlantique)* is seen dramatically from above, or the smoker's head in *Untitled* is taken from way below. In many the idea of the photograph as a kind of residue is thematized within the image, as in the burnt waste of *New York (Transatlantique)* or the cigarette ash of *Untitled* or the crushed tin of *8th Street*. In almost all of them the (readymade) object as the generator of the event is insisted upon even when the object is unseen, as in *The Enigma of Isidore Ducasse*, or anthropomorphized, as in *Homme (Man)* or *Portmanteau*. And of course the rayograph as Man Ray practiced it would continue and even heighten each of these aspects.

Is this to say that in subtracting the readymade—and the photograph—from the condition of "token," or pure exchange-value, to which the Dada practice of Duchamp and Picabia had consigned it, Man Ray had betrayed the readymade logic by somehow returning the object to the realm of painting? The answer, I think, should be no. Since the readymade logic itself was aimed squarely at the realm of high art in order to reveal the sense in which art was already caught up in the system of exchange and of the deracination of objects by removing them from their original sites in order to circulate them within the rootless condition of the museum, the notion of the object attached to its shadow should not be seen as regressive. Rather, it seems to look forward to a larger project into which Man Ray's photography would flow in the later 1920s and '30s, in which the art system itself would continue to be critiqued from the point of the view of the object that—caught by the heel—is able to hold out against exchange.[6]

5
Man Ray tells this anecdote in his *Self-Portrait* (Boston: Little, Brown, 1963), pp. 66-67.

6
For an analysis of this, see Denis Hollier, "The Use-Value of the Impossible," *October*, no. 60 (Spring 1992).

MOLLY NESBIT

Duchamp's READYMADES

MARCEL DUCHAMP, COMB, 1916*

They were things, remember.

Take them off your mind.

It bears noting that there was never anything consistent about the things Duchamp called ready-mades. There still is not, though many have tried plotting a logic for them, sometimes with genital roles. But there was nothing logical or specific about them, best to be clear. There was nothing clear. There they sit, perpetual, old-fashioned conundrums, eternally open questions, or better, since they are not themselves questions, eternally open, intractable objects, like tops with no bottom or spin. Duchamp imagined a reciprocal readymade with these instructions: "Use a Rembrandt as an ironing board."[1] Alone in his room, he joked.

He liked laughing beyond the pale.

Readymades were not made to ever become works of art. They existed differently, lived in Duchamp's studio which was also his bedroom, as sporadic hot and light negations, like the idea of paint not yet melted, like the idea of a Rembrandt bleeding brown through the weave of a shirt. A brighter readymade would be chosen at random at a specific time on a specified day.[2] For one, the dog comb which apparently fell into his line of sight at 11 a.m. on February 17, 1916, to leave the dog's side forever, like the other readymades, permanently dissociated now, kept apart. It would often happen that by accident, when moving house, someone else would expand upon this distance and throw the readymade out.

What had it meant in the first place to pull these things away?

All this was born of Duchamp's indifference: he felt it important to insist that good taste be spurned; he made fun of those, like Gertrude Stein, who loved their objects; he did not love his.[3] He did not think it at all worthwhile to find them beautiful. As for those who wanted to, that was their affair, their philistine endeavor, rank mistake. He was looking for another kind of relation to experience.

If possible, do not look.

In late 1916 he enameled Guillaume Apollinaire by taking a sign for Sapolin Enamel and pulling at its letters, painting the poet, who was then off fighting World War I, into an empty bed. Indifference would not preclude memory or wit.

What hears a thing laugh?

The line of things started with the bicycle wheel in 1913 in Paris, having, he said, no fireplace and seeing that the bicycle wheel if spun could stand in for the flicker of the flames.[4]

1
Michel Sanouillet and Elmer Peterson, eds., *Salt Seller: The Writings of Marcel Duchamp* (*Marchand du sel*) (Oxford: Oxford University Press, 1973), p. 31.

2
Ibid.

3
Walter Arensberg took notes from a conversation he had been having with Duchamp on the matter of taste and Gertrude Stein: "Gertrude Stein + the Steins are *people of taste*. Even when their taste is bad. Marcel spoke of the bibelots on their mantel pieces— objets d'art which they have picked up in Italy etc etc etc and handle and love etc etc." The note seems to date from the spring of 1916 and has been published by me and Naomi Sawelson-Gorse in "Concept of Nothing: New Notes by Marcel Duchamp and Walter Arensberg," in Mignon Nixon and Martha Buskirk, eds., *The Duchamp Effect* (Cambridge, Massachusetts: The MIT Press, 1996), pp. 130–75.

4
Georges Charbonnier, *Entretiens avec Marcel Duchamp* (Marseilles: André Dimanche, 1994), p. 60.

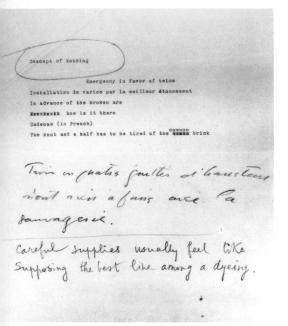

Mounting the wheel on a stool, he left the matter there. The second readymade came along then next year. It was an ordinary metal rack, the kind used to dry wine bottles; Duchamp simply bought one at the great basement hardware display in the Bazar de l'Hôtel de Ville and brought it back home to live quietly, unmoved, as something other than itself. About it not being a work of art he was quite explicit.[5] Like all the readymades, it would remain detached. In the future Duchamp would further cut the readymades away by putting a brief inscription on each.[6] Later the readymades would be known by these inscriptions; *3 ou 4 gouttes d'hauteur n'ont rien à faire avec la sauvagerie* would be written down the spine of the comb. But at the time when they were made, or, as Duchamp would say, chosen, all the readymades were first of all things, his things, no more, no less.

At first, only those who knew him well enough to visit would know of their existence. They might know something more of *The Bride Stripped Bare by Her Bachelors, Even (Large Glass)* (1915–23) (p. 50). Were the readymades studies for it? No. For the *Large Glass* he was envisioning a complicated apparatus, or rather two, one for some bachelors and one for a bride, which began as extrapolations from car engines and film projections but would soon enough be twisted into a set of unfinished figures and much speculation. Be that as it may, as the *Glass* became more fantastic and obscure, as its story fell away and sexual possibility alone seemed to be the point, the readymades started to become more numerous. Two of them, the comb and the ventilator inscribed *Pulled at Four Pins*, had been considered as figures for the *Glass*, but once actualized, they were eliminated from its plan; their existence would henceforth be elsewhere; they would be thick volumes, not transparent, readymades kept apart now too from sex.

5
Duchamp made the point repeatedly in interviews. See especially Pierre Cabanne, *Dialogues with Marcel Duchamp* (New York: The Viking Press, 1971), p. 47; Charbonnier, *Entretiens avec Marcel Duchamp*, p. 62; Otto Hahn's interview with Duchamp, published as "G255300 United States of America," *Art and Artists*, 1 (July 1966), p. 10. I have written elsewhere on the ways and means Duchamp used to explore the non-aesthetic; see especially "Readymade Originals: The Duchamp Model," *October*, no. 37 (Fall 1986), pp. 53–64, and "His Common Sense," *Artforum*, 33 (October 1994), pp. 92–95, 124, 126.

6
The bottle rack would get an inscription, which, like the bottle rack, is now lost. From New York, Duchamp sent instructions for painting one on its rim to his sister Suzanne. The letter in which he did so has been published and discussed by Francis Naumann, "Affectueusement, Marcel: Ten Letters from Marcel Duchamp to Suzanne Duchamp and Jean Crotti," *Archives of American Art Journal*, 22, no. 4 (1982), p. 5.

HENRI-PIERRE ROCHÉ, 33 WEST 67 STREET STUDIO WITH HANGING HAT RACK, 1917–18*

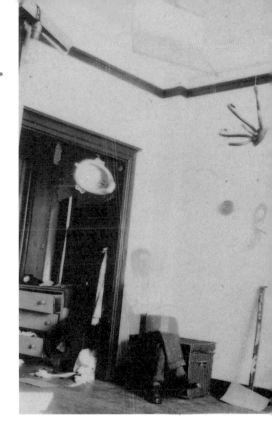

What could care?

The readymades would be called readymades in 1915 once Duchamp moved to New York. There he would learn English, find the company of the Arensberg circle, and develop his work into the various spaces of opportunity opening up there.[7] There was the Arensbergs' salon at 33 West 67th Street and Duchamp's room above, which he would come to occupy in late 1916. The Americans wanted to think of him as a painter, although he did not think of himself that way any-more. He did, however, allow some of his old paintings to be bought and he exhibited in a group show at the Bourgeois Gallery in April 1916 on condition that two of his readymades be shown.[8] They were placed (by the gallery?) in an umbrella stand by the door. Something for the observant, a little quirk, a sign of his charming contempt. They went unremarked. As part of the promotion for the show, a lady reporter had come to call at the studio; Duchamp's friend, the painter Jean Crotti, pointed out the snow shovel hanging from the ceiling.[9] Crotti told her he thought it beau-tiful. If Duchamp said anything about it, she did not write it down. No one told her it had an inscription, *In Advance of the Broken Arm* (1915) (p. 51). No one told her how they were pulling her leg.

The readymades were by then developing in tandem with the language experiments Duchamp had begun in Paris and continued with Walter Arensberg. They played with the wide range of designation possible whenever one used words. French did not have to give way to English; both men spoke both. Arensberg was a practiced cryptographer; Duchamp played to no particular

7
On Duchamp and the Arensbergs, see Naumann, *New York Dada 1915–23* (New York: Harry N. Abrams, 1994) and Naomi Sawelson-Gorse, "Marcel Duchamp's 'Silent Guard': A Critical Study of Louise and Walter Arensberg," Ph.D. diss. (Santa Barbara: University of California, Santa Barbara, 1994). Duchamp describes his sense of his professional identity in his correspon-dence with Walter Pach, published by Naumann as "Amicalement, Marcel: Fourteen Letters from Marcel Duchamp to Walter Pach," *Archives of American Art Journal*, 29, nos. 3–4 (1989), pp. 36–50.

8
See Naumann, *New York Dada 1915–23*, p. 228 n. 35.

9
Nixola Greeley-Smith, "Cubist Depicts Love in Brass and Glass; More Art in Rubbers Than in Pretty Girl!", *The Evening World*, April 4, 1916, p. 3.

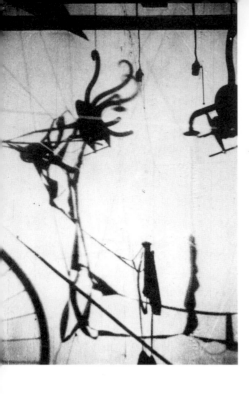

10
For a discussion of these language experiments and the place of the inscriptions there, see Nesbit and Sawelson-Gorse, "Concept of Nothing."

system, seeming to prefer the space between languages where nothing made any sense. *The* was part of this. So were the inscriptions for the readymades, which Arensberg worked up into a poem called "Concept of Nothing." The inscriptions followed from an arbitrary sequence of numerical moves, themselves in an order: each letter would have a numerical equivalent and the phrase's words would take their cue from two given number-letters. So that a(1) and b(2) would begin *In Advance of the Broken Arm* and g(7) would follow from *3 ou 4 gouttes d'hauteur n'ont rien à faire avec la sauvagerie.*[10] As the game spun out, the rules would mutate and the system would fold, but not before Duchamp and Arensberg each wrote phrases on the page of the "Concept of Nothing." And not before the word came in to show that the lengths to which the things were going were incomprehensible.

If possible, do not read.

Theirs was a journey with no stops. These things were private. As if to show how private, Duchamp sent one of the readymades to an exhibition slated to open in April 1917. This particular readymade would have all the qualities of a demonstration. The exhibition was being organized by a group wanting to promote modern art in America, hoping to capitalize on the success of the Armory Show and to give artists an annual salon on the model of the French Salon des Indépendants. They would call theirs the Society of Independent Artists and claim that any work submitted would be accepted, that all that was new was good. Their sense of the modern was full of

liberal good intention; consequently their understanding of avant-garde art was deeply flawed. For then, as now, the avant-garde often worked on the line where modern form transgressed; beauty and pleasure were not necessarily priorities; and for Duchamp, neither was art an aim. But the large public exhibition was anyway for him an unsuitable space since it existed for the sake of a public which only wanted to see what it already knew and at least half-liked. Duchamp, being completely uninterested in contributing to this kind of liking, chose a urinal. It became the readymade he sent off to the Society of Independent Artists under a pseudonym, R. Mutt, a play on the name of Mott, the plumbing manufacturer, concocted from the comics.[11] Mutt's true identity was a closely guarded secret. The work was blithely called *Fountain* (1917) (p. 90). The organizers of the show did not want the sidelong urinal showing them the full extent of their many limitations. They sent it back. Duchamp and his friends would then publicize this as a scandal, devise copy that seemed to justify the *Fountain* in terms someone might support, and have Alfred Stieglitz photograph it for a special number of *The Blind Man*. And yet the secret behind the *Fountain* was not shared. The *Fountain* itself slipped back to the space that it had occupied in the first place, a space with no general social ambition or visibility or meaning. Duchamp hung it briefly, it seems, in his room. There it had an existence, just one readymade among the flotsam of the others.

Duchamp turned to consider the readymades' physical properties and effects. He nailed a coatrack to the floor, called it *Trébuchet (Trap)* (1917) (p. 92) and expected it to trip people up. He hung a hatrack and a corkscrew from a line, cut up a few colored shower caps and stretched them across the room, then photographed the long oblique shadows all these things together cast upon the wall. Some of those shadows would be used for his last painting, a commission from Katherine Dreier, *Tu m'* (1918) (p. 106). The shower cap would be called *Sculpture for Traveling* (1918) and would be taken off to Argentina, where Duchamp would go once America entered the war. He called this readymade a cobweb.[12] It would be almost the last of its kind. It too came without attachments.

After a while, the thing took its own revenge and rotted out.

11
The facts of the episode have been established by Naumann, *New York Dada 1915–23*, pp. 46ff., 176ff., and William A. Camfield, *Marcel Duchamp: Fountain* (Houston: The Menil Collection, 1989). See also the reading of the incident by Thierry de Duve in *Kant After Duchamp* (Cambridge, Massachusetts: The MIT Press, 1996), pp. 87ff.

12
See his letter to Jean Crotti, July 8, 1918, in Naumann, "Affectueusement, Marcel," p. 10.

ROBERT ROSENBLUM

A DADA BOUQUET for NEW YORK

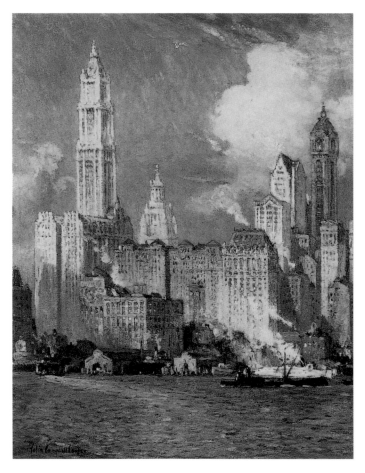

COLIN CAMPBELL COOPER, VIEW OF WALL STREET (STUDY FOR WATERFRONT OF NEW YORK), n.d.*

From Seurat on through Chagall, Delaunay, and Tamara de Lempicka, artists in Paris would depict on their centuries-old skyline that new beacon of technology, the Eiffel Tower, as a symbol of the exaltingly unfamiliar mix of ugliness and beauty that was beginning to soar in modern cities. But this lonely icon could hardly match the full-scale embrace of New York City's modernity, a challenge to both young natives and young Turks from abroad who wanted nothing less than total immersion in the dawn of a new century and a new era.

For a slightly older generation, the rupture between past and present could still be moderate, as seen in the decorously dappled canvases of the American Impressionist Colin Campbell Cooper.[1] Before 1902, he was off in Europe, signing his aristocratic, triple-barreled name to paintings of Gothic marvels, but then he settled in New York, where, as a critic put it in 1906, "he…quickly discovered that Manhattan Island has as much of the striking and picturesque as the Old World towns among which he had been roaming. What is more, the monster buildings that he saw around him, a distinctive New World product, offered an undreamt of field of opportunities…the suggestion of sublimity, the spirit of progress and promise, the manifestation of a surging, restless, all-attempting, all-achieving life essentially American."[2] Within less than a decade, however, Campbell's brightly hued, but politely nuanced views of Manhattan's skyscrapers, where even the pollution of smoke from ferries and chimneys has the loveliness of clouds adrift on a summer day, would be toppled by the most explosive "youthquake" of our century, as a generation of artists born plus-or-minus 1880 hit their twenties. With a seesawing balance of raucous excitement and the most refined drawing-room wit, they fell under the frenetic spell of New York, whose blindness to the past and open-eyed welcome to the future could even turn the City of Light into a graveyard of history. Soon, such photographers as Alfred Stieglitz and Alvin Langdon Coburn began to venerate the gravity-defiant heights of New York's rising skyscrapers,[3] recording in 1912, for example, the almost-completed tallest building in the world, Cass Gilbert's Woolworth Building—a "cathedral of commerce," as it was called by a clergyman at its dedication the following year. In Coburn's photograph, the structure seems to float on the pillows of industrial smoke that had replaced the clouds of Christian heavens.

This 729-foot, 60-story shrine to business and engineering, complete with observation deck reached by the latest velocities in electric elevator technology, summed it all up. After Duchamp arrived in the city on June 15, 1915, he not only claimed that the New York skyscraper was more beautiful than anything Europe might offer, but expressed his hope of finding a studio in some skyscraper's lofty turret[4] (though, in fact, after several moves, he ended up settling a bit closer to earth, on the third floor of the 14-story Atelier Building at 33 West 67 Street, one flight above the Arensbergs). And one year later, shifting from the practical problems of finding housing in New York to his feather-touched undermining of what seemed to him B.C. conceptions of art, he wrote in his notes that he wished to find an inscription for the Woolworth Building in order to declare it a "readymade,"[5] a lofty aesthetic cerebration upon this freshly minted urban symbol of an A.D. world that, by comparison, makes John Marin's earlier, speed-swept views of the building look as old-fashioned as Cubism.

That Dada spirit of total defiance, of flushing all artistic conventions (as Duchamp was

1
For the fullest and only up-to-date account of this fascinating painter, see William Gerdts, *Impressionist New York* (New York: Abbeville Press, 1994), passim.

2
From Willis E. Howe, "The Work of Colin C. Cooper, Artist," *Brush and Pencil*, 18 (August 1906), pp. 76–77, quoted in Gerdts, *Impressionist New York*, p. 31.

3
For an especially well-documented study of these photographic images of Manhattan skyscrapers as well as of all the other related imagery, see Merrill Schleier, *The Skyscraper in American Art, 1890–1931* (*Studies in the Fine Arts: The Avant-Garde*, no. 53) (Ann Arbor: UMI Research Press, 1986).

4
Press interview for the *New York Tribune*, September 12, 1915, reproduced in Francis M. Naumann, *New York Dada 1915–23* (New York: Harry N. Abrams, 1994), p. 36.

5
In note 58 (January 1916), reproduced in facsimile in Arturo Schwarz, ed., *Notes and Projects for the Large Glass* (New York: Harry N. Abrams, 1969), p. 96.

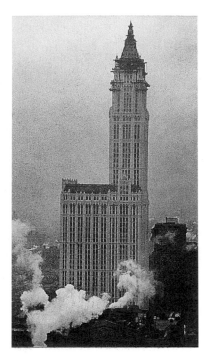

almost literally to do with the scandalous fountain-urinal of 1917, a tribute to, among other things, the American plumbing he admired in New York) was particularly well suited to New York themes, as Man Ray was swiftly to demonstrate. In 1917, jettisoning the traditional materials of arty sculpture in favor of the grass-roots tools of industry, he fixed a carpenter's C-clamp around the varied organ-pipe heights of tilted wooden slats, evoking the dizzying angles and speeds of the city whose name he used for the very title, *New York*, of this heretical version of three-dimensional art. (After this "sculpture" was lost, he would later reconstruct it, in 1966 (p. 87), almost as a relic of his past, now using chrome-plated bronze—more permanent than wood, if less Dada—and wittily lengthening these abstract towers as if to accommodate the ever-rising heights of the New York skyline.) No less charged with Dada's spirit of blasphemous invention is another "sculpture" of 1920 titled *New York* or *Export Commodity* (p. 128). Perhaps in part a response to Duchamp's 1919 gift to Walter Arensberg of exactly 50 cc. of exported Paris air in a pharmacist's ampule, Man Ray enclosed in a 10-inch-high glass cylindrical jar (inscribed at the top NEW YORK) not the olives it originally contained but regimented clusters of metal ball bearings, a perfect New York export item that might suggest anything from rising and falling elevators to the compact lives of high-rise city dwellers. In fact, the following year he literally exported it, taking it to Paris with him, a bottled souvenir of the city that had nurtured his ironic audacities.

Man Ray also took, and reused, a photograph—likewise made in 1920 and first titled *New York* (in Paris, it was later given a second title, *Transatlantique* [p. 2]). If the bottled ball bearings symbol-

ized the regimented and clinically sterile aspect of New York as the Machine Age city, this overhead photo of the discarded contents of an ashtray told quite another story. Once we look down, it seems to say, from the gleaming, sun-shot heights of the skyscrapers to the shadowy New York earth, we find a chaos of filth at our feet, in this case, a total mess of cigarette butts, used matches, crumpled paper, and ashes, the kind of urban debris that Dada often loved to elevate from the bottom of the garbage pail to the lofty domain of art. It is telling that in the same year, 1920, Man Ray looked downward again to photograph the dust that Duchamp had been "breeding" on top of the immaculate, laboratory-like panes of the *Large Glass* (p. 50), obscuring its quasi-scientific cast of hygienic sex machines; and that this same New York oxymoron of repellent detritus mixed with glistening glass and metal could be found in the work of Joseph Stella.

Probably inspired by Duchamp's replacement of canvas by glass, a material fraught with Machine Age symbols of transparency and light (especially mythic in the domain of new architecture), Stella painted and pasted a typically New York vignette on a glass ground: a white-collared, black-hatted man neatly sliced through the glazed geometries of a framed window on one of the elevated trains that, running up and down Third, Sixth, and Columbus Avenues and out into the Bronx, Brooklyn, and Queens, could encapsulate the mechanical, radiating excitement of the shuffling of glass, speed, and people in the city of the future.[6] Elsewhere, Stella's attraction to collage techniques (which in *Man in Elevated [Train]* expands to the witty pasting of a magazine clipping to the rear, not the front, of the glass, thereby adding an extra level of transparency) rejects this

6
Stella's painting is reproduced and discussed in Naumann, *New York Dada 1915–23*, pp. 143–45.

left: JOSEPH STELLA, MAN IN ELEVATED (TRAIN), 1916*
right: JOSEPH STELLA, STUDY FOR SKYSCRAPER, c.1922*

belt-line precision in favor of the grungiest crushes of material from the bottom of a wastebasket, rivaling even Schwitters in the defiance of sanitary proprieties. In one, reproduced in *The Little Review* in 1922,[7] Stella constructs a study for a skyscraper from tilting fragments of dirty, tattered paper (the bottom one punched PAID), opposing streamlined feats of engineering with New York's indifference to streetside cleanliness, a phenomenon still apparent to foreign visitors at the end of our century.

It was already apparent in 1913. When Gabrielle Buffet-Picabia arrived in New York with her husband, Francis Picabia, in late January to attend the Armory Show (where, beginning February 15, two of his paintings were to be unveiled to the public), she was shocked, later telling reporters that her "first impression on landing was that New York must certainly be the dirtiest and dustiest city in the world."[8] Her husband, however, had no problem looking beyond this street-level truth into the city's cleaner, mechanical heart. The American press was eager to greet this couple from Paris, and to capitalize on the antics of those loony, modernist foreigners who were causing such a scandal at the "International Exhibition of Modern Art" at the 69th Infantry Regiment Armory on 25th Street and Lexington Avenue. In fact, the *New York Tribune* commissioned Picabia to do a group of watercolors about the city and gave them front-page coverage in its March 9 issue, with the predictable pro-and-con commentaries.[9] Quite a few steps beyond the two 1912 paintings Picabia put into the Armory Show, works which, over the decades, have become easily legible even to the small children to whose art they were often sneeringly compared, these loose-jointed reveries,

7
The Little Review, 9, no. 3 (Autumn 1922), n.p.

8
Cited in Naumann, *New York Dada 1915–23*, p. 19.

9
Reproduced in ibid., p. 18.

some clearly inscribed NEW YORK at the upper left, keep eluding identities, moving closer to an impalpable world of thought and feeling, which the artist referred to as *pensée pure* (pure thought). They evoke not so much particular, tangible objects, whether people or things, but rather a blurred sense of the city's drifting, perpetual motion against a backdrop of roughly perpendicular fragments. More mood than fact, they almost look backwards, via the fractured geometries of Cubism, to such late Impressionist city views as Monet's, inspired a decade earlier by a visit to London. But then, of course, Picabia's first responses to New York date back to 1913, before the insolent spirit of Dada had fully opened its Pandora's box, transforming, in his case, modern city dwellers to sex-crazed robots, about as sentimental as a light bulb or a carburetor.

Seven years later, in 1920, Picabia's soft-edged watercolors, with their almost gentle impressions of the city's dynamic flow, could become as hard-edged and impersonal as a factory. So it was also in Charles Sheeler and Paul Strand's path-breaking, 6 1/2 minute silent movie, *Manhatta* (pp. 27–31). Using the medium of film, whose modernity and ostensibly cold documentary character seemed ideally suited to recording the greatest metropolis of the new century, they paralleled Léger's own postwar hymns to the severe geometry and beauty of the modern city, but pushed their shifting, fragmentary images to sublime extremes of contrast, appropriate to the vertiginous drama of the New York experience. Pitting against each other collisions of large and small, high and low, near and far, movement and stability, and fusing interior views with expansive thrusts of bridges and harbors to the seas and skies beyond, this breathtaking cinematic collage of New York's micro- and macrocosms offers a mechanical god's-eye view of a twentieth-century Jerusalem. And to assert this world's American ancestry, the prophetic ghost of Walt Whitman looms behind it all, with quotes from his poems interspersed among the urban images.

Like Picabia's and Duchamp's humanoid populations, Sheeler and Strand's vision of New York came close to science fiction. But there were other, more relaxed and agreeable ways to translate New York's realities into art, especially as seen in the hands of two women: one, Florine Stettheimer, now famous again; and the other, Juliette Roche, known, if at all, as the wife of a lesser Cubist, Albert Gleizes, who took her to New York in 1915 for what turned out to be a five-year sojourn. For both these women, depicting New York meant not bowing before the altar of the machine, but liberating more pleasurable aspects of their imagination that might deal, in a fresh new spirit, with the kind of leisurely urban themes explored a half-century earlier by the Impressionists. In awkwardly rhymed verse, Stettheimer described how in the New York of her childhood memory "skyscrapers had begun to grow/ and front stoop houses started to go," and then went on to her modest credo:

> And out of it grew an amusing thing
> Which I think is America having its fling
> And what I should like is to paint this thing.[10]

That fling is captured in a canvas of 1918, *New York*.[11] As cosmic in its panoramic vista as *Manhatta*, Stettheimer's idea of New York is nonetheless the cheeriest spectacle of holiday pageantry, triggered in this case by the flag-waving displays that greeted President Woodrow Wilson on his

10
Barbara J. Bloemink, *The Life and Art of Florine Stettheimer* (New Haven and London: Yale University Press, 1995), p. 54.

11
Ibid., pp. 52–54, and Naumann *New York Dada 1915–23*, p. 152, for other discussions of this painting.

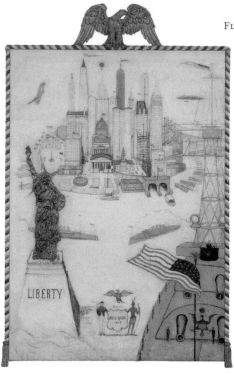

return from what at last was a war-free Europe. Patriotic fervor has never been less scary, transformed here into a spectator's fantasy, a personal mix of high sophistication and folk art that might be equally at home on a rural signboard or in an aggressively modern art exhibition that experimented with collage, semiotics, and urban simultaneity. Everything comes in amusing inventories of childlike sizes, shapes, and categories. The American flag turns up huge, but with thirty-two stars, in the foreground, and is then telescoped to Lilliputian scale on the roofs of distant skyscrapers and on the front and top of the destroyer that bears the president. The American eagle, symbol of the "liberty" that is the painting's alternate title, is seen with wings flapping, down, and raised, and emerges as triumphant sculpture crowning the red, white, and blue rope coil of a frame. And the skies above offer a New York version of Cubist aeronautics, with a lofty trio of biplane, balloon, and dirigible. As for New York's architecture and topography, Stettheimer offers a whimsical scramble of history, from the Greek Revival style of the US Sub-Treasury Building to the tapered Neo-Gothic heights of the five-year-old Woolworth Building, and blithely relocates Grant's Tomb and Columbus Circle for better stacked viewing. And as a breezy flouting of Old Master conventions of painting, a branch off Dada's tree, the Statue of Liberty is rendered not as oil on canvas but as a flattened collage of gilded putty.

Such a freewheeling approach to the holiday-mood potential of New York was shared by Juliette Roche, in both words and images. Separating herself from the more orthodox modernism of her husband, who fit everything from Broadway signage to Brooklyn Bridge cables into generic

Cubist molds, she eagerly explored other new avenues in her responses to the city they both instantly loved. One was literary. During her New York years, she composed dozens of free-verse poems in French that would seize the thrilling rush of the city's sights and sounds. Sprinkled with words like Biltmore, Jazz-Band, Tipperary, West 88, Cyclone, Triangle Play Film, these verbal collages were published in a limited edition, *Demi Cercle*, upon her return to Paris in 1920.[12] Of these, the most visually adventurous is *Brevoort* (1917) (p. 268), which refers to the chicly international hotel, restaurant, and café on the northeast corner of 8th Street and Fifth Avenue. Transporting the pleasures of Parisian café life to New York, she first sets the scene, top center, with the most minimal image of a Cubist glass on a table, but then moves on to the more adventurous territory of capturing the simultaneous buzz of music and conversation around her with sentence fragments that evoke the orchestra playing an Italian song as well as snippets of overheard dialogue, a verbal potpourri of arty Greenwich Village talk that covers everything from Nietzsche and anarchy to Washington Square and Japan.[13] And moving from the liberties charted by avant-garde typography to the perspectival and figural innovations of avant-garde painting, Roche could also pinpoint her tourist's visions of New York with oil paint. Avoiding the obvious landmarks of Manhattan, she turned instead to a surprising locale that must be singular as a theme for art, the swimming pool at the St. George Hotel in Brooklyn Heights (*Brooklyn, St. George Hotel Piscine*, c. 1918) (p. 112). With a kaleidoscopic freedom that transcends her husband's more stable Cubist structure, she provides a rapidly shifting aerial view of the pool, splintering its rectangular enclosures into dizzying, jigsaw-puzzle fragments, populated by the lankiest new species of indoor athletes who run, swim, and dive with the anatomical elasticity of such loony comic-strip characters as Little Nemo and Krazy Kat. In her role of a French Gulliver discovering New York, Roche gives us the most delightfully unexpected glimpse of how swarms of diminutive locals enjoy themselves when not crowding into subways or elevators on their way to work in mountain-high offices.

From Man Ray to Sheeler, from Stella to Roche, New York, during the heyday of its soaring twentieth-century youth, could unbridle one imagination after another, tempting artists to remake the world in this crazy but tonic image. And the magic never stopped. Even in its later twentieth century decades, when other great cities began to challenge its high-speed pulse and its architectural heights and depths, New York can still inspire such total avowals of love as Red Grooms' *Ruckus Manhattan* (1975–76) and Rem Koolhaas' *Delirious New York* (1978). But that is another story.

12
Juliette Roche, *Demi Cercle* (Paris: Éditions d'Art "La Cible," 1920), a limited edition of 500.

13
Brevoort was first reproduced and discussed in Naumann, *New York Dada 1915–23*, pp. 98–99.

DICKRAN TASHJIAN

AUTHENTIC SPIRIT *of* CHANGE:
The POETRY *of* NEW YORK DADA

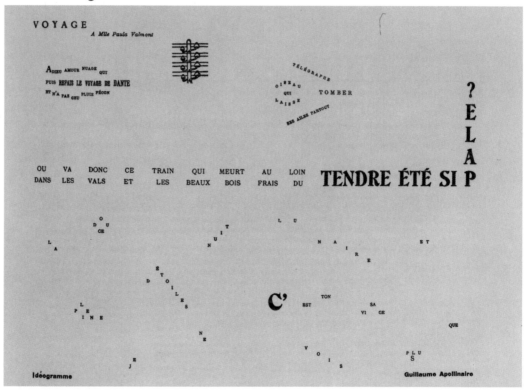

GUILLAUME APOLLINAIRE, VOYAGE, 1914*

"What were we seeking?" William Carlos Williams asked in his *Autobiography*. "No one knew consistently enough to formulate a 'movement.' We were restless and constrained, closely allied with the painters. Impressionism, dadaism, surrealism applied to both painting and the poem.'" From the vantage of 1950, Williams glossed over the movements, but he still remembered the energized atmosphere among poets and painters during the decade of World War I. Despite the absence of a programmatic avant-garde movement, there were ragtag groups of writers, painters, poets, and photographers gravitating around Alfred Stieglitz's 291 gallery on Fifth Avenue and the apartment of Louise and Walter Arensberg on West 67th Street. Francis Picabia, a poet in his own right, and his laconic friend Marcel Duchamp stood at the center of the Dada activities effervescing during the war.

Like Zurich in 1916, New York became a pressure cooker. "No sooner had we arrived [in 1915]," recalled Gabrielle Buffet-Picabia, "than we became part of a motley international band which turned night into day, conscientious objectors of all nationalities and walks of life living in an inconceivable orgy of sexuality, jazz and alcohol." American neutrality was a sham, "nothing but seething slag from the furnace that raged beyond the ocean."[2] The despair, the nihilism, the anarchism, the idealism—the ingredients were there for Americans and European émigrés, men and women, painters and poets alike, who, in an inversion of Molière's *bourgeois gentilhomme*, discovered that they spoke Dada all along.[3]

Before Dada hit New York in 1915, American poets had been shocked by the introduction of Imagism in *Poetry*, a little magazine published by Harriet Monroe in Chicago. Exported from England by Ezra Pound in 1913, Imagism called for a modern poetry that swept away the impressionistic sentimentalism prevalent among American poets.[4] Despite its salutary focus on the image, which was to be rendered with verbal precision and economy, Imagism remained almost primly formalistic with its do's and don'ts. In contrast, with its noisy declaration of war against everything genteel, Dada exploded the formalism of Imagist verse. Consider Mina Loy, for example, a young woman from England via the Futurists in Italy: her "Love Songs to Joannes," celebrating "Pig Cupid/his rosy snout/Rooting erotic garbage," offers a vividly precise image, though one that hardly remains within the bounds of good taste.[5]

The nonsense at the core of Dada inevitably permeated its poetry. Nonsense verse appeared lawless, disobeying the rules of grammar and syntax, and so refused to respect boundaries, spilling over from one medium to another, merging the verbal and the visual. Paradoxically, the antipoetics of nonsense were often intensely poetic in releasing new linguistic and visual possibilities for American writers.[6] From one side, poets saw ways to visualize the verbal; from the other, painters introduced verbal texts among their visual images. Dada brought them together in varying degrees of collaboration.

When Picabia returned to New York in 1915, Stieglitz solicited his participation in *291*, a luxurious portfolio that claimed the poetic legacy of Guillaume Apollinaire, reprinting his calligrammatic "Voyage" in the first issue from *Les Soirées de Paris*. With the publication of Picabia and his machine portraits in the fourth and fifth issues, however, Apollinaire's typographic play moved through Futurism's aggressive liberation of words to the ironic sensibilities of Dada. Picabia's sardonic

1
William Carlos Williams, *The Autobiography* (New York: Random House, 1951), p. 148.

2
Gabrielle Buffet-Picabia, "Some Memories of Pre-Dada: Picabia and Duchamp," in Robert Motherwell, ed., *The Dada Painters and Poets: An Anthology* (New York: George Wittenborn, 1951), p. 259.

3
Because of the broad sweep of Dada, I have selected for discussion American poets whose writings appeared in the context of Dada manifestations, especially in little magazines affiliated with Dada, during World War I in New York.

4
For a history of Imagism, see William Pratt, ed., *The Imagist Poem* (New York: E.P. Dutton & Co., 1963).

5
This poem first appeared in *Others* (July 1915), reprinted in Mina Loy, *The Last Lunar Baedeker*, ed. Roger C. Conover (Highlands, North Carolina: The Jargon Society, 1982), p. 91.

6
As Willard Bohn rightly claims, "[I]n the best poems, one encounters a critique of language itself and an attempt to deconstruct the cultural sign system"; see his "Introduction," *The Dada Market: An Anthology of Poetry* (Carbondale: Southern Illinois University Press, 1993) The best anthology remains Motherwell's *The Dada*

Painters and Poets. For a no-nonsense discussion of nonsense, see folklorist Susan Stewart, *Nonsense: Aspects of Intertextuality in Folklore and Literature* (Baltimore: The Johns Hopkins University Press, 1979).

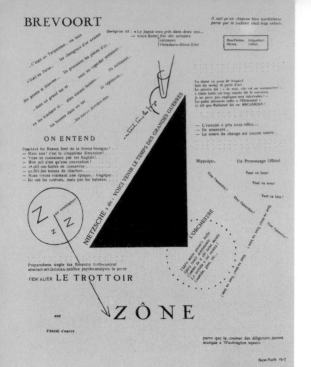

JULIETTE ROCHE, BREVOORT, 1917

mechanomorphs culminated in a misogynist collaboration with the Mexican caricaturist Marius de Zayas, whose accusatory "Femme" verbally explodes in a diatribe against the alleged mindlessness of the New Woman, who was disconcertingly no longer the little woman, but, as visualized by Picabia, a sleek and phallic machine in her own right: "Voilà Elle."

In contrast to the men, Agnes Ernst Meyer and Katharine N. Rhoades submitted full-page visual poems that voice the inner doubts and ironic self-deprecations of their female narrators as they struggle to shore up their fragile identities. Juliette Roche, the self-assured wife of Cubist painter Albert Gleizes, constructed a visual poem that dramatizes the ambience of the Café Brevoort in Greenwich Village, one of the few venues that echoed café life in Paris. Organized around a dark triangle, *Brevoort* (1917) presents a cacophony of voices, a Babel of French and English in a "ZONE" where vocal simultaneity celebrates anarchy.[7]

These typographic constructs of visual and verbal interplay served to encourage e.e. cummings, whose most radical poems appeared in the Dada-influenced, Paris-based American magazine *Broom* and its adversarial partner *Secession* in the early 1920s. Cummings' virtuoso poems never resort to extraneous visualization but embed the visual in a dazzling array of verbal manipulations on the page, a tribute to "all the grandja/that was dada."[8]

Poetry was prominent in the Dada magazines following *291*. In the first issue of *The Blind Man*, Henri-Pierre Roché invoked the spirit of Walt Whitman in celebrating the juryless exhibition of the Society of Independent Artists held at the Grand Central Palace in April 1917.[9] In the second

7
Guillaume Apollinaire, "Voyage," in *291*, no. 1 (March 1915), [p. 3]. "Voyage" originally appeared in *Les Soirées de Paris*, nos. 26-27 (July-August 1914), pp. 386–87. Picabia's *Fille née sans mère* (*Girl Born Without a Mother*) appeared in *291*, no. 4 (June 1915). Five of his machine portraits appeared in *291*, nos. 5-6 (July-August 1915). Agnes Ernst Meyer's poem "Mental Reactions" appeared in *291*, no. 2 (April 1915), p. 2. Katherine N. Rhoades' poem "Flip-Flap" (a giant amusement ride at the Franco-British Exposition of 1908), appeared in *291*, no. 4 (June 1915), [p. 2], along with Picabia's *Fille*. Juliette Roche's poem "Brevoort" appeared in *Demi Cercle*, 1920. For a brief account of the poem, see

Francis M. Naumann, *New York Dada 1915–23* (New York: Harry N. Abrams, 1994), p. 98.

8
For a discussion of cummings' radical typography and Dada in *Broom*, see Dickran Tashjian, *Skyscraper Primitives: Dada and the American Avant-Garde, 1910–1925* (Middletown, Connecticut: Wesleyan University Press, 1975), pp. 165–87. For a general study of cummings' visuality, see Milton A. Cohen, *Poet and Painter: The Aesthetics of e. e. cummings's Early Work* (Detroit: Wayne State University Press, 1987).

9
Roché promised to "print an annual Indeps for poetry, in a supplement open to all," thereby following the principles of the exhibition; *The Blind Man*, no. 1 (April 1917), p. 4.

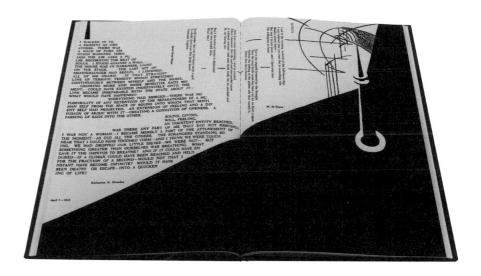

issue, taking up the "Richard Mutt Case," after Duchamp's urinal *Fountain* (1917) (p. 90) had been rejected by the organizing committee of the exhibition (in violation of their own rules), the poets came out in arms. Robert Carlton Brown, who would gain notoriety for inventing a reading machine called "the Readies," offered "A Resolution Made at Bronx Park Zoo": "I'm going to get/ a great big/ feather-bed/ of a pelican," he vowed, "and keep him/ in the house/ to catch the/ flies, mosquitoes and mice,/ lay eggs for me/ to make omelettes of,/ and be my downy couch at night." Picabia was less playful, one might say harsh, in dismissing "Artists of speech/ who have only one hole for mouth and anus." Charles Duncan's "Portrait Sketch" came with instructions: "To be read beginning with lowest line. Top line last," so that one starts at the bottom, "In In, thru eyes, sleepy slumber heave," and ascends to "waking waking/ blind/ in lighted sleepness."[10]

Prominent among these poets was the wealthy collector Walter Arensberg, who was especially close to Duchamp. In a 1916 collection of his poetry, titled *Idols*, Arensberg displayed a wide poetic range, extending from French Symbolist-inspired poems ("Voyage à l'infini") to protests against the war ("the mouths of Krupp/ Are mocking still") and some naughty Dada. The statues outside the Boston Public Library are asked: "Sisters of bronze upon the granite seated,/ Hast thou an easy stool?"[11]

Increasingly, however, Arensberg became caught up in Duchamp's verbal abstractions and cryptographic play in an effort to decode Francis Bacon in the writings of Shakespeare. Subsequent poems, "Theorem," for example, published in the second issue of *The Blind Man*, have a geometric

10
Robert Carlton Brown, "A Resolution Made at Bronx Park Zoo," Francis Picabia, "Medusa," Charles Duncan, "Third Dimension; Portrait Sketch," all in *The Blind Man*, no. 2 (May 1917), pp. 3, 10, 12.

11
"Voyage a l'infini," "Io Louvain," and "The Inner Significance of the Statues Seated Outside the Boston Public Library," *Idols* (Boston: Houghton Mifflin & Co., 1916), pp. 12–13, 54, 45.

rigor that suggests the precise delineation of invisible forces:

> For purposes of illusion
> > the actual ascent of two waves
> > transparent to a basis
> > which has a disappearance of its own
> is timed
> > at the angle of incidence
> > to the swing of a suspended
> > > lens[12]

The length and place of line on the page may have anticipated Williams' eventual adoption of a variable foot as the formal basis for his poetic simulation of a common American language. Arensberg's poems—Cubist, cryptographic, or Dada—deserve further consideration for their elegant (and enigmatic) virtuosity.

The capaciousness of Dada was nowhere more evident than in its ability to spawn Arensberg's cerebral verse alongside raucous performance, dating back to evenings at the Cabaret Voltaire in Zurich, when the Alsatian poet and mystic Hugo Ball, wearing a cumbersome robotic costume, was carried to the small stage and began to recite "Gadji beri bimba," gradually mimicking the intonations of a Roman Catholic high mass. Blasphemy or magical incantations? Dada poetry in performance carried a large dose of the antipoetic. No wonder, then, that Ball's chants surfaced as prime examples of Dada insanity in America, in the Boston *Evening Transcript* no less.[13]

The antipoetic seemed to be everywhere in an America exoticized by Europeans, who were infatuated with the "primitive" qualities of American culture. Arthur Cravan, nephew of Oscar Wilde and a boxer who had taken on world heavyweight Jack Johnson in Barcelona, seemed hardly the man to assume the vocation of poet. But poet he was, in love with American skyscrapers in the Manhattan machine. And quite willing to lecture in public at the Grand Central Palace on the occasion of the Independents Exhibition, even though, perhaps because, he turned up drunk, spewing obscenities at a bewildered audience, trying to disrobe, and ending up in jail.[14]

Nor was Cravan the only poet willing to perform in New York. An "indigenous" poet such as Little Joe Gould, Harvard graduate, classmate of e.e. cummings, here was a Greenwich Village freeloader who could find poetry in the streets, overheard in the bars and cafés, on the elevated. His grand project: to compile the oral history of the world. And in his own immortal words, no less succinct than any Imagist poem: "In winter I'm a buddhist/And in summer I'm a nudist."[15]

Perhaps the most complex of street poets was the androgynous, volatile Baroness Elsa von Freytag-Loringhoven. Her poetry, championed by Margaret Anderson and Jane Heap, editors of *The Little Review*, was occasionally archaic in diction, altogether too "poetic," and sentimental, yet she was capable of writing "Ready-wear American soul poetry" by stringing together advertising slogans: "nothing so pepsodent—soothing—pussywillow—kept clean with Philadelphia cream cheese."[16] The baroness was quite adept at engendering controversy, as in the debate in *The Little Review* over the possibility of writing insane poetry, a kind of anticipation of the "mad love" that fixated the Surrealists in the 1920s.

12
Walter Arensberg, "Theorem," *The Blind Man*, no. 2 (May 1917), p. 9. I look forward to Naomi Sawelson-Gorse's study of Arensberg, Duchamp, and cryptography.

13
Ball's "Karawane" was published in Isaac Goldberg, "Dada Putting the Jazz into Modern Verse," *Boston Evening Transcript*, January 12, 1921; reprinted in Naumann, *New York Dada 1915–23*, p. 214.

14
For an account of this scandal, see Gabrielle Buffet-Picabia, "Arthur Cravan and American Dada," in Motherwell, *The Dada Painters and Poets*, pp. 13–16. For the relationship between Cravan and Mina Loy, see Roger Conover, "Mina Loy's 'Colossus': Arthur Cravan Undressed," in Rudolf E. Kuenzli, ed., *New York Dada* (New York: Willis Locker & Owens, 1986), pp. 102–19.

15
For an account of Little Joe Gould, see Joseph Mitchell, *Joe Gould's Secret* (New York: The Viking Press, 1965).

16
The baroness generically titled these poems "subjoyride," perhaps suggesting the fleeting advertisements one sees on the subway or elevated. See *The Little Review* Archives, file 48, Golda Meir Library, University of Wisconsin, Milwaukee. For an account of the baroness, see Robert Reiss, "'My Baroness': Elsa von Freytag-Loringhoven," in Kuenzli, ed., *New York Dada*, pp. 81–101.

Her most significant debate, however, centered around Williams' prose poem, *Kora in Hell*, a compilation of improvisations (close to Surrealist automatic writing) with commentary appended. Hurling *ad hominem* arguments (Williams became a "wobbly-legged business satchel-carrying little louse"), the baroness took offense at Williams' attempt to write outside European tradition. But that was precisely his aim, and the reason that Dada found such fertile ground among New York poets. Williams was later irritated at Wallace Stevens for pointing out his interest in the antipoetic. "It's all one to me," Williams responded, "the anti-poetic is not something to enhance the poetic—it's all one piece."[17] That discovery—enhanced, provoked by Dada—provided a fundamental liberation for Williams and American poetry.

17
Elsa von Freytag-
Loringhoven, "Thee I Call
'Hamlet of Wedding-Ring,'"
The Little Review, nos. 7–8
(January–March 1921,
Autumn 1921), pp. 48–55,
108–11; Williams, *I
Wanted to Write a Poem*
(Boston: Beacon Press,
1958), p. 52.

BETH VENN

NEW YORK DADA
Portraiture:
RENDERING MODERN IDENTITY

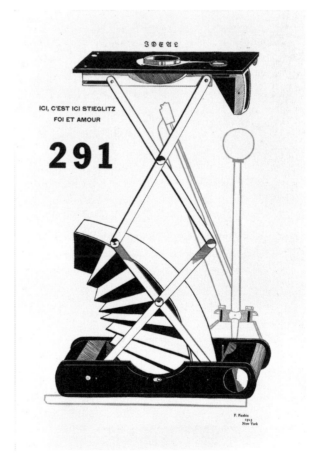

Francis Picabia, ICI, C'EST ICI STIEGLITZ/FOI ET AMOUR (HERE, THIS IS STIEGLITZ/FAITH AND LOVE), 1915

Object portraits. Psychotypes. Absolute Caricatures. Mechanomorphs. An impressive range of novel approaches to the age-old tradition of portraiture signals a profound rethinking of the genre during the Dada years in New York. For a movement generally known for its rejection of traditions, it is ironic that nearly all New York Dada artists executed portraits. And while Dada in this country has long seemed difficult to classify stylistically or conceptually, a review of the portraits establishes at least one connecting thread: at the heart of New York Dada lies a profound questioning of the nature of identity.

At the most basic level, portraiture provided these artists with a means to explore the complexities of personality, without emphasizing likeness. To reveal the inner self, they employed abstract equivalents or imagery appropriated from popular culture as metaphors to suggest motives, belief systems, and character. They fused verbal fragments with abstract shapes to capture fleeting experience. But perhaps most remarkable is that many of these artists went even further, rethinking the relevance of artistic authorship and experimenting with assumed identities through pseudonyms, aliases, and alter egos.

Dadaists explored these complex matters in a limited range of subjects: nearly all the portraits are of Dada colleagues. Just what accounts for this almost incestuous introspection? First, unlike their Swiss or German counterparts, New York Dadaists found themselves in the private world of affluent art patrons, in this case the refined West 67th Street salon of Louise and Walter Arensberg. Far from the raging war in Europe, these soirees took on an air of heady intellectualism as members engaged in chess matches, discussions on the subtleties of modern art, and other cerebral pursuits—including forms of psychoanalysis. Dr. Elmer Ernest Southard, a noted psychiatrist with a keen interest in Freudian theories, was a frequent visitor to the Arensberg apartment. Not only did he assess the personalities of the artists present according to shapes found in their paintings, but he also encouraged them to share their inner thoughts, fears, and anxieties by publicly reciting their dreams.[1] In Beatrice Wood's stream-of-consciousness image, *Beatrice Recounting Her Dreams at the Arensbergs*, a broken line leads from an abstracted figure (presumably the artist) in the foreground to what is likely the projected image of the artist's dream in the upper left. One of the few extant images that record the goings-on in the Arensberg apartment, Wood's drawing reflects the soul-searching that no doubt took place among this motley group of displaced European expatriates as well as American newcomers seeking to establish an identity amidst the lively confusion of New York in the teens.

In large measure, Dada portraiture witnessed its most innovative formal inventions in the work of the Mexican caricaturist Marius de Zayas. In 1912, he had already made the proto-Dada statement, "art is dead."[2] But unlike European Dadaists, he did not go on to denounce logic, embrace absurdities, or make brazen public pronouncements. Instead, he set about creating a group of portraits, works that he claimed "are not art, but simply a graphical and plastic synthesis of the analysis of individuals...the intrinsic expression...of the individuals themselves."[3] Starkly set out in black-and-white in the manner of newspaper caricatures, these portraits fused geometric shapes, alphanumeric characters, diagonal "force lines," and algebraic equations to formulate what de Zayas termed "absolute caricatures," the first truly nonobjective portraits. His clinical, almost

1
Man Ray's recollection of Dr. Southard's attendance at the Arensberg salon can be found in Man Ray, *Self-Portrait* (Boston: Little Brown, 1963), p. 70. For the most complete account of the Arensbergs and their contribution to the Dada movement, see Francis M. Naumann, *New York Dada 1915–23* (New York: Harry N. Abrams, 1994), pp. 22–33.

2
Marius de Zayas, "The Sun Has Set," *Camera Work*, no. 39 (July 1912), p. 17.

3
Marius de Zayas, "Caricature: Absolute and Relative," *Camera Work*, no. 45 (April 1914), p. 22.

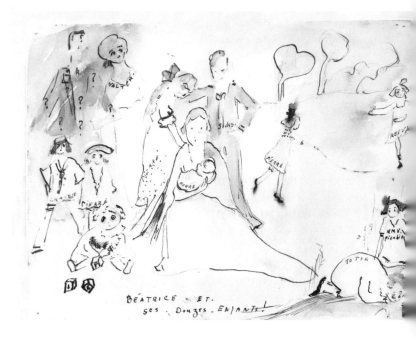

scientific approach to portraiture repudiated the genre's longstanding reliance on surface likeness for a more profound analysis of a subject's inner being, in essence creating a scientific tool for psychological exploration. In many of his works, such as *Mrs. Eugene Meyer, Jr.* (c.1913), de Zayas juxtaposed traces of the subject's physical characteristics—the oval of Mrs. Meyer's hair swept up atop her head repeating the oval of her prominent forehead—with a complex formula of "equivalents" meant to represent character traits. Meyer's lively, dynamic personality is symbolized by strong diagonals, while the complex numeric equation suggests her great intelligence and imagination.

As his theories became increasingly sophisticated, de Zayas discarded all objective reference in favor of pure abstraction. In his radical *Portrait of Francis Picabia* (c.1913) (p. 40), de Zayas forgoes any mention of the subject's physiognomy, instead seeking through abstract shapes an evocation of the essence of the individual. Here an algebraic formula is woven into a composition of sharp, jagged forms and jarring contrasts of black and white. These elements may allude to Picabia's aggressive stand against recognizable subject matter in his efforts to "cut through" the surface veneer of realism in order to reveal the more profound lessons of abstraction.[4]

Like de Zayas, Picabia believed that art was primarily symbolic and intellectual. In the pages of *291*, he submitted his own definitive form of the modern portrait. His "mechanomorphs" are dryly illustrated machines and mechanical apparatuses whose functions are meant to suggest an individual's character. Turning to such mundane sources as mail-order catalogues and trade-journal advertisements, Picabia directly appropriated diagrams of such mechanized objects as a

4
This interpretation was first suggested by Francis M. Naumann in his *New York Dada 1915–23*, p. 21.

camera, a spark plug, a lamp, and an automobile horn. In *Ici, c'est ici Stieglitz/ Foi et amour (Here, This Is Stieglitz/ Faith and Love)* (1915), the great modern art apologist is represented by the fusion of a broken camera with an automobile gear shift and brake lever. The expanding bellows of the camera fail to reach upward toward the attainment of the "ideal," while the neutral-positioned gearshift and the brake in locked position represent the failing efforts of this once energetic, aggressive promoter of modern art.[5] Unlike de Zayas, who proposed relationships among abstract shapes, numeric equations, and the essence of his subject, Picabia employed metaphor to link a subject's personality or character traits to a visually unlike but nonetheless recognizable mechanical image. In doing so, he suggested new dimensions of the self hopelessly intertwined in the burgeoning machine age.

Far from the mechanized, structured, and diagrammatic portraits of Picabia and de Zayas are Beatrice Wood's humorous and clever autobiographical chronicles of her years in the Arensberg circle. *Béatrice et ses douzes enfants! (Beatrice and Her Twelve Children!)* (c. 1917), her watercolor portrait of the group, not only spoofs the subjective nature of all portraiture but underlines the Dadaists' wariness about fixed identity. In this work, Wood is neither inclined to capture a realistic likeness of the group's members nor to pay much attention to accurate labeling. Nonsensical associations abound: a woman labeled "Walter" stands near a companion covered in question marks, while Joseph Stella and Gabrielle Buffet-Picabia appear as children. Duchamp can be located only by his nickname, Totor. Most curious, however, is the ever-changing identity of Henri-Pierre Roché, who is seen once as a baby, twice as a young girl, and finally as an adult woman. Wood's work constitutes an "experiential portrait," for her interest lies in capturing the psychological nuances and interactions of the participants while commenting on their sometimes childlike behavior. Nor is her own attitude neglected: through the title and the central image of a mother cradling baby "Pierre," she expresses her desire to mother and care for this assortment of characters. Wood's work has a conceptual connection with experiments in visual poetry conducted in the pages of *291* and other little magazines of the time, in which experience and one's simultaneous response and reflection on that experience are communicated through typography and its spatial arrangement on the page.

By 1916, visual poetry had entered the realm of portraiture in the form of "psychotypes," "an art which consists in making the typographical characters participate in the expression of the thoughts and in the painting of the states of the soul, no more as conventional symbols but as signs having a significance in themselves."[6] A collaboration between Marius de Zayas and Agnes Ernst Meyer, entitled *Mental Reactions*, is a daring avant-garde creation which seeks to capture a momentary experience by integrating Meyer's thoughts with her environment. Randomly placed words and phrases that suggest a rendezvous—"flirt," "I feel him making a mental note," "Ah, why can not all the loves of the world be mine?," and "I really must go"—are meshed with phrases that set the stage by implying time of day and season—"Twilight," "Silence of snow-covered roof-tops." Such psychotypes sought to forefront the importance of thought in the expression and communication of identity and experience, paralleling artists such as Duchamp and Man Ray who were then emphasizing the workings of the mind over purely retinal expressions.[7] "I was interested in ideas," Duchamp recalled in the 1940s, "not merely in visual products. I wanted to put painting once

5
For a thorough interpretation of the five Picabia "object portraits" that appeared in the July-August issue of *291*, see William Innes Homer, "Picabia's *Jeune fille américaine dans l'état de nudité* and Her Friends," *The Art Bulletin*, 57 (March 1975), pp. 110–15.

6
Marius de Zayas, "291—A New Publication," *Camera Work*, no. 48 (October 1916), p. 62. Psychotypes were strongly indebted both to Gertrude Stein's "word portraits," seen on the pages of *Camera Work* in 1912, and to Guillaume Apollinaire's "calligrammes," which first appeared in this country in the March 1915 issue of *291*. In this same issue, de Zayas discussed Apollinaire's experiments with "simultanism," the idea of expressing the simultaneity of thoughts and emotions.

7
For further analysis of this work, see Willard Bohn, "Marius de Zayas and Visual Poetry: Mental Reactions," *Arts Magazine*, 55, no. 10 (June 1981), pp. 114–17.

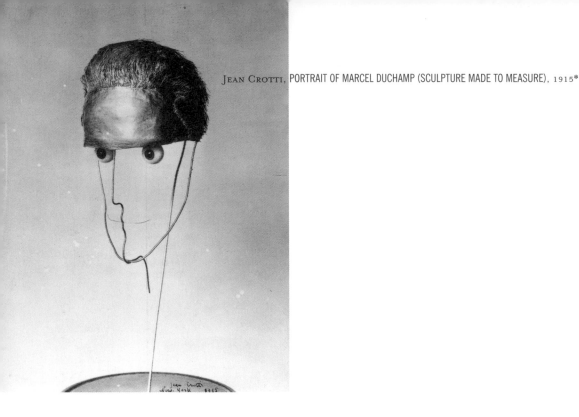

JEAN CROTTI, PORTRAIT OF MARCEL DUCHAMP (SCULPTURE MADE TO MEASURE), 1915*

8
Interview with Marcel
Duchamp by James
Johnson Sweeney, *The
Museum of Modern Art
Bulletin*, 13, nos. 4–5
(1946), p. 20.

9
Quoted in William Camfield
and Jean-Hubert Martin,
*Tabu Dada: Jean Crotti
and Suzanne Duchamp
1915–1922*, exh. cat.
(Bern: Kunsthalle Bern,
1983), p. 10.

10
Naumann, *New York Dada
1915–23*, p. 103.

11
Arturo Schwarz, "An
Interview with Man Ray:
'This Is Not for America,'"
Arts Magazine, 51 (May
1977), p. 119.

12
Man Ray, *Self-Portrait*
(Boston: Little, Brown and
Company, 1988), p. 65.

again at the service of the mind."[8]

Jean Crotti, with a mixture of humor and high seriousness, captured Duchamp's preference for ideas in an unusual three-dimensional portrait of the artist (now lost). Faithfully replicating what Crotti must have found to be Duchamp's most salient features, the assemblaged portrait consisted of piercing glass eyes and a cast (plaster?) forehead sporting a tuft of artificial hair, all supported by an almost incidental wire stand. Crotti insisted that it was "an absolute expression of my idea of Marcel Duchamp. Not my idea of how he looks, so much as my appreciation of the amiable character that he IS....To me, the character of my friend is most strikingly shown in the forehead and eyes...."[9] As Francis Naumann points out, the elements of the sculpture—the forehead representing the mind and the eyes standing in for the retinal or visual component of painting—sum up the two poles of an aesthetic argument that would occupy Duchamp during his time in New York.[10]

Man Ray likewise recalled that in order "to avoid complacency and repetition, we began to use our brains...to express ideas and not just to demonstrate our virtuosity."[11] His *Self-Portrait* (1916) represents perhaps the first attempt by an artist to invite viewer participation: "I simply wished the spectator to take an active part in the creation."[12] Man Ray chose to represent himself with a panel painted silver and black, to which he affixed two round electric bells, which are unconnected with a doorbell-like push button below. Between these two elements appears his handprint—his signature. This enigmatic Dada assemblage frustrated viewers who expected that pushing the button

MAN RAY, SELF-PORTRAIT, 1916*

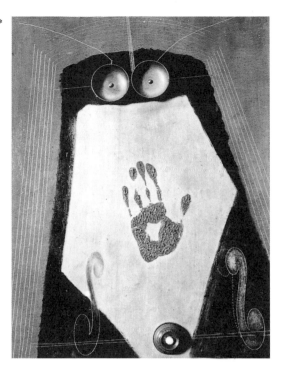

would ring the electric bells. Man Ray, not intending to set up a simple action/response scenario, wished only to engage viewers in the physical properties of the work and perhaps provoke a response of confusion and puzzlement.

It was not a far leap from embodying key Dada tenets in the form of constructed portraits to the living, breathing personification of Dada. After all, Dada, with its emphasis on freedom, humor, and outrage, is among the very few movements for which personification is even possible. While there is no evidence that Marsden Hartley "acted" in a Dada fashion, he clearly understood the broader potential of Dada as a personal doctrine when he titled his 1921 essay "The Importance of Being Dada."[13] But it was in the person of the Baroness Elsa von Freytag-Loringhoven that Dada was rendered incarnate. Dressed in an assortment of rags, a canary cage hanging from a chain around her neck, a shaven and shellacked head topped with a coal scuttle for a hat, the baroness paraded through the streets of Greenwich Village liberated from the constraints of proper society. She seemed to embody the philosophy of the radical proto-Dadaist Benjamin de Casseres, who proclaimed: "We should mock existence at each moment, mock ourselves, mock others, mock everything by the perpetual creation of fantastic and grotesque attitudes, gestures, and attributes."[14] Her ambiguous identity—she had no clearly defined profession and sported a surprisingly masculine visage—was perfectly suited to such a "perpetual creation." The baroness continuously reinvented herself, prompting a friend to remark that "if Dada existed in America it existed largely in the person and poetry of Elsa Baroness von Freytag-Loringhoven."[15] Few if any painted or pho-

13
Marsden Hartley, "The Importance of Being Dada," in *Adventures in the Arts, Informal Chapters on Painters, Vaudeville and Poets* (New York: Boni and Liveright, 1921).

14
Benjamin de Casseres, "Insincerity: A New Vice," *Camera Work*, nos. 42–43 (April-June 1913), p. 17.

15
Djuna Barnes, quoted in Robert Reiss, "'My Baroness': Elsa von Freytag-Loringhoven," in Rudolf E. Kuenzli, ed., *New York Dada* (New York: Willis, Locker & Owens, 1986), p. 81.

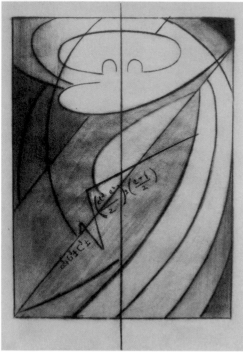

tographed portraits exist to document the baroness' outrageous behaviors and dress. However, Man Ray, who understood fully that the baroness had adopted Dada as a personal philosophy, used her nude portrait—legs spread and pubic hair shaved—to announce the death of Dada in America in a letter to his European colleague, Tristan Tzara.

The baroness' seemingly chance transformation of found objects into personal ornament was not altogether different from the assemblaged portraits she created of her friends. Her *Portrait of Marcel Duchamp* (c. 1919) (p. 124) is as remarkable for its apparent haphazard construction as it is for its striking resemblance to its subject. A slender upright center leads to a solid angular face, the whole of the assemblage overflowing its cocktail glass as if to suggest the artist's continuous out-pouring of creativity. The overall visual effect of the graceful feathers and tiny plumed hat make sly reference to Duchamp's alter ego, Rose Sélavy.

Much like the baroness, but in a more refined and calculated manner, Marcel Duchamp also assumed a persona, at first based on the notoriety of his *Nude Descending a Staircase* (1912) (p. 35), and later his scandalous submission of *Fountain* (1917) (p. 90) to the 1917 Independents exhibition.[16] From his arrival in New York in 1915, his status as prophet of the avant-garde grew more legendary through a series of interviews and newspaper accounts.[17] As recalled by his friend Henri-Pierre Roché, Duchamp "was twenty-nine years old and wore a halo…He was creating his own legend…At that time, Marcel Duchamp's reputation in New York as a Frenchman was equalled only by Napoleon and Sarah Bernhardt."[18] But Duchamp took control of his artistic identity in a more profound way as well through the creation of his alter ego, Rose Sélavy. From her photographic

16
For a thorough exploration of Duchamp's formulation and transmutation of his identity during his early New York years, see Moira Roth, "Marcel Duchamp in America: A Self Ready-Made," *Arts Magazine* 51 (May 1977), pp. 92–96.

17
"The Nude-Descending-a-Staircase Man Surveys Us," *New York Tribune*, September 12, 1915, section 4, p. 2; and Nixola Greeley-Smith, "Cubist Depicts Love in Brass and Glass; 'More Art in Rubbers Than in Pretty Girl!,'" *The Evening World*, April 4, 1916, p. 3.

18.
Henri-Pierre Roché, "Souvenirs of Marcel Duchamp," in Robert Lebel, *Marcel Duchamp*, trans. George Heard Hamilton, 2nd ed., (New York: Grossman, 1967), p. 79; quoted in Roth, p. 92.

portrait by Man Ray to her signature on readymades, Rose came into being complete with a distinguished artistic pedigree and a fabricated air of mystery and glamour. She was further personified in Florine Stettheimer's portrait of Duchamp, where the artist sits in a near-empty room confronted by, while at the same time controlling, his looming alter ego.[19]

Through their struggles to express an inner self at the expense of a more traditional emphasis on outward appearances, Dada artists in New York exploded the constrictions of portraiture, fusing art with life and artistic expression with personal identity. Their investigations into the true nature of the self and the realm of ideas not only provided Dada in this country with its unique character, but also opened a new realm for artistic exploration that laid the foundation for much of the Conceptual and Performance art of the latter half of this century.

19
Upon seeing Stettheimer's portrait of Duchamp, the critic Henry McBride commented: "If you were to study his paintings, and particularly his art constructions, and were then to try to conjure up his physical appearance, you could not fail to guess him, for he is his own best creation, and exactly what you thought. In the portrait [by Stettheimer] he is something of a Pierrot perched aloft upon a Jack-in-the-Box contraption which he is surreptitiously manipulating to gain greater height for his apotheosis.... The most complicated character in the whole contemporary range of modern art has been reduced to one transparent equation"; quoted in Barbara Bloemink, The Life and Art of Florine Stettheimer (New Haven and London: Yale University Press, 1995), p. 145.

BARBARA ZABEL

THE MACHINE
and *NEW YORK*
DADA

MAN RAY, DANGER/DANCER OR L'IMPOSSIBILITÉ, 1920*

The birth of New York Dada coincided with the advent of the machine as the governing paradigm for modern culture, a juncture that offered unprecedented challenges for the European and American avant-garde. The artists of New York Dada, in particular, found in this new paradigm a means of expressing fundamental dilemmas of twentieth-century life, of defining the relationships between man and God, man and woman, and art and nature.

For many artists, the apotheosis of the machine challenged the traditional grounding of existence in religion. Although artistic irreverence was hardly a new phenomenon, the displacement of God by the machine became a defining attribute of New York Dada; indeed, it is now seen as the movement's blasphemous orthodoxy. In 1915, Paul Haviland proclaimed: "We are living in the age of the Machine. Man made the Machine in his own image."[1] Such disruptions of the traditional hierarchy of God, man, and machine became a mainstay of Francis Picabia's New York period. The title of his mechanistic drawing *Fille née sans mère (Girl Born Without a Mother)* (1915), for instance, intimates that the girl/machine came into being not through "normal" procreative processes, but through some kind of mechanical intervention. American artist Morton Livingston Schamberg, assisted by Elsa von Freytag-Loringhoven, mocked machine dominance by sticking a plumbing trap into a miter box and calling it *God* (c. 1917) (p. 86). In recognizing the machine as a quasi-religious icon of the modern world, Schamberg echoed Henry Adams, who, in the Hall of Machines at the 1900 Universal Exposition in Paris, "began to feel the forty-foot dynamos as a moral force, much as the early Christians felt the Cross."[2] With Dada irony, Schamberg suggested that the twentieth century had quite literally produced its "deus ex machina."

Such inquiries into the metaphysics of the machine engendered a breakdown of the distinctions between the human and the mechanical. As Picabia proclaimed, "The machine has become more than a mere adjunct of human life. It is really part of human life—perhaps its very soul."[3] The Dadaist strategy of fusing human and machine forms, animate and inanimate matter, necessarily represented ambivalent sentiments: is such a merger to be celebrated or feared? Marcel Duchamp, for instance, depicted his *Nude Descending a Staircase* (1912) (p. 35) as a kind of Dada automaton—both a humanized machine and a mechanized human—thereby acknowledging how profoundly human beings have been affected by the omnipresence of the machine.

Following Duchamp's lead in viewing the human figure as an assemblage of disparate parts, many Dadaists turned to collage, an art of construction rather than mimesis. Made up of discrete parts assembled like mechanical components, collage can be seen as a visual embodiment of the new machine environment.[4] Arthur G. Dove, for instance, constructed *The Critic* (1925) (p. 175) entirely from newspaper cutouts. Through such varied images as roller skates, a vacuum cleaner, and a magnifying glass, Dove satirizes the critic. Rather than a sentient being endowed with insight and thoughtfulness, this critic is a robot outfitted with mechanical appendages, the dehumanized product of the machine age. Likewise, Man Ray pieced together his *Jeune fille* (1916) (p. 77) out of geometric shapes, also suggesting an analogy between human anatomy and the machine. For the Dadaists, then, the machine became a new model, indeed a new paradigm for art making.

The blurring of the mechanical and the human in Dada works also comments on the contemporary erosion of traditional gender distinctions. This is manifest in both Man Ray's *Jeune fille*

1
Paul Haviland, in *291*, nos. 7–8 (September-October 1915), n.p.

2
Henry Adams, *The Education of Henry Adams* (1907; New York: The Modern Library, 1931), p. 380.

3
Quoted in "French Artists Spur on an American Art," *New York Tribune*, October 24, 1915, reprinted in Rudolf E. Kuenzli, ed., *New York Dada* (New York: Willis Locker & Owens, 1986), p. 131.

4
Cecelia Tichi, *Shifting Gears: Technology, Literature, Culture in Modernist America* (Chapel Hill and London: University of North Carolina Press, 1987), was instrumental in my formulation of the connection between the machine and the collage aesthetic.

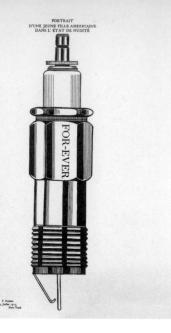

FRANCIS PICABIA, PORTRAIT D'UNE JEUNE FILLE AMÉRICAINE DANS L'ÉTAT DE NUDITÉ
(PORTRAIT OF A YOUNG AMERICAN GIRL IN A STATE OF NUDITY), 1915

and Picabia's *Portrait d'un jeune fille américaine dans l'état de nudité* (*Portrait of a Young American Girl in a State of Nudity*) (1915). The *jeune fille américaine* had become the personification of the new century, and many writers and artists linked their own sense of radical liberation from tradition with that of the young American girl. For his portrait of this new archetype, Picabia extracted a spark plug from its automotive function. Much like the dress fashions of the time, the straight-edged silhouette of the spark plug is altogether lacking in "feminine" characteristics. Picabia's *jeune fille américaine*, like Man Ray's geometricized image, is remarkably androgynous. Yet she is also highly charged erotically; according to Gabrielle Buffet-Picabia, Picabia viewed the young American girl as a perpetual "kindler of flame."[5] In radical defiance of traditional feminine guise and demeanor, the machine-woman assumes a masculine profile and an active sexual role. Thus the Dadaists not only embraced a new model of art making, but also acknowledged the shifting contours of gender difference in this era of the New Woman.

Again and again in Dada works—in Picabia's *Machine tournez vite* (*Machine Turn Quickly*) (c.1916–18) and *Parade amoureuse* (*Amorous Parade*) (1917), in Duchamp's *The Bride Stripped Bare by Her Bachelors, Even* (*Large Glass*) (1915–23) (p. 50), in Jean Crotti's *Les forces mécaniques de l'amour en mouvement* (*The Mechanical Forces of Love in Movement*) (1916), to name just a few works in the exhibition—the (wo)man/machine analogy is defined in terms of sexual processes. Indeed, the frequent employment of machine images to evoke these processes is central to New York Dada. In Picabia's *Machine tournez vite*, for example, the freely meshing gears—labeled "femme" and "homme"—seem to celebrate human sex-

5
Gabrielle Buffet-Picabia, "Some Memories of Pre-Dada: Picabia and Duchamp (1949)," in Robert Motherwell, ed., *The Dada Painters and Poets: An Anthology*, 2nd ed. (Cambridge, Massachusetts, and London: Belknap Press of Harvard University Press, 1989), p. 258.

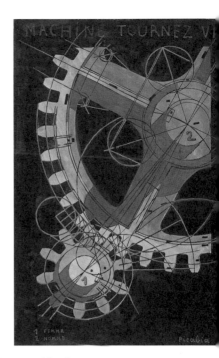

uality through a machine simulation of sex. Man Ray's *Danger/Dancer* (1920), a work "inspired by the gyrations of a Spanish dancer," is likewise composed of intermeshed gears; however, its message is significantly more disquieting.[6] The title associates the swirling motion of the automaton-dancer with some unspecified danger. Man Ray gave the image an ironic twist by interlocking the three gears, thus obstructing any functional interaction or rotation (*L'Impossibilité* is an alternate title). Instead of the uncomplicated meshing of Picabia's freewheeling automatons, Man Ray's work offers a closer parallel to Duchamp's *Large Glass* of 1915–23, which is also, on one level, a metaphor for frustrated physical love. The implied sequential action of *Large Glass* is never completed; the union of the mechanized bride above and the bachelor(s) below is forever thwarted.

The fact that both conceptions of female automatons—Duchamp's bride and Man Ray's dancer—are characterized by sharp-geared "teeth" is not without significance. Unlike the woman in Picabia's *Machine tournez vite*, who is already engaged in what seems an uncomplicated—and unthreatening—sexual coupling, these women are objects of both fear and desire, for the male artist as well as for the observer. We are thereby faced with a double threat: that of machine control, on the one hand, and, on the other, of the unspeakable dangers represented by the mechanized love-object. There is an obvious undercurrent of misogyny in these images, suggesting some dread of the New Woman of the postwar years. Given such aversions, it is not surprising that references to masturbation emerge as part of Dada's obsession with mechanized sex, the most notorious being Duchamp's *Chocolate Grinder, No. 2* (1914). As Duchamp wrote, "The bachelor grinds his

6
Man Ray, *Self-Portrait* (Boston: Little, Brown and Company, 1988), p. 79.

MARCEL DUCHAMP, CHOCOLATE GRINDER, NO. 2, 1914*

chocolate himself."[7] Man Ray's photograph of an eggbeater, entitled *Homme (Man)* (1918) (p. 108), displays a close kinship to the Duchamp work in this respect, for it is likewise a self-portrait of sorts (Man Ray has punned on his first name), is hand-manipulated, and suggests repetitive action.

The Dadaists' images of mechanized sex reveal an obsession not just with the machine, but with the most intimate of human acts. Could such sexual fantasies represent more than simply the fear of machine control of human behavior? Could their conflations of the human and the mechanical also suggest that the Dadaists saw the relationship as one of interdependency, as extending rather than only threatening human impulses? If so, perhaps such artistic gestures constitute a process of recovery—the recovery of the human within the realm of the machine, or in the words of Philip Fisher, an "effort to free from inside man-made things the fact of their humanity." Fisher's reading counters the traditional view, in which the human is lost within machine culture. Perhaps, then, the attempt to find a sign of the human within the mechanical can be read as a "fundamental act of connection," essential for survival in a man-made world.[8]

In the end, it is not at all clear whether the mechanical imagery of Dada represents dehumanization or a new potential for human existence. What is clear is that the machine engendered an entirely new basis for image making. However they perceived the machine—as impoverishing the human spirit or as infused with human attributes and meanings—the Dadaists incorporated it into their work in a way that profoundly changed the making of art, and this is possibly their greatest legacy to the postmodern age. Furthermore, it is through their appropriation of the constructive methods of machine technology that the Dadaists forged a new content for the machine age. The New York Dadaists thus embody the complex mediations which informed the technological-cultural nexus of the time, and their works reveal the multiple challenges involved in defining art in the machine age.

7
Marcel Duchamp, note
from *From the Green Box*,
in Michel Sanouillet and
Elmer Peterson, eds.,
*Salt Seller: The Writings of
Marcel Duchamp* (New York:
Da Capo Press, 1989), p. 68.

8
Philip Fisher, "The Recovery
of the Body," *Humanities
in Society*, 1 (Spring 1978),
pp. 141, 145–46.

Selected Bibliography

ADES, DAWN. *Dada and Surrealism Reviewed* (exhibition catalogue). London: Arts Council of Great Britain, 1978.

AGEE, WILLIAM. "New York Dada, 1910-30." *Art News Annual*, 34 (October 1968), pp. 104-13.

Arts Magazine, 51 (May 1977). Special issue devoted to New York Dada & the Arensberg Circle.

Avant-Garde Painting and Sculpture in America, 1910-1925. Wilmington: Delaware Art Museum and University of Delaware, 1975.

BARR, ALFRED H., JR., ED. *Fantastic Art: Dada, Surrealism* (exhibition catalogue). New York: The Museum of Modern Art, 1936.

BAUR, JOHN I.H. "The Machine and the Subconscious: Dada in America." *Magazine of Art*, 44 (October 1951), pp. 233-37.

BROWN, MILTON W. *American Painting from the Armory to the Depression*. New Jersey: Princeton University Press, 1955.

CHAMPA, KERMIT S., ED. *Over Here: Modernism, The First Exile, 1914-1919* (exhibition catalogue). Providence: David Winton Bell Gallery, Brown University, 1989.

DACHY, MARC. *The Dada Movement, 1915-1923*. New York: Rizzoli, 1990.

Dada and New York (exhibition catalogue). New York: Whitney Museum of American Art, 1979.

Dada Artifacts (exhibition catalogue). Iowa City: The University of Iowa Museum of Art, 1978.

DAVIDSON, ABRAHAM A. *Early American Modernist Painting: 1910-1935*. New York: Harper & Row, 1981.

FOSTER, STEPHEN C., ED. *Dada/Dimensions*. Ann Arbor: UMI Research Press, 1985.

HENNING, EDWARD B. "The Dada Prelude." In *The Spirit of Surrealism* (exhibition catalogue). Cleveland: Cleveland Museum of Art, 1979.

KUENZLI, RUDOLPH E., ED. *New York Dada*. New York: Willis Locker & Owens, 1986.

LIPPARD, LUCY R., ED. *Dadas on Art*. Englewood Cliffs, New Jersey: 1971.

MOTHERWELL, ROBERT, ED. *The Dada Painters and Poets: An Anthology*. New York: Wittenborn, Schultz, 1951.

NAUMANN, FRANCIS M. "The Big Show: The First Exhibition of the Society of Independent Artists." *Artforum*, Part I, 17 (February 1979), pp. 34-40; Part II, 17 (April 1979), pp. 49-53.

_____. "The New York Dada Movement: Better Late Than Never." *Arts*, 54 (February 1980), pp. 143-49.

_____. *New York Dada 1915-23*. New York: Harry N. Abrams, 1994.

NEFF, TERRY ANN R. *In the Mind's Eye: Dada and Surrealism*. Chicago: Museum of Contemporary Art, 1984.

RICHTER, HANS. *Dada: Art and Anti-Art*. Trans. David Britt, 1965; rpt. New York: Oxford University Press, 1978.

RUBIN, WILLIAM S. *Dada and Surrealist Art*. New York: Harry N. Abrams, 1968.

_____. *Dada, Surrealism, and Their Heritage* (exhibition catalogue). New York: The Museum of Modern Art, 1968.

SANOUILLET, MICHEL. *Dada 1915-1923*. London and New York: 1963.

SAWELSON-GORSE, NAOMI, ED. *Women in Dada*. Cambridge, Massachusetts: The MIT Press (forthcoming).

SCHWARZ, ARTURO. *New York Dada: Duchamp, Man Ray, Picabia* (exhibition catalogue). Munich: Städtische Galerie im Lenbachhaus, 1973.

SECKEL, HÉLÈNE. "Dada New York." In *Paris—New York*. Paris: Centre Georges Pompidou, 1977, pp. 342-67.

TASHJIAN, DICKRAN. "New York Dada and Primitivism." In STEPHEN C. FOSTER and RUDOLF E. KUENZLI, EDS. *Dada Spectrum: The Dialectics of Revolt*. Iowa City: University of Iowa, 1979, pp. 115-44.

_____. *Skyscraper Primitives: Dada and the American Avant-Garde, 1910-1925*. Middletown, Connecticut: Wesleyan University Press, 1975.

WATSON, STEVEN. *Strange Bedfellows: The First American Avant-Garde*. New York: Abbeville Press, 1991.

ZABEL, BARBARA. "The Machine as Metaphor, Model, and Microcosm: Technology in American Art 1915-30." *Arts Magazine*, 57 (December 1982), pp. 100-105.

LOUISE AND WALTER ARENSBERG

KUH, KATHARINE. "Walter Arensberg and Marcel Duchamp." *The Saturday Review*, September 5, 1970, pp. 36-7, 58; reprinted in Kuh, *The Open Eye: In Pursuit of Art*. New York: Harper & Row, 1971, pp. 56-64.

The Louise and Walter Arensberg Collection. Vol. 1, 20th-century section; vol. 2, Precolumbian sculpture. Philadelphia: Philadelphia Museum of Art, 1954.

NAUMANN, FRANCIS M. "Cryptography and the Arensberg Circle." *Arts Magazine*, 51 (May 1977), pp. 127-33.

_____. "Walter Conrad Arensberg: Poet, Patron, and Participant in the New York Avant-Garde 1915-1920." *Philadelphia Museum of Art Bulletin*, 76 (Spring 1980), pp. 1-32.

STEWART, PATRICK L. "The European Art Invasion: American Art and the Arensberg Circle, 1914-1918." *Arts Magazine*, 51 (May 1977), pp. 108-12.

JOHN COVERT

HAMILTON, GEORGE HEARD. "John Covert: Early American Modern." *College Art Journal*, 12 (Fall 1952), pp. 37-41.

KLEIN, MICHAEL. "John Covert and the Arensberg Circle: Symbolism, Cubism, and Protosurrealism." *Arts Magazine*, 51 (May 1977), pp. 113-15.

_____. *John Covert, 1882-1960*. Washington, D.C.: Hirshhorn Museum and Sculpture Garden/Smithsonian Institution Press, 1976.

JEAN CROTTI

Camfield, William, and Jean-Hubert Martin. *TABU DADA: Jean Crotti & Suzanne Duchamp 1915-1922*. Paris: Museé National d'Art Moderne, Centre Georges Pompidou, 1983.

Naumann, Francis M. "Affectueusement, Marcel: Ten Letters from Marcel Duchamp to Suzanne Duchamp and Jean Crotti." *Archives of American Art Journal*, 22 (Spring 1982), pp. 2-19.

STUART DAVIS

KELDER, DIANE, ED. *Stuart Davis*. New York: Praeger Publishers, 1971.

LANE, JOHN R. *Stuart Davis: Art & Art Theory* (exhibition catalogue). New York: The Brooklyn Museum, 1978.

SIMS, LOWERY STOKES. *Stuart Davis, American Painter* (exhibition catalogue). New York: The Metropolitan Museum of Art, 1991.

WILKIN, KAREN. *Stuart Davis*. New York: Abbeville Press, 1987.

CHARLES DEMUTH

EISEMAN, ALVORD L. *Charles Demuth*. New York: Watson-Guptill Publications, 1982.

FAHLMAN, BETSY. *Pennsylvania Modern: Charles Demuth of Lancaster* (exhibition catalogue). Philadelphia: Philadelphia Museum of Art, 1983.

FARNHAM, EMILY. *Charles Demuth: Behind a Laughing Mask*. Norman: University of Oklahoma Press, 1971.

HASKELL, BARBARA. *Charles Demuth* (exhibition catalogue). New York: Whitney Museum of American Art, 1987.

RITCHIE, ANDREW CARNDUFF. *Charles Demuth* (exhibition catalogue). New York: The Museum of Modern Art, 1950.

ARTHUR DOVE

HASKELL, BARBARA. *Arthur Dove*. San Francisco: San Francisco Museum of Art, 1974.

JOHNSON, DOROTHY RYLANDER. *Arthur Dove: The Years of Collage* (exhibition catalogue). College Park: University of Maryland Art Gallery, 1967.

MORGAN, ANN LEE. *Arthur Dove, Life Work with a Catalogue Raisonné*. Newark: University of Delaware Press, 1984.

WIGHT, FREDERICK S. *Arthur G. Dove* (exhibition catalogue). Los Angeles: The Art Galleries, University of California, Los Angeles, 1958.

KATHERINE DREIER

BOHAN, RUTH L. "Katherine Sophie Dreier and New York Dada." *Arts Magazine*, 51 (May 1977), pp. 97-101.

_____. *The Société Anonyme's Brooklyn Exhibition: Katherine Dreier and Modernism in America*. Ann Arbor: UMI Research Press, 1982.

DREIER, KATHERINE S. *Western Art and the New Era: An Introduction to Modern Art*. New York: Brentano's, 1923.

GALASSI, SUSAN GRACE. "Crusader for Modernism." *Art News*, 83 (September 1984), pp. 92-97.

HERBERT, ROBERT L., ELEANOR S. APTER, and ELISE K. KENNEY. *The Société Anonyme and the Dreier Bequest at Yale University, A Catalogue Raisonné*. New Haven: Yale University Art Gallery, 1984.

LEVY, ROBERT J. "Katherine Dreier: Patron of Modern Art." *Apollo*, 113 (May 1981), pp. 314-17.

SAARINEN, ALINE B. "Propagandist: Katherine Sophie Dreier." In *The Proud Possessors: The Lives, Times and Tastes of Some Adventurous American Art Collectors*. New York: Random House, 1958, pp. 238-49.

MARCEL DUCHAMP

CABANNE, PIERRE. *Dialogues with Marcel Duchamp*. Trans. Ron Padgett. New York: The Viking Press, 1974.

Conspiratorial Laughter, A Friendship: Man Ray and Duchamp (exhibition catalogue). New York: Zabriskie Gallery, 1995.

DE DUVE, THIERRY, ED. *The Definitively Unfinished Marcel Duchamp*. Cambridge, Massachusetts: The MIT Press, 1991.

GOLDING, JOHN. *Marcel Duchamp: "The Bride Stripped Bare by Her Bachelors, Even."* New York: The Viking Press, 1972.

D'HARNONCOURT, ANNE AND KYNASTON MCSHINE, EDS. *Marcel Duchamp* (exhibition catalogue). Philadelphia: Philadelphia Museum of Art; and New York: The Museum of Modern Art, 1973.

HULTEN, PONTUS, ED., *Marcel Duchamp, Work and Life*. Cambridge, Massachusetts: The MIT Press, 1993.

KUENZLI, RUDOLPH E., AND FRANCIS M. NAUMANN, EDS. *Marcel Duchamp: Artist of the Century.* Cambridge, Massachusetts: The MIT Press, 1989.

LEBEL, ROBERT. *Marcel Duchamp.* Trans. George Heard Hamilton. New York: Paragraphic Books, 1959.

NAUMANN, FRANCIS M. "The Bachelor's Quest." *Art in America,* 81 (September 1993), pp. 67, 69, 72-81.

_____. "Marcel Duchamp's Letters to Walter and Louise Arensberg." In NAUMANN AND RUDOLF KUENZLI, EDS. *Marcel Duchamp: Artist of the Century.* Cambridge, Massachusetts: The MIT Press, 1989, pp. 203-227.

NESBIT, MOLLY. "His Common Sense." *Artforum,* 33 (October 1994), pp. 92-126.

_____. "Ready-Made Originals: The Duchamp Model." *October,* 37 (Summer 1986), 53-64.

ROTH, MOIRA. "Marcel Duchamp in America: A Self Ready-Made." *Arts Magazine,* 51 (May 1977), pp. 92-96.

SANOUILLET, MICHEL AND ELMER PETERSON, EDS. *Salt Seller: The Writings of Marcel Duchamp.* New York: Oxford University Press, 1973.

SCHWARZ, ARTURO. *The Complete Works of Marcel Duchamp.* New York: Harry N. Abrams, 1969.

TASHJIAN, DICKRAN. "Henry Adams and Marcel Duchamp: Liminal Views of the Dynamo and the Virgin." *Arts Magazine,* 51 (May 1977), pp. 102-107.

BARONESS ELSA VON FREYTAG-LORINGHOVEN

BIDDLE, GEORGE. *An American Artist's Story.* Boston: Little, Brown, 1939, pp. 137-42.

REISS, ROBERT. "'My Baroness': Elsa von Freytag-Loringhoven." In KUENZLI, RUDOLPH E., ED. *New York Dada.* New York: Willis Locker & Owens, 1986, pp. 81-101.

RODKER, JOHN. "Dada and Elsa von Freytag-Loringhoven." *The Little Review,* 7 (July-August 1920).

FRANCIS PICABIA

BORRÀS, MARIA-LLUÏSA. *Picabia.* New York: Rizzoli, 1985.

CAMFIELD, WILLIAM A. "The Machine Style of Francis Picabia." *Art Bulletin,* 48 (1966), pp. 309-22.

_____. *Francis Picabia* (exhibition catalogue). New York: Solomon R. Guggenheim Museum, 1970.

HOMER, WILLIAM I. "Picabia's *Jeune fille américaine dans l'état de nudité* and Her Friends." *Art Bulletin,* 58 (March 1975), pp. 110-15.

SANOUILLET, MICHEL. *Picabia.* Paris: L'Oeil du Temps, 1964.

THOMPSON, JAN. "Picabia and His Influence on American Art, 1913-17." *Art Journal,* 39 (Fall 1979), pp. 14-21.

MAN RAY

BELZ, CARL. "Man Ray and New York Dada." *Art Journal,* 23 (Spring 1964), pp. 207-13.

FORESTA, MERRY A. *Perpetual Motif: The Art of Man Ray* (exhibition catalogue). Washington, D.C.: National Museum of American Art, Smithsonian Institution, 1988.

Man Ray (exhibition catalogue). Paris: Musée National d'Art Moderne, 1972.

MAN RAY. *Self Portrait.* Boston: Little, Brown and Company, 1963; reprinted Boston: New York Graphic Society and Little, Brown and Company, 1988.

NAUMANN, FRANCIS M. "Man Ray and the Ferrer Center: Art and Anarchy in the Pre-Dada Period." *Dada/Surrealism,* no. 14 (1985), pp. 10-30.

_____. "Man Ray's Early Paintings 1913-1916: Theory and Practice in the Art of Two Dimensions." *Artforum,* 20 (May 1982), pp. 37-46; reprinted in *Art Vivant,* no. 31 (1989), pp. 73-91.

_____. *Man Ray: The New York Years, 1913 to 1921* (exhibition catalogue). New York: Zabriskie Gallery, 1988.

PENROSE, SIR ROLAND. *Man Ray.* Boston: New York Graphic Society, 1975.

PINCUS-WITTEN, ROBERT. "Man Ray: The Homonymic Pun and American Vernacular." *Artforum,* 13 (April 1975), pp. 54-59.

SCHWARZ, ARTURO. "An Interview with Man Ray: 'This Is Not for America.'" *Arts,* 51 (May 1977), pp. 116-21.

SERS, PHILIPPE, AND JEAN-HUBERT MARTIN, EDS. *Man Ray: Objets de mon affection.* Paris: Philippe Sers, 1983.

JULIETTE ROCHE

ADDINGTON, SARAH. "New York is More Alive and Stimulating Than France Ever Was, Say Two French Painters." *New York Tribune,* October 9, 1915, p. 7.

AIBERT, PIERRE. *Albert Gleizes: Naissance et avenir du cubisme.* Saint-Etienne, France: Dumas, 1982.

"French Artists Spur on an American Art." *New York Tribune,* October 24, 1915, sec. 4, pp. 2-3, reprinted in RUDOLF E. KUENZLI, ED. *New York Dada.* New York: Willis Locker & Owens, 1986, pp. 128-35.

ROBBINS, DANIEL. "The Formation and Maturity of Albert Gleizes; A Biographic and Critical Study: 1881 through 1920." Ph.D. dissertation. New York: Institute of Fine Arts, New York University, 1975.

ROCHE, JULIETTE. *Demi Cercle.* Paris: Editions d'art "La Cible," 1920.

_____. "La Minéralisation de Dudley Craving Mac Adam." *La Vie des Lettres et des Arts,* 8 n.s. (1922), pp. 22-271; rpt. Paris: Croutzet, 1924.

MORTON LIVINGSTON SCHAMBERG

Agee, William C. "Morton Livingston Schamberg (1881-1918): Color and the Evolution of His Painting." *Arts Magazine*, 57 (November 1982), pp. 108-119.

_____. "Morton Livingston Schamberg: Notes on the Sources of the Images." In Rudolf E. Kuenzli, ed., *New York Dada*. New York: Willis Locker & Owens, 1986, pp. 66-80.

Powell, Earl A., III. "Morton Schamberg: The Machine As Icon." *Arts Magazine*, 51 (May 1977), pp. 122-124.

Wolf, Ben. *Morton Livingston Schamberg*. Philadelphia: University of Pennsylvania Press, 1963.

CHARLES SHEELER

Charles Sheeler (exhibition catalogue). Washington, D.C.: Smithsonian Institution Press, 1968.

Friedman, Martin. *Charles Sheeler*. New York: Watson-Guptill Publications, 1975.

Horak, Jan-Christopher. "Modernist Perspectives and Romantic Impulses: *Manhatta*." In Maren Stange, ed. *Paul Strand Essays on His Life and Work*. New York: Aperture, pp. 55-71.

Lucic, Karen. *Charles Sheeler and the Cult of the Machine*. London: Reaktion Books, 1991.

Rourke, Constance. *Charles Sheeler: Artist in the American Tradition*. New York: Harcourt, Brace and Company, 1938.

Stebbins, Theodore E., Jr., and Norman Keyes, Jr. *Charles Sheeler: The Photographs* (exhibition catalogue). Boston: Museum of Fine Arts, 1987.

JOSEPH STELLA

Baur, John I.H. *Joseph Stella*. New York: Praeger Publishers, 1971.

Haskell, Barbara. *Joseph Stella* (exhibition catalogue). New York: Whitney Museum of American Art, 1994.

Jaffe, Irma B. *Joseph Stella*. Cambridge, Massachusetts: Harvard University Press, 1970.

Stella, Joseph. "Discovery of America: Autobiographical Notes." *ArtNews*, 59 (November 1960), pp. 41-3, 64-7.

Zilczer, Judith. *Joseph Stella* (exhibition catalogue). Washington, D.C.: Smithsonian Institution Press, 1983.

FLORINE STETTHEIMER

Bloemink, Barbara J. *The Life and Art of Florine Stettheimer*. New Haven: Yale University Press, 1995.

McBride, Henry. *Florine Stettheimer* (exhibition catalogue). New York: The Museum of Modern Art, 1946.

Sussman, Elisabeth, and Barbara J. Bloemink. *Florine Stettheimer: Manhattan Fantastica* (exhibition catalogue). New York: Whitney Museum of American Art, 1995.

_____. *Florine Stettheimer: Still Lifes, Portraits, and Pageants 1910-1942* (exhibition catalogue). Boston: The Institute of Contemporary Art, 1980.

Tyler, Parker. *Florine Stettheimer: A Life in Art*. New York: Farrar, Straus and Company, 1963.

CLARA TICE

"The Blacks and Whites of Clara Tice with a Recent Portrait of the Artist." *Vanity Fair*, 5 (September 1915), p. 60.

Fornaro, Carlo de. "Action Plus and Art that Pulsates: A Word About Clara Tice and Her Rapid-Fire Drawings." *Arts & Decoration*, 18 (November 1922), pp. 14-15.

Keller, Marie T. "Who Was Clara Tice," introduction to Clara Tice, *ABC Dogs.*, New York: Harry N. Abrams 1995.

M[alkin], S[ol]. "Obituary Note." *AB Bookman's Weekly*, 51 (1973), p. 571.

BEATRICE WOOD

Beatrice Wood Retrospective (exhibition catalogue). Fullerton: California State University, 1983.

Hapgood, Elizabeth Reynolds. "All the Cataclysms: A Brief Survey of the Life of Beatrice Wood." *Arts Magazine*, 52 (March 1978), pp. 107-109.

Life with Dada: Beatrice Wood Drawings (exhibition catalogue). Philadelphia: Philadelphia Museum of Art, 1978.

Wood, Beatrice. *I Shock Myself: The Autobiography of Beatrice Wood*. Lindsay Smith, ed. San Francisco: Chronicle Books, 1985; reprinted 1988; originally published Ojai, California: Dillingham Press, 1985.

MARIUS DE ZAYAS

Bailey, Craig R. "The Art of Marius de Zayas." *Arts Magazine*, 53 (September 1978), pp. 136-144.

"How, When, and Why Modern Art Came To New York: Marius de Zayas." Introduction and notes by Francis M. Naumann. *Arts Magazine*, 54 (April 1980), pp. 96-126.

Hyland, Douglas. *Marius de Zayas: Conjurer of Souls*. Lawrence, Kansas: Spencer Art Museum, 1981.

Rünk, Eva Epp. "Marius de Zayas: The New York Years." MA thesis. Newark: University of Delaware, 1973.

Works in the Exhibition

Dimensions are in inches, followed by centimeters; height precedes width precedes depth.

RICHARD BOIX

DA-DA (NEW YORK DADA GROUP), 1921
Ink on paper, 11 1/4 x 14 1/2 (28.6 x 36.8)
The Museum of Modern Art, New York; Katherine S. Dreier Bequest

JOHN R. COVERT (1882-1960)

RESURRECTION, 1916
Oil on composition board, 25 1/4 x 27 (64.1 x 68.6)
Whitney Museum of American Art, New York;
Gift of Charles Simon 64.18

TEMPTATION OF SAINT ANTHONY, 1916
Oil on canvas, 25 5/16 x 23 5/16 (64.3 x 59.2)
Yale University Art Gallery, New Haven;
Gift of Collection Société Anonyme

HYDRO CELL, 1918
Oil on cardboard, 23 1/2 x 25 3/4 (59.7 x 60.3)
Philadelphia Museum of Art;
The Louise and Walter Arensberg Collection

BRASS BAND, 1919
Oil, cord (probably sisal fiber), nails, and possibly tempera
over gesso on commercial pieced wood, covered both sides
in cardboard, 26 x 24 (66 x 61)
Yale University Art Gallery, New Haven,
Gift of Collection Société Anonyme

EX ACT, 1919
Oil on plywood and cardboard, 23 1/4 x 25 1/4 (59.1 x 64.1)
The Museum of Modern Art, New York;
Katherine S. Dreier Bequest

WILL INTELLECT SENSATION EMOTION, 1920-23
Oil on commercial pieced wood, covered both sides in cardboard,
23 3/16 x 25 3/16 (58.9 x 64)
Yale University Art Gallery, New Haven;
Gift of Collection Société Anonyme

FROM WORD TO OBJECT, 1923
Oil on canvas, 26 x 20 (66 x 50.8)
Yale University Art Gallery, New Haven;
Gift of Collection Société Anonyme

JEAN CROTTI (1878-1958)

PORTRAIT OF MARCEL DUCHAMP, 1915
Graphite on paper, 21 1/2 x 13 1/2 (54.6 x 34.3)
The Museum of Modern Art, New York; Purchase

THE CLOWN, 1916
Miscellaneous objects attached to glass, 14 9/16 x 7 7/8 (37 x 20)
Musée d'Art Moderne de la Ville de Paris

DIEU (GOD), 1916
Gouache on board, 20 x 14 1/2 (50.8 x 36.8)
Collection of André Buckles

Study for LES FORCES MÉCANIQUES DE L'AMOUR EN
MOUVEMENT (THE MECHANICAL FORCES OF LOVE IN
MOVEMENT), 1916
Watercolor and gouache on board, 21 x 27 (53.3 x 68.6)
Collection of André Buckles

SOLUTION DE CONTINUITÉ (INTERRUPTION), c. 1916
Mixed media under glass, 13 1/4 x 10 15/16 (34 x 28)
Private collection

STUART DAVIS (1892-1964)

CIGARETTE PAPERS, 1921
Oil, bronze paint, and graphite on canvas, 19 x 14 (48.3 x 35.6)
The Menil Collection, Houston

UNTITLED, 1923
Mixed media and watercolor on paper, 14 1/2 x 9 1/2 (36.83 x
24.13)
Collection of Earl Davis; courtesy Salander-O'Reilly Gallery, New York

CHARLES DEMUTH (1883-1935)

BUSINESS, 1921
Oil on canvas, 20 x 24 (50.8 x 61)
The Art Institute of Chicago; Alfred Stieglitz Collection

SPRING, c. 1921
Oil on canvas, 22 1/8 x 24 1/8 (56.2 x 61.3)
The Art Institute of Chicago; Through prior gift of the Albert
Kunstadter Family Foundation

ARTHUR G. DOVE (1880-1946)

GEAR, c. 1922
Oil on canvas, 22 x 18 (55.9 x 45.7)
Collection of Mr. and Mrs. William C. Janss

THE CRITIC, 1925
Collage, 19 3/4 x 13 1/2 x 3 5/8 (50.2 x 34.3 x 9.2)
Whitney Museum of American Art, New York; Purchase, with funds
from the Historic Art Association of the Whitney Museum of
American Art, Mr. and Mrs. Morton L. Janklow, the Howard and
Jean Lipman Foundation, Inc., and Hannelore Schulhof 76.9

KATHERINE S. DREIER (1877-1952)

ABSTRACT PORTRAIT OF MARCEL DUCHAMP, 1918
Oil on canvas, 18 x 32 (45.6 x 81.3)
The Museum of Modern Art, New York;
Abby Aldrich Rockefeller Fund

MARCEL DUCHAMP (1887-1968)

BICYCLE WHEEL, 1913 (1964 replica)
Readymade: wheel mounted on painted wood stool,
49 3/4 (126.4) high
Collection of D.R.A. Wierdsma

PHARMACY, 1914
Rectified readymade: gouache on commercial print,
10 x 7 1/2 (25 x 19.1)
Collection of Arakawa

NINE MALIC MOLDS, 1914-15
(1966 reconstruction by Richard Hamilton)
Glass, lead, and lead paint, 26 x 39 (66 x 99.1)
Collection of Richard Hamilton

In Advance of the Broken Arm, 1915 (1964 edition)
Readymade: wood and galvanized iron shovel,
47 3/4 x 12 3/8 x 13 3/8 (121.3 x 31.4 x 34)
Indiana University Art Museum, Bloomington;
Partial gift of Mrs. William Conroy

The, 1915
Ink and graphite on paper, 8 3/4 x 5 5/8 (22.3 x 14.3)
Philadelphia Museum of Art;
The Louise and Walter Arensberg Collection

The Bride Stripped Bare by Her Bachelors, Even
(Large Glass), 1915-23
(1991-92 reconstruction by Ulf Linde, Henrik Samuelsson, and
John Stenborg)
Oil and lead wire on glass, 110 5/16 x 73 11/16 (283 x 189)
Moderna Museet, Stockholm

Rendez-vous du Dimanche 6 Février 1916
(Sunday Rendez-vous, February 6, 1916), 1916
Typewritten text on four postcards taped together,
11 1/4 x 6 1/2 (28.6 x 16.5)
Philadelphia Museum of Art;
The Louise and Walter Arensberg Collection

With Hidden Noise, 1916 (1964 edition)
Readymade: metal and twine,
4 1/2 x 5 1/8 x 5 1/8 (11.4 x 13 x 13)
Indiana University Art Museum, Bloomington;
Partial gift of Mrs. William Conroy

Apolinère Enameled, 1916-17
Readymade: painted tin, 9 1/4 x 13 1/4 (23.5 x 33.7)
Philadelphia Museum of Art;
The Louise and Walter Arensberg Collection

Fountain, 1917 (1964 edition)
Readymade: porcelain, 16 1/8 x 26 3/4 (41 x 67.4)
Collection of Barbara and Richard S. Lane

Trébuchet (Trap), 1917 (1964 edition)
Readymade: wood and metal coatrack,
4 5/8 x 39 3/8 x 4 3/4 (11.7 x 100 x 12.1)
Indiana University Art Museum, Bloomington;
Partial gift of Mrs. William Conroy

Shadows of Readymades, 1918
Gelatin silver print, 35 5/8 x 23 13/16 (90.5 x 60.5)
Marcel Duchamp Archives, Villiers-sous-Grez, France

Tu m', 1918
Oil on canvas with bottle brush, three safety pins, and a bolt,
27 1/2 x 122 3/4 (69.9 x 311.8)
Yale University Art Gallery, New Haven;
Gift of the Estate of Katherine S. Dreier

50cc of Paris Air, 1919 (1949 replica)
Readymade: glass ampoule, 5 1/4 (13.3) high
Philadelphia Museum of Art;
The Louise and Walter Arensberg Collection

Belle Haleine, Eau de Voilette, 1921
Perfume bottle, 6 x 6 7/16 x 4 7/16 (15.2 x 16.4 x 11.3)
Collection of Yves Saint-Laurent and Pierre Bergé

The Non-Dada, 1922
Found object (paper) with added inscription, 5 1/2 x 4 1/4
(14 x 11)
Scottish National Gallery of Modern Art, Edinburgh

BARONESS ELSA VON FREYTAG-LORINGHOVEN (1874-1927)

Earring—Object, c. 1917-19
Steel watch spring, celluloid, ebony bead, brass ear screws, plastic
ivory screw guards, pearl earrings, and Rodoid wire,
4 4/3 x 3 x 3 (12.1 x 7.6 x 7.6)
Collection of Howard Hussey

Portrait of Marcel Duchamp, c. 1919
Pastel and collage, 12 3/16 x 18 1/8 (31 x 46)
Collection of Arturo Schwarz

Dada Portrait of Berenice Abbott, c. 1922–23
Collage of synthetic materials, cellophane, metal foils, paper, stones,
metal objects, cloth, and paint, 8 5/8 x 9 1/4 (21.9 x 23.5)
The Museum of Modern Art, New York; From the collection of
Mary Louise Reynolds

FRANCIS PICABIA (1879-1953)

New York, 1913
Gouache on cardboard, 21 1/2 x 29 3/4 (54.6 x 75.6)
Barbara Mathes Gallery, New York

New York Perceived Through the Body, 1913
Watercolor on paper and gouache on board,
21 5/8 x 29 1/2 (54.9 x 74.9)
Galerie Ronny van de Velde, Antwerp

Fille née sans mère
(Girl Born Without a Mother), 1915
Ink on paper, 10 3/8 x 8 1/2 (26.4 x 21.6)
The Metropolitan Museum of Art, New York;
Alfred Stieglitz Collection

Paroxysme de la douleur (Paroxysm of Pain), 1915
Ink and metallic paint on cardboard, 31 1/2 x 31 1/2 (80 x 80)
National Gallery of Canada, Ottawa

Révérence (Reverence), 1915
Oil on cardboard, 39 1/4 x 39 1/4 (99.7 x 99.7)
The Baltimore Museum of Art; Bequest of Saidie A. May

Voilà Haviland (Here is Haviland), 1915
Ink and collage on paper, 25 3/4 x 18 3/4 (65.5 x 47.7)
Kunsthaus Zurich

Le Fiancé, c. 1915-17
Metallic paint and tempera on enamel ground,
10 x 12 3/4 (25.4 x 32.4)
Musée d'Art Moderne de Saint-Etienne, France

Machine tournez vite
(Machine Turn Quickly), c. 1916-18
Gouache and metallic paint on paper, mounted on canvas,
19 1/2 x 12 7/8 (49.5 x 32.7)
National Gallery of Art, Washington, D.C.; Patrons' Permanent Fund

Vertu (Virtue), c. 1917
Ink and gouache on paper, 9 5/8 x 12 5/8 (24.4 x 32.1)
Musée National d'Art Moderne, Centre Georges Pompidou, Paris;
Purchase by the CNAC GP

Paroles, 1917-19
Ink on paper, 10 1/4 x 13 5/8 (26 x 34.6)
Collection of Ronny van de Velde

L'Enfant Carburetor
(The Child Carburetor), c. 1919
Oil, gilt, graphite, and metallic paint on plywood, 49 3/4 x 39 7/8
(126.4 x 101.3)
Solomon R. Guggenheim Museum, New York

MAN RAY (1890-1976)

FIVE FIGURES, 1914
Oil on canvas, 36 x 32 (91.4 x 81.3)
Whitney Museum of American Art, New York;
Gift of Katharine Kuh 56.36

MADONNA, 1914
Oil on canvas, 20 1/8 x 16 1/8 (51.1 x 41)
Columbus Museum of Art, Ohio; Gift of Ferdinand Howald

MAN RAY 1914, 1914
Oil on board, 6 11/16 x 4 11/16 (17 x 11.9)
Anthony Penrose Collection; courtesy Scottish National Gallery of
Modern Art, Edinburgh

WAR: A.D. MCMXIV, 1914
Oil on canvas, 37 x 69 1/2 (94 x 176.5)
Philadelphia Museum of Art; A.E. Gallatin Collection

SILHOUETTE, 1916
Ink on paper, 20 15/16 x 25 1/4 (51.6 x 64.1)
The Solomon Guggenheim Foundation, New York; Peggy
Guggenheim Collection, Venice

THE ROPE DANCER ACCOMPANIES HERSELF WITH HER
SHADOWS, 1916
Oil on canvas, 52 x 73 3/8 (132.1 x 186.4)
The Museum of Modern Art, New York; Gift of G. David Thompson

SELF-PORTRAIT, 1916 (1964 replica)
Mixed-media assemblage: push button and doorbells
mounted on panel, 27 1/4 x 19 (69.2 x 48.3)
Collection of William and Marilyn Van Keppel

SYMPHONY ORCHESTRA, 1916
Oil on canvas, 52 x 36 (132.1 x 91.4)
Albright-Knox Art Gallery, Buffalo; George B. and
Jenny R. Mattews Fund, 1970

REVOLVING DOOR SERIES III: ORCHESTRA, 1916-17
Collage and ink on board, 22 1/16 x 14 1/16 (56 x 35.7)
Private collection

REVOLVING DOOR SERIES IV: THE MEETING, 1916-17
Collage and ink on board, 22 1/16 x 14 1/16 (56 x 35.7)
Collection of Richard S. Zeisler

REVOLVING DOOR SERIES VII: JEUNE FILLE
(YOUNG GIRL), 1916-17
Collage and ink on board, 22 1/16 x 14 1/16 (56 x 35.7)
Collection of Mr. and Mrs. Andrew P. Fuller

REVOLVING DOOR SERIES VIII: SHADOWS, 1916-17
Collage and ink on board, 22 1/16 x 14 1/16 (56 x 35.7)
Collection of Mr. and Mrs. Meredith Long

REVOLVING DOOR SERIES IX: CONCRETE MIXER, 1916-17
Collage and ink on board, 22 1/16 x 14 1/16 (56 x 35.7)
Collection of Mr. and Mrs. Meredith Long

REVOLVING DOOR SERIES X: DRAGONFLY, 1916-17
Collage and ink on board, 22 1/16 x 14 1/16 (56 x 35.7)
Collection of Mr. and Mrs. Meredith Long

AUTOMATON, 1917
Cliché-verre, 9 11/16 x 7 3/4 (24.6 x 19.7)
Collection of Mark Kelman

DÉCOLLAGE, 1917 (1947 replica)
Collage on paper (hair, hair pins), 15 3/8 x 11 7/16 (39.7 x 29.1)
Collection of Mrs. Melvin Jacobs

INVOLUTE, 1917
Mixed-media collage on laminated board,
24 1/4 x 18 1/4 (61.6 x 46.4)
Scottish National Gallery of Modern Art, Edinburgh

NEW YORK, 1917 (1966 edition)
Chrome-plated metal and metal clamp, 17 1/2 (44.5) high
Property of the Whitney Museum of American Art, New York

PERCOLATOR, 1917
Oil on board, 21 x 16 (53.3 x 40.6)
The Art Institute of Chicago; Through prior gift of the
Albert Kunstadter Family Foundation

SEC, 1917
Oil on board, 25 1/4 x 19 (64.1 x 48.3)
Private collection

SUICIDE, 1917
Ink, tempera, and varnish on cardboard, 24 x 18 1/4 (61 x 46.4)
The Menil Collection, Houston

BY ITSELF I, 1918 (1966 replica)
Bronze, 16 6/8 x 7 1/4 x 7 7/16 (42.5 x 18.4 x 18.9)
Collection of Marion Meyer

BY ITSELF II, 1918
Wood, 23 5/8 x 8 1/4 x 7 1/2 (60 x 21 x 19)
Kunsthaus Zurich

FEMME (WOMAN), 1918
Gelatin silver print, 17 3/16 x 13 1/4 (43.7 x 33.7)
Gilman Paper Company Collection, New York

HOMME (MAN), 1918
Gelatin silver print, 19 15/16 x 15 1/8 (50.6 x 38.4)
Jedermann Collection, N.A.

STILL LIFE + ROOM INTERIOR, 1918
Oil on board, 34 1/2 x 35 1/2 (87.6 x 90.2)
Tokyo Fuji Art Museum

ADMIRATION OF THE ORCHESTRELLE
FOR THE CINEMATOGRAPH, 1919
Ink and gouache airbrushed on paper, with traces of graphite,
26 x 21 1/2 (66 x 54.6)
The Museum of Modern Art, New York; Gift of A. Conger Goodyear

AEROGRAPH or UNTITLED, 1919
Spray paint on cardboard, 26 3/8 x 19 5/8 (67 x 49.8)
Staatsgalerie Stuttgart, Graphische Sammlung

LAMPSHADE, 1919 (1959 replica)
Painted metal, 24 (70) high
Collection of Mark Kelman

SEGUIDILLA, 1919
Watercolor, gouache, airbrush, ink, graphite, and colored pencil on
paperboard, 22 x 27 13/16 (55.9 x 70.6)
Hirshhorn Museum and Sculpture Garden, Smithsonian Institution,
Washington, D.C.; The Joseph H. Hirshhorn Purchase Fund and
Museum Purchase

LA VOLIÈRE (THE AVIARY), 1919
Graphite and ink airbrushed on paper,
27 3/4 x 21 7/8 (70.5 x 55.6)
Scottish National Gallery of Modern Art, Edinburgh

COMPASS, 1920
 Gelatin silver print, 4 5/8 x 3 3/8 (11.7 x 8.6)
 The Metropolitan Museum of Art, New York; Ford Motor Company
 Collection, Gift of Ford Motor Company and John C. Waddell

DUST BREEDING, 1920
 Gelatin silver print, 8 1/4 x 16 (21 x 40.6)
 Kunsthaus Zurich

DUST BREEDING, 1920
 Gelatin silver print, 2 7/8 x 4 3/8 (7.3 x 11.1)
 Jedermann Collection, N.A.

FLYING DUTCHMAN, 1920
 Oil on board, 19 x 25 1/4 (48.3 x 64.1)
 Private collection

L'INQUIÉTUDE, 1920
 Gelatin silver print, 4 5/8 x 3 5/8 (12.1 x 9.2)
 Houk Friedman Gallery, New York

MOVING SCULPTURE, 1920
 Gelatin silver print, 3 1/2 x 5 1/2 (8.9 x 14)
 Jedermann Collection, N.A.

NEW YORK or EXPORT COMMODITY, 1920
 Gelatin silver print, 11 1/2 x 8 (29.2 x 20.3)
 The Menil Collection, Houston

NEW YORK or EXPORT COMMODITY, 1920 (1973 edition)
 Metal ball bearings in glass olive jar, 10 1/4 x 2 3/8 (26 x 6.8)
 Collection of Giorgio Marconi

NEW YORK (TRANSATLANTIQUE), 1920
 Gelatin silver print, 9 5/16 x 11 1/2 (23.7 x 29.2)
 Collection of Giorgio Marconi

OBSTRUCTION, 1920 (1961 replica)
 Clothes hangers, 29 1/2 (74.9) overall
 Moderna Museet, Stockholm

PORTMANTEAU, 1920
 Gelatin silver print on original mount, 9 1/8 x 6 (23.2 x 15.2)
 Private collection

PORTRAIT (MINA LOY), 1920
 Gelatin silver print mounted on paperboard, 5 x 3 7/8 (12.7 x 9.8)
 The Menil Collection, Houston

PUÉRICULTURE or RÊVE/PUÉRICULTURE
(DREAM/CHILDCARE), 1920
 Metal and plaster, 10 1/2 x 4 5/6 (26.7 x 12.3)
 The Art Institute of Chicago; Bequest of Florence S. McCormick

ROSE SÉLAVY, 1921
 Gelatin silver print, 6 7/8 x 4 15/16 (17.5 x 12.5)
 Marcel Duchamp Archives, Villiers-sous-Grez, France

ROSE SÉLAVY, 1921 (1970 print)
 Gelatin silver print, 15 3/4 x 11 13/16 (40 x 30)
 Collection of Lucien Treillard

ƎƧOЯROSE SEL À VIE, 1922
 Rayograph, 4 7/8 x 4 (12.4 x 10.2)
 Papers of *The Little Review*, Golda Meir Library, University of
 Wisconsin, Milwaukee

JULIETTE ROCHE (1884-1980)
NEW YORK, 1918
 Oil on canvas, 31 1/2 x 18 7/8 (80 x 47.9)
 Fondation Albert Gleizes, Paris

BROOKLYN, ST. GEORGE HOTEL PISCINE, c. 1918
 Oil on paper, 41 3/8 x 19 15/16 (105.1 x 50.6)
 Fondation Albert Gleizes, Paris

MORTON LIVINGSTON SCHAMBERG (1881-1918)
PAINTING VIII (MECHANICAL ABSTRACTION), 1916
 Oil on canvas, 30 x 24 1/4 (76.2 x 61.6)
 Philadelphia Museum of Art;
 The Louise and Walter Arensberg Collection

TELEPHONE, 1916
 Oil on canvas, 24 x 20 (61 x 50.8)
 Columbus Museum of Art, Ohio; Gift of Ferdinand Howald

UNTITLED (MECHANICAL ABSTRACTION), 1916
 Oil on composition board, 20 x 16 (50.8 x 40.6)
 Whitney Museum of American Art, New York;
 50th Anniversary Gift of Mrs. Jean Whitehill 86.5.2

GOD, 1917
 Gelatin silver print, 4 x 2 (10.2 x 5.1)
 The Metropolitan Museum of Art, New York;
 Elisha Whittelsey Collection, Elisha Whittelsey Fund

MORTON LIVINGSTON SCHAMBERG AND
BARONESS ELSA VON FREYTAG-LORINGHOVEN
GOD, c. 1917
 Miter box and plumbing trap, 10 1/2 x 11 5/8 x 4
 (26.7 x 29.5 x 10.2)
 Philadelphia Museum of Art;
 The Louise and Walter Arensberg Collection

CHARLES SHEELER (1883-1965)
BARONESS ELSA'S PORTRAIT
OF MARCEL DUCHAMP, c. 1920
 Platinum silver print, 8 x 6 (20.3 x 15.2)
 Collection of Ronny van de Velde

PHOTOGRAPH OF DUCHAMP'S
"BRIDE STRIPPED BARE BY HER BACHELORS, EVEN,"
 c. 1921
 Gelatin silver print, 7 5/8 x 8 3/4 (19.4 x 22.2)
 Museum of Fine Arts, Boston; The Lane Collection

SKYSCRAPERS, 1922
 Oil on canvas, 20 x 13 (50.8 x 33)
 The Phillips Collection, Washington, D.C.

PAUL STRAND (1891-1976) AND CHARLES SHEELER
MANHATTA, 1920
 35mm film, black-and-white, silent film; 9 minutes
 Film Collection, The Museum of Modern Art, New York

JOSEPH STELLA (1877-1946)
Study for MAN SEEN THROUGH THE WINDOW
ON THE ELEVATED, 1916 (signed 1918)
 Collage of graphite, charcoal, and newspaper,
 15 x 15 1/2 (38.1 x 39.4)
 Gertrude Stein Gallery, New York

PRESTIDIGITATOR, 1916
Oil and wire on glass, 13 5/16 x 8 1/2 (33.8 x 21.6)
Whitney Museum of American Art, New York;
Daisy V. Shapiro Bequest 85.29

COLLAGE, NUMBER 21, c. 1920
Collage of paper, 10 1/2 x 7 1/2 (26.7 x 19.1) sight
Whitney Museum of American Art, New York; Purchase 61.42

FLORINE STETTHEIMER (1871-1944)
LA FÊTE À DUCHAMP, 1917
Oil on canvas, 35 x 45 1/2 (89 x 115.6)
Private collection

NEW YORK/LIBERTY, 1918
Oil on canvas, 60 x 42 (152.4 x 106.7)
Collection of William Kelly Simpson

PORTRAIT OF DUCHAMP, 1923
Oil on canvas, 30 x 26 (76.2 x 66)
Collection of William Kelly Simpson

PORTRAIT OF MARCEL DUCHAMP, c. 1923
Oil on canvas, 23 x 23 (58.4 x 58.4)
Museum of Fine Arts, Springfield, Massachusetts;
Gift of the Estate of Ettie and Florine Stettheimer

ALFRED STIEGLITZ (1864-1946)
MARCEL DUCHAMP, FOUNTAIN, 1917
Gelatin silver print, 9 1/4 x 7 (23.5 x 17.8)
Marcel Duchamp Archives, Villiers-sous-Grez, France

PORTRAIT OF DOROTHY TRUE, 1919
Gelatin silver print, 9 1/2 x 7 1/2 (24 1/8 x 19)
National Gallery of Art, Washington, D.C.;
Alfred Stieglitz Collection

CLARA TICE (1888-1973)
PORTRAIT OF FRANK CROWNINSHIELD, c. 1921
Colored pencil on paper, 11 1/2 x 8 (29.2 x 20.3)
Private collection

INSECT FROLIC, 1923
Ink and gouache on board, 21 1/2 x 13 7/8 (54.6 x 35.2)
Private collection

EDITH CLIFFORD WILLIAMS (1880-1971)
TWO RHYTHMS, 1916
Oil on canvas, 29 x 29 (73.7 x 73.7)
Philadelphia Museum of Art;
The Louise and Walter Arensberg Collection

BEATRICE WOOD (b. 1893)
DIEU PROTÈGE LES AMANTS
(GOD PROTECTS LOVERS), 1917
Watercolor, ink, and graphite on paper, 10 3/4 x 8 1/4 (27.3 x 21)
Collection of Elaine Lustig Cohen

LIT DE MARCEL (MARCEL'S BED), 1917
Watercolor, 8 3/4 x 5 3/4 (22.2 x 14.6)
Private collection

UN PEUT [sic] D'EAU DANS DU SAVON
(A LITTLE WATER IN SOME SOAP), 1917 (1977 replica)
Graphite, colored pencil, and soap on cardboard,
10 1/2 x 8 1/4 (26.7 x 21)
Whitney Museum of American Art, New York;
Gift of Francis M. Naumann

POSTER FOR THE BLINDMAN'S BALL, 1917
Offset lithograph, 27 1/2 x 9 11/16 (69.9 x 24.6)
Yale University Art Gallery, New Haven;
Gift of Francis M. Naumann

SOIRÉE (EVENING PARTY), 1917
Graphite, watercolor, and ink on paper,
8 5/8 x 10 7/8 (21.9 x 27.6)
Private collection

BÉATRICE ET SES DOUZES ENFANTS!
(BEATRICE AND HER TWELVE CHILDREN!), c. 1917
Watercolor, ink, and graphite on paper,
8 3/4 x 10 3/4 (22.2 x 27.3)
Philadelphia Museum of Art; Gift of the Artist

POUR TOI—PSYCHOLOGIE, c. 1917
Album of handwritten text and watercolors, 8 x 10 (20.3 x 25.4)
Philadelphia Museum of Art; Gift of the Artist

POUR TOI—ADVENTURE DE VIERGE, c. 1917-18
Album of handwritten text and watercolors, 8 x 10 (20.3 x 25.4)
Philadelphia Museum of Art; Gift of the Artist

MARIUS DE ZAYAS (1880-1961)
ALFRED STIEGLITZ, c. 1912
Photogravure, 10 x 8 (25.4 x 20.3)
Zayas Archives, Seville, Spain

MRS. EUGENE MEYER, JR., c. 1913
Photogravure, 10 x 8 (25.4 x 20.3)
Zayas Archives, Seville, Spain

PAUL HAVILAND, c. 1913
Photogravure, 10 x 8 (25.4 x 20.3)
Zayas Archives, Seville, Spain

PORTRAIT OF FRANCIS PICABIA, c. 1913
Photogravure, 10 x 8 (25.4 x 20.3)
Zayas Archives, Seville, Spain

THEODORE ROOSEVELT, c. 1913
Photogravure, 10 x 8 (25.4 x 20.3)
Zayas Archives, Seville, Spain

WORK IN THE ARENSBERG APARTMENT RECONSTRUCTION

GEORGES BRAQUE (1882-1963)
FOX, 1912
Drypoint etching, 10 x 6 (25.4 x 15.2)
Philadelphia Museum of Art;
The Louise and Walter Arensberg Collection

PAUL CÉZANNE (1839-1906)
LANDSCAPE WITH TREES, 1890-94
Watercolor on paper, 11 1/2 x 18 (29.2 x 45.7)
Philadelphia Museum of Art;
The Louise and Walter Arensberg Collection

MARCEL DUCHAMP (1887-1968)
Nude Descending a Staircase, No. 2, 1912
Oil on canvas, 58 x 35 (147.3 x 88.9)
Philadelphia Museum of Art;
The Louise and Walter Arensberg Collection

Chocolate Grinder No. 1, 1913
Oil on canvas, 24 3/8 x 25 1/2 (61.9 x 64.8)
Philadelphia Museum of Art;
The Louise and Walter Arensberg Collection

HENRI MATISSE (1869-1954)
Mlle. Yvonne Landsberg, 1914
Oil on canvas, 58 x 38 3/8 (147.3 x 97.5)
Philadelphia Museum of Art;
The Louise and Walter Arensberg Collection

FRANCIS PICABIA (1879-1953)
Physical Culture, 1913
Oil on canvas, 35 1/8 x 46 (89.2 x 116.8)
Philadelphia Museum of Art;
The Louise and Walter Arensberg Collection

PABLO PICASSO (1881-1973)
Female Nude, 1910-11
Oil on canvas, 38 3/4 x 30 3/8 (98.4 x 77.2)
Philadelphia Museum of Art;
The Louise and Walter Arensberg Collection

MAGAZINES

MARCEL DUCHAMP
"The Richard Mutt Case," in Marcel Duchamp, Henri-Pierre Roché, and
Beatrice Wood, eds., The Blind Man, no. 2 (May 1917)
Private collection

MARCEL DUCHAMP, ed.
Rongwrong, no. 1 (August 1917)
Philadelphia Museum of Art;
The Louise and Walter Arensberg Collection

MARCEL DUCHAMP AND MAN RAY, eds.,
New York Dada (April 1921)
Three copies:
Philadelphia Museum of Art;
The Louise and Walter Arensberg Collection
Collection of Ronny van de Velde
Private collection

MARCEL DUCHAMP, HENRI-PIERRE ROCHÉ, AND BEATRICE WOOD, eds.
The Blindman, no. 1 (April 1917)
Philadelphia Museum of Art;
The Louise and Walter Arensberg Collection

The Blind Man, no. 2 (May 1917)
Philadelphia Museum of Art; Arensberg Archives

ROBERT LOCHER
Prudes Descending a Staircase, in Allen Norton, ed.,
Rogue, vol. 1 (May 15, 1915)
Private collection

FRANCIS PICABIA
Ici, c'est ici Stieglitz/Foi et amour (Here, This Is
Stieglitz/Faith and Love), reproduced on cover; Le saint
des saints/C'est de moi qu'il s'agit dans ce portrait
(The Saint of Saints/This Is a Portrait About Me);
Portrait d'une jeune fille américaine dans l'état de
nudité (Portrait of a Young American Girl in a
State of Nudity); De Zayas! De Zayas!; Voilà
Haviland (Here Is Haviland), in Paul Haviland and Marius
de Zayas, eds., 291, nos. 5-6 (July-August 1915)
Private collection

Âne (Donkey), cover of Francis Picabia, ed., 391, no. 5
(June 1917)
Yale Collection of American Literature, Beinecke Rare Book and
Manuscript Library, Yale University, New Haven

Américaine (American), cover of Francis Picabia, ed.,
391, no. 6 (July 1917)
Private collection

Ballet mécanique (Mechanical Ballet), cover of Francis
Picabia, ed., 391, no. 7 (August 1917)
Yale Collection of American Literature, Beinecke Rare Book and
Manuscript Library, Yale University, New Haven

Construction Moléculaire
(Molecular Construction), cover of Francis Picabia, ed.,
391, no. 8 (February 1919)
The Museum of Modern Art, Library, New York

Mouvement Dada, in Tristan Tzara, ed.,
Anthologie Dada, May 19, 1919
The Museum of Modern Art, Library, New York

FRANCIS PICABIA AND MARIUS DE ZAYAS
Voilà Elle (Here She Is), and Elle (She), in Paul Haviland
and Marius de Zayas, eds., 291, no. 9
(November 1915)
Library of The Metropolitan Museum of Art, New York

MAN RAY, ed.
The Ridgefield Gazook, March 31, 1915 (facsimile)
Private collection

MAN RAY, HENRY S. REYNOLDS, AND ADOLF WOLFF, eds.
TNT, no. 1 (March 1919)
Philadelphia Museum of Art;
The Louise and Walter Arensberg Collection

CLARA TICE
Who's Who in Manhattan, in Cartoons Magazine
(August 1917)
Philadelphia Museum of Art;
Arensberg Archives

Nude with Butterfly, cover of Bruno's Garret
(July 1915)
Collection of Marie T. Keller

Untitled Bookplate
Collection of Marie T. Keller

BEATRICE WOOD

Mariage d'une amie (Marriage of a Friend),
in Allen Norton, ed., Rogue, n.s. no. 3 (December 1916)
Private collection

MARIUS DE ZAYAS

291 Throws Back its Forelock, cover of Paul Haviland and
Marius de Zayas, eds., 291, no. 1 (March 1915)
Library of The Metropolitan Museum of Art, New York

BOOKS

WALTER ARENSBERG (1878-1954)

Poems, 1914
Private collection

Idols, 1916
Private collection

The Cryptography of Dante, 1921
Private collection

The Cryptography of Shakespeare, 1922
Private collection

MARCEL DUCHAMP

Some French Moderns Says McBride, 1922
Collection of Ronny van de Velde

JULIETTE ROCHE

Brevoort and N'Existe Pas Pôle Tempéré in Juliette Roche,
Demi Cercle, 1920
Private collection

La Minéralisation de Dudley Craving
Mac Adam, 1924
Private collection

UNKNOWN DESIGNER

Society of Independent Artists, exhibition catalogue, 1917
Private collection

DOCUMENTARY PHOTOGRAPHS

MAN RAY

Baroness Elsa von Freytag-Loringhoven, 1920
Gelatin silver print, 4 1/4 x 3 1/4 (10.8 x 8.3)
Papers of Elsa von Freytag-Loringhoven,
Special Collections, University of Maryland at
College Park Libraries

Installation View of the Société Anonyme
Galleries, 1920
Gelatin silver print, 4 x 5 (10.2 x 12.7)
Collection of Giorgio Marconi

Marcel Duchamp's Rotary Glass Plates
(in Motion), 1920
Gelatin silver print, 4 15/16 x 3 (12.5 x 7.6)
Collection of Timothy Baum

Studio—basement 8th St., N.Y., 1920
Gelatin silver print, 3 13/16 x 4 9/16 (9.7 x 11.6)
Collection of Timothy Baum

Baroness Elsa von Freytag-Loringhoven, c. 1920-27
Gelatin silver print, 3 x 2 3/16 (7.6 x 5.5)
Papers of Elsa von Freytag-Loringhoven, Special Collections,
University of Maryland at College Park Libraries

CHARLES SHEELER

Living Room of New York Apartment of Louise and
Walter Arensberg (East Wall, from above), 1919
Photograph, 7 1/2 x 9 1/2 (19.1 x 24.1)
Collection of Charles C. Arensberg

Living Room of New York Apartment of Louise and
Walter Arensberg (Northwest Corner), 1919
Gelatin silver print, 7 15/16 x 9 7/8 (20.2 x 25.2)
Whitney Museum of American Art, New York;
Gift of James Maroney and Suzanne Fredericks 80.30.3

Living Room of New York Apartment of Louise and
Walter Arensberg (Section of East Wall), 1919
Gelatin silver print, 7 15/16 x 9 15/16 (20.2 x 25.2)
Whitney Museum of American Art, New York;
Gift of James Maroney and Suzanne Fredericks 80.30.2

Living Room of New York Apartment of Louise and
Walter Arensberg (Section of South Wall), 1919
Gelatin silver print, 7 15/16 x 9 15/16 (20.2 x 25.2)
Whitney Museum of American Art, New York;
Gift of James Maroney and Suzanne Fredericks 80.30.4

Living Room of New York Apartment of Louise and
Walter Arensberg (Southeast Corner), c. 1919
Gelatin silver print, 7 15/16 x 9 15/16 (20.2 x 25.2)
Whitney Museum of American Art, New York;
Gift of James Maroney and Suzanne Fredericks 80.30.1

UNKNOWN PHOTOGRAPHERS

Men from the Others Group, c. 1916
Gelatin silver print, 8 x 10 (20.3 x 25.4)
The Poetry/Rare Books Collection of the University Libraries,
State University of New York at Buffalo

Women from the Others Group, c. 1916
Gelatin silver print, 8 x 10 (20.3 x 25.14)
The Poetry/Rare Books Collection of the University Libraries,
State University of New York at Buffalo

Marcel Duchamp, Francis Picabia, and
Beatrice Wood at Coney Island, June 21, 1917
Gelatin silver print, 4 1/2 x 3 1/4 (11.5 x 8.3)
Private collection

Arthur Cravan, n.d.
Photograph, 3 1/2 x 3 (8.9 x 7.6)
Collection of Marcel Fleiss

Arthur Cravan, n.d.
Photograph, 4 3/8 x 4 (11.1 x 10.2)
Collection of Marcel Fleiss

ADDITIONAL DOCUMENTARY MATERIAL

GEORGE BIDDLE (1885-1973)
THE BARONESS ELSA VON FREYTAG-LORINGHOVEN, 1921
Lithograph: sheet, 14 1/8 x 17 7/16 (35.9 x 44.3)
image, 10 x 3 5/16 (25.4 x 8.4)
Private collection

ARTHUR CRAVAN
LETTER TO MINA LOY
(ON HOTEL BELLEVUE STATIONERY), 1917
Ink on paper
Collection of Marcel Fleiss

LETTER TO MINA LOY, 1917
Ink on paper
Collection of Marcel Fleiss

MARCEL DUCHAMP
PLACE CARD FOR CARL VAN VECHTEN, 1917
Ink on paper, 8 7/8 x 5 3/4 (22.7 x 14.6)
Collection of Ronny van de Velde

PLACE CARD FOR FANIA MARINOFF, 1917
Ink on paper, 8 7/8 x 5 3/4 (22.7 x 14.6)
Collection of Ronny van de Velde

PLACE CARD FOR FRANCIS PICABIA, 1917
Ink on paper, 8 7/8 x 5 3/4 (22.7 x 14.6)
Collection of Ronny van de Velde

HENRI HAYDEN (1883-1970)
PORTRAIT OF ARTHUR CRAVAN, C. 1912
Oil on canvas, 23 1/2 x 19 1/2 (59.7 x 49.5)
Collection of Roger Lloyd Conover

FRANCIS PICABIA
LETTER TO WALTER ARENSBERG
(WITH POSTSCRIPT BY TRISTAN TZARA), November 8, 1920
Philadelphia Museum of Art;
The Louise and Walter Arensberg Collection

TRISTAN TZARA
LETTER TO MARIUS DE ZAYAS
(WITH POSTSCRIPT BY MARCEL JANCO), 1916
Zayas Archives, Seville

LETTER TO MAN RAY ON MOUVEMENT DADA STATIONERY,
February 3, 1921
Collection of Marion Meyer

BEATRICE WOOD
DIARY OF BEATRICE WOOD, VOL. 1, 1915-19
Ink on paper, 6 1/4 x 5 x 1 (15.9 x 12.7 x 2.5)
Private collection

PHOTO ALBUM, 1917
15 1/2 x 13 1/2 x 1 1/2 (39.4 x 34.3 x 3.8)
Private collection

DIARY OF BEATRICE WOOD, VOL. 2, 1920-24
Ink on paper, 6 1/4 x 5 x 3/4 (15.9 x 12.7 x 1.9)
Private collection

UNKNOWN ARTISTS
BARCELONA FIGHT POSTER
(ARTHUR CRAVAN VS. JACK JOHNSON), 1916
37 x 25 (94 x 64)
Collection of Fabienne Cravan Benedict

INVITATION CARD FOR THE BLINDMAN'S BALL, 1917
4 x 4 1/2 (10.2 x 11.4)
Marcel Duchamp Archives, Villiers-sous-Grez, France

ILLUSTRATED WORKS NOT IN THE EXHIBITION

GUILLAUME APOLLINAIRE (1880-1918)
VOYAGE, in Alfred Stieglitz and Marius de Zayas, eds., 291, no. 1
(March 1915)
Library of The Metropolitan Museum of Art, New York

ALEXANDER ARCHIPENKO (1887-1964)
SEATED WOMAN (GEOMETRIC FIGURE SEATED), 1920
Painted plaster, 22 1/2 (57) high
Tel Aviv Museum; Gift of the Goeritz Family, London

WALTER ARENSBERG (1878-1954)
"Vacuum Tires: A Formula for the Digestion of Figments," in Man Ray,
Henry S. Reynolds, and Adolf Wolff, eds., TNT, no. 1
(March 1919)
Philadelphia Museum of Art;
The Louise and Walter Arensberg Collection

CHARLIE CHAPLIN (1889-1977)
Still from A WOMAN, 1915
The Museum of Modern Art/Film Stills Archive, New York

ALVIN LANGDON COBURN (1882-1966)
THE WOOLWORTH BUILDING or NEW YORK FROM ITS
PINNACLES, 1912
Gelatin silver print, 15 7/8 x 9 1/2 (40.5 x 24.2)
George Eastman House, Rochester, New York

COLIN CAMPBELL COOPER (1856-1937)
VIEW OF WALL STREET (Study for WATERFRONT OF
NEW YORK), n.d.
Oil on canvas, 21 x 17 (53.3 x 43.2)
Private collection; courtesy Sotheby's Inc., New York

KENYON COX (1856-1919)
AN ECLOGUE, 1890
Oil on canvas, 48 x 60 1/2 (121.9 x 153.7)
National Museum of American Art, Smithsonian Institution,
Washington, D.C.; Gift of Allyn Cox

JEAN CROTTI (1878-1958)
PORTRAIT OF MARCEL DUCHAMP (SCULPTURE MADE TO
MEASURE), 1915
Original work lost
Photograph, courtesy of Ronny van de Velde

Composition with Square, 1916
Collage, gouache, sequins, encased gear, and lead wire on glass, 30 1/2 x 25 1/4 (77.3 x 63.8)
Philadelphia Museum of Art; On extended loan from André Buckles

Les forces mécaniques de l'amour en mouvement (The Mechanical Forces of Love in Movement), 1916
Oil, metal tubing, and wire affixed to glass, 23 5/8 x 29 1/8 (60 x 74)
Private collection

STUART DAVIS (1894-1964), GAR SPARKS, AND HENRY GLINTENCAMP (1887-1946)
Bla! as reproduced in Bruno's Weekly, February 5, 1916

CHARLES DEMUTH (1883-1935)
Turkish Bath, 1916
Watercolor on paper, 7 5/8 x 11 (19.4 x 28)
Fogg Art Museum, Harvard University Art Museums; Loan from Private Collection

MARCEL DUCHAMP (1887-1968)
Three Standard Stoppages, 1913-14
Assemblage of thread, canvas, glass, and wood, 11 1/8 x 50 7/8 x 9 (129.2 x 22.9 x 28.3)
The Museum of Modern Art, New York; Katherine S. Dreier Bequest

Chocolate Grinder, No. 2, 1914
Oil, thread, and graphite on canvas, 25 9/16 x 21 1/4 (65 x 54)
Philadelphia Museum of Art; The Louise and Walter Arensberg Collection

The Bride Stripped Bare by Her Bachelors, Even (Large Glass), 1915-23
Oil and lead wire on glass; 109 1/4 x 69 1/8 (277.5 x 175.5)
Philadelphia Museum of Art; Bequest of Katherine S. Dreier

Comb, 1916
Readymade comb, 6 1/2 x 1 1/4 (16.5 x 3.2)
Philadelphia Museum of Art; The Louise and Walter Arensberg Collection

"Archie Pen Co.," 1921
Magazine advertisement in The Arts, 1 (February-March 1921), p. 64

MARCEL DUCHAMP (1887-1968) AND WALTER ARENSBERG (1078 1054)
Concept of Nothing, c. 1915
Ink on paper
Philadelphia Museum of Art; Arensberg Archives

ALBERT GLEIZES (1881-1953)
"La Peinture Moderne," in Francis Picabia, ed., 391, no. 5 (June 1917)
Yale Collection of American Literature, Beinecke Rare Book and Manuscript Library, Yale University, New Haven

RUBE GOLDBERG (1883-1970)
Untitled, cartoon reproduced in Marcel Duchamp and Man Ray, eds., New York Dada (April 1921)
Philadelphia Museum of Art; The Louise and Walter Arensberg Collection

ROBERT HENRI (1865-1929)
Cori Looking Over the Back of a Chair, 1907
Oil on canvas
Whereabouts unknown

MINA LOY (1882-1966)
Virgins Plus Curtains Minus Dots, Reproduced in Allen Norton, ed., Rogue, no. 2 (August 15, 1915)
Yale Collection of American Literature, Beinecke Rare Book and Manuscript Library, Yale University, New Haven

FRANCIS PICABIA (1878-1953)
Nature Morte: Portrait of Cézanne/Portrait of Renoir/Portrait of Rembrandt, 1920
Stuffed monkey mounted on board, whereabouts unknown
As reproduced in Cannibale, April 25, 1920

MAN RAY (1890-1976)
Self-Portrait, 1916
Gelatin silver print, 3 13/16 x 1 13/16 (9.7 x 4.6)
J. Paul Getty Museum, Malibu

Danger/Dancer or L'Impossibilité, 1920
Airbrush on glass, 25 3/4 x 14 1/8 (65.4 x 35.9)
Private collection

La Femme, 1920
Gelatin silver print, 15 3/8 x 11 3/8 (39 x 29)
Musée national d'art moderne, Centre George Pompidou, Paris

L'Homme, 1920
Gelatin silver print, 15 3/8 x 11 3/8 (39 x 29)
Marguerite Arp Foundation, Lugano

Rrose Sélavy, 1921
Gelatin silver print
Philadelphia Museum of Art; Samuel and Vera White Collection

Letter to Tristan Tzara, n.d.
Ink and gelatin silver print on paper
Bibliothèque Littéraire Jacques Doucet, Paris

KATHARINE N. RHOADES (1885-1965), AGNES ERNST MEYER (1887-1970), MARIUS DE ZAYAS (1880-1961)
Woman, in Alfred Stieglitz and Marius de Zayas, eds., 291, no. 2 (April 1915)

HENRI-PIERRE ROCHÉ (1879-1959)
Photograph of Duchamp's 33 West 67th Street Studio with Hanging Hat Rack, 1917-18
Gelatin silver print, 2 3/4 x 1 7/8 (7 x 4.8)
Philadelphia Museum of Art; Lent by Mme. Marcel Duchamp

KURT SCHWITTERS (1887-1948)
Merz 19, 1920
Paper collage, 12 9/16 x 9 (31.7 x 23.1)
Yale University Art Gallery, New Haven

JOSEPH STELLA (1877-1946)

Man in Elevated (Train), 1916
Oil, wire, and collage on glass, 14 1/4 x 14 3/4 (36.2 x 37.5)
Washington University Gallery of Art, Saint Louis; University
Purchase, Kende Sale Fund

Study for Skyscraper, c. 1922, whereabouts unknown
Reproduced in Margaret Anderson and Jane Heap, eds., *The Little
Review*, 9, no. 3 (Autumn 1922)

CLARA TICE (1888-1973)

Virgin Minus Verse, in Allen Norton, ed., Rogue, no. 2
(August 15, 1915)
Yale Collection of American Literature, Beinecke Rare Book and
Manuscript Library, Yale University, New Haven

UNKNOWN ARTIST

Multiple photograph of Chico Marx, c. 1909,
in Groucho Marx and Richard J. Anobile, *The Marx Brothers
Scrapbook* (New York: Harpers, 1973)

Marcel Duchamp's Studio
33 West 67th Street, 1917–18
Photograph with pochoir coloring, 1940
Private collection

"do you want to know what a dada is?," 1921
Invitation card for the Société Anonyme
Scrapbook of Katherine S. Dreier, Yale Collection of American
Literature, Beinecke Rare Book and Manuscript Library,
Yale University, New Haven

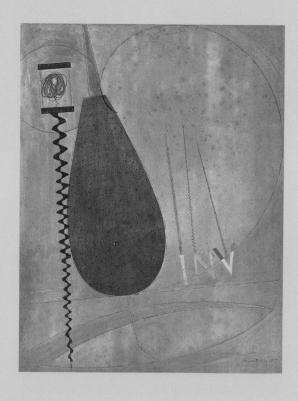

Man Ray, INVOLUTE, 1917

ARTIST BIOGRAPHIES: PHOTOGRAPH CAPTIONS

Louise Arensberg, c. 1917-18, photograph by Beatrice Wood,
copy photo by Donald William Seban (p. 178, top)

Walter Arensberg, 1928 (p. 178, bottom)

Beatrice Wood, c. 1917, photograph by Jessie Tarbox Beals
(p. 182)

Baroness Elsa von Freytag-Loringhoven, photograph
courtesy Papers of Elsa von Freytag-Loringhoven, Special Collections,
University of Maryland at College Park Libraries (p. 184)

Marius de Zayas (p. 186)

Man Ray, 1915, photograph by Alfred Stieglitz © 1996 Artists
Rights Society (ARS), New York/The Man Ray Trust/ ADAGP, Paris &
SPDA, Tokyo (p. 188)

Marcel Duchamp, 1915, photograph by Pach Brothers,
from *Vanity Fair*, September 1915 (p. 189)

Joseph Stella, courtesy Archives of American Art, Smithsonian
Institution (p. 190, top)

Clara Tice (p. 190, bottom)

Florine Stettheimer, c. 1914, courtesy Rare Book
and Manuscript Library, Columbia University Library (p. 192)

Charles Demuth, 1922, photograph by Alfred Stieglitz, courtesy
The Metropolitan Museum of Art, Alfred Stieglitz Collection, photograph
© All rights reserved, The Metropolitan Museum of Art (p. 194)

Francis Picabia, 1915, photograph by Alfred Stieglitz, courtesy
National Gallery of Art, Washington, D.C., Alfred Stieglitz Collection 1949
(p. 196)

Jean Crotti, photograph by Alan Zindman (p. 197)

John Covert, c. 1917, courtesy Charles Covert Arensberg,
Pittsburgh (p. 198)

Morton Livingston Schamberg, 1913-18, photograph
by Charles Sheeler, courtesy Museum of Fine Arts, Boston, The Lane
Collection (p. 200)

Katherine Dreier, c. 1910, courtesy Beinecke Rare Book and
Manuscript Library, Yale University, La Société Anonyme (p. 202)

Juliette Roche, c. 1917, courtesy Albert Gleizes Foundation,
Paris (p. 204)

Stuart Davis, c. 1930, © Estate of Stuart Davis/Licensed by VAGA,
New York (p. 206)

Arthur G. Dove, 1911, photograph by Alfred Stieglitz, courtesy
The Art Institute of Chicago, Alfred Stieglitz Collection, photograph ©
1996, The Art Institute of Chicago (p. 207)

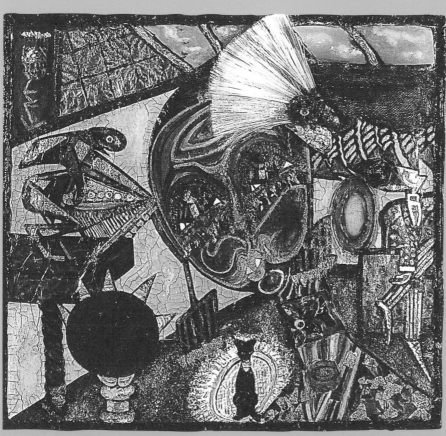

Baroness Elsa von Freytag-Loringhoven,
DADA PORTRAIT OF BERENICE ABBOTT, c. 1922–23

Notes on the Contributors

TODD ALDEN is an artist, etc. His most recent publication is *Collector's Shit (Todd Alden Collection): *Detachment from the Collection.*

ALLAN ANTLIFF is currently completing his dissertation, "The Culture of Revolt: Art and Anarchism in America, 1908-1920," at the University of Delaware. His article "Carl Zigrosser and the Modern School: Nietzsche, Art, and Anarchism," was recently published in the *Archives of American Art Journal.*

JAY BOCHNER teaches English at the University of Montreal and is writing books on Albert Gleizes, Blaise Cendrars, and Alfred Stieglitz.

ABRAHAM A. DAVIDSON is professor of art history at the Tyler School of Art, Temple University. His previous books include *Early American Modernist Painting, 1910-1935*; his most recent book is *Ralph Albert Blakelock.*

LINDA DALRYMPLE HENDERSON, professor of art history at the University of Texas at Austin, is the author of *The Fourth Dimension and Non-Euclidean Geometry in Modern Art. Duchamp in Context: Science and Technology in the "Large Glass" and Related Works* will be published in 1997.

AMELIA JONES is an associate professor of contemporary art and theory at the University of California, Riverside. She is the author of *Postmodernism and the En-Gendering of Marcel Duchamp.* She recently curated "Sexual Politics: Judy Chicago's *Dinner Party* in Feminist Art History," an exhibition at UCLA's Armand Hammer Museum of Art, for which she also co-authored the catalogue.

ROSALIND KRAUSS is Meyer Schapiro Professor of Modern Art and Theory at Columbia University and a founding editor of *October.* She is the author of numerous books on art and the avant-garde, including *The Optical Unconscious.* She has also guest curated several major exhibitions, most recently, *L'Informe: mode d'emploi* at the Centre Georges Pompidou, Paris.

FRANCIS M. NAUMANN has written extensively on Marcel Duchamp, Man Ray, and New York Dada. He is the author of *New York Dada 1915-23* and the forthcoming *Marcel Duchamp: The Art of Making Art in the Age of Mechanical Reproduction*, the editor of Marius de Zayas' *How, When and Why Modern Art Came to New York*, and co-editor of *Marcel Duchamp: Artist of the Century.*

MOLLY NESBIT is associate professor of art at Vassar College. She is the author of *Atget's Seven Albums* and has written numerous articles for *Artforum* and *October.* Most recently she co-authored an essay, "Concept of Nothing: New Notes by Marcel Duchamp and Walter Arensberg," with Naomi Sawelson-Gorse.

ROBERT ROSENBLUM is a professor of fine arts at New York University. He has written numerous articles and books on art from the eighteenth century to the present. He recently joined the Solomon R. Guggenheim Museum as a part-time curator of twentieth-century art.

DICKRAN TASHJIAN, author of *Skyscraper Primitives: Dada and the American Avant-Garde, 1910-1925*, is currently chair of the department of art history at the University of California, Irvine. His most recent book is *A Boatload of Madmen: Surrealism and the American Avant-Garde, 1920-1950.*

BETH VENN is associate curator of the Permanent Collection at the Whitney Museum of American Art. She has recently curated "Joseph Cornell: Cosmic Travels" at the Whitney Museum and "American Art 1940-1965: Traditions Reconsidered. Selections from the Permanent Collection of the Whitney Museum of American Art" at the San Jose Museum of Art.

STEVEN WATSON has written widely on the social constellations of the avant-garde. He is the author of *Strange Bedfellows: The First American Avant-Garde* and *The Birth of the Beat Generation: Visionaries, Rebels, and Hipsters.*

BARBARA ZABEL, professor of art history at Connecticut College, has published widely on American modernism and machine culture. She is currently completing *Assembling Art: The Machine and the American Avant-Garde.*

This publication was organized
at the **Whitney Museum**
by MARY E. DelMONICO, *Head, Publications;*
SHEILA SCHWARTZ, *Editor;* HEIDI JACOBS, *Copy Editor;*
NERISSA DOMINGUEZ, *Production Coordinator;* JOSÉ FERNÁNDEZ, *Assistant/Design,*
SARAH NEWMAN, *Assistant,* & ELIZABETH EDGE, *Intern.*

Design: LORRAINE WILD *with* AMANDA WASHBURN
Printing: Dr. Cantz'sche Druckerei, Ostfildern
Binding: Kunst–und Verlagsbuchbinderei/Leipzig

Printed and bound in Germany